NEEDLEWORK THROUGH HISTORY

An Encyclopedia

Catherine Amoroso Leslie

GREENWOOD PRESS
Westport, Connecticut • London

This book is dedicated to my grandmother, Kay Murphy and my mother, Colleen Murphy Hilliard, who taught me to value the legacy of needlework.

Library of Congress Cataloging-in-Publication Data

Leslie, Catherine Amoroso.
 Needlework through history : an encyclopedia / Catherine Amoroso Leslie.
 p. cm.—(Handicrafts through world history, ISSN 1552–8952)
 Includes bibliographical references and index.
 ISBN-13: 978–0–313–33548–8 (alk. paper)
 ISBN-10: 0–313–33548–6 (alk. paper)
 1. Needlework—Encyclopedias. 2. Needlework—History. I. Title.
TT750L48 2007
 746.403—dc22 2006100691

British Library Cataloguing in Publication Data is available.

Library of Congress Catalog Card Number: 2006100691
ISBN-13: 978–0–313–33548–8
ISBN-10: 0–313–33548–6
ISSN: 1552–8952

First published in 2007

Greenwood Press, 88 Post Road West, Westport, CT 06881
An imprint of Greenwood Publishing Group, Inc.
www.greenwood.com

Printed in the United States of America

The paper used in this book complies with the
Permanent Paper Standard issued by the National
Information Standards Organization (Z39.48–1984).

10 9 8 7 6 5 4 3 2 1

Contents

List of Entries

Acknowledgments

It is recognized that a book of this type is not the work of one person, but the work of many who often go unmentioned. I would like to thank the unknown needleworkers throughout history, whose innovation and creativity enhanced the experience of everyday life. Often illiterate and prohibited from owning property, these talented stitchers left a cultural legacy and their mark on history through needlework. I also thank those who wrote before me, carefully documenting techniques and traditions, often as a labor of love.

The images that accompany this text are due to the generosity of the director, registrar, and staff of the Kent State University Museum. My sincere thanks to Jean Druesedow and Joanne Fenn and their student assistants, Katrina Campbell and Kelly Shultz, who searched databases, closets, and drawers to find examples of needlework from around the world. The textiles were photographed by Erin Burns, whose knowledge and skill in digital imagery was essential in documenting these treasures.

On a personal note, I am deeply grateful for the support of mentors and friends, especially Dr. Carole J. Makela, Dr. Teena Jennings-Rentenaar, and Ellen Swendroski Evett, who provided invaluable insights about organization and presentation of this vast topic. This work was also greatly enhanced by its editor, Debby Adams of Greenwood Press, who not only guided me in writing but had a sincere interest in the history of needlework. Finally, I am thankful for the encouragement of my family and especially my husband, James Leslie, whose continuous belief in my abilities made all the difference.

Introduction

People have been creating and embellishing textiles for thousands of years. Bone needles and seed beads found in Western European caves provide archaeological evidence of early needlework. It is thought that the invention of the needle and the warmth of sewn clothing allowed early peoples to migrate north. In addition to functional purposes, needlework has communicated individual and social identity, spiritual beliefs, and aesthetic ideals throughout time and geography. Needlework, like all handicrafts, is an important part of the human experience, and more specifically, a part of the female experience. With few exceptions, needlework is women's work. Making and using textiles is an integral part of women's culture around the world, with many traditions associated with rituals and celebrations of life events. Often overlooked, doing needlework and creating needlework objects offer insights by documenting the history of everyday life.

Needlework is a broad and encompassing term. On its most basic level, needlework can be defined as making or embellishing textiles using a needle and fiber, thread, or yarn. Included in this definition would be embroidery, which is used to decorate existing fabric, and knitting, which creates a new fabric. A broader definition of needlework includes hand techniques that employ other small tools. This would encompass crochet, which uses a hook, and tatting, which uses a shuttle. Some needlework techniques, like macramé, may not require any equipment. The commonality is that they are household arts. Another unfortunate commonality is that, with the exception of pockets of contemporary enthusiasts, folk traditions, and goods created for trade, the expertise related to many of the skills has been lost to time. This is largely due to the availability of machine-made alternatives and changing preferences in leisure activities.

To explore the history of needlework, this book surveys techniques around the world and through time. Some techniques are defined by the process, for example running stitch, and some by materials, for example mirrorwork. This

text contains a comprehensive listing of general topics, with selected examples to illustrate the diversity of experience and changes over time. There are likely to be traditions that have gone unmentioned, but it is hoped that the examples enhance appreciation of needlework, especially its part in the history of everyday life. A greater familiarity with needlework techniques can help to make connections between history and the objects of material culture found in the collections of local, regional, and national museums.

Some techniques have been excluded, most notably weaving and plain sewing. Weaving has a long and extensive history and warrants its own examination. In plain sewing, existing fabric is cut and shaped into a finished product with a needle and thread. Plain sewing also includes marking, the ancestor of monogramming. More decorative types of stitching are known as fancy sewing, which is synonymous with embroidery. For the purpose of this book, fancy sewing is considered a type of needlework, where plain sewing is not.

There are countless variations on each of the needlework techniques. Some carry similar names, but are very different processes. One example is needlepoint, which most popularly is used to describe embroidery on canvas, but can also describe needle lace. Filet lace generally refers to geometric openwork netting. A similar effect is achieved by looping with a hook and is called filet crochet. Needlework and its practice are constantly changing, with some traditions such as sprang and beadwork dating from the very earliest civilizations. Others, such as latch hooking and needle felting, are late-twentieth-century innovations.

Throughout history, techniques traveled with merchants and explorers, creating a legacy of cross-cultural exchange. Embroidery traditions that began in China were passed along the Silk Road. Many of the Western European traditions originated in the Middle East, and traveled westward to Morocco, then northward into Spain and Italy. Techniques were reinvented by nuns for fine ecclesiastical or church textiles. Boosted by goods brought back during the Crusades, this "nun's work" quickly spread to the rest of Europe. Beginning in the sixteenth century, the English, Spanish, and Portuguese disseminated European techniques around the world through exploration and conquest. Embroidery from China imported by the British East India Company furthered the cross-cultural needlework exchange that continues into contemporary times.

Some techniques, such as cross-stitch embroidery, are virtually universal, but others, such as Native American porcupine quillwork, were confined to areas where quills were adequately available. Seemingly identical techniques are practiced by cultures on opposite hemispheres with little evidence of cross-cultural exchange. A notable example is the reverse appliqué practiced in both South America and Southeast Asia. Some techniques, such as patchwork, originated with settlers and were re-invented as indigenous arts. These examples can lead to a greater understanding of the development of cultural traditions and the historical value of seemingly everyday activities and objects.

This survey of cultural traditions in needlework can inform a wide range of readers, from those unfamiliar with needlework to practitioners seeking a broader understanding of their art. There are several ways to use this book. A general idea of techniques can be learned from the reading the entries. Bibliographic information is provided to allow for more in-depth exploration. Boldface cross-references make connections among related techniques and places of practice. Finally, specific countries are included to allow the reader to identify traditions associated with certain areas of the world, recognizing that place names have changed over time. Whether in regard to a cultural tradition or creative expression, it is hoped that this survey will lead to a greater appreciation of the historical record that is reflected in the practice of needlework throughout the world.

Timeline

Before 3000 B.C.E.	Needles with eyes were used by prehistoric people dating back 30,000 years. Beads of stone and animal teeth were used to decorate clothing as early as 38,000 B.C.E. The buttonhole stitch was used over 8,000 years ago.
	Single needle knitting, a variation of the buttonhole stitch, was used by peoples of ancient Egypt, ancient Peru, and the Judean desert, and dates from 6500 B.C.E. Evidence of the buttonhole stitch was found in Denmark and dates from the Stone Age, around 4200 B.C.E.
	The earliest extant piece of netting was found in Egypt and dated to around 3500 B.C.E. The Chinese were the first to discover the secret of sericulture or silk production around 3000 B.C.E.
3000 B.C.E.– 499 B.C.E.	The metal needle was invented during the Bronze Age (2000–800 B.C.E.). Egyptian kings were ornamented by a net of colored silk thread or beads as early as 2100 B.C.E.
	The oldest extant embroidered pieces were found in Egyptian tombs. Archeological finds revealed that cotton cloth was decorated with embroidery and appliqué in India as early as 2000 B.C.E.
	Sprang was practiced in the Neolithic period at the start of the Iron Age, with the earliest extant examples found in Denmark, Egypt, and Peru dating to 1100 B.C.E.
	The oldest extant examples of chain stitch in China date from the Warring States period (475–221 B.C.E.).
	Macramé and fringe can be seen in Assyrian stone carvings from the Middle East, dated 850 B.C.E.
500 B.C.E.–0	The earliest extant textiles from the African continent were found in Egypt, dating to the fifth century B.C.E.

The Middle East was producing highly developed needlework by the fifth century B.C.E.

The oldest extant Eastern European textiles were found in Siberia, dating from the fourth century B.C.E., with appliqué in use by this time.

Professionally executed embroidered silks and gauzes were being created in China as early as the fourth century B.C.E.

In South America, the Nazca peoples of pre-Columbian Peru created intricate figures in single needle knitting as early as 200 B.C.E.

The oldest extant pieces of wool embroidery date to the first century B.C.E.

1–999 The first double needle or "true" knitting was practiced by the Copts, an Egyptian Christian sect. The earliest examples date from 200 C.E.

Chinese embroidery reached Korea and Japan by the fifth century.

Embroidery, knotting, and other techniques come to Western Europe with the Moors (Moroccans) in 711 C.E.

Although practiced for centuries, the oldest extant piece of cross-stitch dates from about 850 C.E.

1000–1099 The Bayeux Tapestry, documenting the "Norman Conquest," was stitched about 1077. This crewelwork piece reveals many variations in embroidery stitches that were already highly developed by this time, including running stitch, satin stitch, buttonhole stitch, and cross-stitch.

1100–1199 Glass bead net was used to embellish European ecclesiastical clothing.

Knitting reached the British Isles.

1200–1299 The oldest extant pieces of Western European double needle or "true" knitting dates from thirteenth-century Spain.

Smocking emerged on linen clothing worn by agricultural workers in the British Isles.

1300–1399 Blackwork was mentioned in Chaucer's *Canterbury Tales* (1387–1400).

Knitters were portrayed in European paintings and written references.

Records include close-fitting coifs or bonnets netted with gold by nuns.

The earliest extant European bed quilts originated in Sicily. Quilted clothing and bedcoverings were made in France, Germany, Italy, Spain, and England.

1400–1499 The earliest usage of crewel or cruell referred to a thin, worsted yarn.

Raised embroidery embellished ecclesiastical garments in Eastern and Western Europe, including Italy, Germany, Hungary, and Czechoslovakia.

1500–1599 Blackwork became popular for secular clothing with Catherine of Aragon, Henry VIII's first queen.

The earliest written evidence of samplers in Western Europe and the British Isles was recorded in a Spanish inventory.

The indigenous people of South America had early contact with Spain and Portugal.

The earliest gold and silver laces were made in Genoa (Italy). Gold lace was worn by King Gustavus Vasa of Sweden.

Queen Elizabeth I (1558–1603) formalized embroidery practices by granting a charter to the Broiderers' Company in 1561.

The first pattern book for embroidered lace was printed in Germany in 1523. Pattern books were published in Germany, Italy, and France.

The earliest known dated sampler was made in England in 1598.

The first bobbin laces were made around Venice, Italy, and bobbin lacemaking spread quickly to Milan, Genoa, Flanders, and other parts of Europe.

The earliest pattern book entirely concerned with cutwork was published in Venice in 1542.

Over 150 pattern books for lace and embroidery were printed in Western Europe in the sixteenth century.

The first knitted garments were imported into Scandinavia.

Machine needlework began when the stocking frame was invented near Nottingham, England, in 1589.

Printed cross-stitch patterns inspired by Asian designs and symbols were published in Germany, Italy, and France.

Hardanger and Hedebo emerged in the seventeenth century in Denmark and Norway.

1600–1699 Hand knitting was introduced to Ireland. The earliest complete examples of knitted garments—stockings, gloves, a purse, and two caps—date from this time.

Books about needle lace became available for the public.

Silk stockings, gloves, and shirts were commonly worn by the upper class in Denmark and Sweden.

The first knitted sweaters were made.

The first raised embroidery was done by professionals on church vestments.

Knotting was practiced in Western Europe and the British Isles.

1700–1799 There was resistance to the growth of mechanization as early as 1710, when stocking-frame knitters protested in London.

Needle lacemaking had all but died out, replaced by bobbin lace.

Aran Island women established a cottage industry spinning coarse wool.

Ribbon embroidery became part of fashion in the Rococo period.

By 1764, background net could be made on a machine, which negatively affected all lacemaking.

Needlework schools were established for poor children in Ireland, Scotland, and England beginning in the 1760s.

The earliest written documentation of *sashiko* was in 1788, where it was noted as an important traditional craft for its grace and beauty.

1800–1899 A mechanized weaving system was invented by Joseph Jacquard in France in 1801.

The first Berlin work patterns were made by a printer in Germany in 1804.

The bobbin net or bobbinet machine was invented in Nottingham, England, in 1808.

The Luddites destroyed nearly a thousand English needlework machines between 1811 and 1818.

In 1812, a Frenchman started tambour stitch classes for girls in Coggeshall, England.

Colonial Americans opened their first ribbon factory in 1815.

Beetle wings were first seen in Western Europe in the early 1820s.

The first type of crochet pattern was published in Holland in 1824.

The Swiss hand lace machine was invented in 1828.

In the 1830s, four Irish nuns trained in a French convent introduced crochet to Ireland.

In 1830, a French tailor was awarded a patent for a chain stitch machine.

In 1834, a Paris, France, exhibition unveiled a tambour stitch machine.

Queen Victoria took the English throne in 1838, and the Victorian era began.

Lace knitting in the Shetlands started in the 1840s.

The immigration of Scandinavian peoples beginning in 1840 introduced Hedebo and Hardanger to the United States.

The lace industry in Ireland was essential to generate income during the potato famine years around 1846.

In 1847, tatting was introduced as a cottage craft for famine relief. The word tatting appeared in English literature after 1842.

Reverse appliqué *mola* panels of the Kuna peoples began in mid-century.

The chain stitch machine, invented in 1855, could make tambour embroidery on net, harming the market for fine handwork.

By 1856, English chemist William Perkin had developed the first synthetic dye.

In 1857, a Virginia farmer patented the first chain stitch sewing machine in the United States.

The Schiffli embroidery machine was first developed in 1863.

The first successful chain stitch embroidery machine was patented in 1865 by a French engineer.

By 1868 it was difficult to distinguish handmade laces from those stitched by machine.

In the 1870s and 1880s the strong craft revival arts and crafts movement turned away from machines and towards handicraft, until about 1910.

The word "crazy" was first used in 1878, with crazy piecing reaching its peak in the late 1880s and continuing into the 1920s.

Around 1895, a woman from Dalton, Georgia, attempted to copy a candlewick bedspread.

1900–1999 The Embroiderers' Guild in England was established in 1906.

The production of Fair Isle knits for sale was established by 1910.

The Needle and Bobbin Club was established in 1916.

The Prince of Wales, Edward VIII, wore a Fair Isle sweater for a public event in 1921.

The first Aran sweaters were worn by young Irish boys in the late 1920s and early 1930s.

Punch needle or *bunka* embroidery was introduced to America after World War II.

The International Old Lacers organization was founded in 1953.

The Embroidery Research Institute in China was established in 1957.

The Embroiderers' Guild of America (EGA) was established in New York in 1958 as a branch of the Embroiderers' Guild of London.

The needlework revival related to the back-to-nature movement grew in the United States in the late 1960s and early 1970s.

The American Needlepoint Guild (ANG) was formed in 1970. The UN Peace Rug was completed in 1975 and the State Seal Rug completed in 1977.

In 1972, Australian fiber artist Patricia Benson developed the modern locker hooking technique.

The Lace Guild was founded in 1976.

Beginning in the late 1970s, Hmong people immigrated to North America, bringing their rich needlework heritage with them.

Needle felting was developed in the early 1980s by American artisans.

During the 1990s ribbon embroidery became popular in Australia and the rest of the world.

Bosnian crochet was marketed throughout the world, often as part of Fair Trade initiatives such as Bosnian Handicrafts, founded in 1995.

2000 and beyond Contemporary needlework enthusiasts and fiber artists continue needlework traditions and create new innovations.

The Encyclopedia

Africa

The world's second largest and second most populated continent, home to 53 independent countries. Africa can be divided into five regions: Eastern Africa, Middle Africa, Northern Africa, Southern Africa, and Western Africa. Some of the most notable cultural needlework traditions are found in the North African countries of Morocco, Egypt, Algeria, Tunisia, Libya, and Sudan. Other countries with significant traditions include, but are not limited, to Congo (formerly Zaire), Ghana, Nigeria, and South Africa. Many of the rich and complex African needlework pieces are influenced by religion, particularly Islam in the area north of the Sahara Desert. Needlework styles were also influenced by Christianity and Judaism, although to a lesser extent.

The earliest extant textiles from the African continent were found in Egypt, dating to the fifth century B.C.E. Ancient Egyptian textiles survive in part due to the dry and hot climate and also because of burial practices. Beginning in the first century, Christianized Egyptians, or Copts, created detailed embroideries. Coptic textiles were dominated by Christian themes and human figures worked in split stitch, stem stitch (**running stitch**), **satin stitch, chain stitch,** and **needleweaving** in wool thread on linen. Coptic people also used **single needle knitting** to create clothing items such as socks.

The Islamic religion originated in the **Middle East,** spreading along northern Africa from east to west in the seventh and eighth centuries. In Morocco, Muslims founded the city of Fèz in 808, which also had a vital Jewish population. The rise of Islam significantly influenced North African design in that Islamic custom discourages representations of human and animal figures. Popular motifs on African Islamic textiles included the candelabra, tree of life, flowers, eight-pointed stars, geometric shapes, boxes, wheels, jagged teeth, intertwined knots, and the crescent moon.

The Islamic Mamluk dynasty ruled parts of the Middle East and Egypt between 1250 and 1517. Mamluk embroiderers created complicated pieces in royal workshops, known as *tiraz,* that were established in Tunisia, Algeria, and Morocco. Working in linen, silk, and wool, Mamluk textiles used the double running stitch and needleweaving. In the late sixteenth century, Jewish people in Fèz were involved in manufacturing gold thread, **lace,** and **embroidery.**

Embroidery is the most common needlework technique worked on the African continent, although **patchwork, appliqué,** and forms of **knitting** were also practiced. For example, the Dervishes of Sudan showed their rejection of the material world by wearing robes made of patchwork, and men's societies in Ghana make appliqué banners and flags that convey allegorical messages. A fascination with ancient Egypt following the discovery of the tomb of Tutankhamen in 1922 led Egyptian tent and awning makers to make appliqué versions of tomb paintings for the commercial market. Mostly practiced in **Western Europe** and the United States, **Tunisian crochet** may have evolved from hooked knitting, which was practiced in Egypt, Afghanistan, and Tunisia.

In the North African countries of Morocco, Algeria, and Tunisia, popular embroidery stitches and techniques include the **buttonhole stitch** and eyelet,

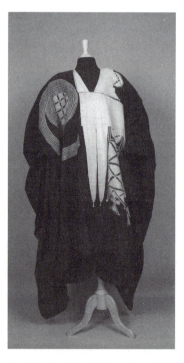

Hand-embroidered Nigerian chief's robe, mid- to late twentieth century. KSUM, Silverman/Rodgers Collection, 1985.45.13ab.

chain stitch, **couching,** satin stitch, **metallic threads,** and **pulled threadwork.** Nomadic women living in the oases of Western Egypt use red **cross-stitch** to embellish their black dresses. This tradition is related to Palestinian embroidery in the Middle East. **Blackwork** originated in Morocco, which was the home of the Moors who settled in southern Spain beginning in 711 A.D. The Moors developed an embroidery style of geometric motifs outlined in black on a white ground that were later adapted by the Spanish, and subsequently by other Western Europeans. Also known as "Spanish work," blackwork is characterized by "Arabesque" designs in repeating step and box shapes. In North Africa, both men and women embroider, decorating costumes, towels, tablecloths, pillow covers, wall hangings, and animal trappings.

In the West Africa country of Nigeria, chain stitch is used to create linear designs on men's "eight knives" shirts. Most of the finest embroidery is worn by men for ceremonial purposes. Detached buttonhole stitch or **single needle knitting** is also practiced. Most of the embroidery on clothing in West Africa is done by men. Throughout Africa, **embellishment**s are used on clothing, often with symbolic meanings. Cowrie **shells** from the Indian Ocean have been used in parts of Africa for 4,000 years. In the past, cowrie shells formed a part of a woman's marriage price or dowry. Today, the shells are used for decorative rather than nuptial purposes, often mixed with **beadwork.** Cowrie shells are thought to resemble an eye and are used for protection from the evil eye. A tradition practiced among the Zulu people of South Africa involved densely sewn or woven bead belts and bands. Usually made in white and red, bead belts or "love letters" conveyed messages. The arrangement and coloring of beads on a young girl's belt signified her romantic intentions.

A notable African cultural tradition is practiced by the Kuba people of Congo (formerly Zaire). Raffia fibers are used to embellish skirts and decorative squares in a number of different techniques including embroidery, appliqué, **reverse appliqué,** and patchwork. Fine-quality raffia cloths made in Africa were admired and collected by Western Europeans. For example, a sixteenth-century Portuguese painting depicts the Virgin Mary and an angel kneeling on raffia cloth. The abstract patterning of Kuba raffia inspired modern artists including Klee and Matisse, who displayed his large collection on a wall of his studio. Raffia cloth uses the same patterns as other Kuba art forms, including wood sculpture, metalwork, and women's body scarification.

Raffia cloths were worn for ceremonial occasions, which are quite rare today, but the tradition continues for funerary purposes. The most difficult and prestigious decoration is cut-pile embroidery. A small square could take as long as a month to complete. Embroidery designs are drawn from a large repertoire of patterns, with at least 200 known by name. The most common are the comma-shaped "tail of a dog" and lozenges punctuated with circles worked in eyelet stitch. Larger pieces are made with appliqué and patchwork. Kuba men are responsible for decorating their own skirts, while women decorate female dancing skirts and cut-pile embroidered panels. There is considerable variation in quality in contemporary

raffia work, especially that done for tourists. In a poor and often tumultuous society, raffia pieces are a source of pride and provide income and employment.

FURTHER READING

Clarke, Duncan. (2002). Kuba Raffia Cloth. Online: http://www.adire.clara.net/kubaintro. htm.

Denamur, Isabelle. (2003). *Moroccan Textile Embroidery.* Paris: Flammarion.

Gillow, John, & Bryan Sentance. (1999). *World Textiles: A Visual Guide to Traditional Techniques.* Boston: Little, Brown.

Gotstelow, Mary. (1977). *The Complete International Book of Embroidery.* New York: Simon and Schuster.

Harris, Jennifer. (1999). *5000 Years of Textiles.* London: British Museum Press.

Kennett, Frances. (1995). *Ethnic Dress.* New York: Facts on File.

Appliqué

A general term for adding pieces of material to an existing ground fabric. Rather than creating a new textile, appliqué is a decorative technique usually used for **embellishment.** It may have developed from the practice of sewing patches to damaged cloth and in many cultures is associated with poverty and renunciation of material goods. A wide range of fabrics can be used for appliqué. The most common are cloth, felt, and leather, although any flat material can be appliquéd, including fish skin.

Appliqué has been practiced since ancient times. Archeologists have dated an Egyptian canopy of appliquéd leather to 980 B.C.E. Tomb excavations in Siberia and Mongolia found leather and felt appliqué on carpets, saddle covers, and wall hangings from the fourth century B.C.E. Throughout history, appliqué has been frequently used for creating banners and embellishing military uniforms.

There are three main types of appliqué. The first and most common is called overlaid appliqué. In this technique, pieces are cut out and applied, leaving areas of the ground fabric visible. In inlaid appliqué, a piece of contrasting fabric is cut to fit exactly into a hole in the ground fabric. The third and most complicated type is called **reverse appliqué** or *mola*. In reverse appliqué, motifs are cut from layers of fabric and edges of the holes turned under to reveal the fabrics underneath.

Felt and leather are ideal for overlaid appliqué because they do not fray and are quite durable for clothing and other utilitarian items. Strong traditions for embellishing sheepskin jackets and vests with appliqué are found in the folk dress in **Eastern Europe,** Russia, and **Scandinavia,** most notably in Hungary,

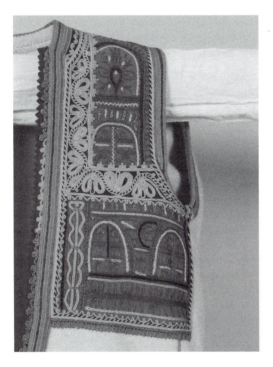

Nineteenth-century Eastern European vest heavily embellished with appliquéd braid. KSUM, transferred from the Allen Memorial Art Museum, Oberlin College, Oberlin, Ohio. Gift of Mary L. Mathews, 1944, 1995.17.134.

Bulgaria, Romania, the Baltics, Ukraine, Turkmenistan, Siberia, Greenland, Iceland, Sweden, and Lapland. These traditional costumes include tassels, braid, pom-poms, floral **embroidery,** and leather appliqué with shapes cut of leather, punched with holes, and secured with a sewing machine. Leather appliqué is also found in Pakistan, where it is coupled with embroidery in thick thread or couched **metallic thread** braids to embellish covers and men's clothing. Furthermore, traditional Moroccan leather slippers are often decorated with embroidery and leather appliqué.

Felt appliqué is common in many parts of the world. It has been traditionally been used by the nomadic tribes of **Central Asia** to embellish bags for the struts of their yurts (or tents), camel trappings, and most notably for counterchange floor coverings. In counterchange appliqué, felt fabric is folded and repetitive patterns are cut out. The resulting motifs are mirror images of each other. In Eastern Europe, felt appliqué is used to decorate in home furnishings such as mats and folk aprons. Women's aprons are an important part of traditional dress and are thought to provide spiritual protection.

If overlaid pieces are made of a woven fabric, rather than felt or leather, the edges must be hemmed. Appliqué motifs are cut out and tacked onto the ground fabric. Then the edges are turned in and sewn under using a hem or slip stitch. Overlaid appliqué traditions using woven fabric with turned-in edges are widespread throughout the world. For example, in **Africa**, Asafo men's societies of Ghana display cotton appliquéd flags with allegorical messages. The Kuba of the Congo (formerly Zaire) create dance skirts in raffia **patchwork** and appliqué.

On the **Indian Subcontinent,** appliquéd cloths have several uses, including covers to hide piles of quilts as well as brides being taken to their husbands' villages on ox-carts. *Chakla's* are square hangings with dense appliqué, **mirror-work,** and embroidery created in Northwest India. Appliquéd cloths serve religious purposes when Hindu and Muslim pilgrims leave cloths as shrine offerings in Uttar Pradesh, India. In China, boldly colored appliqué was used to decorate the coats and collars of officials from Manchuria. The appliqué work was often accompanied by embroidery in **cross-stitch, satin stitch, pulled threadwork,** laid work, and **couching.** Overlaid appliqué is also an important tradition in **East and Southeast Asia.**

Overlaid appliqué has been traditionally used in **Western Europe** and the Americas, too. Native North Americans embellished clothing and other items with appliqué in various materials, including fish skin in Alaska and western Canada. In **South America,** Mexican festival dress is embellished with appliqué, and appliquéd hangings featuring depictions of the peasant lifestyle are popular among tourists in Colombia. The technique known as **whitework** often includes appliqué, and a popular type of **quilting** includes floral motifs appliquéd on a white background. Appliqué of printed chintz flowers on a solid fabric foundation was popular in the late nineteenth century and known as *broderie perse.*

Lace-like fabrics can also be created with overlaid appliqué. Beginning in the early nineteenth century, motifs made of lace, **netting,** or muslin were hand-applied to a machine-made ground using **buttonhole** and **chain stitch.** Made in Belgium and the **British Isles,** these types of appliquéd laces include Brussels, Honiton, and Carrickmacross. The appearance of appliquéd laces was eventually reproduced on Swiss hand embroidery and Schliffli machines. Appliqué was a popular embellishment technique used on fancy cloaks and capes in the 1890s, along with passementerie braids and **cutwork.**

Inlaid appliqué involves cutting motifs out of the foundation material and fitting other fabrics within the spaces. The seams that join the two are hidden by one or more rows of chain stitch or couched braids of gold or silver. This method is used for appliqué tent hangings, which include complex designs such as Arabic calligraphy and are created by the nomadic Berbers and other peoples of the **Middle East.** Patchwork is also a form of inlaid appliqué that has been associated with frugality and the rejection of material goods. The inlaid technique is used in sawtooth edging on quilts and wall hangings in many parts of the world. In sawtooth edging, triangular points of fabric are pieced together to form border patterns.

South American appliqué table runner in red and white, twentieth century. KSUM, gift of the Vera Newmann Collection, 1989.63.60.

Finally, the technique of reverse appliqué or *mola* is most commonly associated with the Kuna Indians of Panama and the H'mong peoples of Vietnam and Cambodia. Rather than adding material to a foundation, layers of woven fabric are stacked on top of each other and pieces cut away to create the motif. Although reverse appliqué takes fabric away rather than adding it, the edges are finished in a similar method to overlaid appliqué using slip stitches.

All forms of appliqué continue to be practiced by traditional and contemporary needleworkers. The Appliqué Society was founded in 1997 to promote, teach, and encourage the art of appliqué. The society publishes newsletters, holds national meetings, and has local chapters in many areas in the United States and abroad. Contemporary fiber artists appliqué a variety of materials to create wall hangings, quilts, and wearable art.

FURTHER READING

The Appliqué Society. Online: www.theappliquesociety.org.
Central Rappahannock Regional Library. Online: www.answerpoint.org.
De Dillmont, Thérése. (1996). *The Complete Encyclopedia of Needlework* (3rd Ed.). Philadelphia: Running Press. (First published by Dollfus-Mieg Company, France, in 1884.)

Gillow, John, & Bryan Sentance. (1999). *World Textiles: A Visual Guide to Traditional Techniques.* Boston: Little, Brown.

Gotstelow, Mary. (1977). *The Complete International Book of Embroidery.* New York: Simon and Schuster.

Aran

Knitting in complex bold, raised patterns of cables and bobbles named for the Aran Islands off the Atlantic coast of Ireland. Harsh weather made warm woolen clothing necessary, especially for fishermen. The twists and turns of the close-knit Aran patterns create air pockets that help to insulate from cold air. These textured knitting patterns were used to make socks, hats, and vests, but the most common application is the "fishermen sweater." Originally Aran sweaters were knitted in undyed unscoured wool that retained its natural sheep lanolin, providing water resistance and insulation even when wet. There are specific stitches and patterns used in creating Aran knits, although the term "Aran" has come to describe any highly decorative knit stitch pattern.

Aran knit sweaters are relatives of the heavy woolen patterned sweaters worn by French, English, and Scottish fishermen. These sweaters are known as **gansey,** from the Gaelic word "geansaí," meaning Guernsey, one of the Channel Islands located between France and England. Both ganseys and Aran sweaters are quite square with shortened sleeves that would not become wet while fishing. Ganseys generally have patterning across shoulders. A similar style is seen in Aran sweaters said to be made "in the old manner," with moss and stocking stitch in horizontal bands across the yoke and the tops of the sleeves. Photographs and written documentation show this type of sweater worn by Aran fishermen in 1907.

The sweater patterns have been attributed to ancient designs shown in the *Book of Kells,* an illuminated manuscript made by Celtic monks around 800 A.D. The motifs have also been linked to stone carvings on megaliths around Northern and **Western Europe.** Although the Aran patterns have a similar aesthetic to these ancient sources, their application to knitting is unsubstantiated. Hand knitting was first introduced to Ireland in the seventeenth century, and by the mid-eighteenth century, Aran Island women had established a cottage industry spinning coarse wool and knitting stockings, which they sold to pay their rent. Knitting was a communal activity, and the complicated knitting patterns evolved over time. Patterns were rarely written down; knowledge and skills were passed from one generation to the next. New patterns were disseminated by word of mouth, and women actively sought to duplicate a new stitch in their own knitting work.

Eventually the leap was made from stockings with patterned tops to larger garments with knitted-in decoration. The first Aran sweaters were worn by young island boys in the late 1920s and early 1930s, when family members began to create special sweaters for boys to wear for their first Holy Communion. As a source of family pride visible to the community, great effort went into the patterning. In addition to Holy Communions, sweaters were made for other sacramental occasions, like weddings. The association of the Aran sweater with family may be the origin of the myth that different stitch patterns can be identified with a particular clan.

A commonly believed and perpetuated story is that each family had a sweater with a unique design, so that if a fisherman drowned and was found on the beach, his body could be identified. There is little evidence for this claim, but the origin of the story may have come from a 1904 play, where the body of a dead fisherman was identified by the handknit stitches on one of his garments. However, the garment was actually plain and was identified by the number of stitches rather than by decorative pattern. The link between Aran patterns and family identification is more likely a type of marketing tool for a cottage industry. With the lack of employment and famine in Ireland, hand knitting, weaving, and other home crafts were encouraged as a way to generate income in poor rural communities. Over time, many knitters had favorite stitches and pattern combinations that they reused often, becoming easily recognizable. An official register of these historic patterns has been compiled by the Aran Sweater Museum.

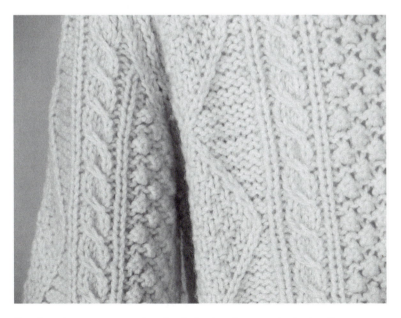

Handknit Aran sweater purchased in Ireland, early 1980s. Author's collection.

The Aran sweater usually features four-to-six texture patterns positioned vertically in two-to-four inch wide columns. The patterns are symmetrical on either side of the center front and extend down the sleeves as well. There are over 20 traditional stitches used in Aran knitting that have come to have religious or spiritual significance. The honeycomb represents the hard-working bee, the cable stands for safety and good luck when fishing, and the diamond is a wish of success wealth and treasure. Patterns known as the Ladder of Life and Holy Trinity have obvious religious links. The Tree of Life is one of the original stitches found in the earliest examples of Aran knitwear. It represents a desire for unity, with long-lived parents and strong children.

Up until the 1970s, most Aran sweaters were hand knit with homespun yarn. As the island people were isolated and **needles** were often scarce, some women knit with goose quills, willow branches, and even bicycle spokes. A finished sweater contains approximately 100,000 stitches and can take a knitter up to 60 days to complete. Initially, Aran sweaters were knitted like socks "in the round," using four needles and having no seams.

The first Aran-type sweaters were sold to the public in 1935. In 1930, the Irish Homespun Society opened a store in Dublin called the Country Shop. A few years later the owner visited the Aran Islands and began buying hand knits from local women. Some early examples of these sweaters, dating from the 1930s, 1940s, and 1950s, are in the collection of Dublin's National Museum. Knowledge of Aran designs spread when knitting patterns were published in the 1940s by Patons of England and, in the United States, *Vogue* magazine featured Aran sweaters in 1956. In the late 1950s, an Irish government grant funded an effort to teach Aran women to make garments using standard international sizing. This led to a growth in exports to **North America.** As demand grew, companies started supplying the island women with needles and wool, recruiting more and more knitters, and making knitting part of the island's subsistence economy.

Today, Aran sweaters made by machine or by hand are standard items in Irish tourist shops. Sweaters made in cashmere, alpaca, mohair, linen, and silk can be found in elegant boutiques in Paris, New York, London, Milan, and Tokyo, Japan. The demand for Aran sweaters continues to grow. The lack of skilled knitters and the economic gains to be had from machine production of the sweaters has resulted in a huge reduction in the number of hand knits available. Authentic handknit Aran sweaters have become rare and valuable. They are highly sought after for their quality, history, and heritage. It is possible to buy imitations as far away as Katmandu in Nepal.

FURTHER READING

Achill Knitwear. Online: http://www.achillknitwear.com/Aranknit1.html.
Aran Sweater Market. Online: http://www.clanArans.com/ca/catalog/.

Aran sweaters—a little history. Online: http://www.inverallanhandknitters.co.uk/history.htm.
Family or Clan Aran Sweaters. Online: http://www.dochara.com/tips/Aransweater.php.
Gillow, John, & Bryan Sentance. (1999). *World Textiles: A Visual Guide to Traditional Techniques.* Boston: Little, Brown.
Haggerty, Bridget. (2005). Aran Isle Sweaters—how a dropped stitch gave rise to a popular myth. Irish Culture and Customs. Online: http://www.irishcultureandcustoms.com/AEmblem/Sweaters.html.
Wikipedia. Aran sweater. Online: http://en.wikipedia.org/wiki/Aran_sweater.

Beadwork

The art of using beads to embellish an existing structure or incorporating beads in a textile as it is created. Beads are generally small, often round, pieces of material with a hole that is used for stringing or threading. Beads can be made of glass, metal, wood, **shell,** plastic, seeds, clay, and resin. They are forms of **embellishment** along with shells, sequins, coins, buttons, chains, **feathers and beetle wings,** and fish scales. Beadwork is primarily used to fashion jewelry and adorn clothing, but also creates striking wall pieces and sculptures. Beadwork has been used since prehistoric times as a symbol of status, wealth, and power. In some cultures, beads are thought to provide spiritual and magical protection. For example, red beads ensure fertility and vitality, and blue beads provide protection against the evil eye in the **Middle East** and **Central Asia.**

Trade routes and diplomatic relations were designed around the exchange of beads and trinkets. Explorers and colonists often used beads as currency; for example the English purchased Manhattan Island, now the site of New York City, from the Mohawk people for trade goods, which included glass beads. Among the most coveted beads were those made of gold and ivory from **Africa,** precious stones from the **Indian Subcontinent,** amber from the **Eastern Europe,** glass from Italy, jade from **Western Asia,** lapis lazuli from Afghanistan, and coral from the **Eastern Mediterranean.**

Beads made from stone and animal teeth were discovered in France, and the oldest extant piece of beadwork dates to around 3000 B.C.E. Excavated in Switzerland, it is a fragment of two woven sections joined together with knotted **netting.** The lower piece is ornamented with beads made from little hollow seeds with the ends cut off. All beadwork begins with threading beads onto a yarn or string. After that, they can be embroidered onto the surface of a textile or incorporated into a fabric through weaving, netting, **crocheting, knitting,** or **knotting.**

Using a **needle,** beads can be sewn on individually, attached in a row together, or couched onto the fabric surface. Attaching beads in rows was the most common

method used by Native North Americans. Misunderstanding of the intricacies of beading and stereotyping led to the technique being named the "lazy stitch." In recent years, this method has become known as the "lane stitch." Another method, **tambour** beading, uses a small hook and **chain stitch** to attach beads, sequins, mirrors, silk thread, chenille, braid, and **metallic thread.** The finest tambour work is done by the House of Lesage in Paris, France. From 1860 to the present day, Lesage has been the preeminent embroiderer for the haute couture designers.

Alternatives to sewing beads onto a base fabric are to weave them on a loom, create a beaded net, or use them in crochet and knitting. Bead weaving is a popular method of making decorative belts and bands in Africa and was used by Native Americans to construct wampum and other decorative objects. Bead netting can be traced back to ancient Egypt where mummy shrouds and clothing were created in netting with faience (quartz ceramic) bugle-shaped beads.

As early as 1100 c.e., glass bead net was used to embellish European ecclesiastical clothing. France produced fine beadwork including a group of purses and shoes decorated with motifs commemorating the first successful launch of a hot-air balloon in 1783. Some of the most exquisite beadwork was created during the Victorian period, when bags, clothing, and home furnishings were embellished with bead netting, crochet, and knitting. An unrelated use of the word "bead" emerged during this time and continues to be used today. "Bead edge" or

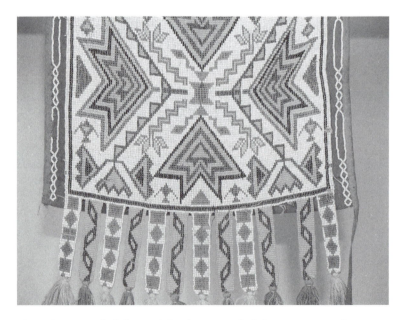

Native American cloth bag with bead-woven embellishment, nineteenth century. KSUM, gift of Mrs. Randolph R. Fawcett, 1986.34.1ab.

"beading" is used to describe a narrow border of bobbin or eyelet **lace** with holes through which ribbons are threaded. Beading of this type is often seen on lingerie and children's clothing.

Cultural traditions using beadwork can be found throughout the world. In Africa, Indonesia, and Polynesia densely sewn, bead-encrusted textiles are common. Young South African Zulu women weave beaded "love letters" to give to young men as part of the courtship ritual. The arrangement and coloring of the beads convey an allegorical message. In Nigeria, bead netting embellishes the elaborate headdresses of the Yoruba tribe. Taman women in Indonesia wear beadwork skirts and shell-work jackets. Coconuts wrapped in a bead net decorated with good luck symbols, such as the swastika, are made for wedding parties in India.

In Brazil, a rich cultural melding of Native American, Western European, and African influence can be seen in embroidered bead designs. Native North Americans are well-known for their beadwork and other embellishments. After the arrival of the Europeans in **North America,** glass beads quickly replaced porcupine **quillwork** and shells on the clothing of the Plains tribes. The majority of beadwork was done on brain-tanned leather, although the Woodlands tribes also beaded on imported

Native American pipe bone bead necklace, early twentieth century. KSUM, Silverman/ Rodgers Collection, 1983.1.998.

velvet or wool trade cloth. Bead netting can be found on Native American shoulder and chest ornaments, collars, capes, aprons, and head pieces.

During the late nineteenth and early twentieth centuries Native Americans in the Niagara Falls region created "whimsies," beaded stuffed and padded objects, for sale to tourists. Shaped like hearts or high-heeled boots, whimsies were embellished with crystal glass beads. They were purely decorative and were often mistakenly used as pin cushions. Variations of bead fashions have come and gone throughout the twentieth century, most notably in the 1920s, 1950s, 1970s, and 1990s. A recent interesting use of beads is found in the work of the contemporary artist Liza Lou. Lou created a 168-square foot kitchen with every pie, every muffin, every bit of cereal entirely covered with beads. It took an estimated 30 million beads and five years to complete her work, which was exhibited at the New Museum of Contemporary Art in New York in 1996. She continues to create art installations using beads as the medium.

FURTHER READING

Bead Netting History. Online: http://www.beadwrangler.com/samplers/netting1/bead_netting_history.htm.

Gillow, John, & Bryan Sentance. (1999). *World Textiles: A Visual Guide to Traditional Techniques.* Boston: Little, Brown.

Gotstelow, Mary. (1977). *The Complete International Book of Embroidery.* New York: Simon and Schuster.

Native Languages of the Americas. Online: http://www.native-languages.org/beadwork.htm.

Nicholas, Jane (2004). *The Stumpwork, Goldwork, and Surface Embroidery Beetle Collection.* Bowral, NSW, Australia: Sally Milner Publishing.

Berlin Work

A type of **needlepoint** done in soft brightly colored wool using a pre-printed pattern. Berlin work originated in Germany and was very popular in England, France, **North America,** and Australia from 1820 to 1880. The printed patterns of Berlin work replaced the time-consuming task of custom drawing patterns, allowing the stitcher to follow a chart in a sort of "paint-by-number" style. It was executed in many colors, creating a three-dimensional appearance through shading. Berlin work became the dominant needlework fashion in the mid-to-late nineteenth century after **samplers** and **cross-stitch** went into decline. When Berlin work first began, high-quality, fine canvaswork was being done in **Western Europe,** most notably still life images in silk tent stitch. Although

skilled stitchers continued to create fine needlepoint into the 1840s, their work was largely overshadowed by the less-complicated Berlin work.

Berlin work was simple to stitch, requiring little skill to follow the colored chart. The term Berlin work was in use as early as 1847, becoming almost synonymous with all types of canvas work.

The first Berlin work patterns were made by a printer in Germany as early as 1804. Printed on paper in black and white and then hand-colored, they quickly were improved when done on charted paper, much like cross-stitch patterns today. The graph paper made the patterns easier to follow, and with the patterns published as single sheets, Berlin work was affordable to the masses. Exported throughout the world, it is estimated that 14,000 different designs were published between 1810 and 1840. Eventually, the patterns were painted or printed onto the canvas itself. Berlin wool work was primarily done in tent and cross-stitch and embellished with silk thread, chenille yarn, and **beadwork.** It gained even more attention when Berlin work was exhibited in England's Great Exhibition of 1851. Eventually, a pile stitch, also known as plush stitch, was added to give the pieces three dimensionality. Elaborate plush-stitch pictures were sent out for professional cutting and shaping. Over time, the designs became uninteresting and the stitching coarse. Berlin work gained a reputation for a profusion of dust-collecting amateurish knick knacks, discredited by social critics, including Mark Twain.

The craze for Berlin work was bolstered by experiments in dye technology, which began in the 1830s. By 1856, English chemist William Perkin had developed the first synthetic dye, made from coal-tar chemicals. Perkin's dye, known as "mauvine," resulted in a variety of shades of purple, magenta, and violet. Although it began in England, the center of dye technology quickly became Germany, where it remained until World War I.

Berlin work also benefited from societal changes in the mid-nineteenth century. With the greater availability of domestic help, consumer goods, and modern innovations, North American women had more leisure time in which to make purely decorative items. For Victorian homemakers, stitching was a part of everyday life, learned from an early age. By the mid-nineteenth century, Berlin work was available to women of all social classes. Patterns for fire screens, cushions, footstools, bell pulls, pincushions, seat covers, rugs, bags, purses, men's smoking caps, and slippers could be ordered by mail from *Godey's Lady's Book, Peterson's Magazine, Harper's Bazaar,* and *Leslie's* magazines.

Berlin work was just one of a myriad of decorative crafts, including wax fruit, feather flowers, China painting, glass domes, plaited hair jewelry, and even taxidermy, that were practiced in the Victorian era. These accomplishments were labors of love, and the symbol of a good wife in a happy home. The earliest patterns were geometric in design followed by elaborate floral designs on black backgrounds. Complex floral designs were valued for their naturalistic qualities and subtle shading, which increased realism. Many Berlin work floral designs,

scenes, exotic birds, animals, and figures were adapted to needlework from contemporary paintings and prints.

Berlin work often included biblical quotations and allegorical messages, which came to be known as "mottos." Placed in an area of prominence, such as over a doorway, mottos represented Christian values and important ideals. Some popular mottos were "God Bless Our Home," "Forget Me Not," "Remember Me," "Love In Absence," and "Look To Jesus." Mottos were also stitched on printed heavy punched paper, known as perforated "card work." Although paper was more affordable than linen, card work was done by the wealthy, too. Patterns from popular women's magazines were stitched in brightly colored variegated threads, and mottos were typically displayed in an ornate frame. During World War I, perforated card work was included in "occupational therapy" at the Sailors' Hospital in Greenwich, England. Wounded men stitched patriotic motifs like the flags of the Allies on perforated cards with blunt **needles** and wool.

The constant presence of Berlin work in most Victorian parlors influenced other arts and crafts. In the third quarter of the nineteenth century, American and English sailors created wool pictures along with other crafts like **macramé.** Nostalgic scenes of ships on the high seas, called "woolies," were made on sailcloth, embroidered in wool with ship rigging in cotton and linen threads. Sometimes a foundation was included to give the stitching three dimensionality. Woolies rise off a flat canvas, like plush work.

Another craft influenced by Berlin work is Tunbridge Ware, a form of marquetry where colored wooden sticks are glued together to make a patterned veneer. From about 1830 to 1875, Berlin work designs were borrowed to decorate furniture and wooden boxes. Examples include marquetry tea caddies and writing desks with floral designs and grape vine borders.

Berlin work experienced its height of popularity between 1850 and 1870, falling out of fashion by 1880. At its lowest point, Berlin work was reduced to prestitched floral canvases with nothing left but the "fill-in-background." Berlin work was challenged by an increasing interest in fine embroidery, furthered by the Royal School of Art Needlework, founded in 1872. Art needlework was an important part of the arts and crafts movement, promoted by William Morris and his daughter, May. Today, needlepoint kits are available in a wide range of materials and quality levels. Contemporary needlepoint is very different from Berlin work. Enthusiasts use a great variety of stitches and threads, emphasizing creative work rather than copying patterns.

FURTHER READING

Bogisch, Michael. Intarsia. Online: http://www.intarsia.de/HISTORY/history.html.

Bvio. (October 2004). Berlin wool work. http://bvio.ngic.re.kr/Bvio/index.php/Berlin_wool_work.

The Cross-stitch Guild. Online: http://www.thecross-stitchguild.com/study1.asp.

Gillow, John, & Bryan Sentance. (1999). *World Textiles: A Visual Guide to Traditional Techniques.* Boston: Little, Brown.

Gotstelow, Mary. (1977). *The Complete International Book of Embroidery.* New York: Simon and Schuster.

Harris, Jennifer. (1999). *5000 Years of Textiles.* London: British Museum Press.

Sign of the *Hygra*. Antique Boxes in English Society 1760–1900. Online: http://hygra.com/uk/wb/wb103/index.htm.

Vainius, Rita. Needlework, Knots and Other Crafts on the High Seas. Online: http://www.caron-net.com/featurefiles/nautica.html.

Victorian Berlin Wool Work Men's Shoes—c 1850s. Victoriana. Online: http://www.victoriana.com/Mens-Clothing/mens-shoes.html.

Vintage Needleworks Motto History. What an Idea! Online: http://www.vintageneedleworks.com/Motto%20History.htm.

Wikipedia. Berlin wool work. Online: http://en.wikipedia.org/wiki/Berlin_wool_work.

Blackwork

A form of **embroidery** characterized by a sharp contrast of black stitching on a cream or white ground. Blackwork, also known as "Spanish Work," originated in North **Africa** and spread to southern Spain with the Moors. Heavily influenced by Islamic art, the earliest blackwork patterns were geometric in appearance. Blackwork reached the **British Isles** by the Middle Ages and was mentioned in Chaucer's *Canterbury Tales* (1387–1400). At first, it was done for ecclesiastical embroidery, but it became more secular by the sixteenth century. The popularity of blackwork increased when the Spanish noblewoman Catherine of Aragon became Henry VIII's first queen in 1509. Blackwork was a beautiful substitute for **lace** in a time when sumptuary laws prevented all but nobility to wear excessive ornamentation. Blackwork-type embroidery was also done in other colors, most notably in red, which is known as redwork or scarletwork.

There are three main styles of blackwork, all of which reached England by the sixteenth century. The first, linear blackwork, was composed of geometric embroidery motifs outlined on a white plain-weave ground. These counted-thread patterns in step and box shapes may have been adapted from Egyptian **samplers.** Geometric blackwork is well documented in Tudor and Elizabethan portraits, many of which were painted by Hans Holbein, Henry VIII's official court painter. Holbein not only painted for the king, but he also designed Henry's sleepwear and bedroom furnishings. Because of the prevalence of blackwork in his portraits, the double-**running stitch** is often called the Holbein stitch.

When England's Henry VIII broke with the Catholic Church and dissolved the monasteries and convents, embroidery was more often seen on secular items, especially clothing and home furnishings. This was the time when nightshirts were beginning to be worn and the whole idea of special bedclothes was new. Up until the fifteenth century, Western Europeans either slept without clothing or in the shirts or chemises worn underneath their work clothes during the day. Blackwork decorated the exposed collars and cuffs. Because the embroidery would be seen from both sides, the stitching was reversible. Other blackwork items included nightcaps, jackets, sleeves, coifs, stomachers, gloves, and purses. In sixteenth-century England, the bedroom was not the private space it is today. It was part of the living area and was thus on view to visitors. Beds and carved oak benches were embellished with blackwork cushions, pillows, hangings, and coverlets.

Under the rule of Henry VIII's daughter Elizabeth, the second style of black-work developed. English design was beginning to emerge as an individual style with delicate flowers, scrolling vines, and strong outlines filled with repetitive patterns. This blackwork was often accented with gold **metallic thread** and "owes" (sequins). Designs were influenced by wrought-iron scrollwork, and especially the new availability of printed materials. Black and white plates with images of native plants and allegorical stories were reproduced in black and white embroidery. Common patterns included peas, strawberries, grapes, flowers, animals, and butterflies, often directly copied from engravings and wood cuts. Sometimes the

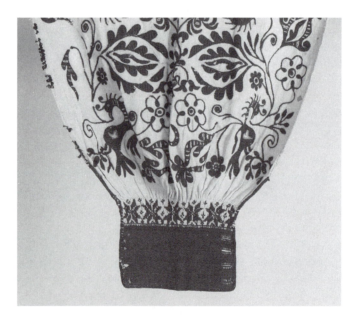

Blackwork on sleeve of Spanish blouse, 1700–1750. KSUM, transferred from the Allen Memorial Art Museum, Oberlin College, Oberlin, Ohio. Museum Purchase, 1941, 2006.11.84.

motifs would be filled with small running stitches, called seeding or speckling, which imitated the printer's ink.

As time progressed, chemises and shirts, earlier thought of as underwear, began to be visible through split skirts and slashed sleeves. Blackwork was used to decorate stomachers, bodices, and petticoats. The stomacher, a long triangular piece attached to the front of women's dresses, was extended to include detachable sleeves. Over time, the sleeves grew very large and became an important element in the fashion trend called "slashing and puffing." In English and Western European Renaissance style, slashes were made in the outer garment to allow the embellished shirt or chemise to show through.

The third style of blackwork has its origins in strapwork. Strapwork refers to a shallowly carved surface that resembled leather straps on Spanish and English furniture. Strapwork was also used to describe Celtic designs that were passed down through the ages. Repetitive strapwork patterns in stem stitch (running stitch) or **chain stitch** are often seen in the portraits of Henry VIII. In this type of blackwork, parallel rows of stitching create a strongly geometric design.

While most often associated with England, blackwork embroidery can be found in other parts of Europe as well. Blackwork is used in the folk clothing of **Eastern Europe** including Hungary, Yugoslavia, Serbia, Montenegro, and Romania, where color schemes indicate regional identity. Paintings of gypsy fortune tellers from the sixteenth century include blackwork around the neck and cuffs of their dresses. This may be related to a superstition that embroidered edges on clothing protect the body from evil spirits. The geometric patterns and cross-stitched motifs reflect both agricultural life and Muslim influence.

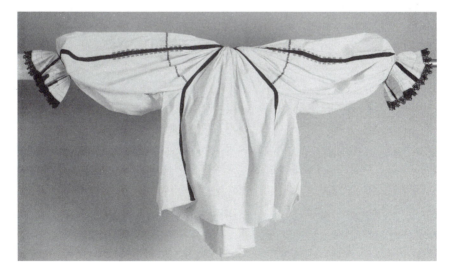

Blackwork on Romanian folk costume blouse, 1875–1899. KSUM, in memory of Costea, Rusanda & Roska, Elena, 1993.71.10.

Blackwork largely fell out of fashion by the early seventeenth century, but has seen revivals, especially in the nineteenth and twentieth centuries. During and after World War I blackwork was used to decorate tablecloths, table runners, tray cloths, bell pulls, banners, shawls, and handbags. After about 1950, blackwork, like many other forms of embroidery, began to be done in a more free-form style. Traditional patterns were adapted to reflect new aesthetics, and in the 1960s some French designers used blackwork to achieve pop art effects in couture clothing. Contemporary blackwork is done in various colors and uses various methods of shading. Blackwork motifs have been adapted to canvas work, or **needlepoint,** too. It is sometimes combined with other techniques such as **pulled threadwork,** Hardanger, **cutwork,** and Assisi, a type of **cross-stitch.**

FURTHER READING

Blackwork. Historical Needlework Resources. Online: http://medieval.webcon.net.au/technique_blackwork.html.

Gotstelow, Mary. (1977). *The Complete International Book of Embroidery.* New York: Simon and Schuster.

Higginbotham, Carol Algie. (Winter 1983). "Blackwork: An Introduction." *Needle Pointers* XI(5). Online: http://www.needlepoint.org/Archives/Blackwork/Article.htm.

Marmor, Paula Katherine. (2002). Elizabethan Blackwork. Online: http://blackworkarchives.com/bw_cost.html.

Root, Rissa Peace. (2004). A Blackwork Embroidery Primer. Online: http://prettyimpressivestuff.com/blackwork.htm.

Schwall, Katherine L. (February 19, 2001). Century Chest Project: Needlework History 1940–1970. The Embroiderers' Guild of America Rocky Mountain Region. Online: http://rocky_mtn_embroidery.tripod.com/.

Wilson, Erica. (1973). *Erica Wilson's Embroidery Book.* New York: Charles Scribner's Sons.

Bobbin Lace

One of the two main types of handmade **lace,** created by twisting threads in an intricate manner. Unlike **needle lace,** which is made with a single-thread technique and **embroidery** stitches, bobbin lace is made with multiple-threads that are plaited, interwoven and twisted, but not knotted. Also known as "pillow lace" or "bone lace," bobbin lace is made on a pillow on which a paper pattern is pinned. Between 20 and 200 individual threads are wound upon a number of short sticks called bobbins, which can be made of any strong material including bone, glass, ivory, wood, and bamboo. Bobbin lace can be divided into two groups: non-continuous or "piece" lace and "straight" or continuous lace.

Because of the many hours of labor required to produce bobbin lace, it has been worn as a sign of wealth and prosperity since the early sixteenth century.

It is difficult to precisely locate the origin of bobbin lace in both time and place. Some believe it started in ancient Rome (Italy), citing small bone cylinders that could have been early bobbins. These "bobbins" were most likely used to make fancy braids, called "passementeries," and colored silk threads. In the early sixteenth century, the braids began to be made in linen, creating laces used for decorative insertions and borders. Fashion and lacemaking are closely linked, both products of **Western Europe** and the Renaissance. Lace was more suited to fashion changes than embroidery was. It could be removed from one garment and attached to another to follow different styles. Bobbin lace was softer, lighter in weight, and more suitable for clothing than stiff needle lace. During this period, pleated lace neck adornments, known as ruffs, were worn by all but the lowest classes. Yards of lace were required for even the most modest ruff, making elaborate ones extremely costly. Lace was also used to trim a wide variety of textiles including altar cloths, ecclesiastical vestments, tooth cloths, and pillow cases. Demand for lace was huge, and to meet demand many women became lacemakers.

The first bobbin laces were made around Venice, Italy, and bobbin lacemaking spread quickly to Milan, Genoa, Flanders (Belgium), and the British Isles. Its growth was enhanced when Charles V (1500–1558), Holy Roman Emperor, decreed that lacemaking be taught in the schools and convents of the Belgian provinces. Lace schools for village girls were founded by noblewomen. Children of both genders were enrolled at about age five or so, with boys usually leaving as they grew strong enough for harder labor. Lacemakers of all ages worked from dawn until dusk, often in crowded, unventilated rooms. Since linen thread becomes brittle when dry, spinning and working fine thread required dampness. Lacemakers frequently worked in basements with poor lighting. Although the work was difficult, it enabled girls to save money for their dowries and contribute to their family income before, during, and after marriage.

Since that time, many styles of lacemaking have developed, almost all of them in the Belgian provinces, often called the cradle of lace. This area, known as Flanders, was dominant in bobbin lace production from 1660 to 1760. Both needle and bobbin laces were made, often with parts of the process performed by different women under the supervision of a master. Bobbin lace is made on a pillow and follows a pattern. Early patterns, called "parchments," were traditionally made of translucent goatskin. Old parchments were jealously guarded and treated as heirlooms. All bobbin lace is the result of two simple movements: the "cross" and the "twist." Combinations of these stitches can create the most intricate designs, similar to the way that complicated **knitting** patterns are made from the basic "knit" and "purl" stitches. As the threads are manipulated, they are held in place with a pin. The process is very time

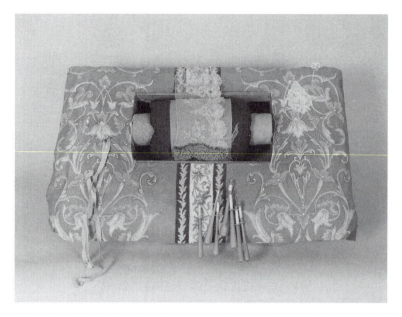

Pillow for making bobbin lace, late nineteenth century. KSUM, gift of Winifred Blacklow, 2005.3.1.

consuming; the corner of a handkerchief may take a lacemaker about three days, depending upon her level of skill.

In addition to Belgium, early bobbin lace was also made in Saxony, Switzerland, and England. It was introduced by Italian and French lacemakers, some of whom were refugees and settled in these areas. By the seventeenth century, lacemaking was a large industry in some areas; for example it is estimated that one-quarter of the population (about 30,000 people) of Buckinghamshire, England, was employed in making lace in 1698. While the wealthy wore the most costly lace, the middle classes wore a more affordable bobbin lace, known as "torchon." Torchon is a strong bobbin lace made of flax thread about one to two inches wide. It was most commonly made for narrow edgings or insertions, often trimming linen or cotton underwear. Torchon lace was made commercially in Belgium, France, Italy, Saxony, Sweden, and Spain. It was sometimes known as "peasant," "beggars," or "dishcloth" lace because of its durability and inexpensiveness.

There are many regional styles of bobbin lace, from the cottage industries of rural England to the sophistication of Brussels and the **Eastern Mediterranean** styles of the islands of Malta and Cyprus. Russian and Czechoslovakian lace was made with red and blue threads that followed a maze-like pattern through deep scallop shapes. Swedish lace was largely utilitarian, made for church and household linen, including bridegroom shirts in geometric designs. There is not much

of a lacemaking tradition in **North America,** but at the end of the eighteenth century, fairly coarse lace was made in Ipswich, Massachusetts. Bobbins were made of bamboo, imported by the East India Trading Companies. Lacemaking in Ipswich ended in the 1820s, coinciding with the decline of handmade lace in the rest of the world. The Spanish brought bobbin lacemaking to Puerto Rico, where it became a time-honored **needle** art. Known as "mundillo," meaning "little world," this important tradition is documented in the Puerto Rican Museum of History, Archeology and Anthropology.

The European lacemaking industry diminished dramatically in the nineteenth century. For example, in 1814 there were 5,500 lacemakers in Neufchatel, France, and only 10 in 1844. This was due to many factors, including changes in fashion, low-cost imports, and developments in machine lacemaking. With the failure of the lace market, old parchments, once valuable heirlooms, were boiled down for glue. By the early twentieth century, near perfect copies of torchon lace were being made on the Barmen machine. This considerably reduced the market for the handmade form along with cotton lace imported from China. In the 1870s and 1880s there was a strong craft revival, which included **cutwork**s, Battenburg, and Renaissance laces, although in much coarser forms. The perpetuation of lace has been mainly championed in the United States by the Needle and Bobbin Club, which was established in 1916, and the International Old Lacers, founded in 1953. Somewhat similar institutions in England are the Embroiderers' Guild,

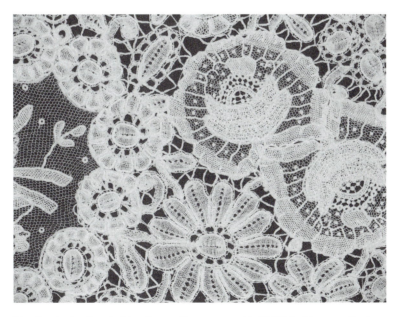

Handmade Duchess bobbin lace collar, 1900–1909. KSUM, Silverman/Rodgers Collection, 1983.1.1819.

established in 1906, and the Lace Guild in 1976. Outside of enthusiasts, there is little hand lacemaking done today. In Bruges, Belgium, about one thousand lace workers, all of them between 50 and 90 years of age, make bobbin lace for the tourist market, but handmade lace is no longer manufactured for commercial purposes.

FURTHER READING

Cathcart, Lara. Bobbin lace. Online: http://home.aol.com/lclacemker/bobbinlacepage1.html.
Earnshaw, Pat. (1982). *A Dictionary of Lace.* Bucks, UK: Shire Publications.
Florida Folklore. Online: http://www.historical-museum.org/folklife/flafolk/torruella.htm.
Gillow, John, & Bryan Sentance. (1999). *World Textiles: A Visual Guide to Traditional Techniques.* Boston: Little, Brown.
Mallett, Marla. Antique Bobbin lace. Online: http://www.marlamallett.com/l-bobbin.htm.
Trabel. The History of Lace. Online: http://www.trabel.com/belgium-lace-history.htm.
Whiting, Gertrude. (1971). *Old-Time Tools and Toys of Needlework.* New York: Dover. (Unabridged and unaltered republication of the work originally published by Columbia University Press, New York, in 1928 under the title *Tools and Toys of Stitchery.*)

Bosnian Crochet

A specialized form of **crochet** made in a single slip stitch that results in an extremely dense fabric. Bosnian crochet has a similar appearance to woven braid, but is remarkably elastic. The term "Bosnian" has been used by English-speaking needleworkers since the Victorian era. The technique is sometimes also called "Old World Crochet." Bosnia is located in **Eastern Europe,** in the middle of the former Yugoslavia, bordered by Croatia, Serbia, and Montenegro. It has a tumultuous history and is home to a number of ethnic groups. Bosnia was the site of an armed conflict from March 1992 to November 1995. After the war, Bosnians were suffering from the results of conflict and the destruction of their homes and businesses. It is out of this tragedy that cottage industries in traditional crafts, including Bosnian crochet, emerged and grew, especially to the benefit of women.

A traditional needlework technique in Bosnia and most Muslim countries, Bosnian crochet may be the oldest type of crochet known. It is a domestic art taught by mothers to daughters at an early age. Known as *hekljanje,* crochet is an important part of preparation for marriage. As part of their trousseau, young Muslim women crochet intricate tablecloths and doilies, incorporating traditional motifs, such as two mirror images of geese. Made in the whitest of threads, these domestic textiles carry religious significance. Cleanliness is a central tenet of

Islam; it is essential that the crocheted work is absolutely white upon completion. Similar needlework traditions are also found among Muslim women in Albania and Kosovo.

The Bosnian technique begins with a chain, and then stitches are worked in the back of the loop. It is done with a slip stitch; the crochet hook is inserted into the stitch, then yarn is wrapped around the hook making a new loop, which is pulled through both the stitch and the loop on the hook. Bosnian crochet is characterized by a ridge in the fabric that is formed by working in the back loop of the stitch in the previous row. In addition to white domestic linens, a variety of Bosnian designs are made, in one or several colors. Bosnian crochet is well suited for accessories such as hats, scarves, bags, belts, collars, cuffs, jewelry, and fancy braids. The denseness of the finished product makes warm coats, sweaters, afghans, and cushions.

Stabilizing the Bosnian economy has been a long and slow process since the war ended in 1995. The unemployment rate is over one-third of the population. Before the war, many women worked in state factories, most of which were destroyed during the conflict. Possibilities for employment were limited, and with

Slovak armband made in a form of Bosnian crochet, 1900–1983. KSUM, Silverman/Rodgers Collection, 1983.1.1995.

the loss of men in war, many women had the added responsibility of taking care of their children and parents alone. One prominent group, Women for Women International (WWI), mobilizes women in conflict and postconflict environments to change their lives. WWI has 136 centers in Bosnia, where they hire local instructors to teach crafts and small business development, including business cooperatives, marketing, basic accounting, pricing, and business plans. The women in these programs have regained their dignity and self-confidence. They are able to support themselves and have a better life.

In Bosnia, women learn carpet weaving, **embroidery, knitting,** pottery, glass painting, and crochet. Women working together create a support system, an atmosphere of trust and security. WWI needlework classes are coupled with various topics including women's human rights, economics, politics, family sciences, and health. The women pass on this information to other women in their families and communities. The first efforts offering crochet were programs in the centers where displaced women and their children were living. Needlework gave refugee women something to occupy their minds and a way to earn money. They could increase their skills and grow their businesses through courses and small business loans. Bosnian crocheted goods are now distributed throughout the world, often as part of Fair Trade initiatives.

A success story is Bosnian Handicrafts, a modern production and retail business that trains and employs female refugees displaced by the war. Founded in 1995, the program began as a way to provide a sustainable means of income generation for women who suffered the loss of family members and homes during the war. Bosnian Handicrafts currently employs 500 women from different religious and ethnic groups. These women are able to support themselves financially while nurturing their own cultural traditions. The company's handmade products are marketed globally and sold to elite international designers and retailers in Bosnia and Herzegovina, the United States, France, Slovenia, and Switzerland.

Bosnian crochet is an important source of pride and identity among Bosnian immigrants in the United States. Needlework groups, exhibitions, and demonstrations strengthen cultural traditions and preserve folk arts. In recent years, several states have awarded cultural grants to Bosnian artists. An example is the part Bosnian crochet played in the "In My Country" exhibition in Portland, Oregon. This project documented the lives and artistry of 10 members of a refugee/immigrant sewing circle. The sewing circle was developed to address the isolation of refugee and immigrant women in the United States. In creating the "In My Country" catalog, video, and exhibition, members worked as a group to document each other's needlework. Children and grandchildren participated as translators, facilitating the project, while at the same time learning about their own and other cultural traditions.

FURTHER READING

Bosnian Handicrafts (www.bhcrafts.org). Schwab Foundation for Social Entrepreneurship. Online: http://www.schwabfound.org/schwabentrepreneurs.htm.

Cosh, Sylvia, & James Walters. Crochet. Online: http://crochet.nu/scjwc/work/bosnian/.

Crochet Products. BOSFAM (Bosnian Family). Online: http://www.bosfam.ba/novosti_en.htm.

Folk Art Festival. (April 23, 2005). Children's Museum, Utica, NY. Online: www.museum4kids.net.

Folk Arts 2006. The Schweinfurth Memorial Art Center, Auburn, NY. Online: http://www.schweinfurthartcenter.org/events/folk.html.

IRCO Arts for New Immigrants. In My Country: A Gathering of Refugee & Immigrant Fiber Traditions. Immigrant and Refugee Community Organization. Online: http://www.irco.org/IRCO/Events.asp.

Nieb, Cynthia. (2005). Iowa Arts Council Happenings. Iowa Cultural Coalition, Des Moines, IA. Online: http://iowaculturalcoalition.org/taxonomy/term/11/9/.

Quadrennial Project 2003–2007. (November 2004). Project Independence: Women Survivors of War. Online: http://www.soroptimist-gbi.org/quadrennial_project_nov04.

Stanziano, Dee. (2006). Get to know them: The Different Types & Techniques of Crochet. Online: http://members.aol.com/crochetwithdee/typesof.html.

Stories from the Front: Women for Women International. Online: http://www.womenforwomen.org/sfbosniaandherzegovina.htm.

British Isles

The area of the world including, but not limited to, England, Ireland, Scotland, and Wales. The first major piece of **embroidery** from the British Isles is the Bayeux Tapestry. Made over 900 years ago, this monumental strip of cloth depicts the King of England's "Norman Conquest" in 1066. The Bayeux tapestry is actually an example of **crewelwork,** multicolored worsted wool thread worked on linen. All of the embroidery stitches in the Bayeux tapestry are still in use today. Different from other geographical regions, the British Isles do not generally have traditional folk clothing. The finest British needlework was created as a form of **embellishment,** used by church and crown to show power and wealth. The height of English embroidery began with the Northern Renaissance in the sixteenth century, largely because of cross-cultural exchange.

One example of this creative exchange is **blackwork,** also known as "Spanish Work," which originated in northern **Africa** and spread to southern Spain with the Moors. Blackwork reached England by the Middle Ages. At first used for ecclesiastical embroidery, when Catherine of Aragon became Henry VIII's first queen in 1509 blackwork became a popular substitute for **lace.**

Needlework is closely associated with British royalty. Mary Queen of Scots and her ladies in waiting made fine *lacis* or **drawnwork** pieces and **needlepoint** panels of wild animals during her long imprisonment. Queen Elizabeth I (1558–1603)

formalized embroidery practices, granting a charter to the Broiderers' Company in 1561. During Elizabeth's reign the steel **needle** and pattern books became more accessible. Fine Elizabethan embroidery decorated bodices, stomachers, coifs, nightcaps, bags, and purses.

A wide variety of needlework techniques are associated with the British Isles. Due to cultural tradition and global contact, needleworkers in Great Britain have practiced **appliqué, Aran** knitting, **beadwork, Berlin work,** blackwork, **bobbin lace, candlewicking,** crewelwork, **crochet, cross-stitch, cutwork,** drawnwork, embellishment, embroidery, **Fair Isle** knitting, **feathers and beetle wings, Gansey, hairpin lace, knitting, knotting, machine needlework, macramé, metallic threads, needle lace,** needlepoint, **needleweaving, netting, patchwork, plaiting and braiding, pulled threadwork, punch needle** embroidery, **quilting, ribbonwork, samplers, shadow work, smocking, stumpwork, tambour, tatting, Tunisian crochet,** and **whitework.**

English women were taught to sew at an early age, but lessons differed according to social class. Girls from wealthy families concentrated on fancy work, like samplers and decorative sewing, where girls from less well-to-do families learned to make clothing and domestic linens. Poor families relied on women's plain work and mending skills to make textiles last as long as possible. Much of the variety in British needlework is due to the many styles practiced in the Victorian era. During the long reign of Queen Victoria (1819–1901), a confluence of cultural and societal factors greatly influenced society in Great Britain and the United States. Victoria supported local needleworkers, making their creations popular. She commissioned handmade Honiton appliqué lace for her 1838 coronation, her wedding veil, and the royal christening gown. Victoria's patronage coupled with the craze for whitework helped thousands of poor women in Ireland, Scotland, and England in the 1840s and 1850s.

Charitable efforts became thriving cottage industries. In the 1760s, the Dublin Society established schools for poor children, followed by others in Ayrshire, Scotland, Limerick, Ireland, and Coggeshall, England, in the 1790s. By 1814, these cottage industries were making fine whitework with tambour, embroidery, crochet, and knitting. Scottish Ayrshire work was popular from 1814–1870. Inspired by Dresden (Germany) drawnwork and French pierced embroidery, Ayrshire is characterized by floral patterns and popular for christening robes. Ayrshire flowers are filled with openwork, either drawnwork or cutwork, with needle lace bars.

In 1812 a Frenchman started tambour stitch classes for girls in Coggeshall, England. Their fine tamboured **chain stitch** in white cotton thread on net was very popular between 1829 and 1910, especially for wedding veils. Carrickmacross was made in Limerick, Ireland. This complicated technique was done with a layer of net appliquéd under a linen ground. The linen is cut away and the opening finished with a tamboured chain stitch and embroidery. Carrickmacross was used for small shawls, collars, and fichus.

In the 1830s, four Irish nuns trained in a French convent introduced crochet to Ireland. Imitating historic Venetian lace patterns, Irish women began doing "lace-like" crochet. Their intricate and elaborate motifs are known as Irish crochet or guipure lace. The lace industry in Ireland was essential to generate income during the potato famine years around 1846. A similar effort was begun in 1847 when tatting was introduced as a cottage craft for famine relief. Tatted lace was moderately successful.

Knitting reached the British Isles by the twelfth century, and knitters are portrayed in fourteenth-century paintings. Mary Queen of Scots knitted, and it was a widespread occupation in England by 1698. In the eighteenth century, poor workhouse children in Ireland knitted baby caps and other items, earning prizes for fine work. The Scottish Shetland Islands were world renowned for their lace-like knitted shawls by the 1840s. Also known for their heavy **Fair Isle** sweaters, Shetland shawls or "marriage" shawls could be five feet across and fine enough to pass through a wedding ring. The knitting was time consuming and could take as long as one hour to complete a single row.

Smocking embellished traditional clothing worn by agricultural workers in parts of England and Wales in the eighteenth and nineteenth centuries. The improved status of rural Englishmen led to occupational pride symbolized in smocking patterns. A man's place of origin and trade were identified by their smocks. During the Industrial Revolution, smocks declined in popularity as their full sleeves were unsafe around farm machinery.

Finely knitted Scottish Shetland shawl, 1890s. KSUM, transferred from the Allen Memorial Art Museum, Oberlin College, Oberlin, Ohio. Gift of Jean Birge Rock, 1954, 2006.11.71.

Machinery negatively impacted the hand-embroidery industry. The chain stitch machine was invented in 1855. It could make tambour embroidery on net, which harmed the market for fine handwork. Advocates of the arts and crafts movement sought to revive traditional crafts in the late nineteenth century. John Ruskin encouraged English cottagers to make drawnwork and cutwork on handspun and handwoven linen in the 1870s. Smocking was reinvigorated in the 1880s by Mrs. Oscar Wilde and other artistic dress reform advocates. Dressmakers in London and Paris came to specialize in smocked dresses for women and children. Diverse cultural traditions in the British Isles continue to be strong, with a long needlework heritage supported by enthusiasts and organizations, including the Royal School of Needlework and the Embroiderers' Guild.

FURTHER READING

Coss, Melinda. (1996). *Reader's Digest Complete Book of Embroidery.* Pleasantville, NY: Reader's Digest.

Durand, Diane (1982). *Diane Durand's Complete Book of Smocking.* New York: Van Nostrand Reinhold Company.

Earnshaw, Pat. (1982). *A Dictionary of Lace.* Bucks, UK: Shire Publications.

Fiber Images. History of Crochet. Online: http://www.fiber-images.com/Free_Things/What%20Is/history_of_crochet.htm.

Gotstelow, Mary. (1977). *The Complete International Book of Embroidery.* New York: Simon and Schuster.

Warnick, Kathleen. (1988). *The Legacy of Lace.* New York: Crown.

Harran, Susan, & Jim Harran. (December, 1997). Remembering a Loved One with Mourning Jewelry. *Antique Week.* Online: http://www.hairworksociety.org.

Paludan, Lis. (1995). *Crochet History and Techniques.* Loveland, CO: Interweave Press.

Wilson, Erica. (1973). *Erica Wilson's Embroidery Book.* New York: Charles Scribner's Sons.

Buttonhole Stitch

A versatile **embroidery** stitch that can either embellish an existing fabric or be used to create a fabric on its own. The buttonhole stitch has a long history with a vast array of applications around the world. It is functional in its ability to reinforce edges and, at the same time, highly decorative with many different variations. When worked independently of a base fabric, the buttonhole is the basic stitch in **single needle knitting** and **needle lace,** where it is built up row by row. The stitch is made by wrapping the thread under the **needle** during the stitching process and pulling the loop tight. It appears to be a series of "L" shaped lines on the edge of a fabric, or a small knot around a base thread when worked alone.

The buttonhole stitch has prehistoric origins, used over 8,000 years ago. The earliest extant pieces come from Israel, Denmark, Egypt, and Peru, all created before the year 0. The buttonhole stitch has several common variations: blanket stitch, eyelet stitch, and detached buttonhole stitch. Blanket stitch was developed to finish the raw edges of coverings and wraps. In blanket stitch, a series of stitches are made around the edge, each linking through the previous stitch, creating a line of thread around the piece that prevents it from fraying. Blanket stitches are placed at a distance from each other; generally the length of the "L" is equal to its width. Blanket stitch is most appropriate for tightly woven or felted fabrics that do not unravel easily. For woven fabrics that fray, such as fine plain-weave cotton or linen, buttonhole stitch is more appropriate.

Buttonhole stitch is worked the same way as blanket, but the stitches are packed tightly together for greater strength around holes and on edges. Buttonhole stitch has a solid appearance, completely covers raw edges, and is especially suited for scalloped edges and **cutwork** floral motifs. Eyelet stitch has the same appearance as buttonhole stitch, but rather than finishing cut edges, it is used pull a hole open and hold it in place. A circle of stitches is worked from a common point, creating a finished hole in the fabric. Eyelet stitch is especially important in **whitework,** where an open appearance is desired. The detached buttonhole stitch is not worked into a woven material, but is stitched row upon row, building a completely new textile. It is the basis of

Buttonhole stitch on needle lace parasol, late nineteenth to early twentieth century. KSUM, anonymous gift, X2006.1.

all needle lace, using a continuous thread that is looped around itself to form bars and motifs. Finishing raw edges of cutwork, **drawnwork,** and **pulled threadwork,** with the buttonhole stitch eventually evolved into a free-form fabric called **lace.**

Many cultural needlework traditions include forms of the buttonhole stitch. There are as many as 80 different variations and a multitude of applications for this versatile stitch. One notable example is found among the nomads of **Central Asia,** where felt bags protect tents while being carried by pack animals. The bags are embroidered in buttonhole or **chain stitch** accompanied by bands of herringbone stitch, a variation of **cross-stitch.** Buttonhole and herringbone are also used for fine embroidery in Afghanistan and Turkmenistan. Eyelet stitches are common in **Africa** and the **Middle East.** In the Congo (formerly Zaire), the Kuba people make skirts and hangings from raffia. Rectangular **patchwork** panels are decorated with circles worked in eyelet stitch. In Nigeria, embroidered decoration around the neckline of "eight knives" shirts is primarily worked in buttonhole stitch

The *abocchnai* or wedding shawl is made for women of the merchant and land-owning classes in Pakistan. Complicated patterning is done in a variety of stitches including buttonhole stitch, *shisha,* or **mirrorwork,** and herringbone stitch. The floral patterns on embroidery in Ecuador reflect Western European influence in cross-stitch, **satin stitch,** and buttonhole stitch. Buttonhole stitch is also widely used in Russia and **Scandinavia** along with backstitch (**running stitch**), chain stitch, and satin stitch. In Denmark, Hedebo embroidery began as a decoration for folk clothing and domestic linens. Men's shirts, women's collars and cuffs, and bed coverings were made in cutwork and drawnwork. The oldest form of Hedebo dates back to the 1700s. With edges finished in buttonhole stitch, it evolved in the mid-nineteenth century to include bars and needle lace motifs. The more contemporary form of Hedebo includes rings of buttonhole stitch embellished with picots, similar to **tatting.**

The whitework style known as *broderie anglaise* is associated with England, but it may have originated in **Eastern Europe,** probably Czechoslovakia. A type of cutwork, broderie anglaise included flowers, leaves, and stems done entirely in buttonhole stitch. It was extremely popular between 1840 and 1880 for women's underclothing and children's wear. Broderie anglaise motifs had open areas in many sizes; some were punched with a stiletto before finishing the edge and some were embroidered first and then the hole was cut afterwards with scissors. A form of whitework composed entirely of eyelets was Madeira work. Created on a Portuguese island off the west coast of Morocco, Madeira work was primarily created for the tourist trade, with a wide range of quality. Over time, the eyelet patterns were accompanied by satin stitch and cutwork, which more closely resembled broderie anglaise.

Beginning in the 1870s, the designs and techniques of broderie anglaise could be copied by the Swiss hand-embroidery machine, which could make intricate

whitework embroideries with openwork fillings. The Schliffli embroidery machine was also used to simulate hand embroidery beginning in the 1890s, but not as successfully. Pieces worked with the Schliffli machine had a fuzzy appearance which distinguished them from hand needlework. Over time, the success of machine-made copies negatively affected the extent of buttonhole stitching done by hand.

FURTHER READING

Barber, E.J.W. (1991). *Prehistoric textiles. The Development of Cloth in the Neolithic and Bronze Ages with Special Reference to the Aegan.* Princeton, NJ: Princeton University Press.

Coss, Melinda. (1996). *Reader's Digest Complete Book of Embroidery.* Pleasantville, NY: Reader's Digest.

Earnshaw, Pat. (1982). *A Dictionary of Lace.* Bucks, UK: Shire Publications.

Gardner, Beth. (2003). The Traveling Thread: Hedebo. Online: http://www.ega-gpr.org/article_Hedebo.html.

Gillow, John, & Bryan Sentance. (1999). *World Textiles: A Visual Guide to Traditional Techniques.* Boston: Little, Brown.

Gotstelow, Mary. (1977). *The Complete International Book of Embroidery.* New York: Simon and Schuster.

Stitch with the Embroiders Guild. Buttonhole stitch. Online: http://www.embroiderersguild.com/stitch/stitches/index.html.

Wilson, Erica. (1973). *Erica Wilson's Embroidery Book.* New York: Charles Scribner's Sons.

Candlewicking

A form of **whitework embroidery** using soft cotton yarn worked on cotton muslin. Candlewick designs are characterized by shadow and texture using bulky threads and raised stitches in large areas where delicate whitework stitches might be lost. Candlewicking was well suited for the all-white furnishings of the Neoclassical style. It was most popular between 1790 and 1845 and continued to be prevalent on bedspreads, pillows, and tablecloths through the end of the nineteenth century. Candlewicking receives its name from the thick cotton thread, known as roving, that resembles the wick used in a candle.

In late-seventeenth-century England, there was a fashion for white embroidered bedspreads with designs of vines, flowers, and baskets of fruit. They were primarily stitched in raised embroidery including French and bullion **knot stitch, running stitch,** stem stitch, backstitch, and **satin stitch.** By the early eighteenth century, this technique had crossed the Atlantic to **North America.** The growth of candlewicking, like **quilting,** has been attributed to colonial fru-

gality, but in both cases, it was the Industrial Revolution that allowed them to flourish. The vogue for whitework bedcovers started after the invention of the cotton gin in 1792. Along with mechanized spinning and weaving, mass production of American cotton was possible by the early nineteenth century. It was with this cotton that candlewick bedspreads were designed and hand stitched for home use or as wedding gifts.

Most candlewicked bedspreads include a central motif surrounded by one or more border patterns. Popular designs were often inspired by nature and include an urn, a basket of flowers, or a cornucopia. They sometimes featured an eagle, the symbol of the new American republic. In colonial candlewicking, the central motif was traditionally surrounded by grapevines, flowers, swags, and bowknots. Candlewick patterns often mirrored designs used in trapunto quilting or Marsailles work. Rather than using the running stitch and stuffing, candlewicking employed dimensional stitches to create the pattern. The designs were drawn directly onto either homespun or commercially woven cloth with charcoal or a pencil. Candlewicking was primarily done on cotton, although linen was also used. It is best worked in a hoop or frame, which keeps the embroidery tight. Linear and circular designs lend themselves to candlewicking.

Two important stitches in candlewicking are the colonial knot and the stem (running stitch) or outline stitch. The colonial knot is also called a "figure of eight knot" because the thread is wrapped around the **needle** in a twist. It has a higher profile than the French knot stitch, which makes it better suited for large pieces. Different effects can be achieved by varying the stitch as well as the thickness of the yarns. Early candlewicking was sometimes limited to one or two stitches, but as the technique grew it popularity, so did the stitch repertoire. Other popular textural stitches used in candlewicking include the back, split, **buttonhole,** satin, fishbone, herringbone (see **cross-stitch**), coral, and **chain stitch** as well as bullion and French knot stitches.

In some early American candlewicking, small running stitches were slightly raised on the surface by working the stitch over a small twig. These loops were usually left uncut, although sometimes they were cut, which created a tufted appearance. The most notable candlewicking traditions are generally concentrated on the eastern coast of the United States. An exception is found in Australia. The Australian gold rush of the 1850s brought American men along with American women. They taught Australian ladies candlewicking. It became a popular form of needlework for many years, even after it declined in the United States.

Candlewicking was made by both hand and machine. Its height of popularity as a needle art began to wane around 1840, when machine-made bedcovers became available. An alternative to hand needlework was the Bolton woven coverlet. Made on looms in England, these "raised-weft" textiles were first imported to the United States in the early nineteenth century. The Bolton coverlet resembled

candlewicking, made of cotton with coarse pattern wefts drawn up in loops. Examining the back of a bedspread reveals its maker. Machine-made bedspreads are smooth, neat, and even, where those made by hand show knots, loops, and stretched yarns. In recent years, contemporary embroiderers have rediscovered hand candlewicking. Using many of the same materials as 250 years ago, heavy cotton yarns are combined with cotton embroidery floss, perle, and **crochet** cotton in many thicknesses. The traditional all-white patterns have been updated with accent colors and other types of embroidery.

White-on-white **punch needle** embroidery has a similar tufted appearance to candlewicking, but is a completely different technique. Candlewicking employs a needle and thread, where punch needle uses a wooden-handled hook, to create loops from the back side of the fabric. Punch needle embroidery can be done with heavy white threads, but the process is closer to **rug hooking** than it is to embroidery.

Tufted chenille is another separate technique that resembles the appearance of candlewicking. Around 1895, a woman from Dalton, Georgia, attempted to copy a candlewicking bedspread by using the "turfing" stitch. Turfing used a needle and thick cotton yarn to make the running stitch on cotton sheeting. Once finished, stitches on the surface were cut and the piece washed in hot water. Washing promoted shrinking and intensified the tufted look of the 12-ply cotton thread.

A wedding bedspread led to other orders, and the tufted bedspreads became a cottage industry when others in the Dalton area set up their own "spread shops." Patterns were geometric and often based on quilt designs. Thousands of bedspreads were shipped from this tiny southern town to individuals and department stores between 1910 and the 1940s. Over time, industrial sewing machines were modified to mimic the technique by clipping and stitching rows of fuzzy chenille yarn. Eventually, the machine chenille technique evolved into America's carpet industry.

FURTHER READING

Evett, Ellen Swendroski. (2003). Candlewicking and Tufted Chenille. Unpublished manuscript. Holliston, MA: Heirloom Collection.

EZ Digitize. History of Embroidery. Online: http://www.kwbrokers.com/extra/candlewicking.php.

Harbeson, Georgiana Brown. (1938). *American Needlework*. New York: Bonanza Books.

Hollander, Stacy C. (Spring/Summer 2006). "White on White (and a little gray)." *Folk Art* 33–41. Online: http://www.folkartmuseum.org/default.asp?id=1302.

Meldrum, Sandie. Traditional Candlewicking. Online: http://www.white-works.com/candlewicking.htm.

McConnell, Megan. Candlewicking. BellaOnline. Online: http://cross-stitch.about.com/.

Swan, Susan Burrows. (1977). *Plain and Fancy: American Women and Their Needlework, 1700–1850.* New York: Rutledge.

Whiteworks. Candlewicking. Online: http://www.whiteworks.com/candlewicking.htm.

Central Asia

The part of the world also known as Turkistan, including, but not limited to, Afghanistan, Kazakhstan, Kyrgyzstan, Turkmenistan, and Uzbekistan. Central Asia is characterized by its nomadic peoples living in the crossroads of the Silk Road. Their culture was impacted by the movement of people, goods, and ideas between Asia, the **Middle East,** and **Western Europe.** Central Asia is an area of the world that has uncertain borders between countries and has witnessed much turmoil and war. The oldest extant textiles date from the fourth century B.C.E. and include leather and felt **appliqué** carpets, saddle covers, and hangings.

Because of the nomadic nature of many people in Central Asia, some of the oldest needlework traditions embellish tents and animal trappings. Nomadic peoples, such as the Turkmen and the Uzbek, carry their circular felt dwellings, known as *yurts,* with them across the region. Yurts have a wooden lattice frame that is covered by felt. The struts are carried on camels in felt bags, which are decorated with appliqué, **embroidery**, and tassels. In addition to bags, horse blankets and covers are also appliquéd and embroidered with **buttonhole stitch, chain stitch,** and herringbone, a variation of **cross-stitch.** Counterchange floor coverings or *numdah* are also decorated with appliqué. Several layers of different colored felt are cut at the same time so that positive and negative pieces may be interchanged.

Embellishment is important in Central Asia, both for effect and for spiritual purposes. Clothing and other items are decorated with talismans to avert evil and misfortune. For example, amulets resembling ram's horns used because of their association with vitality and power and blue beads are considered to be good protection from the evil eye. Common embellishments used in Central Asia include **metallic threads, mirrorwork,** discs, bells, beads, **shells,** and coins. **Fringes** and tassels are also important. Some bags and hangings are made by **plaiting** or **netting,** ending in tassels. Nomadic people carry "spoon" bags, made of fringe with a cloth bag inside. Tassels are also worn in the women's hair. In recent years, Central Asian refugees, especially in Afghanistan, have started **knitting** with wool yarn from sheep or goats along with materials given by aid organizations. Like **Bosnian crochet,** knitting skills have helped women in war-torn areas improve their lives.

Embroidery on clothing is an important cultural tradition in Central Asia. The most common stitches are densely worked **couching,** including Bokhara couching, buttonhole stitch, and herringbone. Threads are embroidered or couched directly onto fabric or done in bands, borders, or panels, which are later attached. Cotton and silk are the most common fibers for both thread

and ground fabric, although floral embroidery is also done on sheepskin waist-coats. Similar to those made in the Ukraine and **Eastern Europe,** sheepskin garments are found in the mountainous regions. Women of the Uyghur, a minority ethnic group in Kazakhstan, Kyrgyzstan, and Uzbekistan, elaborately embroider skull caps, which are worn on their own or wrapped with a turban.

The most common embroidered motifs in Central Asia are ram's horns, flowers, sunwheels, stars, lozenges, hooks, and tulips stitched in bright colors. A notable use of embroidery is for the bridegroom smock. White cotton shirts are embroidered with black thread, which pulls the fabric into vertical ridges. Usually the neckline is embroidered with pink thread. These shirts can also be made with red, green, or white stitching on a white fabric.

A prominent use of embroidery in Central Asia is for *suzani,* embroidered hangings made by a bride and her family that become part of her dowry. These traditional needlework pieces were used by women of all classes to adorn the wedding hall, provide an awning for the bride and groom, and cover the bridal bed. After the wedding, the suzani would be treasured and often wrapped around the body at death. The oldest examples are dated to the eighteenth century, although they may have been made earlier. The tradition of creating suzanis continued into the early twentieth century. Suzanis were made by a community of stitchers and could take years to complete. An expert drew out the design on several strips of cloth. Each strip was then embroidered by different women and stitched together when finished. The embroidery was worked with special care and followed a

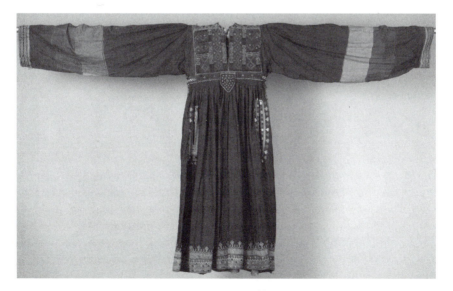

Deep red velvet girl's dress from Afghanistan with couched metallic braid, 1900–1925. KSUM, Silverman/Rodgers Collection, 1983.1.884.

local repertoire of patterns and stitches. The main filling stitches on suzanis were Bokura couching and chain stitch (either by **needle** or **tambour** hook).

Suzanis were embroidered on white cotton with red and white stitching, although shades of green and purple were sometimes included. The motifs and patterns were designed to give the bride good luck and protect her from evil. Images of carnations and pomegranate flowers, symbols of fertility, were combined with swirling tendril patterns that may have been inspired by Chinese bat wing motifs, symbols of happiness. Suzanis also included other floral motifs, large circular patterns called suns and moons, leaves, and petals in a symbolic garden of stitches. Some suzanis included magic patterns such as knives against the evil eye, pepper as protection from evil, and birds for happiness. For at least two centuries, these traditional needlework hangings connected young brides with their community and their culture at large.

FURTHER READING

Franses, Michael. (2000). *The Great Embroideries of Bukhara*. London: Textile & Art Publications.

Gillow, John, & Bryan Sentance. (1999). *World Textiles: A Visual Guide to Traditional Techniques*. Boston: Little, Brown.

Harris, Jennifer. (1999). *5000 Years of Textiles*. London: British Museum Press.

Metropolitan Museum of Art. Central and North Asia, 1800–1900 A.D. Online: http://www.metmuseum.org/toah/ht/10/nc/ht10nc.htm.

Tumar Art Group. Handicrafts. Online: http://eng.tumar.com/handicraft.

Wikipedia. Yurt. Online: http//en.wikipedia.org/wiki/Yurt.

Chain Stitch

A versatile **embroidery** stitch used to define lines and borders that can also be effective as a filling stitch. Chain stitch has ancient origins and is an important part of many cultural needlework traditions, especially for patterns that appear to be drawn in thread. Subtle shading can be achieved by filling in shapes with rows of chain stitch. It is a main component of the floral, bird, and animal motifs used on folk clothing and wall hangings throughout the world. Chain stitch is also known as **tambour** work; the same effect can be achieved with a fine hook as with a **needle** and thread. Chain stitch made with a hook or *ari* originated in India and eventually developed into **crochet.**

Chain stitch is created by creating a line of loops that are secured to the top of a base fabric. The thread is brought up from the underside, a loop held in place

with the thumb, and the next stitch drawn through the loop. Rather than pulling tight, the loops are left loose and built one after another. The underside of the chain stitch resembles the backstitch. There are many variations of the chain stitch, including open chain, double chain, feathered chain, and detached chain. The detached chain stitch is called the lazy daisy. Commonly used for floral motifs, the chain stitch loops of the lazy daisy are worked independently and radiate from a common center point. Chain stitch is often combined with other stitches such as the **satin stitch** and the backstitch.

Chain stitch is incorporated in needlework traditions in many diverse areas of the world, especially in **Western Asia,** the **Middle East,** and the **Indian Subcontinent.** Examples of chain stitch worked in silk from the Warring States period (475–221 B.C.E.) have been excavated in China. Other extant pieces have been found in the Middle East. Delicate floral and bird designs traveled to Iran along the Silk Road from Asia. In Iran, dense chain stitch embroidery with floral motifs and arabesques is made on felted wool in the city of Resht. A type of **patchwork** or **appliqué,** Resht or *Rašt* work, was used to make saddle cloths, wall hangings, and cushion covers. Small pieces of flannel wool are applied to a cotton or wool foundation with chain, **buttonhole,** and feather stitches (see **cross-stitch**). Patchwork in bands of different colored materials frames the central motif while individual elements such as petals and feathers are appliquéd. The richly colored designs include the paisley or *buti,* floral sprays, and birds on scrolling branches. Some older pieces included busts of women and men in circular medallions. Extant examples of Resht work date from the seventeenth, eighteenth, and nineteenth centuries, but the technique is much older. Resht work is still done in the traditional style in Iran today.

Nomads in **Central Asia,** including Afghanistan, embellish felted wool animal trappings and hangings with chain and buttonhole stitch. In Uzbekistan, chain stitch is sometimes substituted for **couching** on *suzanis,* large hangings that are an important part of a bride's dowry. In northwest India, women's blouses or *cholis,* skirts, and pictorial wall hangings are richly embroidered with chain stitch and **mirrorwork.** Chain stitch is also very popular in the **Eastern Mediterranean.** On the island of Crete, traditional costume includes richly decorated skirts with borders of tulips and carnations embroidered in chain stitch, satin stitch, pattern darning, and couching. Chain stitch is also used for flowing designs on garments in north **Africa,** especially Tunisia and Egypt. In **Eastern Europe,** densely worked chain stitch embroidery known as "big writing" is an important **embellishment** for folk costume and other items. Chain stitch combined with backstitch, buttonhole stitch, satin stitch, and **needleweaving** is especially prevalent in Hungary and Russia.

On the other side of the world in **South America,** the Quechua people, modern descendants of the Incas in Ecuador, Peru, and Bolivia, use chain stitch in brightly colored threads to embellish men's jackets, pants, and ponchos as well as women's *huipil* blouses and skirts. The main stitch is satin, but

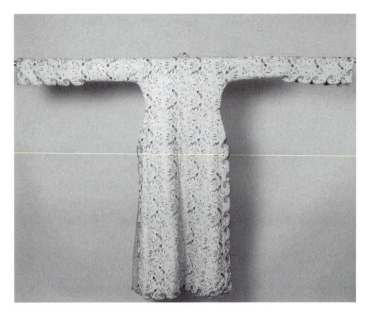

Turkish robe with intricate chain stitch embroidery, 1875–1900. KSUM, Silverman/Rodgers Collection, 1983.1.1985.

it is often accented by chain stitch and pattern darning, a form of **running stitch.** In these highland areas of South America, motifs such as geometric birds, snowflakes, and diamonds have been passed down from ancient times. In Ninhue, Chile, local women have recently developed a folk tradition for needle-painting with pictorial embroidery that illustrates their heritage. Colorful scenes of dancing and festivals are worked in chain stitch, Romanian couching, and French **knot stitches.**

The first sewing machines were based on the chain stitch. There were various attempts and patents from 1795–1830, but none of them worked reliably. In 1830, a French tailor was awarded a patent for a chain stitch machine. Eighty of the machines were installed in a factory in Paris. Other tailors, threatened by the prospect of the machines taking their business, invaded the factory and destroyed the machines. In 1857, a Virginia farmer patented the first chain stitch sewing machine in the United States. These early chain stitch sewing machines were designed to construct clothing. The first successful chain stitch embroidery machine was patented in 1865 by a French engineer. Its method was very similar to tambour work, and its use became a cottage industry in Switzerland. Using small machines in their homes, Swiss peasants made stoles, collars, and shawls in chain stitch on net. They also created appliqué **lace** similar to Carrickmacross, but with the shapes attached by chain stitch instead of a couched cord.

FURTHER READING

Coss, Melinda. (1996). *Reader's Digest Complete Book of Embroidery.* Pleasantville, NY: Reader's Digest.

Gillow, John, & Bryan Sentance. (1999). *World Textiles: A Visual Guide to Traditional Techniques.* Boston: Little, Brown.

Shazadeh, Roxane Farabi. The History of Persian Embroidery. Online: http://www.roxanefarabi.com/Embroidery/Embroidery.htm.

Stitch with the Embroiders Guild. Chain stitch. Online: http://www.embroiderersguild.com/stitch/stitches/index.html.

Wikipedia. Sewing Machine. Online: http://en.wikipedia.org/wiki/Sewing_machine.

Wilson, Erica. (1973). *Erica Wilson's Embroidery Book.* New York: Charles Scribner's Sons.

Couching

A method of **embroidery** where threads or cords are laid on a piece of fabric and stitched onto the surface. Couching is often used to emphasize lines and borders, and is especially useful for **metallic thread,** which is too thick and abrasive to pull through the fabric. Couching is used in many cultures and can be used to create both curvilinear and geometric designs. To couch, a cord or group of threads is laid in position and then tacked at intervals with a series of tiny stitches in a matching or contrasting thread. To hold the cord tight to the fabric, stitches are placed closer to each other when creating curves than when making straight lines. There are two main methods of couching, surface couching, the most commonly used, and underside couching, an older version of the technique. Underside couching begins with the thread laid on the surface of the fabric, but the stitching threads do not show; instead, they are pulled tight, allowing only a small loop of the metal thread to be visible on the surface. Underside couching is the more difficult method, and, for the most part, was replaced by surface couching in the fifteenth century.

Couching is an extremely striking way of decorating clothing, especially jackets, dresses, and waistcoats. In many parts of the world, couching metal threads was an important **embellishment** method for ecclesiastical robes and military uniforms. Couched metal cords or braids on soldiers' uniforms was known as frogging or *passamenterie.* With the spread of **Western European** imperialism in the eighteenth and nineteenth centuries, these extensive curvilinear patterns were adopted by embroiderers from Canada to Afghanistan. Sometimes couching was worked in a more elaborate stitch, such as blanket stitch or **chain stitch,** and in contrasting colors for extra impact. Couching can also be used to apply strung beads to the surface of a textile.

Two variations of couching are called Bokhara and Romanian. Rather than applying the couched cord with a separate thread, Bokhara couching is worked with a continuous thread. Straight stitches are made and then secured with diagonal stitches. The design is created by blocking the motif with adjacent stitches that are placed diagonally below each other. Romanian couching is similar to Bokhara in that a straight stitch is made and then stitched down with the same thread. The difference is that in Romanian couching, the stitches form a regular pattern but do not line up on the diagonal.

Strong cultural traditions for couching, especially using metal threads, can be found in the **Middle East, Central Asia,** the **Indian Subcontinent, Eastern Europe,** and Asia. In Palestine, Yemen, Syria, and Morocco, couching embellishes women's dresses, bodices, and jackets. Special garments are decorated with silk embroidery and dense couching around the neck and central panel in stylized floral patterns. This type of embroidery is also seen on the Hausa robes of Nigeria.

In Afghanistan, military-style metal thread couching can be found on women's dresses, often in red velvet. Similar heavy couching can also found in Pakistan and India, where men's vests, wedding blouses, and door hangings are embellished with couching, **appliqué,** and sequins. Elaborately couched gold threads are found on military and ecclesiastical garments in Yugoslavia and Russia. In Russia, couching can be found on artifacts dating as far back as the tenth century. Later Russian couching included pearls applied in a string or sewn individually and outlined in metal threads wound around the base.

In **Western** and Southeast **Asia,** especially China, Korea, Japan, and Indonesia, couched work is often combined with **satin stitch, appliqué,** and laid threads. Chinese embroidery often includes entire motifs filled with two parallel gold threads couched with bright red silk thread. This technique can be seen on eighteenth century "dragon robes" worn by the emperor and his family. Embroiderers in other parts of Asia, including Vietnam and Japan, have adapted many Chinese designs worked in couching. Women of the Chinese hill tribes create a unique style of embroidery that couches silk braids of one or two colors on rectangles of cloth. In Myanmar (Burma), *kalagas,* made on black velvet and edged with cloth from the discarded robes of Buddhist monks, are embellished with **stumpwork** padded motifs in couched cords, glass studs, sequins, and metallic threads.

Some of the finest couching done in Western Europe and the **British Isles** was *Opus Anglicanum* or English work, a style of embroidery popular in the fourteenth century. This intricate work, in silk split stitch and gold threads, was applied by underside couching. Opus Anglicanum embellished ecclesiastical vestments, altar frontals, and *aumonières* (alms purses) in England, France, Germany, and Italy. **Crewelwork** embroidery, popular in England in the sixteenth and seventeenth centuries, used variations on couching, known as trellis or laid work, to fill in large motifs. Crewelwork made by the eighteenth-century American colonists relied heavily on Romanian couching to fill in large spaces. In the Victorian era,

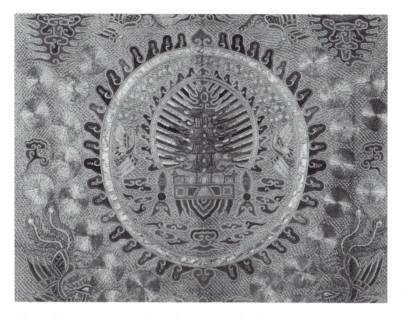

Chinese Taoist vestment with couching in metallic thread, 1800–1825. KSUM, Silverman/Rodgers Collection, 1983.1.1939.

embroidery often included goldwork, which was usually couched on the surface of dresses and accessories.

Bokura couching is the main stitch used on embroidered coverlets, blankets, and hangings in **Central Asia** to create blocks of solid color in motifs such as stars, leaves, flowers, ram's horns, and sunwheels. The most important of these are the embroidered hangings known as *suzanis*. The word suzani is Persian for **needle,** and these beautiful needlework pieces are used by women of all classes to adorn the wedding hall, providing an awning for the bride and groom, and to cover the bridal bed.

Suzanis are made by a community of stitchers. An expert draws out the design on several strips of cloth. Each strip is then embroidered independently by different women and stitched together at the end. Suzanis are usually stitched in chain stitch and Bokhara couching; the dominant images are carnations and pomegranate flowers, symbols of fertility, often worked in red on white. These floral motifs are combined with swirling tendril patterns that may have been inspired by Chinese bat wing motifs, symbols of happiness.

Couching is used by contemporary embroiderers, primarily by those enthusiasts who work with gold thread. There are classes and workshops held all over the world that teach the fine art of gold embroidery in patterns and techniques originating from China, Japan, and England. Couching is used by a wide variety of needleworkers all over the world. It is the best way to decorate an existing

fabric with thick ribbon, metal, or braid and makes for a stunning display of embellishment.

FURTHER READING

The Embroiderers Guild. Couching. Online: http://www.embroiderersguild.org.uk/stitch/stitches/couching.html.

Gillow, John, & Bryan Sentance. (1999). *World Textiles: A Visual Guide to Traditional Techniques*. Boston: Little, Brown.

Gotstelow, Mary. (1977). *The Complete International Book of Embroidery*. New York: Simon and Schuster.

Metal Thread Glossary. Online: http://www.berlinembroidery.com/metalthreadglossary.htm.

Munro, Alianora. Mediaeval Gold and Silk Work. Online: http://aeg.atlantia.sca.org/classes/opusanglicanum.pdf.

Russian embroidery. Online: http://tulgey.browser.net/~kate/sca/rus/.

Crewelwork

A type of **embroidery** done with wool thread. Wool embroidery has been known from the earliest times, but the word crewel generally applies to twisted two-ply woolen yarn. Rather than having its own stitches, crewelwork uses a variety of stitches, but is always worked in wool, usually on a base fabric of linen. The word crewel, with a variety of spellings, can be found in English records back to the thirteenth century. It may have come from the Anglo-Saxon, *cleow,* or *clew,* meaning a ball of thread. The earliest usage of crewel or cruell referring to a thin, worsted yarn was in 1494.

Because of its propensity to deteriorate, few ancient wool embroidered pieces remain. There is some evidence that ancient Greeks and Romans used wool embroidery, and the oldest extant pieces date to the first century B.C.E. These fragments, found in north Mongolia (China), show the face of a nomad warrior. The Bible includes references to curtains, altar clothes, and other hangings embellished with wool embroidery that decorated Jewish tabernacles in Israel and Palestine. Archeologists found wool stitching on an Egyptian tomb hanging that dates from the fourth or fifth century C.E.

Crewelwork, or wool embroidery, spread through England from 400 C.E. to 1400 C.E. The most notable example of early crewelwork is the Bayeux tapestry. Made in the **British Isles** over 900 years ago, this embroidery depicts the circumstances surrounding the Norman Conquest. It is worked in worsted wool thread in black, brick red, brown, light blue, green, grey, and ochre on a 20-inch wide

piece of linen that is 230 feet long. From the fifteenth century on, crewelwork meant any embroidery technique using fine worsted yarns. Fine embroideries were worked during the Middle Ages, but it was the invention of the steel **needle** that led to increasingly intricate and complicated wool work which has come to be known as crewel. Steel needles had been used in **Western Europe** for 150 years, but in the mid-sixteenth century, a greater supply of less-expensive needles became available in England. Queen Elizabeth I was an accomplished embroiderer and promoted embroidery among noblewomen during her reign. It was during the sixteenth and seventeenth centuries that crewelwork had its heyday, becoming known as "Jacobean Embroidery," after King James I came into power in 1603.

The swirling tree-of-life designs characteristic of crewelwork are a result of cross-cultural exchange between East and West. Europeans went to China, and then India, seeking spices to help make unrefrigerated meat palatable. Along with spices, they brought back textiles and other objects, which influenced Western design. The first country involved in the "oriental" trade was Portugal, followed by the Dutch, and finally the English. In 1600 Elizabeth I signed the charter for the East India Company, who introduced painted cottons to the English market. Palampores were large cotton cloths hand-painted with a tree-of-life motif. Painted cottons, called *kalamkari,* had been made on the **Indian Subcontinent** for at least 2,000 years. They became popular for bed coverings, and over time, cross-cultural blending resulted in palampores, textiles made specifically for the English market.

Designs for palampores were dictated by English fashion and translated by Indian painters, evolving into fantastic tree-of-life motifs, often including roses. The import of palampores almost ruined the domestic textile market, and England had to institute trade regulations. In the absence of printed fabrics, designs and motifs from the palampores became prototypes for crewel embroidery. In the first quarter of the seventeenth century, crewelwork's exotic designs were developed and refined. Bed hangings included swirling plants, which grew from Chinese-style mounds accompanied by oversized leaves, flowers, birds, and small animals. Crewelwork stitching became a mixture of pattern and motif. As the century progressed, the popular embroidery style lightened and became more graceful, with silk eventually taking the place of wool. Crewel was of little interest in eighteenth-century England, being replaced with other forms of needlework, such as **stumpwork.**

Although it fell out of favor in England, crewelwork was reinvented by the American colonists, who embroidered textured flowing tree-of-life designs with motifs and techniques of their own. Eighteenth-century American crewelwork designs included more coiling stems and fewer heavy flowers than English crewelwork. Colonists left more of the ground fabric unworked and used yarn-saving stitches such as Romanian **couching,** also known as New England laid work.

Traditionally, heavy two-ply wools were used for crewelwork, with names that reflected their origin: Persian (Iran and Iraq), English, or French. Handwoven

Fragment of English crewelwork, 1680–1689. KSUM, Silverman/
Rodgers Collection, 1983.1.1777.

linen twill was the preferred material because of its firm weave, but cotton was
also used. The smooth surface and slight diagonal rib of a twill fabric provided
a striking contrast to the worsted thread. Occasionally, linen twill was brushed,
creating a raised nap and soft feel. The brushing process originated in Fustat,
Egypt, and became known as "fustian."

The stitches used in crewelwork are not exclusively "crewel" stitches, but rather
common embroidery stitches worked in wool. The most frequently used are the
stem stitch (**running stitch**), **satin stitch, chain stitch, cross-stitch,** backstitch,
couching, and filling stitches. The stem stitch is sometimes called the crewel
stitch, reflecting the abundance of plant stems and outlined motifs used in tree-
of-life designs. Other stitches used in crewelwork include the herringbone stitch,
running stitch, French and bullion **knot stitches,** and the seed stitch.

Crewelwork was a popular **embellishment** on hangings, curtains, bed-
spreads, and other domestic furnishings. The unheated stone castles and wood
structures of sixteenth- and seventeenth-century England were cold, drafty, and
basically unattractive. Bed hangings consisted of two linen curtains that hung
from the top of the four-poster rail at either side of the bed, a headpiece, an
overhead "tester," valances, and the main bedspread. Embroidery added warmth

and charm to the bed, as well as to tables, seat covers, and pillows. Crewelwork was also used for petticoats, jackets, and waistcoats, although it most frequently decorated domestic items.

English crewelwork had fallen out of favor for almost 200 years when it was revived by William Morris, his friends, and his wife, Jane Burden, in the mid-to-late nineteenth century. In their quest to provide an alternative to the rapidly growing industrialized society, Morris and Company led a movement that came to be known as arts and crafts. In their Red House, they experimented with natural dyes, seeking to recreate a long-lost palette of blues and blue greens. Embroidery was just one of the mediums used by William Morris and his entourage in their quest to adapt medieval design to reflect their time.

In the twentieth century, crewelwork has come to mean surface embroidery with wool, without adherence to traditional design motifs. It experienced a revival in the 1960s, which was related to the back-to-nature movement in the United States. Needlework became more experimental and free-form, incorporating many different kinds of fibers and background fabrics. Along with wool yarn, contemporary crewelwork can include stranded floss, acrylic, nylon, and leather in bold colors. Crewel embroidery has witnessed several revivals since its height of popularity in the seventeenth and eighteenth century. The current trend is rediscovering traditional Jacobean crewelwork motifs. Each crewelwork revival alters and redefines design, materials, and techniques, making the ancient craft of wool embroidery a reflection of history and of current times.

FURTHER READING

Alita Designs. Online: http://www.alitadesigns.com/early_embroidery.php.

Creeden, Elizabeth. (1999). How Crewel. Online: http://www.caron-net.com/feb00files/feb00fea.html.

Gotstelow, Mary. (1977). *The Complete International Book of Embroidery.* New York: Simon and Schuster.

Kalidostitch.com. Crewel. Online: http://www.kaleidostitch.com/content%20pages/history%20page/Crewel.htm.

Wilson, Erica. (1973). *Erica Wilson's Embroidery Book.* New York: Charles Scribner's Sons.

Crochet

A needlework technique similar to **knitting** that creates an interloped fabric structure worked with a single continuous yarn. As opposed to knitting, which requires at least two pointed **needles,** crochet is worked with a hook. Crochet

literally means "hook" in French, and the needlework fabric produced with yarn and different sizes of hooks is called crochet. The term "crochet" is most commonly used around the world, except for **Scandinavia.** It is called *Haken* in Holland, *Haekling* in Denmark, *Hekling* in Norway, and *Virkning* in Sweden.

The foundation of every piece of crochet is a chain. The work is created by a succession of loops worked through each other to construct horizontal rows. Variations on the basic stitch involve increasing the number of loops linked together at the same time. Crochet differs from knitting in that the loops are locked laterally as well as vertically. Crochet can be used to create a dimensionally stable and reversible fabric.

Crochet is easily learned and produces quick results. It is most commonly used for creating and trimming clothing and household textiles such as tablecloths, towels, afghans, rugs, antimacassars, and curtains. Crochet is also used for clothing and accessories such as aprons, shawls, collars, cuffs, scarves, handkerchiefs, headwear, purses, socks, and gloves.

One advantage of crochet is that the only materials required are a hook and yarn. It does not need to be worked on a frame, like **sprang,** and thus is portable and can be easily carried and worked on in any convenient moment. Crochet lends itself to openwork patterns and geometric shapes such as squares, octagons, and circles. Crochet can be worked in a variety of materials including wool, cotton, or silk. Hooks vary in size and material based on the fineness of the desired product. Crochet hooks can be made of tortoise shell, bone, wood, steel, fishbone, ivory, brass, wood, or plastic.

The origin of crochet is unknown. Although there are reports of crochet being practiced by Italian nuns in the sixteenth century, there are no extant examples and little convincing evidence that crochet was done in Europe before 1800. Several sources make the link between crochet and what was called "nun's work" or "nun's lace," but these terms were also used for other types of fancy work done by nuns for ecclesiastical textiles. There are several different variations of crochet based on the technique and the tools used.

Early examples of three-dimensional dolls worked in crochet were found in China, but crochet most probably developed from ancient forms of embroidery that originated in the **Middle East,** the **Indian Subcontinent,** and **Africa,** especially Turkey, India, Persia (Iran and Iraq), and Morocco. Domestic textiles and clothing from these regions were sometimes edged with crochet in silk or gold **metallic threads.** The most convincing evidence for the origin of crochet is that it developed from **tambour** work that spread westward from the Middle East on trade routes to Spain, reaching **Western Europe** in the eighteenth century. Tambour evolved into what the French called "crochet in the air," when the background fabric was discarded and the chain stitch worked on its own. By the late eighteenth century, crochet was being practiced as a free-form technique in Western Europe.

Traditionally, crochet patterns were recorded and passed through small **samplers,** which were often kept in a book for referral. The first type of printed crochet

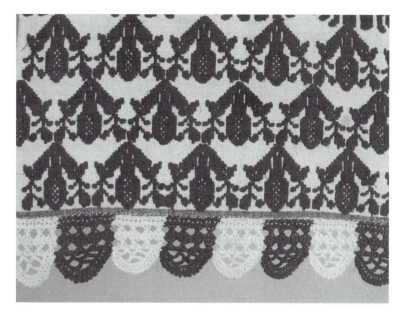

Crochet trim on nineteenth-century red and white embroidered domestic linen from Hungary. KSUM, transferred from the Allen Memorial Art Museum, Oberlin College, Oberlin, Ohio. Gift of Julia Serverance in memory of Permelia Allen, 1953, 2006.11.111.

pattern was for a purse of silk thread, published in Holland in 1824. In the early nineteenth century, **needle lace** and **bobbin lace** patterns were translated into crochet. These patterns were widely distributed throughout Western Europe, the **British Isles,** and **North America,** and by the 1850s, **whitework** crochet borders on sheets, towels, tablecloths, and undergarments were common.

The great variety of modern crochet stitches were developed during the Victorian period, due to both the distribution of patterns and the inclusion of crochet in the education of girls. Creating beautiful needlework was a sign of refinement in England and the United States. Students were taught to hold their hook like a pencil, as it gave the lines of the hand a more feminine and graceful look. Lace-like crochet pieces were used as placemats or to cover chair backs, also known as antimacassars. Crocheting large items requires a slightly different technique. Individual motifs or medallions are created and then linked together with chains.

An important use of the medallion technique is Irish crochet or guipure lace. Irish crochet is characterized by a composition of individually worked leaves and flowers attached to each other with a chain. Legend has it that four Irish nuns learned crochet in a French convent and brought it to Ireland in 1840. During the potato famine in the years around 1846, the art of making crocheted "lace" spread to a much wider area. Like **Fair Isle** and **Aran** knitters, Irish crocheters

were truly masters of their craft, and their skills could generate income. In a nonindustrialized society, Irish crocheters were able to focus on intricate and elaborate patterns in finely detailed work. Their work was exported throughout the British Isles and North America.

Because of its suitability for openwork designs and the ability to reproduce lace patterns, crochet became known as crochet lace in France and chain lace in England. Filet crochet is geometric in form and appears similar to filet lace, which is a form of **netting.** Filet has a strong tradition in Greece and was used extensively beginning in the 1850s for creating curtains, bedspreads, and borders. Bead crochet employs the same techniques as ordinary crochet, but beads are introduced as the piece is worked. Bead crochet bags have been fashionable from the mid-nineteenth century through today.

Tunisian crochet resembles knitting more than crochet. It produces a soft and elastic fabric that is useful for apparel. **Bosnian crochet** resembles woven braid and is often referred to as crochet braiding. It is used for decorative braids characteristic of Eastern European folk clothing. As opposed to other types of crochet, which only require a hook and yarn, hairpin crochet or **hairpin lace** is worked on a two-pronged fork. Hairpin lace shawls are created when strips are connected to each other with a chain stitch.

Crochet has come to be considered a traditional needlework technique in many parts of the world. Notable traditions can be found in the Middle East, Eastern Europe, the Indian Subcontinent, and **Western Asia.** Crochet is part

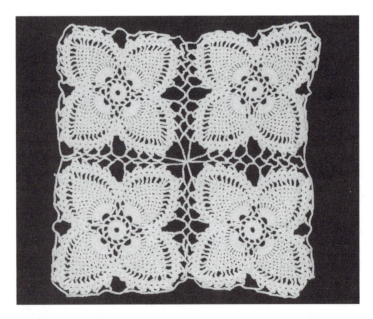

Victorian whitework crocheted doily, late nineteenth century. KSUM, Silverman/Rodgers Collection, 1983.1.2343.

of the needlework heritage of Yugoslavia, Hungary, Spain, India, Pakistan, and Tibet and continues to be a cottage industry in India, Greece, Italy, and China. As is true with other types of needlework, crochet ebbs and flows in popularity. After the initial growth in the nineteenth century, the practice of crochet declined in the early twentieth century when machine-made lace overtook the market and women's undergarments became increasingly made ready-to-wear and in synthetic materials with machine-made trims.

American crochet experienced a revival in the late 1960s and early 1970s in the form of vests, sweaters, and loose jackets. One of the most popular uses of crochet during this time was the "granny square" or "potholder" vest, which was made in multicolored square shapes. Crochet complemented the back-to-nature and hippie-inspired styles during this time. Jiffy crochet, using heavy yarns and large hooks, became popular as people were looking for a handmade article that did not take much time to produce. In the 1980s, crochet witnessed a revival in the creation of afghans, with celebrities such as Vanna White endorsing pattern books for throws and bed coverings in acrylic yarn. Acrylic yarn is inexpensive, easy to work, and washable.

Along with other needlework techniques, crochet became an accepted form among fiber artists and international competitions beginning in the 1970s. The Crochet Guild of America was founded in 1994 and seeks to promote and expand the art of crochet. New fibers and yarns coupled with fashion trends have resulted in a resurgence of crochet as a relaxing pastime and a technique to create accessories such as hats, scarves, shawls, and purses.

FURTHER READING

De Dillmont, Thérése. (1996). *The Complete Encyclopedia of Needlework* (3rd Ed.). Philadelphia: Running Press. (First published by Dollfus-Mieg Company, France, in 1884.)

Gillow, John, & Bryan Sentance. (1999). *World Textiles: A Visual Guide to Traditional Techniques.* Boston: Little, Brown.

Paludan, Lis. (1995). *Crochet History and Techniques.* Loveland, CO: Interweave Press.

Passadore, Wanda. (1969). *The Needlework Book.* New York: Simon and Schuster.

Potter, Annie Louise (1990). *A Living Mystery: The Art & History of Crochet.* [n.p]: A.J. Publishing International.

Whiting, Gertrude. (1971). *Old-Time Tools and Toys of Needlework.* New York: Dover. (Unabridged and unaltered republication of the work originally published by Columbia University Press, New York, in 1928 under the title *Tools and Toys of Stitchery.*)

Cross-stitch

One of the oldest and most widely used **embroidery** techniques that consists of two slanting stitches that cross each other in the center. Regular, closely worked

cross-stitches can be created on even-weave fabrics in motifs that range from geometric patterns to elaborately stylized designs. Cross-stitch is closely related to **needlepoint,** sometimes called "half-cross." The term "cross-stitch" refers to both the type of embroidery and the stitch itself. It is a popular form of embroidery throughout the world.

The most common base fabric for cross-stitch is a balanced plain weave. Cross-stitch can be worked from a design drawn directly on the base fabric or from printed charts. "Counted" cross-stitch is done with a grid-like chart. After establishing the center of the fabric, stitches are placed by counting warp and weft intersections in the base fabric to create the pattern. Any type of thread or floss can be used in cross-stitch, and linen is the most common ground fabric, because the yarns are straight and easily counted.

Cross-stitch may have originated in **Central Asia** and the **Middle East** as an **embellishment** on clothing and household items. The oldest extant piece of cross-stitch dates from about 850 C.E. In the eleventh through thirteenth centuries, Western European noblewomen spent hours cross-stitching. While waiting for their husbands to return from the Crusades, some copied patterns of Middle Eastern rugs made in the "Holy Land." Cross-stitch embroidery was also widely practiced among the rural peoples throughout the world, and variations are often named for the place of origin.

The most widely used variations are herringbone and fishbone stitch. Herringbone stitch is sometimes known as catch stitch or Russian stitch. Rather than a centered "X," herringbone alternates between high and low crossings. It can be used to join pieces of fabric or in ornamental variations commonly used in **patchwork** crazy **quilting.** Fishbone stitch is worked with the crossovers in the center like a spine and is used to create leaves in **crewelwork** embroidery. Originating in Italy, Assisi embroidery uses red or blue cross-stitches to create a pattern in negative, similar to **blackwork.**

Red wool cross-stitch on sleeves and hems can be found on the traditional ethnic or folk costumes of Russia, the Balkans, and Hungary. Red is considered to be the color of life and is often seen with accents of blue and yellow. In **Scandinavia,** cross-stitch on Swedish ethnic costume is embellished with similar colors. In the **Eastern Mediterranean,** especially Greece and Crete, women cross-stitch domestic linens with red silk thread. The fabric can be linen, cotton, or silk and varies in color among natural, bleached, indigo, or black. In these embroideries, cross-stitch is often coupled with *Cretan* stitch (a form of herringbone), **chain stitch,** and stem stitch (**running stitch**).

One of the most unique uses of cross-stitch is found on the dresses of Bedouin women in Syria, Palestine, Israel, Jordan, and Western Egypt. Using red cross-stitch and herringbone stitches on black fabric, these nomadic peoples identify themselves by the part of their garment that is embroidered. This intense embroidery is often seen on men's and women's wedding clothes. In Afghanistan, red, green, or white herringbone stitches are used to embellish felt animal trappings. Cross-stitch in various forms is also popular in northern **Africa.**

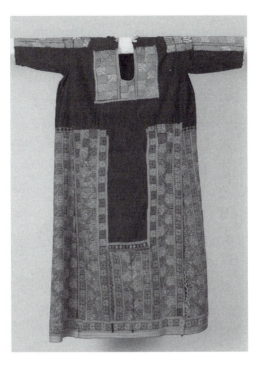

Cross-stitch on a late nineteenth-century Bedouin's dress. The embroidered panels were originally on another dress, cut off, and appliquéd on. KSUM, gift of Gene H. LePere, 1996.26.1.

On the **Indian Subcontinent,** cross-stitch in a variety of shades with gold and silver thread embellishes *chaklas* and skirts. On skirts, flowers and stylized parrots are filled in with large herringbone and fishbone stitches, which can appear almost solid. In **Western** and Southeast **Asia,** Chinese women used indigo-dyed cotton thread on a white cotton ground to create motifs such as birds, butterflies, and fish on aprons and children's clothing. Cross-stitch traditions are also strong in Myanmar (Burma) and Indonesia. In Vietnam, Zhao brides wear head cloths embellished with rows of cross-stitch.

Cross-stitch traditions in Middle and **South America** are the result of Western European influence and culture blending. In Panama and Guatemala, counted threadwork was practiced by the mestizos—people of Spanish and native descent. Yokes and hems of men's shirts and flounces of women's dresses are finely embellished in cross-stitch coupled with floral motifs in **satin stitch.** Mexican blouses, skirts, and heavy cotton shirts are sometimes embroidered in the same fashion. European influence is seen in Ecuador, where floral patterns in blue cross-stitch are placed on the yoke and down the center of the sleeves.

Although folk cross-stitch techniques were practiced in **Western Europe** from the Middle Ages, geometric-patterned embellishments spread during the

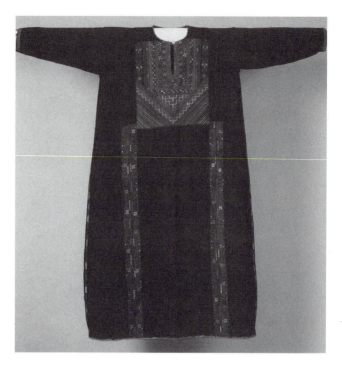

Palestinian embroidered dress. In some Middle Eastern countries, women wear almost identical dresses, distinguished only by the cross-stitch embroidery. Placement of stitches and motifs signifies the ethnicity of the wearer. KSUM, transferred from the Allen Memorial Art Museum, Oberlin College, Oberlin, Ohio. Gift of Harriet-Louise H. Patterson, 1950, 1995.17.569.

Italian Renaissance. Cross-stitch, along with **drawnwork** and **pulled thread-work** on the edges of noble's and priests' clothing, led to the development of **lace.** Printed cross-stitch patterns inspired by Asian designs and symbols were published as early as the sixteenth century in Germany, Italy, and France. During the seventeenth century, natural red dyes from America led to the popularity of cross-stitch in red or purple thread on white linen, especially in Italy, Greece, and Spain.

In eighteenth-century England and the American colonies, cross-stitched **samplers** in silk or wool came to be a sign of female accomplishment. With time, samplers became more complicated and landscape designs appeared. With the growth of women's magazines and books in the Victorian era, cross-stitch became very popular among women of all social classes. In the late nineteenth-century America, Deerfield embroidery heavily relied on cross-stitch, feather stitch, and herringbone stitch as well as Romanian stitch, stem stitch (running stitch), and French **knot stitches.**

But, by the turn of the century, cross-stitch, along with other needlework techniques, such as **Berlin work,** were considered amateurish and declined in practice. For many twentieth century women, cross-stitch was done on inexpensive printed linens and not considered a **needle** art. This changed in the early 1980s when counted cross-stitch experienced a great resurgence fueled by new and fresh designs. For many contemporary men and women, the repetition of cross-stitching is soothing and relaxing. Cross-stitch continues to be practiced all over the world. It has an especially strong connection with Scandinavian culture and in 1983 became the official stitch of Denmark.

FURTHER READING

De Dillmont, Thérése. (1996). *The Complete Encyclopedia of Needlework* (3rd Ed.). Philadelphia: Running Press. (First published by Dollfus-Mieg Company, France, in 1884.)

A few notions about cross-stitch's history. Translated from *L'encyclopedie du Point de Croix* (Prima Donna Editions), a French document. Online: http://ecross-stitch.free.fr/GALERIES/History.htm Accessed: 11/11/05.

Gillow, John, & Bryan Sentance. (1999). *World Textiles: A Visual Guide to Traditional Techniques.* Boston: Little, Brown.

Gotstelow, Mary. (1977). *The Complete International Book of Embroidery.* New York: Simon and Schuster.

Cutwork

A type of **embroidery** characterized by openwork patterns created by outlining shapes in tight **buttonhole** or **satin stitches** and cutting away the background fabric. Cutwork embroidery is sometimes called "embroidered **lace**" because of its open appearance, but it is not considered to be true lace. Instead, cutwork is fabric made "lacy" by cutting away the ground. Finished holes are sometimes filled in with bars of buttonhole stitch. Cutwork is one of the three main techniques used in **whitework,** along with **drawnwork, pulled threadwork,** and **needle lace.**

Whitework is strongly associated with Western European nuns who created intricate patterns for ecclesiastical textiles. Over time, they began to remove threads, which resulted in geometric patterns with a strong contrast between dark and light. Cutwork evolved from drawnwork when, rather than removing individual threads, whole pieces of the background fabric were removed. Originally, only nuns did this fine work, but as the Roman Catholic Church expanded, peasants were employed to embroider church vestments and linens. These hired

stitchers took their skills home and used them to decorate their own domestic linens.

Cutwork reached its height of beauty and technical expertise during the Renaissance. The term cutwork was first used by English writers to describe the earliest forms of lace such as Italian drawnwork, *punto tagliato.* The earliest pattern book entirely concerned with cutwork was published in Venice in 1542. Cutworks made in Italy, France, and the Netherlands in the sixteenth and seventeenth century were highly valued among royalty and nobility throughout **Western Europe, Scandinavia,** and the **British Isles.** Mary Queen of Scots received a piece of Flemish cutwork from Belgium as a New Years gift in 1556. She also made her own "cuttit out work" during her long imprisonment. In the same period, England passed sumptuary laws that forbade the wearing of cutwork by anyone below the rank of baron.

The simplest form of cutwork contains small open areas, such as eyelets. Over time larger open spaces were cut in the ground fabric, which required stabilizing bars to hold the piece together. This is known as Renaissance embroidery, where edges are connected by buttonhole bars, worked over a single thread. The technique developed into richly detailed cutworks with floating shapes known as Italian *reticella.*

Complex cutworks or reticellas are the link between cutwork and lace. They were done on increasingly thin linen fabrics with the buttonhole stitch covering the raw edges and buttonholed bars connecting the spaces. Eventually, the linen backing was all but completely cut away, leaving the stitching as a new fabric. Over time, it was discovered that the stitches could be built up by themselves and the background linen was not needed at all. This became known as *punto in aria,* literally "a stitch in the air." *Punto in aria* is the earliest form of needle lace.

There are many different variations of cutwork, most of which have their origin in Western Europe. Well known examples include French Richelieu embroidery, English *broderie anglaise,* Portuguese Madeira work, and Scandinavian Hardanger embroidery. Richelieu embroidery is named after Cardinal Richelieu, the principal minister of Louis XIII of France. In an attempt to build the French economy, Richelieu imposed a duty on all imports and brought Italian lacemakers to France to teach local workers. Over time France became a leader in the field of lacemaking. Richelieu embroidery includes distinctive buttonhole stitch bars that cross the cut out areas.

Broderie anglaise is associated with England, but may have its origins in Czechoslovakia. This type of whitework includes motifs of flowers, leaves, and stems created entirely in eyelets. Broderie anglaise was used extensively for women's undergarments in the Victorian era. Madeira work is a form of Broderie anglaise made on the island of Madeira off the coast of Africa, a Portuguese territory. Madeira work includes eyelet as well as satin stitching and other cutwork techniques. It still continues to be made today, primarily for the tourist trade.

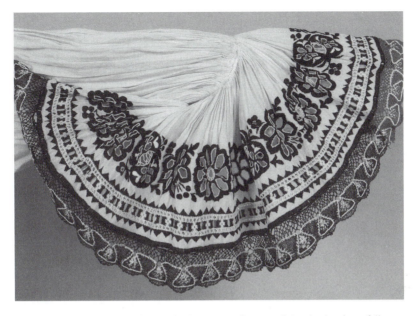

Sleeve ruffle on blouse in black and white cutwork. Part of Czechoslovakian folk costume, 1875–1925. KSUM, transferred from the Allen Memorial Art Museum, Oberlin College, Oberlin, Ohio. Gift of Schauffler College, 1956, 1995.17.574.

Hardanger is a Norwegian style of embroidery that uses satin stitch and blocks of drawn threads or cutwork. It was made in Norway in the nineteenth and twentieth centuries, usually in ecru linen. Hardanger was based on reticella designs, but considered typically Scandinavian, and usually incorporated **needleweaving** and drawnwork. Other types of white cutwork include Venetian (Italy) embroidery with its thickly padded buttonhole stitching, Spanish cutwork with turned-back hemmed satin stitch edges, and the heavily embroidered Colbert embroidery that is often worn by brides in the British Isles.

In some parts of the world, cutwork is done with colored threads. For example, in Moorish or Moroccan cutwork, colorful stitches of silk and gold **metallic thread** are accompanied by loops of gold embroidered cords. These gold cords connect the cutwork and embellish the edges, giving the appearance of intersecting chains. Cutwork traditions can be also found in the **Eastern Mediterranean,** especially in Cyprus and Turkey. A type of Turkish cutwork done in white or colored threads for bridal trousseaus is known as *antep isi*. While antep isi was originally made by women for their own use, a cottage industry now produces bedspreads, tablecloths, napkins, comforters, and pillows for sale to wealthy brides-to-be. Usually worked with silk thread on silk fabric, open spaces are created by drawing threads or cutting out areas and then finishing them with a satin stitch.

Peasants in Eastern European countries such as Ukraine, Poland, Czechoslovakia, and Yugoslavia created elaborately embroidered dresses for weddings and festivals. These folk costumes were embellished in bright colored patterns that often incorporated cutwork. The overall patterns are similar, but each region has its own distinctly identifiable style, stitch, and color combinations. In Sweden, geometric cutworks and drawnworks stitched in pink, red, or blue decorate church textiles, household items, and traditional heavy linen bridegroom shirts. This needlework style is known as Swedish lace or "birch bark embroidery," because fabric could be stretched over a frame of bark and carried by peasant girls to the fields.

Cutwork was taught in America by the mid-eighteenth century, where it was sometimes called pointing, especially when the open spaces were filled with needle lace. In a revival of cutwork during the Victorian era, ladies' magazines often referred to the technique as hollie stitch or hollie point. By 1868, a Swiss hand-embroidery machine was able to pierce holes and finish the raw edges, creating a type of broderie anglaise or Madeira that was often indistinguishable from the handmade type. By the 1890s, the Schiffli machine could be used to create elaborate patterns in white embroidery. Cutwork is still practiced by needlework enthusiasts, although it is not as common as other whitework techniques. Some of this may be due to the availability of lace and lace-like fabrics that came with the invention of embroidery machines.

FURTHER READING

Cutwork. Online: http://www.kulturturizm.gov.tr/portal/sanat_en.asp?belgeno=8744.

Earnshaw, Pat. (1982). *A Dictionary of Lace*. Bucks, UK: Shire Publications

Gotstelow, Mary. (1977). *The Complete International Book of Embroidery*. New York: Simon and Schuster.

Heritage Shoppe. Hand Embroidery. Online: http://www.heritageshoppe.com/heritage/essays/handemb.html.

Lace Fairy. Cutwork. Online: http://lace.lacefairy.com/ID/CutworkID.html.

Whiteworks. Cutwork Embroidery. Online: http://www.white-works.com/cutwork_embroidery.htm.

Drawnwork

A form of openwork created when elements of a base fabric are withdrawn and held in place with **embroidery** stitches. Drawnwork must be done on a plain-weave fabric, usually linen, which is well suited for the removal of threads. Drawnwork is often coupled with **cutwork** and **pulled threadwork** in **whitework** or

shadow work embroidery called "drawn and pulled threadwork." Originating in Egypt before the year 0, drawnwork borders became very popular for table linens and embellishing clothing in the sixteenth century. Drawnwork is known all over the world, with the strongest traditions in **Scandinavia,** especially Denmark, Norway, Sweden, and Iceland.

Drawnwork is an embroidery technique that results in intricate **lace**-like fabrics. It is an ancestor of lace, but not considered "true lace," since the base fabric still remains. In drawnwork, selected threads are removed from the grid created by the warp (vertical yarns) and weft (horizontal yarns). The remaining threads are bunched together and stitched tightly to create geometric shapes and motifs. As a greater number of threads are removed or "drawn" out, the pattern becomes more and more like lace.

Although both are types of counted-thread techniques, drawnwork differs from **cross-stitch** in that threads are removed rather than stitches added. It leaves the fabric weakened, so the base must be strong enough to not fall apart when threads are removed. Drawnwork is most often used to work borders on decorative linens and underclothes. Geometric motifs originated in the **Middle East** and traveled to Sicily (Italy) and other parts of **Western Europe** in the fifteenth century. Advancements in skills created many different patterns recorded on **samplers,** a type of fabric "notebook" jealously guarded and handed down from generation to generation. There was an enormous diffusion of drawnwork patterns due to the invention of the printing press. German pattern books were available by 1525.

Along with other types of whitework, drawnwork relies on a strong contrast between dark and light. The simplest type of drawnwork is a square-looking openwork known as hemstitching. Italian hemstitching or *faggotting* is a bit more decorative, usually used to finish the edges of clothing. In faggoting, threads are removed, creating a row of horizontal holes in the base fabric. The remaining threads are bundled together and held in place with a **buttonhole stitch.**

Many distinctive styles of drawnwork using different combinations of techniques and materials have become cultural traditions throughout the world. For example, in the Philippines, drawn and pulled threadwork was done on piña cloth for domestic use and trade. Well suited for clothing and table linens, piña cloth is a stiff translucent material in a pale yellowish color made from the fiber of the pineapple plant. In Greece, intricate drawnwork in trellis patterns creates a netted effect on the rectangular border of towels. Other important drawnwork traditions include Scandinavian Hardanger and Hedebo, German Dresden work, English Ruskin lace, and Russian lace.

Scandinavian drawnwork has strong local ties in pattern, technique, and motif. One of the earliest of these is Norwegian drawnwork, commonly known as Hardanger. Hardanger is a style of whitework embroidery that uses **satin stitch** and blocks of drawn threads or cutwork to embellish household linens and clothing.

Throughout time, Hardanger had a small but continuing presence in Scandinavian traditions, especially for household linens and clothing. Some techniques such as the drawnwork of Denmark known as Hedebo are not well known outside of the region. Hedebo was almost exclusively worked by Danish peasants to embellish domestic textiles and the traditional linen wedding shirt given by the bride to the groom. Hedebo is recognized by its floral shapes, which were adapted from woodcarving on peasant furniture. Since it was used to create objects for personal use rather than for export, the finest Hedebo pieces are family heirlooms and seldom appear on the market.

In Italy, *punto taglito,* an early form of drawnwork embroidery, embellished the bed covers, curtains, and tablecloths of nobility. Punto taglito developed into the *punto aria* patterns of Venetian (Italy) lace. On Romanian folk costume, white-on-white drawnwork known as *firele trase* embellishes women's costumes and household textiles. Firele trase patterns vary by region; the oldest were geometric, but over time, stylized floral and animal patterns emerged. The lace-like quality of Romanian drawnwork may have originally developed as a method of imitating the lace so popular in upper-class fashion. Firele trase is often seen on the lower edge of sleeves.

By many accounts, the finest drawn threadwork was done around Dresden, Germany. The base for Dresden work was an almost transparent plain

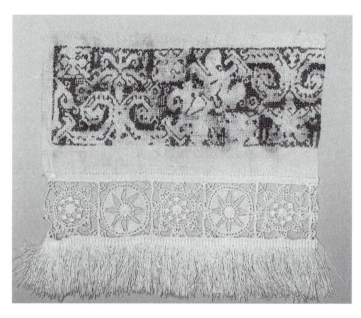

Italian drawnwork, 1650–1750. KSUM, transferred from the Allen Memorial Art Museum, Oberlin College, Oberlin, Ohio. Oberlin-Carnegie Corporation Fund, 1931, 1995.17.767.

weave fabric, usually lawn or muslin. Threads were counted and rearranged to produce a mesh ground filled with many different varieties of openwork patterns. Dresden work became popular throughout Western Europe on ladies' collars, caps, and aprons beginning in the mid-eighteenth century. This exquisite whitework was a perfect accompaniment to the fashion for less-formal dresses influenced by the English countryside. Because of its popularity, there were many attempts to imitate the intricacies of Dresden work. Similar though inferior forms were made in Sweden, Scotland, other parts of Europe, and the Americas.

Drawn threadwork is often accompanied by other techniques such as **cutwork,** pulled work, and **needleweaving** for whitework embroidery. With a combination of drawn and pulled threadwork, Scottish Ayrshire developed into a significant cottage industry in Scotland beginning around 1814. Drawnwork is also used as a marking technique, to keep squares regular for other types of needlework. For example, in Ruskin lace, single warp and weft threads are removed to make a square in the base fabric, which is cut out, and the hole finished in buttonhole stitch. Ruskin lace was a product of the workshops of John Ruskin, an important figure in the English arts and crafts movement. With an emphasis on handicraft, Ruskin lace was made on linen that was handspun and handwoven by cottagers beginning in the 1870s.

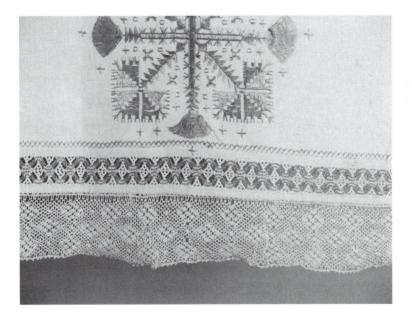

Drawnwork on "turkish" towel from Eastern Europe, possibly Hungary, nineteenth century. KSUM, transferred from the Allen Memorial Art Museum, Oberlin College, Oberlin, Ohio. Gift of Mrs. Fred White, 1943, 2006.11.68.

Although usually seen in white on white, drawnwork traditions throughout the world also include bright colors. This is especially true in **Eastern Europe, South America,** and the Middle East. With origins in the late fifteenth century, colored silk drawnwork known as Russian lace embellished folk clothing in Russia, Croatia, and the Ukraine. By the sixteenth century, drawnwork pieces in bluish green, rose pink, and canary yellow silk were being made for ecclesiastical and household linens in Sicily. Folk traditions for colored drawnwork are also found in Mexico and Syria, where it creates decorative borders on veils.

Between 1840 and 1920, Scandinavian immigrants brought drawnwork traditions to America, with instructions for Hardanger and Hedebo published in women's magazines starting in the first decade of the twentieth century. Drawnwork was most popular before the advent of modern laundering methods. Domestic textiles with delicate patterns could not stand up to washing machines and detergents. Today, most drawnwork is hemstitching, which decorates the edges of tablecloths, guest towels, and handkerchiefs.

Drawnwork experienced a revival in the back-to-nature movement of the late 1960s and 1970s with the publication of instructions and pattern booklets. Today, fine drawnwork is perpetuated through courses and patterns of the Embroiderers' Guild of America and needlework designers. These traditional forms of needlework are practiced by enthusiasts and reflect an important part of Scandinavian, Eastern, and Western European heritage.

FURTHER READING

De Dillmont, Thérése. (1996). *The Complete Encyclopedia of Needlework* (3rd Ed.). Philadelphia: Running Press. (First published by Dollfus-Mieg Company, France, in 1884).

Earnshaw, Pat. (1982). *A Dictionary of Lace.* Bucks, UK: Shire Publications.

Eliznik Web Pages. Decorative Embroidery—Drawn Thread Work: Romanian Costume. Online: http://www.eliznik.org.uk/RomaniaPortul/decoration-drawnthread.htm.

Embroiderers' Guild of America, Inc (EGA). Online: http://www.egausa.org.

Gillow, John, & Bryan Sentance. (1999). *World Textiles: A Visual Guide to Traditional Techniques.* Boston: Little, Brown.

Gotstelow, Mary. (1977). *The Complete International Book of Embroidery.* New York: Simon and Schuster.

Manetti, Maria Margheri.(1999). *Il Punto Antico/ Drawn-Thread Work.* Florence: Libreria Editrice Fiorentina. Online: http://florin.ms/puntoantico.html.

Schwall, Katherine L. (February 19, 2001). Century Chest Project: Needlework History 1940–1970. The Embroiderers' Guild of America Rocky Mountain Region. Online: http://rocky_mtn_embroidery.tripod.com/.

St. George, Aldith Angharad. (Summer 2000) Whitework. Filum Aureum. The West Kingdom Needleworkers Guild. Online: http://www.bayrose.org/wkneedle/Articles/Whitework. html/.

Thompson, Angela, and Bayne, Avril. (n.d.). Hedebo. Online: http://lace.lacefairy.com/ID/ Hedebo.html.

East Asia, Southeast Asia, and the Pacific

The area of the world referred to as East and Southeast Asia, Polynesia, and the South Pacific, including, but not limited to, Australia, Cambodia, Hawaii, Indonesia, Laos, Myanmar (Burma), New Guinea, New Zealand, the Philippines, Tahiti, Thailand, and Vietnam. Every major world religion is represented in these widely scattered countries including Buddhism, Catholicism, Christianity, and Islam. Cultural needlework practices are varied, with no style common to the entire area. The region has distinctive traditions utilizing indigenous materials that have been influenced and disseminated by trade and migration. The needlework of this area has a strong relationship to **Western Asia,** with design motifs and techniques such **couching, metallic thread,** and **satin stitch** adapted from the Chinese.

The needlework of East Asia, Southeast Asia, and the Pacific has also been impacted by settlers from **Western Europe** and the **British Isles** as a result of colonization. For example, European-style **embroidery, drawnwork, pulled threadwork,** and **knitting** were introduced to Indonesia and the Philippines in the nineteenth century. Sometimes these imported techniques became cultural traditions. Beginning in the 1840s, finely knitted openwork stockings and shawls were made with aloe fiber in the Azores and the Philippines. Aloe was also used for **plaiting** and **tatting,** with local people making placemats and other table coverings for the tourist trade.

In the Pacific Islands of Hawaii, Tahiti, and the Cook Islands, traditional mat designs were reproduced in embroidery on cotton. **Quilting, patchwork,** and **appliqué** are important native traditions, especially in Hawaii, where they were introduced by missionaries in the early nineteenth century. In some areas, western settlers inspired other western settlers. For example, North Americans arriving in Australia for the Gold Rush inspired a **candlewicking** tradition. Australians and New Zealanders are also known for their **ribbonwork** and **locker hooking.**

Most East and Southeast Asian embroidery is done in silk or **metallic threads** on a ground of silk or cotton. Other indigenous materials include pineapple, bark, and wild-orchid fibers. The most popular stitches and techniques are **buttonhole stitch, chain stitch,** couching, **cross-stitch,** drawnwork, embroidery, **needleweaving,** pulled threadwork, **running stitch,** satin stitch, and **stumpwork.** Many Southeast Asian needlework traditions include **embellishment** such as **shells, feathers and beetle wings,** and sequins. **Knotting, fringes, tas-**

sels, and pompoms are also used, especially for folk costume and utilitarian items.

Embroidery and embellishment are most commonly seen on clothing, wall hangings, curtains, covers, and table linens in motifs of flowers, animals, birds, triangles, and other geometric shapes. Women of the hill tribes of China, Thailand, Vietnam, Laos, and Myanmar (Burma) decorate their costume and baby carriers with panels worked in **reverse appliqué.** Their work is so fine that it is often mistaken for embroidery. Reverse appliqué is used as an indigenous art form in very different parts of the world. Specifically, the *mola* technique of the Kuna people from Panama (**South America**) is interestingly similar to the *paj ntaub* made by the Hmong people of Laos, Vietnam, and Cambodia.

Lei making is an important cultural technique throughout the Pacific Islands of Polynesia and is most well known in the American state of Hawaii. Leis evolved from an ancient tradition that values the head and shoulders as sacred parts of the body. The leis were symbols of esteem for gods, loved ones, and oneself. Leis can be made from both permanent and temporary materials including **shells,** seeds, bone, stone, feathers, hair, leaves, vines, and flowers. The lei has become a symbol of Hawaii, expressing *aloha* or love, friendship, gratitude, and affection. Leis are presented on special occasions and celebrations such as marriages, birthdays, and funerals. In a display of leis' importance as part of Hawaiian culture, the state legislature opens with thousands of lei-wearing representatives and senators.

Leis are made by stringing, braiding, twining, sewing, and knotting, depending on the material. Lei-making **needles** are long, ranging from 3 to 14 inches, and come in different thicknesses. Flower leis, most strongly associated with island visitors, became a tradition with the steamships of the late nineteenth and early twentieth century. Visitors would be presented with leis upon arrival and departure. As the ship left Honolulu, passengers would throw their leis into the sea, with the hope that they would float to shore, symbolizing an eventual return to the islands.

In the Pacific Islands, shredded colored cloth is stitched into intricate and vibrant patterns to create quilt-like garments. This important cultural tradition is related to ideas of death and renewal as the cloth is broken down and reworked into a precious object. **Patchwork** textiles are presented at life-cycle events such as significant birthdays, a boy's first haircut, weddings, and funerals. Based on traditional patterns of painted sleeping mats, these textiles include many tiny pieces sewn together. In addition to patchwork, appliqué is also used. Floral and leaf motifs are appliquéd in four layers embellished with detailed embroidery. Important representations of the spirit of the maker, pieced textiles are used to decorate the graves of departed loved ones.

Embroidery is a long-standing needlework tradition in the Philippines, largely because of early contact with needlework from China and India, many years before the arrival of Spain. Using indigenous pineapple or *piña* fibers,

Filipino women from the rain forest, countryside, and city worked fine domestic embroideries for their families. With the Spanish educational reforms of 1863, embroidery took the place of "academic subjects" taught to all schoolgirls from the third to seventh grade.

Students would begin by learning backstitch, stem stitch (running stitch), and cross-stitch on stamped cotton fabric, later progressing to *piña* cloth. In other schools run by Spanish, French and Belgian nuns, Filipino girls created exquisite embroidery that would be framed and hung in their family home as a sign of accomplishment, similar to **samplers** in Western Europe and **North America.** In 1912, the American public school system continued to teach needlework in the Philippines, opening the School of Household Industries in Manila. The intensive course was six to eight months of training in embroidery and **lace**making.

As many as 40 American embroidery factories were built in Manila in the 1910s and 1920s. Almost the entire output of these factories was exported to the United States, and later expanded to India, Australia, and China. During its height, the Philippine embroidery industry employed between thirty thousand and fifty thousand workers. Cloth was cut, stamped, and prepared in factories for women who stitched in their homes. Upon completion of the work, it was returned to Manila, where it was inspected, and if approved, cut, sewn, laundered, and shipped. This cottage system provided work for skilled women and much-needed income for many families.

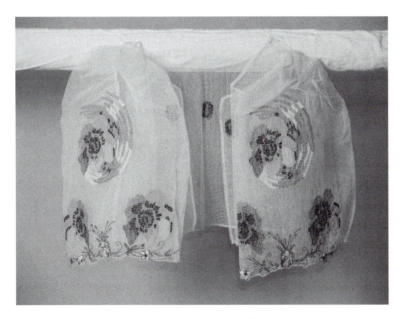

Jacket of embroidered *piña* (pineapple) cloth ensemble from the Philippines, 1900–1935. KSUM, gift of Helen Knox Wagner, 1984.11.1a-c.

FURTHER READING

Chung, Young Yang. (2005). *Silken Threads: A History of Embroidery in China, Korea, Japan, and Vietnam.* New York: Harry N. Abrams.

de la Torre, Visitacion R. The Tradition of Embroidery on the Barong Tagalog and Other Garments. Online: http://www.myBarong.com.

Gotstelow, Mary. (1977). *The Complete International Book of Embroidery.* New York: Simon and Schuster.

Harris, Jennifer. (1999). *5000 Years of Textiles.* London: British Museum Press.

Ide, Laurie Shimizu. (2003). *Hawaiian Lei Making.* Honolulu: Mutual Publishing.

Küchler, Susanne. (2005). Why are there quilts in Polynesia? In *Clothing as Material Culture.* Susanne Küchler and Daniel Miller, eds. Oxford, UK: Berg, 175–192.

Leis. (1996). Online: http://www.folklife.si.edu/hawaii/lei.htm.

Were, Graeme. (2005). Pattern, Efficacy, and Enterprise: On the Fabrication of Connections in Melanesia. In *Clothing as Material Culture.* Susanne Küchler and Daniel Miller, eds. Oxford, UK: Berg, 159–174.

Eastern Europe

The area of the world that includes Albania, Bulgaria, Czechoslovakia, Hungary, Montenegro, and Romania; the Balkan States of Estonia, Latvia, and Lithuania; countries of the former Yugoslavia consisting of Bosnia, Croatia, and Serbia; and Russia, along with Belarus, the Ukraine, Siberia, Georgia, and Armenia. Cultural needlework traditions are especially strong for **embroidery** on folk costume and domestic textiles. Other needlework techniques used in Eastern Europe are **appliqué, lace, embellishment,** and **crochet.**

The oldest extant Eastern European textiles were found in Siberia, dating from the fourth century B.C.E. In the frozen tombs of Pazyryk, archeologists found carpets and saddle covers constructed from layers of cloth, felt, and leather, evidence that appliqué was in use by that time. The earliest needlework patterns were based on geometric weaving, stylized floral and animal motifs including the earth mother, eagles, and eight-pointed stars. In the later half of the nineteenth century, freestyle nongeometric floral motifs developed. Changes in embroidery styles were the result of sharing among regions and between urban and rural areas. The most elaborate stitching was done around 1900, with many different techniques combined to embellish a single garment or textile.

Motifs and patterns from Islam have played a dominant role in Eastern Europe, especially in those areas that were occupied by Turkey such as Bulgaria and parts of Romania and Yugoslavia. There are also strong Catholic and Orthodox Christian traditions, but they did not significantly influence embroidery design. For

the most part, women are the embroiderers in Eastern Europe, with the exception of ecclesiastical textiles, which were made by male professional artists. Taught at home or in Christian convents and church schools, young Eastern European girls did not practice on **samplers.** They learned to stitch by making embroidered towels, tablecloths, sheets, and folk costumes.

Color is important in Eastern European culture, with bright red predominating. Red signified innocence and contentment with life, especially for young women. Embroidery was usually done on natural or bleached open-weave linen in cotton, wool, or silk thread. It was often worked in narrow borders of repeating motifs that decorated the edges of domestic textiles. Embroidery was also important for women's traditional costumes, embellishing skirts, blouses, aprons, scarves, petticoats, and caps. In some areas, men's hats, shirts, and trousers were also decorated with folk embroidery.

The most frequently used stitch in Eastern Europe is **cross-stitch.** It is usually seen on sleeves and hems in repeating motifs. Eastern Europeans have developed many varieties of the basic cross-stitch including cross-stitches worked on a trellis of laid threads, exaggerated long-legged cross-stitches, and the herringbone stitch, also known as the Russian stitch. Other embroidery stitches used in Eastern Europe include **chain stitch,** flat or padded **satin stitch,** backstitch, and **buttonhole stitch.** A distinctive Hungarian style with densely worked chain stitches is known as "big writing."

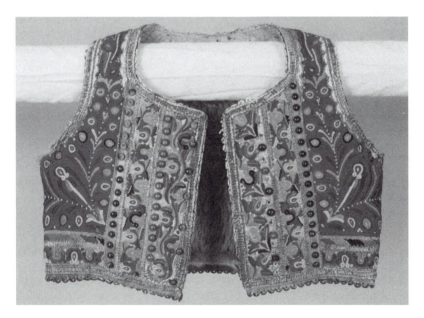

Heavily embellished Romanian sheepskin vest includes leather appliqué, metal studs, and wool embroidery, 1860–1869. KSUM, gift of Louis and Jane Martin, 1987.65.11.

Needleweaving in geometric patterns of lattices and crosses also decorated the borders of shawls, towels, and table linens in many parts of Eastern Europe. Often worked in one color, needleweaving was featured on traditional peasant costume, particularly in Armenia and the Ukraine. **Drawnwork** and **pulled threadwork** using colored silks was done in Croatia, Russia, and the Ukraine. **Cutwork** is particularly associated with Czechoslovakia, and fine **whitework** with northern Russia and Estonia. Islamic influence is seen in the **blackwork** of Bohemia, Montenegro, and Transylvania. Chieftains and military officials in Serbia, Montenegro, Albania, Yugoslavia, Russia, Georgia, and Siberia wore costumes with elaborate **couching** in **metallic thread**s. Embroiderers in Romania created a type of embroidery called "embossing." Worked in white or off-white silk threads, the material is puckered or raised, like **smocking.**

Sheepskin garments are a long-standing cultural tradition in rural areas of Eastern Europe. In the Baltic States, Ukraine, Siberia, Hungary, Bulgaria, and Romania, long jackets and waistcoats are embellished with floral embroidery and leather **appliqué.** The strongest traditions are found in Hungary and the Ukraine. In Hungary, sheepskin coats are decorated with tassels, braids, pompoms, floral embroidery, and appliqué. Traditional Ukrainian costumes include a sheepskin waistcoat embellished with floral embroidery and leather appliqué. Similar garments are also worn in the mountainous regions of Afghanistan. In northern areas, leather is embroidered with reindeer hairs and occasionally appliquéd with fish skins.

Embellishments are an important part of Eastern European folk costume, especially on headdresses and aprons. For festivals, Hungarian women wear several types of caps, which are embellished with **ribbonwork,** spangles, and long tubular beads. Similar decorations are found in Bulgaria including **fringe,** beads, coins, metal chains, **shells,** and buttons. Sparkling embellishments are attached to clothing, particularly the hats of children, to provide magical protection. Eastern European folk costume usually included an apron. Thought to protect from evil spirits, aprons were appliquéd, embroidered, and trimmed with **macramé** and fringe.

Like embroidery, **bobbin lace** made in Eastern Europe characteristically includes brightly colored threads. In Bohemia, an area of northwest Czechoslovakia, peasant lacemakers created a Torchon lace for the local markets in the nineteenth century. This lace often incorporated red and blue threads. The Slavic laces, as they are called, were abstract in design, including wandering coils and swirls. In the former Yugoslavia, **Bosnian crochet** is a cultural needlework tradition. Resembling a woven braid, it is usually worked in one or more colors of cotton cord. Bosnian crochet is used for belts, collars, cuffs, and braids used on Eastern European folk clothing. Other lesser-used needlework techniques include **knitting** and **needlepoint.** Handknit socks and purses made with beads can be found throughout the region. Hungarian point is a type of needlepoint similar to Bargello, achieving a similar shading effect with shorter stitches offset by longer stitches.

FURTHER READING

Earnshaw, Pat. (1982). *A Dictionary of Lace.* Bucks, UK: Shire Publications.

Gillow, John, & Sentance, Bryan. (1999). *World Textiles: A Visual Guide to Traditional Techniques.* Boston: Little, Brown.

Gotstelow, Mary. (1977). *The Complete International Book of Embroidery.* New York: Simon and Schuster.

Hungarian Online Resources. Hungarian Embroideries. Online: http://hungaria.org/hal.php?halid=5.

Kelly, Mary B. (1994). *Goddess Embroideries of Eastern Europe.* Hilton Head Island, SC: StudioBooks.

Welters, Linda. (1999). *Folk Dress in Europe and Anatolia.* New York: Berg.

Eastern Mediterranean

The area of the world formerly known as Anatolia, the Byzantine Empire, and the Ottoman Empire including, but not limited to, Armenia, Crete, Cyprus, Greece, the Ionian Islands, and Turkey. The Eastern Mediterranean is a maritime area on international trading routes. Constant interaction and cross-cultural exchange spread needlework designs and techniques throughout the region and the world. The Eastern Mediterranean was heavily impacted by the Turkish Ottoman Empire, which lasted from 1299 to 1923. It was not until the nineteenth and early twentieth centuries that Greece and other countries achieved independence. There was an elaborate redrawing of boundaries and population exchanges following World War I. Islam, Christianity, and Greek Orthodox religions are all present in the region and influence needlework styles.

The Western tradition of **embroidery** has its roots in Islamic styles that were practiced by Arab peoples in Sicily (Italy) and Ottoman Turkey. During the Byzantine Empire, Emperor Constantine's wife, Theodora, strongly encouraged the arts, including embroidery. When the Byzantine Empire declined, embroiderers fled to Ravenna, Italy, bringing Eastern Mediterranean and Middle Eastern embroidery styles to **Western Europe.** Most embroidery is done by women, except for professional work, which is done by men. Young girls traditionally learn from their mothers, or in Christian areas, in convents and church schools.

The strongest needlework traditions are embroidery and **lace,** although other techniques were practiced in the region. The importance of needlework in the Eastern Mediterranean is reflected in the official uniform of the Greek presidential guard. Completely handmade, the uniform includes a kilt or *foustanella,* with 400 pleats, one for each year of Turkish rule. Other components are

Eighteenth-century textile panel from Turkey. KSUM, transferred from the Allen Memorial Art Museum, Oberlin College, Oberlin, Ohio. Gift of Margaret R. Schauffler, Oberlin College Class of 1918, 1978, 2006.11.11.

a red hat with a tassel, a shirt with very wide sleeves, a waistcoat embroidered in white or **metallic threads,** woolen stockings, garters with **fringe,** and red shoes with black pompoms. Braiding and **knitting** were used for animal trappings, carrying bags, and socks, primarily by nomadic and mountain peoples. Greek women create filet **crochet** and **bobbin lace** tablecloths, and in Turkey, good luck talismans of blue glass "eye" beads or *bonjuk* are suspended from **macramé** straps.

Embroidery is worked primarily on women's costumes, with the most intricate work done on marriage outfits. Men's clothing is not generally embroidered. Traditional costumes and textiles are worked in red silk thread on natural, bleached, indigo blue, or black linen, cotton, or silk fabric. **Metallic thread** is often combined with silk embroidery and coins. Coins are worn as jewelry and used as **embellishment** on clothing and headwear. The most prevalent embroidery stitches and techniques in the Eastern Mediterranean are **chain stitch, couching, cross-stitch, cutwork, drawnwork, needleweaving, satin stitch, whitework,** and stem stitch, a variation of backstitch.

Eastern Mediterranean women create domestic embroidery that traditionally decorates bed covers, hangings, towels, cushions, blouses, dresses, skirts, and coats. Stylized designs are prevalent, influenced by Islamic customs, which discourage depiction of human and animal forms. The tree-of-life, "king and queen" leaf patterns, and the double-headed eagle are popular, as are flowers, peacocks,

and animals. These designs have been copied by embroiderers all over the world, especially in Western Europe.

In addition to embroidery, lace is a significant cultural tradition in the Eastern Mediterranean. Variations of lace knotting are done in countries along the eastern and southern sides of the Mediterranean, including Turkey, Armenia, Cyprus, and Greece. Two notable styles are Armenian lace and Turkish *oya*. Although both are forms of **needle lace,** their appearance is markedly different.

Armenia has a long history of domination by outside forces. From the fourth century, it was conquered and ruled by several different groups, finally gaining independence in 1918. Because the Armenians were a politically powerless group, men were forced to conform to the dress and customs of their rulers. Since Armenian women had less contact with the world outside their home, they retained a more distinctive traditional costume. From 1918 to 1923, the Armenians suffered genocide, with as many as 1.5 million deaths. Because of this great loss, there was a lack of information about Armenian lacemaking, but in recent years it has been revived and recognized.

It is thought that Armenian lace, also known as *bebilla* or "Nazareth lace," has existed for as many as 3,000 years. It evolved from **netting** and was first made by knotting with the fingers, eventually evolving into a lace of very tiny

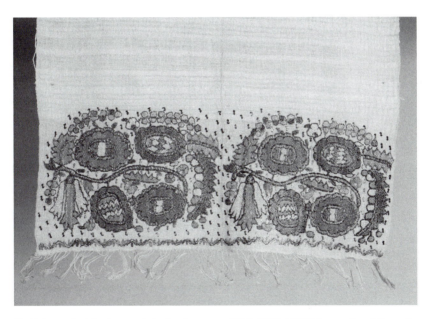

Turkish towel with characteristic floral pattern, 1850–1900. KSUM, transferred from the Allen Memorial Art Museum, Oberlin College, Oberlin, Ohio. Gift of Mrs. Fred White, 1943, 2006.11.69.

knots made with a **needle** and fine cotton thread. Armenians had the custom of making and donating embroidered articles, textiles, carpets, and laces to decorate shrines, temples, and churches, especially for weddings or christenings. While embroidery and finer needle lace was taught in Armenian church schools, convents, and monasteries, secular embroidery and bebilla were taught at home. Armenian lace was made by women of all classes and used as a decorative element on traditional headscarves and lingerie. Young women would make lace as part of their trousseau, embroidering towels and preparing clothing for their married life. Common designs included rosettes, bow-type motifs, and leaf patterns. In their traditional culture, Armenian women gained revered reputations for fine workmanship in complex patterns.

Another notable Eastern Mediterranean lace tradition is *oya,* an important part of traditional Turkish costume. Oya is also a needle knotted lace, but its form and color differ from bebilla. Turkish lace is a three-dimensional decoration of brightly colored silks, like a garland of flowers. Originally thought to have embellished the veils of harem women, needle lace flowers may date as far back as the eighth century B.C.E. The oya technique spread from Anatolia to Greece and then on to Italy and Western Europe. Traditionally, it was used to trim headscarves and undergarments, and later expanded to outer garments, towels, napkins, and bridegroom's headdresses. Every flower and every color in oya lace tells a story in a complicated symbolic language. For example, a purple hyacinth indicates love, a pink hyacinth indicates engagement, and a white hyacinth represents fidelity. Young maidens, new brides, and young women traditionally conveyed their loves, hopes, and expectations as well as unhappiness, resentment, and incompatibility to those around them through needlework.

FURTHER READING

Armenian Library and Museum of America (ALMA). Online: http://www.almainc.org.

Earnshaw, Pat. (1982). *A Dictionary of Lace.* Bucks, UK: Shire Publications.

Gillow, John, & Bryan Sentance. (1999). *World Textiles: A Visual Guide to Traditional Techniques.* Boston: Little, Brown.

Gotstelow, Mary. (1977). *The Complete International Book of Embroidery.* New York: Simon and Schuster.

Kasparian, Alice Odian. (1983). *Armenian Needlelace and Embroidery.* McLean, VA: EPM Publications.

Lind-Sinanian, Susan. Armenian Needlelace. Online: http://www.armenianheritage.com/faneedle.htm.

The Presidential Guard. Presidency of the Hellenic Republic. Online: http://www.presidency.gr/en/proedr_froura.htm.

St. Sarkis Armenian Church. (2003). Bebilla or Armenian Knotted Lace. Online: http://lace.lacefairy.com/ID/ArmenianID.html.

Tansug, Sabiha, and Dilber, Servet. (2006). Lace (Oya), the Language of Anatolian Women. Online: http://www.turkishculture.org/pages.php?ParentID=14&ID=70.

Embellishment

A broad term describing ornamentation embroidered, sewn, or applied to an existing fabric. Embellishment on clothing, accessories, and home furnishings has prehistoric origins and is common to all human beings. Many embellishments are opulent and eye-catching, glittering with brilliant color and iridescence. Embellishment symbolizes identity, rank, and religion. It can also be used for spiritual purposes, protecting the wearer or owner from harm. In many cultural traditions, embellishment is an encapsulated life-force, providing magical power. For example, in the **Middle East** and **Central Asia,** blue embellishments are considered protection against bad luck caused by the evil eye. In **Western, East, and Southeast Asia,** and on the **Indian Subcontinent,** red is the color of life, used to ensure fertility and vitality.

Embellishment includes, but is not limited, to all the forms of **embroidery: blackwork, candlewicking, couching, crewelwork, cross-stitch, cutwork, drawnwork, needleweaving, pulled thread work, punch needle, quilting, ribbonwork, shadow work, smocking, stumpwork, tambour,** and **whitework.** It also includes **appliqué** and other related techniques such as **patchwork** and **reverse appliqué.** The word "embellishment" is especially appropriate for describing purely decorative objects sewn onto fabric such as **beadwork,** beetle wings, coins, **feathers, fringes, lace, metallic threads, mirrorwork,** pompoms, **quillwork, shells,** sequins, and tassels.

Choice of embellishment is a reflection of culture and a result of cross-cultural exchange. Throughout the world, embellishments have ornamented ecclesiastical robes, military uniforms, and court dress. Clothes and objects with spiritual or ceremonial significance are symbolically embellished. Some of the most notable traditions are found in the Middle East, Central Asia, **Eastern Europe,** and on the Indian Subcontinent.

Embellishment in the Middle East is greatly impacted by the tenets of Islamic beliefs. The Sunni form of Islam discouraged depictions of human and animal images. Embroideries rarely contain figures, although peacocks and other birds were sometimes included. Islamic embroiderers adapted Arabic lettering, usually words from the Koran to create *kufic,* a bold and angular writing form. Developed in the end of the seventh century, kufic script decorated floor rugs, wall hangings, Koran covers, pillows, and clothing in Mesopotamia, now Iraq. About 85 percent of the world's Muslims are Sunni and approximately 15 percent are Shi'a. Predominant in southern Iraq and Iran, Shi'a Islam is not as strict about artistic motifs. Different from Sunni, Shi'a needlework includes both animal and human forms.

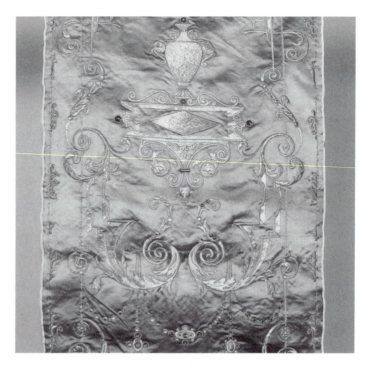

Metallic thread embroidery and gems on Italian furnishing fabric, 1775–1799. KSUM, transferred from the Allen Memorial Art Museum, Oberlin College, Oberlin, Ohio, 2006.11.1.

Islam spread with the Ottoman Empire, becoming the dominant religion in Turkey, north **Africa,** and much of the Middle East. In these areas, remarkable Islamic embroidery on apparel, blankets, upholstery, fabrics, and saddles was produced by professional male embroiderers in royal workshops, known as *tiraz.* In Israel, Judaism is the official religion. When Jewish people immigrated to Israel, they brought embroidery styles learned in their former homes, creating distinctive Judaic designs. Nomads of Central Asia merged their indigenous culture with Islamic beliefs, creating needlework with religious or spiritual connotations. In Afghanistan and Turkmenistan, they use embellishment to protect themselves and their children from evil and misfortune. Clothing, animal trappings, and accessories are decorated with talismans. These include blue beads, discs, bells, beads, cowrie shells, amulet cases containing texts from the *Koran,* coins, and metallic threads. Similar embellishments are used by the nomadic people of Morocco, Algeria, Tunisia, Libya, and Egypt.

Because of the long Turkish occupation, Islam played a dominant role in embroidery in Bulgaria, Hungary, Romania, the former Yugoslavia, and other parts of Eastern Europe. Folk costumes include felt caps, waistcoats, and purses embellished with fringes, ribbonwork, spangles, beadwork, coins, metal chains,

shells, buttons, pearls, and precious stones. Bead **knitting** is also popular in these areas. In Russia, Georgia, and Armenia, professionals created ecclesiastical embroideries for the Eastern Orthodox Church. Women also created embroidered religious icons or covers for painted icons in their homes. Most women learned to embroider from their mothers, or before the Russian Revolution, in convents and church schools. They used their skills to embroider towels, tablecloths, sheets, and costume items.

Some of the most extensive embellishments are found in the folk embroidery of India and Pakistan. Women's blouses, or *choli,* accessories, and *chakla* wall hangings are decorated with embroidery, mirrors, metal, cowrie shells, quilting, fringes, tassels, sequins, and braids. The Indian Subcontinent comprises the predominantly Hindu republic of India bordered by the Islamic republics of Pakistan and Bangladesh. Religion plays a significant role in embroidery design, especially in terms of color. Red and yellow, the colors associated with joy and contentment, are used for bridal outfits and hangings embroidered as marriage gifts.

Hindus create religious hangings that are left at shrines as offerings. These appliquéd cloths are decorated with scenes from Indian mythology, including stylized images of elephants, parrots, flowers, and gods using colored thread in widely spaced **running stitch** on a lightly colored background. Many of the motifs are intended to bring luck and protection.

Metallic thread embroidery is important in textiles and costumes for special occasions or ceremonial purposes on the Indian Subcontinent. *Zardosi,* or metal thread work, was at its peak during India's Mughal Empire and revived in the twentieth century. Zardosi embroidery involves the use of different shapes of metal wire like springs, coils, strips, ribbon, and discs. It is especially popular for wedding saris and vests.

To the east of India, sequin-encrusted needlework hangings are an important tradition in Myanmar (Burma). Buddhist temple decorations or *kalagas* are characterized by a central field of black velvet edged with cloth. They often depict the story of the Buddha's life or feature protective spirits such as elephants and horses. Kalagas use a form of stumpwork with images of people or animals padded and embellished with couched cords, glass studs, sequins, and metallic thread. The heavily embellished kalagas were made from 1830 until about 1880 partially for religious purposes and partially as an export item, but they did not appeal to nineteenth century Western European taste. Revived in the 1970s by aid groups, most contemporary kalagas are made in workshops. They are readily available to a wide tourist market, especially in Thailand.

FURTHER READING

Aber, Ita. (1979). *The Art of Judaic Needlework.* New York: Charles Scribner's Sons.
Gillow, John, & Bryan Sentance. (1999). *World Textiles: A Visual Guide to Traditional Techniques.* Boston: Little, Brown.

Gotstelow, Mary. (1977). *The Complete International Book of Embroidery.* New York: Simon and Schuster.

Harris, Jennifer. (1999). *5000 Years of Textiles.* London: British Museum Press.

Indian Embroidery. Online: www.Indian-embroidery.info/metalembroidery.htm.

Levantine Cultural Center. (2006). Sovereign Threads: The History of Palestinian Embroidery. Online: http://www.levantinecenter.org/pages/sovereign_threads.html.

Los Angeles County Museum of Art. Early Islamic Art. Online: http://www.lacma.org/islamic_art/eia.htm.

Sinderbrand, Laura. (1988). "Introduction." In Palmer White, *Haute Couture Embroidery: The Art of Lesage* (p. 14). Paris: Vendome Press.

Embroidery

The art of ornamenting material with decorative stitches. Although there are many variations, most embroidery requires little more than a **needle,** thread, and an already existing fabric structure. The base fabric is usually woven, but any material that can be pierced with a needle can be embroidered. Hand embroidery has prehistoric origins, and machine embroidery was developed in the Industrial Revolution of the nineteenth century.

Throughout history, embroidery has conveyed symbolic meaning, with color playing an important role. For example, red is associated with life and, therefore, prominent on wedding garments and objects. In many cultures, girls work particularly beautiful embroideries for their trousseaus. On a more modest level, considerable time and care is devoted to embroider rugs, covers, hangings and other household items in local styles.

The ancestor of symbolic decorations on clothing and personal belongings may be tattooing. The migration of prehistoric people to colder climates necessitated coverings made of tanned hides and cloth. Embroidery began when basic stitches used in plain sewing were applied to mirror tattoo patterns in thread. As time progressed, motifs came to communicate individual and group identity. Embroidery was and continues to be a way to adorn oneself as well as to express political, economic, and social status. For example, embroidered birds signified rank on garments and objects in the Imperial Court of Peking, China.

Embroidery is also a form of artistic expression linked to cultural traditions of courtship, marriage, and death. For example, Hill tribe girls in northern Thailand wear embroidered costumes in flirtation ceremonies, and on the **Indian Subcontinent,** a large part of a girl's dowry consists of items embroidered by her and her family. Embroidered funerary cloths discovered in Peru and Siberia offer additional examples of ceremonial stitching. Often ecclesiastical pieces

such as priests' robes and altar cloths are richly embroidered. Embroiderers were often trained at convents, and historic embroidered pieces are sometimes referred to as "nun's work." Throughout cultures and history, embroidery has been practiced both as a domestic craft and a profession. For the most part, domestic work is done by women, but both genders are represented among professional embroiderers.

The oldest extant embroidered pieces were found in Egyptian tombs. These included hem panels on the tunic of King Tutankhamun. Other ancient embroidered artifacts include early Greek domestic textiles and simply embroidered woolen garments from the Bronze Age. Professionally executed embroidered silks and gauzes were being created in China as early as the fourth century B.C.E. The oldest examples of Western European and Middle Eastern Islamic embroidery date from about 700 to 1100 C.E.

One of the most famous embroideries is the "Bayeux Tapestry," which is technically not a tapestry, but a work of embroidery. This long, intricately stitched linen banner depicts the Battle of Hastings (see **British Isles**) in 1066. Many variations in embroidery stitches were already highly developed by this time. In general, stitches can be divided into three basic types: flat, knotted, and linked/looped. Flat stitches lie on the surface of the fabric and include **running, satin, buttonhole stitch,** and **cross-stitch. Knot stitches** create a raised effect and include the French and Pekin knots. In linked/looped stitches, the first stitch is held in place by the subsequent stitches, **chain stitch,** for example.

Embroidery patterns are usually planned on a paper pattern before stitching. Curvilinear motifs are transferred directly onto the fabric, and geometric patterns are created by counting threads. Many different effects can be achieved with embroidery stitches. They are used to reinforce and decorate edges, fill in areas, and create textures. The use of cotton, flax, wool, and silk in embroidery is universal, but a variety of local materials are also used throughout the world. Embroidery traditions include raffia and cowrie **shells** in **Africa,** fish skin and porcupine quills in **North America,** and beetle wings and mirrors on the Indian Subcontinent. **Metallic threads,** beads, and jewels embellish embroidery of the past and the present. Some of the finest embroidery is done by the House of Lesage for today's French haute couture designers.

Throughout the world, cross-cultural contact disseminated techniques that were in turn influenced by local factors. Some motifs, such as the tree-of-life, earth mother, swastika, and eight-pointed star are found in various forms and materials. Until the end of the fifteenth century embroidery was considered to be a fine art. Some of history's most renowned painters produced "cartoons," which were reproduced in stitches. Before the popularity of embroidery in the Victorian era, there were only a few defined techniques that were named for their style and usage. The extent of the term, "embroidery" encompasses many different types of stitching. For example, **beadwork, Berlin work, blackwork,** buttonhole stitch, **candlewicking,** chain stitch, **couching, crewelwork,** cross-stitch, **cutwork, drawnwork,** knot

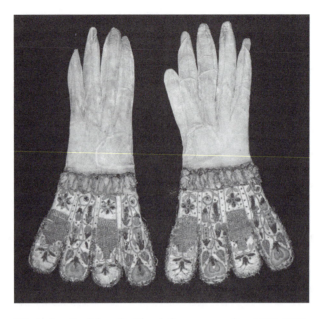

Elizabethan English embroidered gloves or gauntlets, 1500–1599.
KSUM, Silverman/Rodgers Collection, 1983.1.1800ab.

stitch, **lace, mirrorwork, needle lace, needlepoint, needleweaving, pulled threadwork, punch needle, quillwork, quilting, reverse appliqué, ribbonwork,** running stitch, **samplers,** satin stitch, **shadow work, smocking, stumpwork, tambour,** and **whitework** are all relatives of embroidery.

Changing fashions for different types of embroidery grew with the art needlework movement of the late nineteenth and early twentieth centuries. This resulted in art needlework departments in department stores and the growth of large manufacturers of patterns, threads, and materials. The Embroiderers' Guild of America (EGA) was established in New York in 1958 as a branch of the Embroiderers' Guild of London. Its purpose is to "foster the art of needlework and associated arts." EGA has close to 16,000 members, significant educational and philanthropic programs, and a textile collection of nearly 900 pieces in Louisville, Kentucky. Whether practiced as a cultural symbol or a creative pastime, embroidery remains an important decorative art worldwide.

FURTHER READING

Clabburn, Pamela. (1976). *The Needleworker's Dictionary.* New York: William Morrow.
Embroiderers' Guild of America, Inc (EGA). Online: http://www.egausa.org.
Gotstelow, Mary. (1977). *The Complete International Book of Embroidery.* New York: Simon and Schuster.
Harris, Jennifer. (1999). *5000 Years of Textiles.* London: British Museum Press.
White, Palmer (1988). *Haute Couture embroidery: The Art of Lesage.* Paris: Vendome Press.

Fair Isle

A **knitting** technique characterized by horizontal bands of small repetitive color patterns that originated in the Shetland Islands, 200 miles north of mainland Scotland, a part of the **British Isles.** Cold, remote, and windswept, the Shetland Islands were sold to Scotland by Norway in 1469. Hand knitting has played an important role in the history of the islands, providing a significant part of the economy. The southernmost of the Shetlands is called Fair Isle, and it is for this island that the knit patterns are named. The distinctive Fair Isle patterns are made by using no more than two colors in any one row, yet these colors may be changed many times to create complicated designs. The yarn that is not being used is carried along the back of the fabric, resulting in an extra thickness that provides warmth. Although originating Scotland, the term "Fair Isle" is used worldwide to describe similar intricate color patterns used for knitted sweaters, hats, and gloves.

The rugged landscape of the Shetland Islands is home to the Shetland sheep, a hardy breed that was introduced by the Vikings approximately 1,000 years ago. The sheep lived off sparse vegetation and seaweed, producing a soft, light fleece in shades of grey and brown. At first, the wool was spun and woven into a cloth called *wadmal,* but the texture of the Shetland wool was better suited to knitting than weaving. It is thought that knitting probably came to the islands from England. The earliest complete examples of knitted garments—stockings, gloves, a purse, and two caps—date from the seventeenth century. By the beginning of the eighteenth century, Shetland Islanders were trading knitted stockings for money and goods from Dutch and German merchants and fishermen. Islanders traded with passing ships, bartering homemade textiles and fresh produce for goods they could not make themselves.

Lace knitting in the Shetlands started in the 1840s. Visitors to the islands were aware of the skilled local knitters and brought fashionable lace articles to be copied. The finely spun Shetland yarn was well suited for making lace shawls and scarves. The intricate openwork shawls became world famous for their quality and were much sought after by ladies of society. Islanders developed many elaborate patterns, with descriptive names like fern, horseshoe, and cat's paw. The shawls were very desirable for brides, made so fine that they could be passed through a wedding ring. Shetland lace was most popular during the Victorian era and became the mainstay of the island's knitting industry in the second half of the nineteenth century. Queen Victoria wore lace stockings and offered gifts of fine knitted lace on special occasions.

Along with stockings and fine shawls, Shetland Islanders were known for their brightly colored, patterned knitwear, which was part of their knitting repertoire

by 1850. The origin of the Fair Isle patterning is steeped in myth. In 1588, Spanish sailors were stranded on Fair Isle after the breakup of the Armada. Legend has it that the crew inspired Islanders to develop new colors and patterns. A more likely origin of the design is **Nordic knitting.** Shetlanders often traveled as merchant seaman and may have brought back textiles from **Scandinavia** or the Baltic region. Throughout the late nineteenth and early twentieth century, knitters in **Eastern** and **Western Europe** developed regional patterns that were commonly spread along trade routes. Knitters of the Shetland Isles developed a rich vocabulary of stranded multicolored patterns, with local families creating their own "traditional" patterns passed down and adapted through the generations.

Shetland Islanders were strongly attached to the land, making their living over the centuries through fishing, farming, and knitting, both for themselves and to exchange or sell. Income from hand knitting supplemented subsistence farming. Generally, women ran the farm and home, knitting whenever time allowed. Women would even knit while walking back from the peat bank carrying a basket of peat on their back. For these women, knitting was not a hobby or a pastime, but a constant and necessary part of their daily work.

Fair Isle knitting is usually done in the round on double-pointed **needles,** creating a seamless garment with symmetrical patterns. The Fair Isle design usually includes bands of octagons and crosses, called "OXO" patterns, with bands of small patterns in between. They often included symbols that held special meaning. The cross stood for faith, the anchor for hope, and the heart for charity. The earliest designs had small patterns of two to nine rows of knitting, but as time progressed, larger motifs such as the eight-pointed Norwegian star were added, requiring as many as 30 rows to complete the design.

Originally Fair Isle designs were made in a combination of the natural colors of the Shetland sheep: brown, grey, fawn, and white. Islanders also incorporated shades of yellow, orange, green, and purple, colored by natural dyes made from local plants and lichen. Eventually indigo was added to produce blue and madder was added to make red. The invention of brightly colored synthetic dyes increased the color range, but they were only used in small quantities. Patterns in traditional colors of red, blue, brown, yellow, and white were established by 1910, and the production of Fair Isle knits for sale expanded during the First World War.

The largest period of growth in this form of needlework came in the 1920s, when sweaters in natural wool colors became highly fashionable. The attention given to Fair Isle knitting was due in a large part to the Prince of Wales, Edward VIII, who wore a Fair Isle sweater for a public event in 1921. He wore Fair Isle knits for golfing events, public relations events in the British Isles and around the world, and even for a formal portrait. The attention given to Prince Edward led to a great popularity and commercialization of the style. The Fair Isle pattern became so popular that most university students at England's Oxford and Cambridge owned one. Fair Isle knitters expanded their offerings to include hats, gloves, and cardigans in the distinctive motifs.

High-quality Fair Isle garments are still knitted in the Scottish Shetland Islands today. In an attempt to protect and promote genuine Fair Isle products, the Shetland Knitwear Trades Association was established in 1982. In recent years, the cottage knitting industry has been joined by larger Shetland knitwear companies who produce garments with computerized knitting machinery. A small cooperative, Fair Isle Crafts, produces traditional and contemporary Fair Isle knits on hand-frame machines. Whether creating by hand or machine, Shetland knitters are committed to making Fair Isle knits of the highest quality. Patterns for endless variations and adaptations of Fair Isle designs are widely available for hand knitters in the United States and throughout the world. Fashion designers have also taken inspiration from the Fair Isle designs, translating them into modern fibers and contemporary styling. In recent years, Fair Isle patterns have been offered by designers such as Missoni, Burberry, and Ralph Lauren. Rather than using the traditional Shetland wool, these high-end sweaters, socks, and scarves are often made in cashmere, taking what was once a source of needed income into the range of high fashion.

FURTHER READING

Baird, Catriona. Shetland Knitwear. Scottish Textile Heritage Online. Online: http://scottishtextileheritage.org.uk/onlineResources/articles/articlesTem2.asp?articleNo=17.

Fair Isle Knitwear That's Really Fair Isle. Online: http://www.visitshetland.com/area_guides/fair_isle/fair_isle/.

GQ Style Spy. Online: http://www.gqmagazine.co.uk/Features/Style_Spy/default.aspx?pageNo=12.

Knitting and Needlework Teachers' Notes. Celebrating Scotland's Crafts. Online: www.cne-siar.gov.uk/museum/.

Pulliam, Deborah. (2004). Traveling Stitches: Origins of Fair Isle Knitting. Online: http://www.textilesociety.org/abstracts_2004/pulliam.htm.

Reith, Tracy. (2001). Knitting throughout the World: A Brief History. Online: http://www.chatteringmagpie.com/writing/368/knitting-throughout-the-world-a-brief-history.

Richards, Ann. (Summer, 2005). Top 10 men in knitting. Online: http://www.knitty.com/ISSUEsummer05/FEATtopten.html.

Spirit of Shetland. A short history of Shetland knitting. Online: http://www.shetland-knitwear.com/history.html.

Victoria & Albert Museum. Regional Knitting in the British Isles & Ireland. Online: http://www.vam.ac.uk/collections/fashion/knitting/regional/index.html.

Wheeler, Dave. (2006). Online: http://www.fairisle.org.uk/Crafts/arts_crafts.htm.

Feathers and Beetle Wings

Two of the most unusual natural materials used for personal adornment, these opulent and eye catching embellishments exhibit brilliant colors and iridescence

that barely fade over time in many cultures. Feathers and beetle wings have come to symbolize status, achievement, religion, and social standing, setting the wearer above others in terms of importance, wealth, or power.

Feathers and beetle wings were also thought to have spiritual or magical power, protecting the wearer from evil spirits. These rare substances were used in many places in the world, often playing an important role in trade, traveling great distances from their place of origin. Their desirability and use has, in some cases, led to endangering the animals from which they came. For example, traditional Hawaiian ceremonial feather capes were made from indigenous birds, but now imported feathers are used. The native bird population is threatened from predator animals and diseases that were introduced to the islands.

Feathers and beetle wings along with **beadwork,** buttons, bones, braiding, chains, claws, coins, discs, fish scales, **fringes,** plaited human and animal hair, medallions, **metallic threads, mirrorwork, ribbonwork, quillwork,** sequins, **shells,** spangles, tassels, and teeth are used in decorative needlework. The strongest cultural traditions for featherwork are found among the indigenous peoples of **South America, North America,** the Pacific Islands, and Southeast Asia.

In the tropical Amazon rain forests of Brazil, Venezuela, Colombia, Ecuador, and Peru, Aztec feather workers created **embroidery** worked with feathers on a net or canvas ground. The people of the rain forest consider adornment an essential part of their spiritual life, wearing feather necklaces, ear ornaments, and headdresses. For some indigenous peoples of the Amazon basin, these adornments are worn for ceremonial occasions, but they are also worn at other times. These are egalitarian cultures, so there is no association with rank. Amazon feather objects are frequently made of the beautiful plumage of toucan and macaw feathers, which are most colorful in the tropical and equatorial regions of the world.

Featherwork was an important cultural tradition among the native peoples of North America, especially in the Great Plains, Northwest coast, and California. A prominent object representing power and status was the eagle feather war bonnet, worn primarily by the Native Americans of the Plains. On the Northwest coast, vividly colored headdresses were made by **netting,** resulting in a checkerboard pattern composed entirely of feathers. These brightly hued feathers originated in tropical areas, far away from where they were worked. Feathered headdresses created between 1100 and 1400 still retain much of their original vivid color. California peoples glued, stitched, appliquéd, and wove with feathers, often sewing individual feathers together in strips to form bands. They made blankets by incorporating feathers into a structure created by **plaiting**.

Some of the most refined featherwork was made by the Maori of New Zealand. These native peoples traditionally created rain capes from flax and began to incorporate feathers into the borders in the mid-nineteenth century. By the end of the century, a tradition was established to entirely cover the cloaks with feathers of kiwis and other indigenous birds. These "feather cloaks" are called *kaha huruhuru*. Taking as long as a year to finish, these cloaks represent status and

belonging among the Maori. Feather cloaks are made by stretching a foundation cord between two wooden pegs and plaiting from left to right. The quills are secured by bending the ends over and incorporating them as the piece is created. The exact process of creating feather cloaks has been kept secret, passed by word of mouth through the Maori generations. Featherwork is enjoying a revival along with other traditions including wood carving and the Maori language.

The most sought after iridescent beetle wings originate in the hardwood forests of Burma and northern Thailand. The tribes of these regions use beetle wings collected from dead insects to decorate clothing and items for everyday use. Their most important tradition using wings are the "singing shawls." Singing shawls are made of woven red blankets that are embellished with white beads. They are finished with a **fringe** of beetles' wings and bells at the hem. The shawls are worn by young unmarried women at funerals and festive occasions. The sounds of singing shawls are thought to send the deceased safely to the afterworld. Fringes of beetle wings also decorate the skirts and breast cloths worn by the Naga women of northeast India. For these peoples, beetle wings are symbolic and often indicate social rank, embellishing ear ornaments and cloaks worn by men on festive occasions. They are also used to decorate camel trappings, clothing, belts, and door hangings.

Although originating in Southeast Asia, beetle wings became strongly associated with India during the Mughal era (1526–1756) when emerald-colored wings conveyed high status. Ceremonial court robes, furnishings, turbans, and sashes were treasured gifts, awarded for meritorious service to the emperor. The glittering beetle wings were exported to Calcutta where they were worked on silks, satins, velvets, and delicate muslins using precious metallic threads. Beetle wings were first seen in the British Isles and **Western Europe** in the early 1820s. They accompanied gold and silver embroidery on gauzy white cotton muslin fabrics that were exported to the west, with beetle wings in floral designs, scalloped edges, or allover patterns.

By the 1860s, the fashion for the embroidered muslins had declined, but it was reinvigorated when Queen Victoria assumed the title empress of India in 1877. Beetle wings gained new popularity for trimming accessories and decorating entire dresses. Indian artisan centers in Calcutta, Madras, and Delhi created table linens, fans, and other accessories for export to England and the rest of Europe. Beetle wings were also included in Victorian jeweled embroidery, with patterns disseminated through American women's magazines. The designs, generally of stylized flowers and leaves, were embroidered with colored silks, spangles, sequins, beadwork, and beetle wings, outlined with couched gold or silver threads. Over time, the backgrounds for the beetle wing embroideries became richer and darker, often dark green satin or black voile.

An intersection of featherwork and beetle wings was found in the woolen export shawls, also known as Kashmiri or Paisley shawls. Embroidered in northern India, shawls were sometimes sent to cities to be embellished with

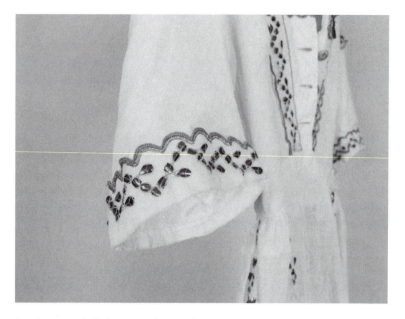

Beetle wing embellishment on dress made in India for export to Western Europe and the British Isles, 1863–1867. KSUM, Silverman/Rodgers Collection, 1983.1.98.

beetle sequins and metallic thread. Shawls, small bags made of silk taffeta or satin, and fans were decorated with exotic peacock feathers and emerald-like beetle wings. A dress ordered from the famous French House of Worth to be worn for the Delhi Coronation in 1903 was designed to be a compliment to the Indian people and also fit in with the sumptuous clothes and jewels of royalty on the **Indian Subcontinent.** The exquisite "peacock dress" was embroidered with a pattern of peacock feathers in gold thread, with a beetle wing forming the eye of each feather. The popularity of needlework with beetle wings continued into the early twentieth century. Wings are still used to decorate clothing, accessories, cushions, and wall hangings in areas of Southeast Asia and the Indian Subcontinent. Today, beetle wings are available in large Asian trade centers such as Bangkok, Thailand. Once purchased, whole beetle wings are pierced around the edges so that they can be stitched to a background.

FURTHER READING

Amazon Featherwork. American Museum of Natural History. Online: http://www.amnh. org/exhibitions/expeditions/treasure_fossil/Treasures/Amazon_Featherwork/amazon. html?50.

Gallery: Peru comes to Brooklyn. The Brooklyn Museum of Art in New York. Online: http:// www.rumbosonline.com/articles/15–88-gallerybrooklyn.htm.

Gillow, John, & Bryan Sentance. (1999). *World Textiles: A Visual Guide to Traditional Techniques.* Boston: Little, Brown.

Gotstelow, Mary. (1977). *The Complete International Book of Embroidery.* New York: Simon and Schuster.

Nicholas, Jane. (2004). *The Stumpwork, Goldwork, and Surface Embroidery Beetle Collection.* Bowral, NSW, Australia: Sally Milner Publishing.

Rivers, Victoria Z. (February 1994). Beetles in Textiles. Online: http://www.insects.org/ced2/beetles_tex.html.

Fringes, Tassels, and Pompoms

Decorative hanging **embellishments** added to the edges of textiles and clothing. Throughout time and geography, fringes, tassels, and pompoms have served both aesthetic and spiritual functions. They symbolized love, status, and religious devotion. The swish and sway of fringes, tassels, and pompoms emphasize movement and were often used to provide protection from evil spirits. Their color and placement can indicate allegiance, rank, and marital status.

Fringe is a decorative edging of threads, cords, or strips. Used for thousands of years, fringe can be created by slitting the edge of a hide, tying raw threads of a woven fabric together, or attaching thread as a separate trim. Overall, fringe is generally linear and fairly flat, with slight three-dimensionality created by an overhand knot. The earliest evidence of fringe is seen on Mesopotamian (Iraq) stone carvings from the eighth century B.C.E. featuring human figures clothed in heavily fringed robes. Knotted fringe can be made by hand alone or a **macramé** shuttle can be used for **knotting** intricate patterns. Macramé is a descendent of fringe; in fact, the word macramé was first used to describe ornamental fringes on headcoverings in the **Middle East.**

Native North Americans decorated hide clothing and other items with cut fringe. Commonly fringed garments were buckskin shirts, leggings, skirts, dresses, and aprons. For special occasions, fringe was coupled with beads, **shells,** elk teeth, **feathers,** animal skins, porcupine quills, and other ornaments. Buckskin and fringe are strongly associated with frontiersmen of the American west. Fringe is also used on Eastern European folk costume and domestic textiles. In Russia and Bulgaria, borders on towels and aprons often include fringe in intricate patterns.

Tassels are threads or cords bound at one end and loose at the other. They are separately constructed elements that increase the three dimensionality of a textile. The simplest form of tassel is made by knotting a bundle of cut threads. Tassels are used for decorating clothing, accessories, home furnishings, and animal trappings throughout the world. A notable example is the tassels worn by Orthodox Jewish

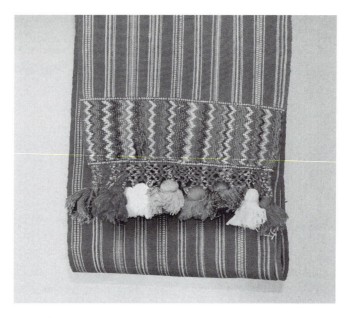

Belt from traditional Guatemalan costume with fringes and tassels. KSUM, gift of DeVoe M. Ramsey, 1998.93.8.

men in the Middle East since ancient times as a reminder to follow the commandments. According to the Book of Moses, tassels should be worn on the corners of garments and contain a blue thread. In the traditional method, the number of wraps in the tassel corresponds to Hebrew letters that spell out Yahweh, the name of God.

The Samurais of ancient Japan hung tassels from their swords. These silk tassels were thought to protect the warrior as he went into battle. Rank was symbolized by color, with blue tassels for warriors, red for officers, and gold for generals. Tassel color also plays an important part in academic regalia. Tassels are worn on mortarboards with the field of study symbolized by different colors. For example, art majors wear brown tassels and engineering majors wear orange. Academic dress dates back to the twelfth century in the **British Isles** and **Western Europe** and was standardized in America during the nineteenth century.

Tassels are important embellishments on the costumes of the Southeast Asian hill tribes. Vietnamese Red Zhao girls wear elaborate headdress made of woolen tassels. In the Lisua tribe of Thailand, tasseled turbans serve a prominent role in women's traditional costumes. These elaborate and colorful items were historically worn for everyday activities, but are now largely reserved for ceremonial and festive occasions. In the Chinese art of Feng Shui, tassels are used to increase the flow of vital energy, comfort, and happiness in a room.

Tassels are often further embellished with beads, knots, **embroidery,** or wrapped cords. In **Central Asia** and the Middle East, tassels embellish clothing

and accessories. Tassels are worn in the hair and used to decorate felt bags. Nomadic peoples of these regions use fringe and tassels to decorate wall hangings that are placed on the inside of the yurt, a felt shelter. From the eighteenth century on, wealthy Western Europeans used large tassels to embellish curtains and drapes. The top of the tassel was often exaggerated by inserting a wooden bead and wrapping the cords around.

Pompoms are ornamental balls that hang freely. Similar to tassels, the pompom is made separately and attached to a textile or the end of a cord or braid. Pompoms are used to decorate curtains or clothing, especially hats and slippers. In Napoleon's army, French officers wore peaked hats called *shakos,* which displayed different colors to signify regiment. The shako, which originated in Hungary, became a standard of Western European military uniforms from 1800 forward. Mien women from Thailand are known for their long black jackets adorned with red pompoms. The enormous Golden Dragon ("Gum Lung") used in America's San Francisco Chinese New Year Parade includes colored lights, silver rivets, and white rabbit fur trim. Requiring 100 people to operate, the Golden Dragon is over 201 feet long and displays rainbow-colored pompoms on its six-foot-long head.

Festival bags and hair ties are embellished with pompoms in **South America.** For example, the traditional dress of Peruvian men and women includes pompoms. The color of a man's knitted cap and the way it is worn indicates whether he is married, committed, or single. Women's garments have different colored pompoms attached to the hem. Pompoms placed on the back of the leg have

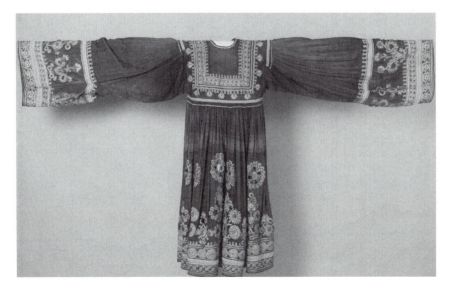

Pompoms decorate this mid-to-late twentieth-century woman's dress from Afghanistan. KSUM, Silverman/Rodgers Collection, 1983.1.886.

special symbolic meaning. A colorful pompom indicates happiness, and a dominantly blue pompom indicates sadness.

On the other side of the world, traditional Scottish dress often includes the "Balmoral" style cap, a close relative of the old broad cap of the Highlander. The Balmoral is generally dark blue, green, or brown and decorated with a red pompom. Early Highland caps were either knitted or crocheted. The pompom decorated the place where threads ended when the cap was finished. The yarns were tied into a knot and cut off flush. When the densely packed threads spread out, they became a pompom.

The official Greek national costume, worn by the Evzone or presidential guard, includes fringes, tassels, and pompoms. Dating back to ancient times, it was worn by soldiers during the 400-year Turkish occupation of Greece (1453–1821). The elaborate handmade uniform became a symbol of Greek independence. Among its many parts, the Evzone features a hat with a silk tassel, blue and white fringe garters, and black shoe pompoms. The traditional shoes, known as *tsaroubia,* are made from red leather with a turned-up pointed toe covered by a large pompom. The fringe, tassels, and pompoms emphasize the ceremonial marching movements done by Greek presidential honor guards.

FURTHER READING

Bible History Online. Ancient Fringes or Tassels. Online: http://www.bible-history.com/sketches/ancient/fringes.html.

Gillow, John, & Bryan Sentance. (1999). *World Textiles: A Visual Guide to Traditional Techniques.* Boston: Little, Brown.

History of the San Francisco Chinese New Year Parade. Online: http://www.imdiversity.com/villages/asian/family_lifestyle_traditions/lunar_new_year/history_san_francisco_parade.asp.

Introduction to Thailand's hill tribes. Online: http://www.1stopchiangmai.com/culture/hill_tribes/.

MacCorkill, Nancy. History of the Scottish Kilt. Online: http://www.geocities.com/~sconemac/kilt.html.

Military Subjects: Organization, Strategy & Tactics. The Napoleon Series. Online: http://www.napoleon-series.org/military/organization/frenchguard/sthilaire/c_sthilaire9.html.

The Presidential Guard. Presidency of the Hellenic Republic Online: http://www.presidency.gr/en/proedr_froura.htm.

Samurai. Online: http://samurai.gungfu.com/.

Gansey

A seamless knitted pullover sweater made from naturally oily wools in the **British Isles.** The gansey sweater is unique because of the textured patterns on the chest,

sleeves, and shoulders. Where **Aran** is a type of knit pattern that is often used in sweater design, a gansey is the sweater itself. It received the name "gansey" from the Irish word *geansaí* or Guernsey, one of the Channel Islands located between France and England. Usually in navy blue from natural indigo dye, ganseys were worn by French, English, and Scottish seamen and fishermen. Over time, the pattern on ganseys came to reflect the individuality of a fisherman's home port and his family. Lighter-weight ganseys were made for summer in pale gray or fawn color. Black ganseys were worn for funerals.

It is not possible to determine precisely when the gansey came into being, but the style of **knitting,** originally used for socks, originated during the reign of Elizabeth I. At that time, licenses were granted to import wool from England. As Western Europeans began to open the New World of **North America,** the fishermen of Guernsey began exploring the cod fisheries of the Grand Banks, off the coast of Labrador, Canada. The sweaters were knitted very tightly so that they would "turn water" (be waterproof) and be wind proof. The textured patterns were established by the beginning of the nineteenth century, with information and expertise passed down orally from mother to daughter. During the Napoleonic Wars, Lord Nelson adopted the sweater as part of the English Royal Navy's uniform, and ganseys were worn at the Battle of Trafalgar in 1805. By 1856, they became official naval issue for soldiers in the British Garrison in Nova Scotia, Canada.

Ganseys were traditionally knit by a fisherman's sweetheart as a betrothal gift. Knitted in 5-ply worsted wool known locally as "seamen's iron," these sweaters were extremely strong and durable. Ganseys were knit in the round, on five or more double-pointed steel **needles,** with gussets under the arms to allow greater freedom of movement. Each gansey is tightly knitted, with as many as 300 stitches around, and they often take more than four weeks to complete. Designed with practicality in mind, the combination of seamless construction, water-resistant wool, and textured patterning produced a garment that was both windproof and waterproof. This was important since, at one time, the gansey was the only top garment a fisherman wore.

Knitting the upper part of the sweater more densely than the lower part provided extra warmth on the upper body. Moreover, the patterned decoration allows air to be trapped, providing insulation. Decoration on the gansey was usually restricted to the shoulder area and the upper half of the arm. The patterning of a gansey is the same on the back and front, allowing it to be reversed to alternate areas of wear, such as the elbows. The sleeves are knitted down from the shoulder and cast off just above the wrist, usually in a plain knit. This allows the cuff to be easily repaired by unraveling the yarn and re-knitting it, often with new wool in a different shade.

Gansey patterns are based on the moss stitch, which is a combination of knit and purl stitches. Women used their surroundings as inspiration, creating motifs representing ropes, nets, anchors, pebbles, waves, and flashes of lightning. Other patterns were of a religious or symbolic nature, including crosses and church windows. The zigzag pattern was made to symbolize the ups and downs of married life. Over time, the tradition arose that each fishing community had its own distinctive

and identifiable gansey pattern. The pattern as well as deliberate "mistakes" or the wearer's initials were often included as the sweater was knit. These elements indicated where a fisherman came from if he was found at sea or washed ashore. By the late nineteenth century, hand knitting was a vital cottage industry, and coastal villages developed their own distinctive patterns and names for the traditional navy blue gansey.

Over time, gansey knitting declined as younger people moved out of the fishing villages. It had all but died out by the 1920s, when an effort began to interview elders, preserving traditions and adding significant knowledge to the social history of the British Isles. The tradition of making ganseys continues, but today, most of the main panels are machine knitted and then the garment is finished by hand. Contemporary ganseys are knitted in the traditional wool or in 100 percent cotton, and handknit patterns are readily available. In recent years, designers such as Prada and Helmut Lang have produced knitwear with obvious reference to the gansey, a piece of fashion history.

FURTHER READING

All About the Guernsey. Online: http://www.guernsey-sweaters.com/system/index.html.
Fish Tales. Online: http://www.twmuseums.org.uk/fishtales/communities/Ganseys.html.
Flamborough Marine Limited. Online: http://www.manorhouse.clara.net/knitwear/history.htm.
Olivier, Jules. (2001). The Uppers Organization. Online: http://www.uppers.org/showArticle.asp?article=262.
Woolovers. Online: http://www.woolovers.com/shop/guernsey_sweater.asp.

Hairpin Lace

Openwork fabric created on a very strong two-pronged steel fork that resembles a hairpin, also known as "hairpin **crochet**." Crochet usually requires only a hook and yarn, but the hairpin technique adds the metal fork. It is used to create lovely and delicate **lace** strips, which consist of loops secured at center with crochet stitches. Long finished strands of hairpin lace can be crocheted together to create an airy and lightweight fabric.

Hairpin lace was popular during the Victorian era. More research is needed to discover its exact origins, as there are no clear sources at this time. During the Victorian era, fancy needlework played an important role in the lives most upper- and middle-class women in **North America,** the **British Isles,** and **Western Europe.** Higher education and careers were rare, while domestic help

gave women the time to indulge in **needle** arts. Interest in needlework was expanded by the increased availability of catalogs, magazines, and booklets, which included patterns and instructions for clothing, furnishings, and purely decorative items. One of the most important of these, Thérése De Dillmont's *Complete Encyclopedia of Needlework,* was first published in 1884 and included a section on hairpin crochet. The hairpin technique was also used by the lower classes; it became a quick, inexpensive substitute for lace.

There are many different stitches used in hairpin lace that result in a multitude of designs. Like all other types of crochet, hairpin is begun with a loose chain. Yarn is wrapped around the prongs of the fork and a hook is used to crochet the middle of the loops. The loom is then flipped vertically and the next stitch is worked. This process is repeated until the desired length is achieved. Hairpin lace forks are sold in different sizes and selected based on the type of yarn used. The width of the prongs determines the width of the piece.

Single strips of hairpin lace are primarily used as a decorative border trim with looped edges. It can be used as both edging and insertion and is often used to embellish cotton or linen undergarments. In the Victorian style of ornamentation, hairpin lace decorated doilies, pillowcases, tablecloths, and baby clothes.

Hairpin lace embellished handkerchief made in Ireland, 1930–1969. KSUM, gift of Audrey M. Kail, 1998.45.63.

When strips of lace are connected together, they can create soft, flowing shawls and afghans.

Although the majority of hairpin lace was made in North America, the British Isles, and Western Europe, traditions can also be found in other parts of the world. Hairpin lace, or *randa,* is one of the traditional needlework techniques practiced in the commonwealth of Puerto Rico, along with **bobbin lace** and **drawnwork.** "Turkish lace" or *oya* is made in several different ways and identified by its brightly colored flower motifs. In Turkey, lace edging has different names depending on the way it was constructed. Hairpin lace is known as *firkete* and is often embellished with beads, sequins, coral, or pearls. Often made in a single color, hairpin crochet trimmed headscarves are worn for everyday as well as for prayers and funerals. This lace also decorated undergarments, towels, napkins, and other domestic textiles. Hairpin lace is still made in Turkey, but has largely been restricted to items made for bridal trousseaus.

Contemporary needleworkers have rediscovered hairpin lace. It is marketed as a technique that gets fast results. The forks are somewhat difficult to find, and lacemakers often locate them in small independent shops or on the Internet. Enthusiasts increase their skills and share patterns on Web sites such as "Hairpin

Nineteenth-century American hairpin lace dustcap. KSUM, Mrs. Kenyon (Louise) Stevenson, 1990.18.6.

lace Crochet" on Yahoo groups.com. Hairpin lace is sometimes used by fiber artists and fashion designers. In 2001, N. Rashmi, a student at the National Institute of Fashion Technology, Bangalore, India, created a garment with hairpin crochet. Named "Venus Ventura," the bodice, made of coated-copper computer wire, was recognized in the second international "Lace for Fashion Award" by the Australian Powerhouse Museum.

FURTHER READING

De Dillmont, Thérése. (1996). The Complete Encyclopedia of Needlework (3rd Ed.). Philadelphia: Running Press. (First published by Dollfus-Mieg Company, France, in 1884.)

Hairpin lace Crochet. Online: http://groups.yahoo.com/group/hairpinlace/.

Powerhouse Museum 2nd International Lace for Fashion Award 2001. Online: http://www.phm.gov.au/pdf/research/lace.pdf.

Republic of Turkey Ministry of Culture and Tourism. Traditional Arts and Crafts. Online: http://www.kultur.gov.tr/.

Ryan, Mildred Graves. (1979). The Complete Encyclopedia of Stitchery. Garden City, NY: Doubleday.

Stitch Diva Studios. Online: http://www.stitchdiva.com/custom.

Sykospark.net's Hairpin Crochet Tutorial. Online: http://www.sykospark.net/hairpin/.

Indian Subcontinent

The area of the world composed of India, bordered by Pakistan and Bangladesh on the west and east. Cultural needlework traditions on the Indian Subcontinent differ by region, but cross national borders in techniques, motifs, and materials. Needlework, especially **embroidery** and **embellishment**, is important throughout the subcontinent, with each region producing their unique needlework style. The main embroidery regions are the northwest, the west coast, and the northeast. The northwest states of India includes Baluchistan, Swat, Kashmir, the Punjab, Chamba, Sind (Pakistan), Gujarat, Rajasthan, and Kutch, with the most notable needlework traditions in Gujarat, Punjab, and Kutch. The west coast includes the state of Goa, which was settled by Portugal, and the northeast region includes Bengal.

The embellishment of clothing and textiles has a long history in India. Archeological finds revealed that cotton cloth was decorated with embroidery and **appliqué** as early as 2000 B.C.E. Overall, needlework styles have remained a consistent symbol of cultural heritage, with little impact from outside influences. In India, the Hindu religion is dominant, where Islam is prominent in

Pakistan and Bangladesh. The religious boundaries are not rigid; there are Hindus in Muslim areas, and Muslims form a large minority in India. Yet, religion does influence needlework. For example, Islamic embroideries do not generally include the human form, instead using stylized figures and symbols. In the majority of India's Islamic states of Baluchistan, Swat, and Sind (Pakistan), stylized motifs dominate, but embroiderers in Kashmir, the Punjab, Chamba, and Kutch create more representational designs.

Motifs found in the needlework of the Indian Subcontinent include ancient symbols such as the tree of life, solar discs, and the *buti* or paisley. Islamic designs feature swirling circles and eye-dazzling zigzags. Popular pictorial images are flowers, trees, elephants, parrots, peacocks, horses, cows, and humans. Hindu needlework also includes gods such as the elephant-headed Ganesh, the heroic monkey Hanuman, and Vishnu, who is represented by images of fire, rain, and sun. Both men and women on the Indian Subcontinent practice the **needle** arts.

Needlework is used for decorating clothing, wall hangings, quilts, rugs, and accessories. It is often seen on the sari, the traditional women's garment of India. The sari has been worn for over 5,000 years. It is a rectangular piece of cloth about 4 feet wide and up to 25 feet long that is draped around the body. Saris are made of many different fabrics and frequently are embroidered with silk and **metallic threads.** The sari is an uncut piece of cloth that is considered to be pure. The earliest garments worn in India were wrapped saris, loincloths, turbans, and shawls. The first cut and sewn clothing was introduced by Islamic people in the eighth century. These garments include tunics, drawstring trousers, veils, shawls, and hats.

An important cultural tradition throughout the Indian Subcontinent is needlework created for weddings. Color plays a significant role, and red is associated with fertility and contentment. Red and yellow are prominent in bridal outfits and hangings embroidered as marriage gifts. In many areas, a girl and her family embroider items as part of her dowry or trousseau. A dowry is a gift of money or valuables given by the bride's family to the family of the groom at the time of their marriage. A trousseau is a set of linens, furniture, and other domestic objects that the wife contributes to the marriage. Popular dowry and trousseau items on the Indian Subcontinent are shawls, blouses, sashes, and hangings.

In the Punjab region of India, *phulkari* or "flower work" is used to decorate shawls made by a bride's maternal grandmother. The finest phulkari, known as *bagh* or "garden," is completely covered with **satin stitch** in yellow and orange silk floss. Other wedding shawls are embroidered with the **buttonhole stitch** or made with strips of metallic ribbon applied to a net ground. Wedding blouses, known as *choli,* are often embellished with **mirrorwork** and sometimes with tiny **shells.** Embroidered wedding scarves and vests are also made for the bridegroom. Using colored thread and **running stitches,** they incorporate symbols of luck and protection. A notable wedding tradition is the "ox-cart tent." The bride-to-be

is taken to her new husband's village in a cart pulled by oxen. On the cart is a boldly appliquéd cube-shaped tent, which hides the bride from prying eyes.

Much of the embroidery on the Indian Subcontinent is made of silk thread on cotton cloth, although other combinations are also popular. Wool is not prevalent, except in mountainous areas, such as Kashmir. Common colors for ground fabric are black, indigo blue, or white. The most popular stitches are satin stitch and *shishadur* or mirrorwork. Other embroidery stitches and techniques include buttonhole stitch, **chain stitch, couching, cross-stitch,** herringbone, **drawn-work, pulled threadwork,** and running stitch. Sparkling embellishments such as mirrors, beetle wings, metallic threads or *zardosi,* sequins, cowrie **shells,** and **beadwork** are commonly used. Mirrorwork originated in the arid desert of the Indian Subcontinent. It is an important component of marriage and festival costume, reminding people of water and deflecting the evil eye away from the bride.

In addition to embroidery, other needlework techniques used on the Indian Subcontinent include **lace, shadow work, quilting, tambour,** and appliqué. Lacemaking was introduced by Western European missionaries in the nineteenth and twentieth centuries. Torchon **bobbin lace** and **crochet laces** were created in India for the export market. Popular items were sets of lace placemats and napkins made of white or ecru cotton. The most prominent form of shadow work originates in India. Called *chikan* embroidery, it is shadow **whitework** done in predominately floral patterns. In Bangladesh, whitework quilts or *kanthas* are made

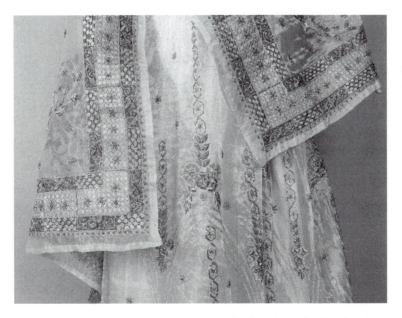

Mid-twentieth-century ensemble from India with silk and metallic thread embroidery. KSUM, Silverman/Rodgers Collection, 1987.41.160ab.

from discarded cloth. Characterized by rows of running stitch, kanthas sometimes include colored stitching in blue, black, or red. Tambour work or *ari,* worked with a small hook, creates chain stitch embroidery in India. Men of the Mochi cobbler caste tamboured skirts, blouses, and temple hangings in silk thread on satin fabric. Another tradition for tambour work can be found in Goa. Bleached white cotton was embroidered with yellow silk floss long before the Portuguese arrived in the early sixteenth century. After contact with Western Europeans, Goa embroiderers created chain stitch motifs that were attractive to tourists.

Appliqué and **reverse appliqué** are frequently used for covers, quilts, pillows, and wall hangings on the Indian Subcontinent. Symmetrical floral and abstract patterns can be created by folding the fabric before cutting out the shapes. Leather and felt animal and baggage covers are also embellished with appliqué. Highly decorated wall hangings or *chakla* and *torans* that hang over the windows and doors are important cultural objects. Often given as wedding gifts, these hangings include folk motifs worked in dense appliqué, mirrorwork, embroidery, sequins, and couched gold metallic thread. Used in a sacred space within the home, chaklas reflect the beauty of Indian embellishment that has inspired needlework throughout the world.

FURTHER READING

Coss, Melinda. (1996). "Mirror, Mirror." *Handmade* 12(3), 64–69. Online: http://hsc.csu.edu.au/textiles_design/shisha.htm.

Gillow, John, & Bryan Sentance. (1999). *World Textiles: A Visual Guide to Traditional Techniques.* Boston: Little, Brown.

Gotstelow, Mary. (1977). *The Complete International Book of Embroidery.* New York: Simon and Schuster.

Harris, Jennifer. (1999). *5000 Years of Textiles.* London: British Museum Press.

Hatanaka, Kokyo. (1996). *Textile Arts of India.* San Francisco: Chronicle Books.

Icke-Schwalbe, Lydia. (July 2–4, 2001). The Art of Craft for Social and Cultural Identity in Ethnic Groups of India. Presented to the International Committee for Museums and Collections of Ethnography. Online: http://icom.museum/icme.

Indian Embroidery. Online: www.Indian-embroidery.info/metal-embroidery.htm.

Nicholas, Jane (2004). *The Stumpwork, Goldwork, and Surface Embroidery Beetle Collection.* Bowral, NSW, Australia: Sally Milner Publishing.

Knitting

A needlework technique in which **needle**s are used to interloop a continuous yarn and create an elastic fabric. Knitting is particularly suited for garments that

snugly cover parts of the body, such as sweaters, hats, and socks. Practiced by both men and women all over the world, knitting is simple to learn and easily transported. Mothers at home, shepherds in the fields, and sailors on the high seas all have been known to knit. Knitting is considered a relatively new needle-work technique, since it did not take hold in **Western Europe** until the Middle Ages. As Christianity spread, knitting spread with it, traveling as far as Peru with the Spanish in the sixteenth century. Knitting is most often practiced in temper-ate or cold climates, yet is widespread throughout the world, with traditions ranging from Scotland and Norway to Afghanistan and Bolivia.

To knit, the first row of stitches is cast on by looping the yarn onto one needle and using the other needle to pull a new series of loops through the first, one stitch at a time. There are two methods of knitting, American and "Continental" or Western European, which vary in how the yarn is manipulated to make the new stitch. The two primary knitting stitches are called "knit" and "purl." A wide variety of textures can be accomplished by varying these basic stitches.

Knitting needles are long slender rods with a point at the end and no eye. They can be made in a variety of materials including steel, bone, wood, and plastic. The choice of needle is based on the type of stitch, thickness of the yarn, end use, and personal preference. Knitting needles are categorized by number and range from very large "broomstick" needles used to make ponchos and blankets to very fine double-pointed needles used to make hosiery. Fineness of knitted fabrics is measured in gauge, or loops per inch.

In addition to a range of sizes, knitting needles come in several different shapes. Straight needles produce flat pieces of knitted fabric, and circular and double-pointed needles are used to create fabric that is "in the round." Hook-like cable needles are employed to produce textures that imitate plaited or twisted rope. Patterns in color are also very important in knitting. Throughout history, many cultures have developed a treasury of color motifs and patterns. Beads can also be incorporated into knitted objects, by stringing them on the yarn and introducing each bead as the piece is knit.

Almost any thread or yarn can be used for knitting. Wool from sheep and camelids, such as alpaca, llama, and vicuña (see **South America**) are very pop-ular in cold climates. Wool yarn is particularly suited for fishermen's sweaters, like **Aran** and **gansey,** because the oil in the wool protects the wearer from harsh weather. Hair from dogs, goats, yaks, and other animals is also used for knitting. In warmer climates, plant fibers such as cotton, flax, and hemp predominate. Other plant fibers that are knitted include those from the aloe plant and ramie.

Before the advent of knitting, **sprang** was the dominant way of creating stretch fabrics. Sprang was not as portable, since it required a frame. Another early type of knitting was spool knitting, but the finished products of both were limited to tubu-lar shapes and cords. **Single needle knitting,** a variation of the **buttonhole stitch,** was used by peoples of ancient Egypt and ancient Peru. The first double needle or

Brightly colored knit socks from Serbia, 1900–1919. KSUM,
gift of Alice H. Turbaugh, 1986.61.5.

"true" knitting is thought to have originated with the Copts, an Egyptian Christian sect. The earliest examples date from the mid-third century A.D.

Once knitting reached Western Europe in the twelfth century, it was quickly recognized for its usefulness in creating warm clothing as well as beautiful openwork patterns. By the fourteenth century, knitting was a common domestic activity as well as a pastime for royalty; Mary Queen of Scots and Queen Elizabeth I of the **British Isles** were knitters. In the sixteenth century, mechanized knitting emerged with the invention of the stocking frame. Although knitted items could be made quickly and efficiently by machine, hand knitting has remained an important needle art to this day.

Cultural knitting traditions can be found all over the world. Some notable examples are found in the British Isles, Scandinavia, and in South America. In England, Scotland, and Ireland, women still make their families handknit woolen socks and sweaters. Two of the most important of these traditions are the Irish Aran cable knit sweaters and the snowflake motif known as **Fair Isle** from the Scottish Shetland Islands. Both Ireland and Scotland are known for their fine **lace**-like knit shawls, which were popular for brides from the 1840s through the early twentieth century. Irish, English, and French knitters also produced finer gauge objects such as beaded purses, baby caps, and shawls.

In cold climates, knitted garments are a necessity. In Scandinavian countries, including Sweden and Norway, sweaters, socks, and hats are made by knitting in the round. Some hats are knitted twice the desired size and then shrunk and felted for extra warmth. In addition to warm clothing, bead-knitting traditions are found in **Eastern Europe,** where hats and purses are created for special occasions. In Afghanistan and other parts of **Central Asia** sheep or goat wool are the most commonly used fibers for knitting warm clothing.

In the Andes Mountains of Bolivia and Peru, knitted hats or *chullo* are made from vicuña, alpaca, llama, or sheep's wool. Both men and women wear these hats with intricately patterned bands depicting animals and birds in dyed and naturally colored yarns. Men also knit hats and belts that record their marital and social status. Knitting in Mexico and Guatemala ranges from fine altar cloths to tough, hard-wearing carrying bags. Important knitting traditions also include finely knit aloe fiber stockings and shawls from Paraguay and the Azores.

Hand knitting has experienced a resurgence in recent years with the advent of interesting new fibers and yarns, especially among young adults. The Knitting Guild of America offers conventions, conferences, design contests, and a monthly magazine. Events such as "knit-ins" bring people from all walks of life to a central place to share their craft and raise funds for charity. In developing countries, knitting is an important technique used to create goods for export, similar to **Bosnian crochet.** For example, refugees from Afghanistan knit their own designs using wool unraveled from garments given to them by aid organizations. In India, discarded saris are shredded, and the silk is spun into knitting yarn.

FURTHER READING

Barber, E.J.W. (1991). Prehistoric textiles. *The Development of Cloth in the Neolithic and Bronze Ages with Special Reference to the Aegan.* Princeton, NJ: Princeton University Press.

De Dillmont, Thérése. (1996). *The Complete Encyclopedia of Needlework* (3rd Ed.). Philadelphia: Running Press. (First published by Dollfus-Mieg Company, France, in 1884.)

Earnshaw, Pat. (1982). *A Dictionary of Lace.* Bucks, UK: Shire Publications.

Gillow, John, & Bryan Sentance. (1999). *World Textiles: A Visual Guide to Traditional Techniques.* Boston: Little, Brown.

The Knitting Guild of America. Online: http://www.tkga.com.

Knot Stitch

A variety of decorative **embroidery** stitches that create small three-dimensional knots on the surface of the textile. Knot stitches are made by wrapping an

embroidery thread around a **needle** and stitching it down. The main knot stitches are the French knot and Pekin (China) knot, raised stitches that create a textured effect. Varying the number of wraps markedly changes the knot's appearance. Larger knot stitches like bullion, coral, and colonial knots add additional dimension to the embroidery. The simple knot stitch is known by many names including French knot, French dot, knotted stitch, twisted knot stitch, wound stitch, Pekin knot, Chinese knot, knot stitch, seed stitch, Forbidden stitch, Forbidden knot, and blind stitch. The term French knot generally describes these stitches, although more than 20 different varieties of knot stitches have been identified throughout the world.

Knotted embroidery originated in ancient China. The oldest extant example is a pair of silk shoes from the Warring States period (475–221 B.C.E.) Knots were popular during the Han Dynasty (200 B.C.E.–200 A.D.), where highly decorative, finely worked silk costumes were embellished with the Pekin knot. Embroideries from China and **Western Asia** reached the **British Isles, North America,** and **Western Europe** along with other trade goods imported by the British East India Company in the 1690s. Chinese embroideries included small knots used as filling stitches on panels that were designed to be sewn onto clothing. These panels depicted flowers, birds, butterflies, and mythological creatures in intricate detail. Areas such as flower petals were densely packed with rows of Pekin knots. Westerners became enamored with the texture of Eastern knotted embroidery.

The Pekin (China) knot was also known as the Forbidden stitch. It received this name based on a legend that stitching the tightly packed little knots continuously for hours at a time led to blindness, and because of this, the stitch was "forbidden." The more probable origin of the name is its association with China's Forbidden City, home to the emperor and his family. Europeans desired the knotted effect, but not the time-consuming process. Rather than filling motifs with hundreds of individual knots, they took lengths of thread, knotted them at one-quarter-inch intervals, and attached the pre-knotted thread with **couching** stitches. This **knotting** method eventually developed into **tatting** in Western Europe and the British Isles.

While Chinese knot embroideries usually employed silk floss, any type of thread of yarn can be used. The size of the knot depends on the thickness of the thread and the number of times it is twisted around the needle. The Pekin knot is formed by wrapping the thread once around the needle. It resembles a seed, flatter, more shapely, and not as twisted other knot stitches. The Pekin knot is different from the Peking or Chinese stitch, which is a form of interlaced backstitch. A French knot is basically the same as a Pekin knot, only the thread is wrapped at least twice around the needle. In the colonial or "figure of eight" knot, the thread is wrapped around the needle in a twist. Colonial knots were used in **candlewicking,** a traditional **whitework** embroidery style done in North America, the British Isles, and in Australia. The bullion stitch is the main stitch used in Brazilian embroidery, a form of three-dimensional embroidery. Bullion

Peking or "forbidden" knot stitch on Chinese coat, 1875–1899.
KSUM, Silverman/Rodgers Collection, 1983.1.811.

knots are made by looping the thread multiple times before inserting it back into the fabric, creating a worm-like shape.

With its origins in **South America,** Brazilian embroidery uses stitches from all types of needlework, especially relying on the bullion knot. This unique dimensional embroidery is characterized by the sheen and smoothness of rayon thread. The first manufactured fiber, rayon was developed from regenerated wood or cotton pulp in the late nineteenth century. Originally called artificial silk, it was first commercially produced in 1910 and became commonly known as rayon in 1924. In the mid-twentieth century, Brazil started producing multicolored rayon threads in several weights. Brazilian embroiderers quickly identified the ease of stitching and beauty of dimensional pieces made with rayon thread. The popularity of this type of embroidery spread rapidly throughout Brazil and to America in the 1960s. Brazilian embroidery is named for the origin of the style. It is identified by bright colors and looped bullions that rise from the ground fabric, resembling **stumpwork.**

Throughout history, the finest knotted embroidery was created in China and other parts of Western Asia. One of the most notable uses of the knotted stitch was the rank badges of Mandarin China. Important men during the Ming (1368–1644) and Qing (1644–1911) dynasties wore square embroidered badges in vivid colors and gold thread on the chest and back of their black silk robes. Mandarin rank badges were a prestigious sign of civil or military achievement. With nine

ranks for each, civil badges featured birds and military badges displayed real and mythological animals. Achieving rank and the right to wear a badge brought fame and wealth to one's family. The badges were displayed with great pride, worn over the colorful dragon robes at all official occasions in the emperor's court.

Chinese rank badges, generally 11 inches square, were created in workshops that specialized in an assortment of techniques. The finest embroidered badges used Pekin knots, **satin stitch,** and **metallic thread** couching on a dark silk background. Some rare examples incorporated seed pearls and peacock **feathers.** White birds like cranes or egrets were punctuated in pearls, and threads spun from peacock feathers produced an iridescent green glow. Rank badges were also embellished with other types of needlework, such as **needlepoint** on gauze fabric for summer robes. There are more extant civil badges than military ones. Qing dynasty military officials destroyed their badges in an attempt to distance themselves from the old regime during the Chinese Republican revolution in 1911.

FURTHER READING

Chang, Europa. (1996). A History of Lace. In J. C. Turner and P. van de Griend (Eds.). *History and Science of Knots,* p. 3. Singapore: World Scientific Publishing.

Coss, Melinda. (1996). *Reader's Digest Complete Book of Embroidery.* Pleasantville, NY: Reader's Digest.

Embroidery Designs Guide. (January 8, 2006). Hand Embroidery Special—Forbidden Stitches from China. Online: http://www.embroidery-designs-guide.com/2006/01/08/hand-embroidery-special-forbidden-stitches-from-china/.

Freitas, Maria A. History of Brazilian Embroidery. Online: http://www.edmar-co.com/help/history.htm.

Gillow, John, & Bryan Sentance. (1999). *World Textiles: A Visual Guide to Traditional Techniques.* Boston: Little, Brown.

Jackson, Beverley. (January 2005). Chinese Rank Badges. *The Journal of Antiques and Collectibles.* Online: http://www.journalofantiques.com/Jan05/featurejan05.htm.

Mallett, Marla. Seed Stitch ("Forbidden Stitch") and Pekinese Stitch. Online: http://www.marlamallett.com/forbidden_stitch.htm.

Stitch with the Embroiders Guild. French knot/ Bullion knot. Online: http://www.embroiderersguild.com/stitch/stitches/index.html.

Wilson, Erica. (1973). *Erica Wilson's Embroidery Book.* New York: Charles Scribner's Sons.

Knotting

A broad term for twisting and entangling threads or yarns to create an open-weave textile. Knotting includes techniques such as **macramé, tatting,** and **lace,**

which are related to **netting** but are not as elastic as net. Knotted textiles are lace-like, and while sometimes called "knotted lace," they are not considered to be "true lace." Knotted lace can be made with bobbins and shuttles, as well as a **needle** and thread. Knotting traditions are found in North Africa, the **Eastern Mediterranean,** the **Middle East, Western Asia,** and **Western Europe** including Turkey, Armenia, Syria, Palestine, Cyprus, Greece, and Italy.

Humans have made knots since the dawn of history. Ropes were knotted to tie animal skins, help build shelters, and construct traps and nets. Over time, knotting techniques developed from purely functional to an aesthetic form of adornment that included belts, bracelets, and anklets. The materials from which the objects were made are subject to decay, so there are no extant examples of knotting older than 5,000 years. Fringed edges of woven fabric can be seen in Assyrian (Iran) bas reliefs from the Middle East, which are dated from 850 B.C.E.

Square knotting reached Western Europe with the Moors (see **Africa**) in 711 A.D. It became part of ecclesiastical pieces, used by nuns to embellish clothing and altar cloths. Knotting techniques became finer and more intricate over time, often used to create decorative panels of silk and linen. During the Renaissance period, Italian knotted lace was known as *punto á gruppo* or knotted lace. It was used to trim garments and domestic linens in Western Europe and the **British Isles.**

Buttonhole stitch knots worked independently of a base fabric are used in **single needle knitting** and **needle lace.** In both of these techniques, textiles are created by building rows of knots upon each other. This same technique is also used to create three-dimensional figures in **stumpwork.** Knotted **fringe** and macramé can be made by hand or by using a shuttle, which aids in developing intricate patterns. Knotting is the primary technique used in making tassels and pompoms.

An important cultural tradition is needle knotted lace called *oya* from the Eastern Mediterranean and the Middle East including Turkey, Syria, Armenia, and parts of Greece. Using a special knot, oya is the three-dimensional decoration of brightly colored silks, like a garland of flowers. It is said that oya originally embellished the yashmaks, or face veils of harem women. According to Turkish tradition, young women could not speak to their mother-in-law until they had been married for two years or had borne a child. The new bride changed her oyas to express her feelings. The species of lace flowers used in oya differed according to a woman's age. For example, brides and young women wore roses, carnations, and daffodils, where women over age 40 wore a bent tulip motif. Elderly women wore tiny wild flowers, which symbolized their impending return to the earth.

Some fine pieces of oya were shown at the Colonial Exhibition of 1886. The exhibition was held in London and was designed to expose the English people to "the wealth and industrial development of the outlying portions of the British Empire (British Isles)." In Turkey, oya was popular in the second half of the

nineteenth century on borders for head scarves and handkerchiefs, sometimes using cotton instead of silk. In the 1920s the appearance of oya was replicated in **crochet** patterns.

Another cultural tradition, Chinese decorative knotting has origins that date back to the late Paleolithic age, 70,000–100,000 years ago, when knotted ropes were used to keep records. It is thought that at least a part of the Chinese written language evolved from these elaborately knotted cords. The manipulation of silk cords was an abstracted form of symbolic communication, expressing blessings, best wishes, and love. Knotting was considered a necessary skill for all young un-married women, with techniques passed down orally from mother to daughter. Knots were especially important at holidays and at weddings, with intricate and beautiful knotwork tied by brides-to-be for their trousseaus. Along with other imported goods, Chinese decorative knotting appeared in the West in the 1690s. Chinese knots displayed more structural complexity than those seen in macramé and tatting.

Some of the notable symbolic Chinese knots are the "true lover's knot," the swastika knot, and the double-coin knot. The true lover's knot symbolizes romance and is tied in an endlessly repeating pattern. The swastika knot was designed after the ancient Indian motif, which Buddhists hold as a symbol of good fortune. The double-coin knot was used by merchants, who hung it over

Ceremonial hat featuring Chinese decorative knotting, 1875–1899. KSUM, Silverman/Rodgers Collection, 1983.1.1952.

the entrances to their shops hoping to attract wealth. Unfortunately, many traditional Chinese arts and crafts disappeared within the time span of a generation. Decorative knotting was a widespread pastime through the 1930s, but by the 1960s it had virtually disappeared, except for museums. In 1976, Lydia Chen sought to document and revive this all-but-lost art. She conducted extensive interviews with knotting artists in Taiwan, researched historical texts, and studied collections in museums and private homes. The result was a series of articles on Chinese decorative knotting and a book in 1982, both of which help to keep the tradition alive.

Macramé and other forms of knotting witnessed a revival during the 1970s. The highest-level knotting was done by professionals who created wall hangings and other large forms to embellish office buildings, theaters, and other public spaces in **North America, Scandinavia,** and Western Europe. In recent years, these techniques have been rediscovered by contemporary fiber artists, expanding the possibilities of creating three-dimensional sculptures with knots.

FURTHER READING

Carter, Roger. (1996). The History of Macramé. In J. C. Turner and P. van de Griend (Eds.). *History and Science of Knots,* pp. 335–344. Singapore: World Scientific Publishing.

Chen, Lydia. (1982) *Chinese Knotting.* Taipei: ECHO Publishing Company.

De Dillmont, Thérése. (1996). *The Complete Encyclopedia of Needlework* (3rd Ed.). Philadelphia: Running Press. (First published by Dollfus-Mieg Company, France, in 1884.)

Earnshaw, Pat. (1982). *A Dictionary of Lace.* Bucks, UK: Shire Publications.

Tansug, Sabiha (2006). Lace (Oya). The Language of Anatolian Women. Online: http://www.turkishculture.org/fabrics_patterns/oya.html.

Whiting, Gertrude. (1971). *Old-Time Tools and Toys of Needlework.* New York: Dover. (Unabridged and unaltered republication of the work originally published by Columbia University Press, New York, in 1928 under the title *Tools and Toys of Stitchery.*)

Lace

A purely decorative free-form fabric that, throughout history, has been coveted, stolen, and smuggled. Since its emergence in fifteenth-century **Western Europe,** handmade lace has been a valuable luxury, made by the poorest women to adorn the rich. Lace was first used to decorate clothing and display wealth. The labor-intensive and specialized nature of lacemaking, along with the economic power that came with production, led governments to court lacemakers and, in some instances, kidnap them.

Lace is a European invention, as is fashion, and both of them emerged in the Renaissance period. The value of lace in the context of history is often underestimated. Originating in Italy or Dalmatia (the coastal region of the former Yugoslavia), lacemaking techniques along with fashions for lace cuffs and collars rapidly spread throughout the continent. At first, this costly ornamentation was limited to royalty and nobles, but with the invention of the printing press and increased buying power of the emerging merchant class, lace fashions could be emulated. The earliest pattern book to show lace was printed in Germany in 1523. Over 150 pattern books for lace and **embroidery** were printed in Western Europe in the sixteenth century.

There are two types of handmade lace—**bobbin lace** and **needle lace**—and their ancestors include embroidery, braiding, and the manipulation of **fringe.** Overall, needle lace developed from embroidery and bobbin lace from braiding and fringe. Lace is probably the most recent of the traditional needlework techniques. Needle lace is slightly older than bobbin, and both were seen in Western European paintings by 1540. Although, they share a similar openwork appearance, **macramé, knitting, crochet, tatting, netting,** and **sprang** are not considered to be "true" lace.

Needle lace or "**needlepoint** lace" is made with a **needle** and thread. Technically a form of sewing, needle lace uses single continuous thread and the buttonhole stitch. Needle lace originated with **cutwork** along with other forms of **whitework.** As embroiderers developed their skills, these techniques evolved to the point where most of the base fabric was discarded. The result was *reticella,* a form of lace in which a lattice grid of **buttonhole stitch** bars hold the motifs together.

Although a distant descendent of fringe, pillow or bobbin lace is not anchored to a woven fabric, but instead a group of many separate threads are twisted together, somewhat like **plaiting and braiding.** The threads, weighted by bobbins, are twisted and pinned on a pillow to create the pattern. With time and development of skill, the way threads were manipulated became more free-form and curvilinear. There is no **knotting** in bobbin lace; instead the pattern is created by twisting threads in an intricate manner.

After lace emerged as a distinct fabric type, centers of production grew up in Europe, specializing in particular techniques and motifs. There are many different types of laces, named more for geography than process. In general, peasants were the lacemakers in **Eastern Europe,** but in Western Europe lacemaking was a profession. The making of lace by hand is extremely slow and even slower with fine threads. Lace was usually made of flax (linen), which results in a finer thread when spun wet. Individual professional lacemakers worked between 12 and 16 hours a day, often in cold, damp rooms. Some lacemakers lost their eyesight due to poor lighting and conditions.

Although simple embroidered, netted, and knotted laces were made before the year 0, they were not important before the late fifteenth century. Lace as

we know it began and mainly continued with the Western Europeans and peoples of the **British Isles.** The most important commercial centers were in Italy, Flanders (Belgium), and France. Lacemaking skill traveled with lacemakers, who continually fled religious and political strife. Spanish lacemakers fled to Flanders (Belgium) and France during the Inquisition in 1529. In 1661 Venetian (Italy) needle lacemakers were smuggled into France. They fled during the French Revolution, settling in England and strongly influencing English laces. Lace was introduced to other parts of the world by Christian missionaries and settlers whose vestments included lace cuffs and collars.

Because of the costliness of lace, some European governments attempted to prohibit its wearing by passing sumptuary laws designed to regulate expenditure and support home industry. Smuggling was a way to get around laws and tariffs. In the nineteenth century, dogs were starved, wrapped with 26 pounds of lace, squeezed into the peeled-off skin of a larger dog, and sent over the border from Belgium into France. The height of the handmade lace industry in Western Europe began to decline when the first machine-made bobbin net was made in France in 1818.

In **North America,** lacemaking did not reach the heights of skill or practice found in Western Europe and the British Isles. Records of lace dating from the eighteenth century are rare and usually refer to imported goods. Lacemaking was part of the arts and crafts movement in the 1870s and 1880s, and the Needle and Bobbin Club was established in America in 1916. One of their outreach efforts was programs that taught lacemaking as a vocational skill to immigrant children. A similar effort was attempted with Native North American children in the 1890s.

For the most part, hand lace and hand lacemaking were not valued in the period between the 1920s and the late 1960s. Unfortunately, many antique laces were discarded. In 1953, the International Old Lacers was formed with the objective of making, studying, and collecting lace. In the late 1960s, fashion designers began purchasing huge quantities of unwanted laces from the nineteenth century and earlier. About the same time, hand lacemaking experienced a revival with the back-to-nature movement and greater recognition of fiber arts. A new generation of lacemakers began to recreate traditional patterns and invent designs of their own. Contemporary fiber artists construct lace in a new variety of colors, fibers, and techniques.

FURTHER READING

Chang, Europa. (1996). A History of Lace. In J. C. Turner and P. van de Griend (Eds.). *History and Science of Knots,* pp. 347–379. Singapore: World Scientific Publishing.

De Dillmont, Thérése. (1996). *The Complete Encyclopedia of Needlework* (3rd Ed.). Philadelphia: Running Press. (First published by Dollfus-Mieg Company, France, in 1884.)

Earnshaw, Pat. (1982). *A Dictionary of Lace.* Bucks, UK: Shire Publications.

Emery, Irene. (1980). *The Primary Structures of Fabrics.* Washington, DC: The Textile Museum.

Gillow, John, & Bryan Sentance. (1999). *World Textiles: A Visual Guide to Traditional Techniques.* Boston: Little, Brown.

International Old Lacers, Inc. (IOLI). Online: www.internationaloldlacers.org.

◈

Latch Hooking

Using a specialized hook and short pieces of yarn to create a long knotted pile on an even-weave base fabric. Latch hooking is a newer style of **rug hooking** and has a strong association with acrylic yarn rug kits in the 1970s and 1980s. During those decades, Americans of all ages created small rugs with pre-cut yarn and a latch hook. Along with other types of "paint by number" crafts, latch-hooked rugs often reflected the color palette of the time. First available in the early 1950s, acrylic is a manufactured fiber that can be made to resemble wool. It is less expensive than wool and can be dyed in very bright colors.

Latch hooking creates a shag-type rug, which is sometimes incorrectly labeled as a "*rya* rug." Although rya rugs from Finland have a shag appearance, they are made with a type of turkey-work **embroidery,** with a **needle** and thread. Latch hooking is mentioned in American Laura Ingalls Wilder's 1941 book, *The Long Winter.* One of the nine books of the "Little House on the Prairie" Series, *The Long Winter* tells the story of a family's struggle to survive the hard winter of 1880–1881 in South Dakota. The term latch hooking is sometimes used to broadly describe rug making with yarn.

The latch hook may be a descendent of the "latch needle," part of a knitting machine that was invented in 1847. It has a hooked end with a "latching" mechanism and a wooden handle. The shaft of a latch hook can be either straight or bent. A short piece of yarn is looped around the hook, behind the latch. The hook is then pushed through one square of very heavy rug canvas and pulled back through, **knotting** it once. Two-and-one-half-inch lengths of yarn produce a one-inch rug pile. Latch hooking is different from traditional rug hooking and **locker hooking.** Locker hooking uses a hook with a needle-like eye to stitch yarn through a base fabric. Rugs made with the latch hook technique must be finished or the base fabric will fray. The reverse side should be trimmed with a binding and possibly a nonstick surface, too.

Latch hooking is easy to learn, and kits with painted canvas, instructions, and pre-cut yarn are readily available. Some interesting educational efforts using latch hook include math lessons and occupational therapy. A Brooklyn, New York, teacher used the geometric grid of latch hooking to teach mathematical concepts. Latch hooking expanded understanding of art and helped students develop patience. The U. S. Veteran's Association includes latch hook in occupational therapy programs. Through these efforts, latch hooking has helped veterans increase social contacts and their ability to set goals. A company in Illinois offers latch hook kits in Braille, making crafts more accessible for the visually impaired.

Latch hooks have several interesting applications that have little to do with rugs. Although not its original intention, the latch hook is used in wig making

and hair styling. Professional wigmakers for the performing arts make an art out of building wigs. Commercial wigs are purchased and remade by **crocheting** or latch hooking individual strands of hair into fabric. A perfect fit requires that each wig be made specifically for each actor. Latch hooking is also a popular way of maintaining dreadlocked hairstyles. The hook is used to tighten dreadlocks after swimming or showering. Some contemporary artists have chosen latch hooking as their medium, exploring the relationships between pixilated images of latch hooked rugs and contemporary technology. New software allows latch hookers to design rugs on their home computers.

FURTHER READING

Gaasch, Cynnie. "Cutting Culture at Buffalo Arts Studio." *ArtVoice*. Online: http://artvoice. com/issues/v5n6/artshorts/cutting_culture_at_buffalo_arts_studio.

Gray, Diana Blake. Fads of the 60s and 70s. Needlepoint on Rug Canvas Novelty and Fad Rugs: From the 1920s to the 1990s. Rugmaker's Homestead. Online: http://www.netw. com/~rafter4/novelty.htm.

Horizons for the Blind Catalog. (June 2003). Online: www.horizons-blind.org/cat2003.htm.

Jamar, Tracy. (2005). Definition of Rug Making Terms. *New Pathways into Quilt History*. Online: www.antiquequiltdating.com/HookedRugs-Jamar-Terms.html.

Koper, Rachel. (August 6, 2004). Stitching Up a Storm. *Austin Chronicle*. Online: http://www. austinchronicle.com/issues/dispatch/2004–08–06/arts_feature.html.

Latch-Hook Kits. Joanna King, Public School 159, Brooklyn, NY. 2005–2006 Classroom Teacher Grants. Kappa Delta Pi, International Honor Society in Education. Online: http://www.kdp.org/scholarships/winners0506.php.

Latch Hook Rugs. Online: http://www.latchhookrugs.com/hooking.shtml.

Latched Hook Style Rugs. Latch Hook Resources. Habitat Farm. Online: http://www. latchhookrugs.com/howto.shtml.

Mabry, Becky. (November 16, 2000). "On the Job: Lisa Lillig." *Inside Illinois* 20(10). Online: http://www.news.uiuc.edu/ii/00/1116otj.html.

Naani. Starter Dreadlocks—Latch-Hook Dreadlocks. Dreadlocks Library. Online: http:// www.naani.com/.

Rug Hookers Network. Online: http://www.rughookersnetwork.com/.

Veteran Exhibits Award-Winning Artwork at 2004 National Veterans Creative Arts Festival. Online: www.creativeartsfestival.org.

Locker Hooking

Using a long hook to pull up loops of thick yarn, wool roving (unspun wool), or fabric strips through the holes of a rug canvas and "locking" them in place with a strong yarn. The locker hook has a **crochet**-like hook at one end and a tapestry

needle eye on the other. The eye of the hook carries the strong locking thread, which is used to secure the loops on top of the canvas. Locker hooking uses leftover yarn, fibers, or strips of cloth to create thick cushiony rugs, wall hangings, and other items. It is different from **latch hooking** and **rug hooking.** Locker hooked items are somewhat preferable to traditional hooked rugs in terms of durability, since the loops of fabric are locked into place and are not easily pulled out.

Locker hooking is not new, but has only gained notice as a needle art since the 1970s. It may be descended from an old rug-hooking technique that originated in the **British Isles.** The earlier form used a heavy, six-ply wool yarn. It was popular in England in the 1920s and in **North America** in the 1940s, but in both countries, its popularity was short-lived. This may have been due to the high cost of the specialized yarn. The renaissance of locker hooking has its roots in Australia (see **East Asia, Southeast Asia, and the Pacific**), where a change in materials reinvigorated the needlework technique.

In 1972, Australian Brian Benson toured Ireland and saw demonstrations of locker hooking. He became fascinated with the technique and brought several hooks home to his mother, well-known fiber artist Patricia Benson. Patricia quickly mastered locker hooking and expanded it by changing the type of wool, keeping the original procedure. She began using unspun, freshly sheared wool, and "Australian locker hooking" was born. Using unspun wool rather than yarn greatly reduced the cost of materials and was well suited to the natural resources of Australia. Patricia promoted the craft in her home country, where sheep breeding and the production of wool are major industries. The resulting rugs were beautifully soft and springy, and wore well, too. The craft was enthusiastically received in Australia and eventually found its way back to America and England, but on a much smaller scale.

Made from wood, bone, or metal, the locker hook is usually six-and-a-half inches long and one-eighth of an inch in diameter. It generally comes in the equivalent of a size eight standard **crochet** hook, although smaller hooks are available for miniature work. The locker thread should be a sturdy cord or yarn that can be easily threaded through the hook's eye. Any color is appropriate, but the goal is that the locking yarn does not show, so it should blend with the basic colors of the piece. Sized rug canvas in cotton or a cotton polyester blend is best. The mesh is generally three or four squares per inch. Australian locker hooking is best suited to simple patterns that are drawn directly on the canvas.

The process is essentially crocheting through the holes in the canvas. The locking yarn is threaded through the eye of the hook, and then the roving, yarn, or fabric strip is held at the back of the canvas, pulling loops to the top of side. Once several loops are on the hook, it is drawn all the way through, pulling the locking yarn through the loops and locking them on the surface of the canvas. Locker hooking is used to make rugs, wall hangings, blankets, cushions, chair pads, placemats, pot holders, coasters, hot pads, baskets, bags, jackets, vests,

purses, and saddle blankets. Almost any material can be use for locker hooking including fleece from dogs, llamas, and alpacas, ribbon, **lace,** leather, real and faux fur, and plastic. It can be embellished with beads, buttons, and **feathers** as well as **embroidery, appliqué,** and crochet.

The Australian locker hooking technique was introduced to the United States in 1980. It gave Americans a chance to work with unprocessed wool without having to master spinning or spend large amounts of money on yarn. Wool in any of a number of stages of finishing can be used for locker hooking, from freshly sheared material to spun yarn with a heavy twist. A variation of locker hooking was done in America using fabric strips and called "anchored loop." Rather than employing the locker hook tool with a hook and eye, anchored loop pieces were made with a combination of two tools; a traditional rug hook to pull though a loop of fabric strip, and a lacing needle or bodkin to secure the loop. Locker hooking is not as well known as other rug techniques. Its full potential has yet to be explored by contemporary needleworkers.

FURTHER READING

Jacobson, Donna. (1999). Alaska Locker Hooking Designs/What is Locker hooking. Online: http://www.geocities.com/lockerhooking/.

Livingston, Marilyn. Locker hooking: An American Perspective. Livingston's Locker Hooking. Online: http://home.earthlink.net/~mslivingston/.

Livingston, Marilyn. (November/December, 1984). Australian Locker Hooking: A Home Craft from Down Under. *Mother Earth News* 90. Online: http://www.motherearthnews.com/library/.

MCG Textiles. Locker Hooking Demonstration/Yarn Locker Hooking Demonstrations. Online: http://www.mcgtextiles.com/.

Rugmaker's Homestead. Anchored Loop Rugs (American "Locker hooking"). Online: http://www.sandpoint.net/~rafter4/anchor.htm.

Machine Needlework

Mechanized techniques for copying hand needlework such as **knitting, lace,** and **embroidery.** Machine needlework goes back to the reign of Queen Elizabeth I, when the stocking frame was invented near Nottingham, England, in 1589. Framework knitting was a significant step in the early history of the Industrial Revolution, and by 1697 Nottingham was the center of machine textile production. The stocking frame, the warp frame, and the bobbinet machine were all invented in Nottingham. Resistance to the growth of mechanization was documented as early as 1710, when stocking frame knitters protested in London. They

were concerned that the hiring of a large number of apprentices at extremely low wages would cause unemployment.

Machine needlework received its biggest boost in the mechanized weaving system invented by Joseph Jacquard at the turn of the nineteenth century. Jacquard's loom used a series of punched cards to raise and lower the warp threads, eliminating the need for a "draw boy." The mechanized loom was first used for weaving patterned silks in Lyons, France, in 1801.

One of the most significant applications of the Jacquard loom was "paisley shawls." Kashmiri shawls decorated with embroidery and **patchwork** were brought to the **British Isles** from the **Indian Subcontinent,** becoming very fashionable in the early 1820s. Heavily embellished authentic handmade shawls were in short supply and very expensive. European manufacturers soon realized the potential for copying embroidered Indian shawl designs with woven patterns. Working on Jacquard looms, weavers in Paisley, Scotland, made shawls for a tenth of the price. In the same period, an adaptation of the Jacquard mechanism simulated **quilting,** making machine-made quilts affordable for many families.

The bobbin net or bobbinet machine was invented in Nottingham, England, in 1808. It worked by turning a handle to create an 18-inch-wide net suitable for tambour embroidery. Nottingham was the most significant center of machine lace in the world until 1811. It was also the home of the Luddites, who named themselves after a boy, Ned Ludd, who violently destroyed warp frames in 1779. The success of the bobbin net machine put local stocking frame workers out of business. It arrived just when silk frame lace was becoming commercially successful and wages were very high. The Luddites were a group of Nottingham journeymen and machine hands who felt threatened with poverty and unemployment. They blamed the machines for their situation and destroyed nearly a thousand English needlework machines between 1811 and 1818.

Despite the efforts of the Luddites, Nottingham had a total of 3,000 lace machines by 1851. The population increased from 47,000 in 1810 to 79,000 in 1830 and to almost 150,000 by 1866. Demand increased when Queen Victoria's daughters appeared dressed in Nottingham lace. Throughout the British Isles and **North America,** Nottingham lace curtains were very popular from the 1860s to the 1950s. Bobbin net manufacturing was also done in France, where the net machine was perfected by 1834. The French machine was capable of creating copies of lace, including fine black Chantilly. A Jacquard attachment produced patterning on machine laces in the 1840s, producing silk laces known as "fancies," which were good imitations of handmade lace.

Tambour hook embroidery was the inspiration for the sewing machine. The first **chain-stitch** machine was patented in 1804, but was at first unreliable. A significant innovation in machine lacemaking occurred in Switzerland with the invention of the "hand machine" in 1828. Other needlework machines and developments followed. In 1834, a Paris, France, exhibition unveiled a machine that could produce tambour stitches many times faster than could be done by hand.

The Wilcox and Gibbs chain-stitch machine came on the American market in 1855. Machine chain-stitch embroidery on net used simpler designs and thicker thread than handmade lace, but the cost and availability made it very popular. By 1860, delicate openwork fillings, similar to Ayrshire (Scotland) could be worked by machine. The first really successful embroidery machine was patented in France in 1865. The Bonnaz machine was small enough to be used in the home, and machine lace became a peasant industry in Switzerland.

A significant innovation in machine needlework was the Schiffli embroidery machine, which was first developed in 1863. In 1868, a modification made it possible for holes to be pierced by machine, imitating the eyelet **buttonhole stitch** of *broderie anglaise* **whitework.** In the 1870s, it became difficult to distinguish handmade laces from those stitched by machine, with some designs and techniques copied identically. Machines continued to improve; Schiffli machines could work 35 stitches per minute by 1878 and 86 stitches per minute by 1887.

Around the same time, the arts and crafts movement began in England and the United States as a search for authentic and meaningful styles and a reaction to the "soulless" machine-made production of the Industrial Revolution. Some proponents considered repetitive and mundane machine work to be the root cause of all evils. The arts and crafts movement turned away from machines and

Late nineteenth-century American machine-made lace. KSUM, transferred from the Allen Memorial Art Museum, Oberlin College, Oberlin, Ohio. Gift of Hazel B. King, 1945, 1995.17.1184.

towards handicraft, including needlework, from the late 1870s until about 1910. The concept that workers should derive satisfaction from the product of their efforts did not stop the growth of machines, but it did continue the long legacy of hand needlework. Similar philosophies inspired other movements like the back-to-nature movement of the late 1960s and early 1970s, paving the way for contemporary needlework enthusiasts and fiber artists.

FURTHER READING

Earnshaw, Pat. (1982). *A Dictionary of Lace.* Bucks, UK: Shire Publications.

Forsdyke, Graham. A Brief History of the Sewing Machine. International Sewing Machine Collectors' Society. Online: http://www.ismacs.net/smhistory.html.

The Paisley Design—Buta & Buti. Online: www.surgillies.com.au/research.

SWF Mesa. The History of Embroidery. Online: http://www.swfmesa.com/embroidery_resources/history_of_embroidery.htm.

Wanner-Jean Richard, Anne. (1987). Development of machine embroidery. Online: http://www.annatextiles.ch/publications/fraefel/2machi.htm.

Wikipedia. Arts and Crafts Movement. Online: http://en.wikipedia.org/wiki/Arts_and_Crafts_movement.

Wikipedia. Machine Embroidery. Online: http://en.wikipedia.org/wiki/Machine_embroidery.

Wikipedia. Stocking Frame. Online: http://en.wikipedia.org/wiki/Stocking_frame.

Macramé

A special type of **knotting** worked with a number of cords to create an open-work fabric. Macramé can be worked in a variety of threads, ropes, and yarns. Although the knotting process is similar, the appearance of macramé pieces vary greatly based on materials used. It is a needlework technique that has transcended class distinctions; being practiced by sailors, royalty, nuns, and people from all walks of life.

The word macramé is derived from the Arabic word *migramah,* which was associated with Middle Eastern weaving. Macramé was first used to describe ornamental **fringes** and braids created by knotting the top and bottom edges of handloomed fabrics. Over time, the meaning was broadened to refer to Turkish fringed towels and napkins and was eventually used to describe shawls, veils, and headcoverings worn by Middle Eastern peoples. As the technique traveled the world, it acquired different names, including *filet-de-carnassière* in France and *punto á gruppo* (knotted **lace**) in Italy. Whether a decoration on existing fabric or a fabric of its own, fringe is the common element in macramé.

Macramé requires little in the way of equipment other than cord and a place to secure it. The working threads are attached to the holding cord using double half hitches or lark's heads. This is the same knot used in **tatting,** but in macramé, other knots such as the square knot can be added. Knots are worked at different intervals to create the pattern. The piece is finished off with tassels or fringe at the edge. Macramé is sometimes worked on a cork board or sand-stuffed pillow.

Macramé is a needlework technique with a wide geographic range. It was first developed by ancient cultures in Egypt, China, and Peru. The oldest extant example is from ancient Egypt and dated circa 3500 B.C.E. An Assyrian stone carving from the **Middle East** dated 850 B.C.E. shows a warrior wearing a macramé-like fringed tunic with fringe on his horse's harness. In the mid-thirteenth century, Marco Polo wrote of fringed saddles in eastern Persia (Iran and Iraq). Macramé may be the first of the lace-type or openwork skills to be recorded, although it is not generally included in the category of lace.

The art of macramé traveled from the Middle East to **Western Europe** in several waves. The Moors (Moroccans) brought macramé, along with other types of needlework, to Spain beginning in the eighth century. Three centuries later, wives and servants traveling with the crusaders learned macramé and brought it home when they returned to Italy.

The knotting technique was taken up by nuns who adapted the coarse wool macramé fringe into free-form needlework. By 1500, they were creating fine, knotted lace in silk and linen. Ecclesiastical textiles such as vestments and altar cloths with macramé edgings were featured in Renaissance paintings such as *The Last Supper* by Sebastian Ricci (1659–1734) and *Marriage in Cana* by Veronese. Macramé then traveled north from Italy and was adopted by Flemish lacemakers in Holland and Belgium. It is said that macramé was introduced to England by Queen Mary, wife of William of Orange, who took the throne in 1689. It is not completely clear whether the knotting done by Queen Mary was macramé, tatting, knotting, or a completely separate technique.

Macramé was a popular royal pastime in seventeenth-century Western Europe. Court dress during the reign of Louis XIV of France included long silk macramé scarves and stoles with long fringes. Queen Charlotte, wife of George III (1760–1820) of England, was an enthusiastic knotter. Inspired by finding of an old piece of *punto á gruppo*, teachers in Genoa, Italy, taught fine macramé to poor schoolchildren beginning in 1843. The macramé-trimmed undergarments and household textiles they made were exported to **South America** and **North America** and were important trousseau items for brides.

The height of macramé's popularity was in the Victorian era, where cultured ladies demonstrated their talents and the wealth of their husbands by creating needlework items. Macramé was used to make fringes, frills, and flounces, which adorned curtain rails, gas lamp brackets, four-poster beds, pincushions, workcases, table runners, antimacassars, and babies' bonnets. The popularity of macramé in

Fragment of macramé lace, nineteenth century. KSUM, gift of Jo Bidner-Heinritz, 2004.27.5.

nineteenth-century England, France, Germany, and the United States resulted in many new products, books, magazines, and pamphlets. Fine knotted pieces were also shown at the Paris Exhibition of 1867.

As with other types of needlework, macramé's popularity ebbed and flowed. Over time and with a backlash against the excessive decoration of the Victorian era, macramé became associated with amateur work and lost its appeal in North America and the **British Isles.** Macramé continued to be worked in convents as well as in Italian and Eastern European villages. For example, Bulgarian folk costume includes an embroidered apron with knotted fringe. The tradition of macramé also continued in the Middle East and **Central Asia** including macramé straps to suspend items such as the Turkish blue glass "eye" beads or *bonjuk,* which are carried for spiritual protection.

Except for a brief period during World War II, when some women did macramé as a way to pass time in air raid shelters, macramé was not generally practiced as a popular needlework technique from the late nineteenth century until the late 1960s. It was rediscovered along with other types of hand needlework by the back-to-nature movement. This macramé revival began in the United States and appealed to people of all classes, who created wall and plant hangers, handbags, shawls, and jewelry through the 1970s. As with its popularity in the Victorian era, increased interest resulted in a surge of books and magazines devoted to macramé. Macramé also became accepted as a fiber art during this time. In recent

years, macramé has been used for creating hemp jewelry and "friendship" bracelets as well as handbags and other utilitarian items.

Throughout waves of interest by the general public, macramé has largely been kept alive and spread throughout the world by sailors. Macramé was an important sailor handicraft along with scrimshaw, model carving, **Berlin work, knitting, rug hooking, Tunisian crochet,** and **embroidery.** Sailors created personal items, gifts for their wives and girlfriends, and crafts they could sell or barter when they came ashore.

In addition to practicing macramé, sailors also spread it through their travels. Native North American and Pacific Island Maori peoples had an already-established tradition of knotting, which was expanded by this culture contact. Knotting traditions can be found in the Eskimo culture of North America as well as among indigenous South American peoples of Peru, Mexico, and Colombia. Macramé was sometimes called Mexican lace, and today artisans in Mexico, Ecuador, and Portugal produce belts, sashes, purses, and shawls for the tourist and export trade.

FURTHER READING

Carter, Roger. (1996). The History of Macramé. In J. C. Turner and P. van de Griend (Eds.). *History and Science of Knots,* pp. 335–344. Singapore: World Scientific Publishing.

Gillow, John, & Bryan Sentance. (1999). *World Textiles: A Visual Guide to Traditional Techniques.* Boston: Little, Brown.

Harvey, Virginia I. (1967). *Macrame: The Art of Creative Knotting.* New York: Van Nostrand Reinhold.

Meilach, Dona Z. (1971). *Macrame: Creative Design in Knotting.* New York: Crown.

Whiting, Gertrude. (1971). *Old-Time Tools and Toys of Needlework.* New York: Dover. (Unabridged and unaltered republication of the work originally published by Columbia University Press, New York, in 1928 under the title *Tools and Toys of Stitchery.*)

Metallic Threads

The use of gold, silver, and other metallic threads as an **embellishment** on textiles and clothing. Metallic thread originated in **Western Asia,** traveling to the **Middle East** on the Silk Road and into **Western Europe** by the Middle Ages. Across time and geographic area, gold and silver worked on costly materials like velvet, silk, and satin has signified military, spiritual, and political power. Metal thread embellishments are prominent on uniforms, with opulence used to indicate rank. Ecclesiastical textiles with lavish gold **embroidery** can be found in churches, mosques, and temples throughout the world. These same costly materials were used to embellish the rich and powerful with eye-catching court costume.

The most expensive gold thread is known as Admiralty or government standard. It is 2 percent gold on white metal. Gilt is about .5 percent gold on silver-plated copper. In making metallic threads, heated gold or silver wire is drawn through successively smaller holes in a metal plate. This fine wire can be hammered flat into ribbon-like strips, formed into a long flexible coil named "purl," or wound around a silk core to make thread. Most professional metal thread work is done by men in workshops using a frame. Metallic folk embroidery was usually done by women who stitched without a frame, resulting in a more textured fabric.

Because metal threads such as purl are often too abrasive to pull through fabric without making a hole, they are laid on the surface and stitched down in a matching or contrasting colored thread. This embroidery technique is known as **couching.** Sometimes metal threads are laid over a base of cotton, cardboard, or wood, which creates three-dimensional embroidery called **stumpwork.** Beaten silver yarns are used for angular patterns of plants and figures in the Middle East. Although still too thick to be embroidered with a **needle** and thread, **tambour** hooks can be used to make **chain stitches** directly into the fabric in fine silver or gold gilt thread. Finer, more flexible, and considerably less expensive than real metal, synthetic *lurex* is a popular substitute for contemporary metallic embroidery, especially in **Africa.**

Metallic thread embroidery originated in China, where thread is laid in coils and couched on a silk ground. This technique was used to embroider five-clawed *lung* dragons on eighteenth century emperor robes. Another use of gold is to **needlepoint** with silk and metal thread on silk mesh. Bird designs or geometric patterns in needlepoint embellished Chinese court clothing. From China, goldwork is thought to have traveled east to Japan and then to **Southeast Asia.** Folk embroidery in Korea, Japan, and Southeast Asia includes metal threads worked on silk or cotton.

The art of metallic threadwork moved from Western Asia to the Middle East, and by the year 0, metal threadwork was in widespread use for both court and folk embroidery. From the Middle East, metal threadwork spread to north Africa, through Spain into Italy and then to Western Europe, the **British Isles, Scandinavia,** and **North America.** Europeans used high-quality goldwork for ecclesiastical or church embroidery, the finest of which was known as *Opus Anglicanum.* Items were exported from England all over Europe including the Vatican in Rome (Italy).

Metallic thread embroidery was also used to decorate clothing and furnishings for the nobility. Portraits and other paintings, including the *Field of the Cloth of Gold* (1520), illustrate clothing with lavish metal embroidery. Records from the fourteenth century include close-fitting coifs or bonnets netted with gold by nuns. The earliest gold and silver **laces,** either in pure metal or an alloy, were made in Genoa (Italy) during the Renaissance. Gold lace was worn by King Gustavus Vasa, who reigned in Sweden from 1523–1560. His granddaughter was buried in a dress and shoes covered in gold and silver lace. These valuable laces

were regulated by sumptuary laws, including an early Massachusetts law that forbade lower-class American colonial men and women from wearing gold or silver lace. To circumvent regulations, metallic laces from Genoa were smuggled into France. Very few of these early metallic laces survive, since many were melted down for their mineral value.

Later, metal threads garnished military dress uniforms and civic regalia as they still do today. As a result of Western European imperialism in the eighteenth and nineteenth centuries, couched metal cords of the frog closures on uniforms inspired embroiderers from around the world. The Spanish introduced metal threadwork to North and **South America.** In the Victorian era, embroidery on heavy silk dresses often included couched gold thread, beads, and even beetle wings.

There are many distinctive traditions for gold and silver threadwork found throughout the world. One of the most notable is from the Southeast Asian country of Myanmar (Burma), where *kalaga* wall hangings feature a distinctive type of stumpwork embellished with couched cords, **beadwork,** glass studs, sequins, and metal thread. Padded images of people or animals are applied to a central field of black velvet and edged with cloth from discarded robes of Buddhist monks. On the **Indian Subcontinent,** *zardosi* is metal embroidery on textiles and costume used for special occasions, including weddings. Metallic threads are also used on folk-embroidered shawls and door hangings in India, accompanied by cowrie **shells,** sequins, and **mirrorwork** decorations. In Pakistan, wedding clothing such as waistcoats and blouses are embellished with **appliqué** panels and couched metal thread braids and spiraling floral patterns of couched flat metal.

Couched gold thread is used extensively for embroidery on the apparel of chieftains in **Eastern Europe.** This heavy metal thread work is still practiced in Yugoslavia, Silesia, Serbia, Montenegro, Albania, Russia, Georgia, and Siberia. Turkey is known for court costumes, home furnishings, and animal trappings elaborately embellished with gold threads. Turkish domination during the Ottoman Empire influenced embroidery in Syria, where gold threads often present a striking contrast on a black silk background. In other areas of the Middle East, particularly Palestine, Lebanon, and Afghanistan, gold threads are couched in cotton and silk on red velvet dresses in military-style motifs and mirrorwork. A traditional short velvet vest worn by both men and women in Lebanon is the *kubran,* embroidered with metallic thread. In north Africa, specifically Algeria and Egypt, gold threads are worked in close diagonal lines of **satin stitch** on a red background.

Much of contemporary professional metallic threadwork is done in China, India, and other countries for the export market. Metal threadwork techniques were preserved and expanded through the efforts of the Royal School of Needlework in London, England, the House of Lesage in Paris, France, and Japanese embroidery masters at home and in the United States. As a result, specialized teachers and enthusiastic embroiderers practice gold and silver embroidery throughout the

Albanian coat heavily embellished with metallic thread and braids, nineteenth century. KSUM, transferred from the Allen Memorial Art Museum, Oberlin College, Oberlin, Ohio. Edna G. Reizenstein, 1995.17.570.

world. Today's needlepoint artists often use metal threadwork, **crewelwork,** and other embroidery techniques to add depth and texture to hand-painted canvases.

FURTHER READING

Berlin, Tanja. Metal Thread History. Online: www.berlinembroidery.com/goldworksupplies. htm.

Earnshaw, Pat. (1982). *A Dictionary of Lace.* Bucks, UK: Shire Publications.

Embroiderers Guild of America. Goldwork. Online: www.embroidersguild.com/stitch/projects/goldwork/index.html.

Gillow, John, & Bryan Sentance. (1999). *World Textiles: A Visual Guide to Traditional Techniques.* Boston: Little, Brown.

Gotstelow, Mary. (1977). *The Complete International Book of Embroidery.* New York: Simon and Schuster.

Middle East

Area of the world known as Mesopotamia, Persia, and the Levant including, but not limited to, the countries of Iran, Iraq, Israel, Jordan, Lebanon, Palestine, Syria, and Yemen. The Middle East was producing highly developed needlework as early as the fifteenth century B.C.E. Unfortunately, with a history of conflict and political upheavals, especially in the twentieth century, many local **embroidery** styles have been discontinued. The main embroidery techniques are not governed by national boundaries, but are heavily influenced by religion, primarily Islam, and Judaism, to a lesser extent. Middle Eastern needlework was significantly impacted by cross-cultural exchange. A series of ancient trade routes became the Silk Road in the first century B.C.E. Embroidery techniques and symbols traveled from China through the Middle East and eventually on to **Western Europe.** In addition, some needlework styles originating in the Islamic world spread to the **Indian Subcontinent, Southeast Asia,** and north **Africa.**

The textile arts have played an important part in Middle Eastern culture since antiquity and were held in high esteem, with traditions changing relatively little over time. Embroidery has a long history in Mesopotamia (Iraq and Iran) and Egypt, being mentioned before painting in the Bible. The roots of embroidery in Western Europe, **Eastern Europe,** and consequently **North** and **South America** largely began with Islamic styles, particularly from Morocco (Africa), Sicily (Italy), and Ottoman Turkey. Babylon was the prominent center of embroidery for more than a thousand years when the Byzantines took power. With the decline of the Byzantine Empire, fine embroiderers fled to Ravenna, Italy. From Ravenna their work spread throughout Western Europe and into the **British Isles.** European embroidery received additional Middle Eastern inspiration beginning in the twelfth century when crusaders brought back textiles and other items.

Before printed pattern books were available, embroidery designs were shared through **samplers,** many traveling from the Middle East and north Africa through Europe. In the Middle East, embroidery and other needlework techniques are generally worked by women for their own purposes and by men for court use.

For the most part, embroidery was the predominant needlework tradition in the Middle East, although other needle arts were practiced. Extant examples of **knitting** and **sprang** were found in Syria. **Fringes** and **macramé** have been in popular use for thousands of years, appearing in Mesopotamian (Iran and Iraq) stone carvings from the eighth century B.C.E. Judaic embroidery and **appliqué** began in the Levant (Israel and Palestine) and traveled throughout the world with the Jewish Diaspora.

The most common Middle Eastern embroidery stitches and techniques are **cross-stitch, satin stitch, chain stitch, couching, buttonhole stitch** eyelets, **drawnwork,** and **needleweaving.** Because of the influence of Islam, Middle Eastern embroideries generally do not include human or animal forms, instead concentrating on geometric, curvilinear, and stylized floral motifs. Embroideries are usually worked in silk and **metallic thread** on linen or cotton, with felted wool used for animal trappings. The most common background colors are black and white, often embroidered with red or gold stitching. Today, Middle Eastern embroidery is also done commercially for local sale or export.

The most popular embroidered items are women's blouses, dresses, and other clothing items. Middle Eastern men's costume was not generally embroidered except for court dress, done by professionals in Turkey and Syria. The finest embroidery work was done for weddings. Throughout the Middle East, especially in Jordan, Israel, Palestine, Syria, and Sinai, brides wear almost identically shaped dresses in black with red cross-stitching. On first glance they appear similar, but there are significant differences in motifs and placement, which identify a woman's region.

Still worn in some areas of the Middle East, intricately embroidered dresses are often referred to under the broad heading of "Palestinian embroidery." Using mainly cross-stitch, Palestinian women identify with their cultural roots by cre-

Drawnwork creates a see-through mesh on a blue burka from the Middle East, twentieth century. KSUM, gift of Estate of Sabra Beaumont, 1994.4.6.

ating embroidered dresses for ceremonial occasions. The finest of these dresses were made in the late nineteenth and early twentieth centuries. As a girl approached marriageable age, she began embroidering her wedding dress and bridal trousseau, which included another three to eight dresses. The intense embroidery could take up to a year and was sometimes commissioned from workshops. The long dresses were made of white or dark linen with triangular sleeves.

Palestinian embroidery covers the square chest piece and panels that hang from the waist. The embroidery varies based on region or town, with ancient symbols of hope, prosperity, good health, and protection such as the moon, the cypress tree, the tree of life, and the bird of paradise. Regional variations included red on black, red or rust on white, and metallic thread on purple. A confluence of regional patterns merged with Western European designs with the arrival of the British in the 1920s.

Conflicts in 1948, 1967, and today have resulted in many Palestinian refugees. Often people fled their homes with only the clothing they wore. Panels from old dresses were removed and attached to new ones, but overall, the tradition of embroidering declined significantly. Palestinian embroidery was a cultural tradition that flourished with prosperity. A certain degree of security and leisure time is required to create these intricate cultural treasures. Many contemporary Palestinians are forgoing the traditional embroidered dresses, choosing white Western-style wedding gowns instead.

In the 1950s, collectors and museums in the United States and England came to recognize the cultural value of Palestinian embroidery. It is through their efforts that, despite the tumultuous history of the Middle East, we are able to see significant cultural needlework traditions. One tradition that has expanded in the last century is Judaic needlework, which became popular in America in the late 1970s. Combining ancient motifs with modern art, Jewish women make beautiful ceremonial pieces for worship at home and with the community.

FURTHER READING

Aber, Ita. (1979). *The Art of Judaic Needlework*. New York: Charles Scribner's Sons.

Gillow, John, & Bryan Sentance. (1999). *World Textiles: A Visual Guide to Traditional Techniques*. Boston: Little, Brown.

Gotstelow, Mary. (1977). *The Complete International Book of Embroidery*. New York: Simon and Schuster.

Harris, Jennifer. (1999). *5000 Years of Textiles*. London: British Museum Press.

Historic Needlework Resources. Middle East. Online: http://medieval.webcon.net.au/loc_middle_east.html.

Hussein Fakhri El-Khalidi, Laila. (1999). *Art of Palestinian Embroidery*. London: Saqi Books.

Munayyer, Hanan Karaman, and Farah Munayyer. (March/April 1997). New Images, Old Patterns: A Historical Glimpse. *Saudi Aramco World*, pp. 2–11. Online: http://www.saudiaramcoworld.com/issue/199702/these.stitches.speak.htm.

O'Neal, Denise. (July 2005). "Threads of Tradition" An Exhibition of Palestinian Bridal and Folk Dress at Antiochian Village. *Heritage* 11(2). Online: http://www.palestineheritage.org/Newsletter_July%202005.htm.

Mirrorwork

A type of **embroidery** that incorporates mirrors or other reflective material. Mirrorwork is an important cultural tradition on the clothing and textiles of nomads, peasants, elites, and merchants throughout the **Middle East** and the **Indian Subcontinent.** Mirrors on clothing and textiles are used as a spiritual talisman to avert the evil eye. Water is scarce in these arid desert areas, and the evil eye is thought to bring bad luck and a lack of water. Called *shisha* by Hindus and *alba* by Muslims, mirrors represent light on water. They are thought to control the evil eye by trapping it, reflecting it, or making it blink.

Mirrorwork embellishes the folk textiles of desert peoples who share a common cultural heritage that transcends national boundaries. They decorate textiles and clothing using different embroidery stitches and mirrors, bright colors and strong patterns that communicate individual and group identity. Certain colors are connected to life events: red means youth and fertility; yellow, birth and spring; indigo blue, love and longing; gray, black, and dark violet, mourning; and white, the spirituality of old age and the afterlife.

Mirrorwork is thought to have originated in India during the reign of the Mughal emperor, Shah Jehan, who built the Taj Mahal for his wife, Mumtaz Muhal. Originally, mica from the Sind desert or beetle wings were used as the reflective material. As time progressed, glass replaced mica. Large sheets of mirrored glass were shattered into hand-sized pieces. The pieces were then cut with scissors into small, square, circular, or triangular shapes. Hand cutting resulted in uneven sizes and rough edges, which were covered by stitching. The hand-cut glass was bubbly and had a faint blue tinge. This type of glass is still available, but it is more expensive and far more fragile than the machine-cut glass that is mass produced today. The machine-cut glass is thicker and smoother and less likely to break.

Shisha work was generally done on closely woven cotton or wool, depending upon the region and the type of materials available. Mirrors are applied to the ground fabric using diagonally placed straight stitches to hold the mirror in place, since it has no holes. The foundation stitches are then pulled to the edges of the mirror with a **buttonhole stitch,** creating a ring around the mirror. Mirror embroidery is often accompanied by various combinations of **satin stitch,** buttonhole stitch, and **cross-stitches** such as herringbone and cretan.

Traditional textiles such as marriage costumes, wall hangings, quilts, cradle cloths, and animal trappings are embroidered, appliquéd, and decorated with **beadwork,** mirrors, sequins, buttons, beetle wings, and **shells.** Patterns using shisha include motifs with stylized local flowers, birds, and animals in white, red, orange, blue, and green thread. Mirrors are often used to represent the centers

of flowers and the eyes of animals. They are placed as a strategic focal point of a design, which reinforces their protective value.

Designs are passed on unchanged from generation to generation. Specific colors, stitches, motifs, and shapes visually announce the wearer's cultural identity. Islamic mirrorwork uses geometric and highly abstract patterns. These patterns are often mixed with floral designs that resemble Islamic gardens. Mirrors are combined with *phulkari,* embroidered with round **chain stitches** and **couching** in circles and spirals. They are also used to represent ears and other body parts on gods and goddesses. In various forms, shisha are used to bring luck, prosperity, and fertility to the owner or wearer.

In many areas of the Indian Subcontinent, mirrors embellish the richly embroidered textiles of a bride's dowry, usually with a predominance of red. Traditionally, family members began work on these treasures on the day a girl was born. As she grew, she joined in the effort. These elaborately appliquéd and embroidered pieces were carried to her new in-laws wrapped in a large *chakla,* or wall hanging. Wedding blouses or *cholis,* skirts, tunics, and trousers are generally embroidered by professionals with mirrors in symbols of fertility and good luck. The strongest traditions for mirrorwork are found in the Indian states of Gujarat

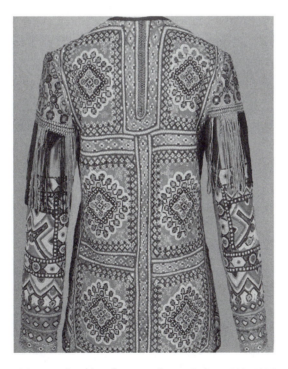

Mirrorwork jacket from northwest India, 1900–1925. KSUM, Silverman/Rodgers Collection, 1983.1.943.

and Rajasthan and the adjoining province of Sind in Pakistan, where women wear embellished clothing not only for weddings and festivals, but as part of their daily costume. Their most important garment is the *odhani,* a large rectangular scarf worn as a veil. The odhani protects the head and back and, if necessary or desired, the face. It is often richly decorated with mirrors.

Apart from the northwest area of the Indian Subcontinent, mirrorwork is found in a number of other locations, traveling by trade and migration. For example, men's smocks and women's dresses from central Afghanistan are decorated with mirrors, **whitework,** and couched metal threads. The Melayu people of eastern Sumatra in **Southeast Asia** also use mirror **embellishment.** In many areas of the Middle East and the Indian Subcontinent, today's textiles come from industrial mills, but the embellishment is done by hand during leisure time. Reflecting the spiritual richness of community, mirrored textiles are valuable objects used in marriage, trade negotiations, and social settings.

FURTHER READING

Classic Stitches. Mirrorwork. Online: www.classicstitches.com/know_how.cfm.

Coss, Melinda. (1996). Mirror, Mirror. *Handmade* 12(3), 64–69. Online: http://hsc.csu.edu.au/textiles_design/shisha.htm.

Gillow, John, & Bryan Sentance. (1999). *World Textiles: A Visual Guide to Traditional Techniques.* Boston: Little, Brown.

Gotstelow, Mary. (1977). *The Complete International Book of Embroidery.* New York: Simon and Schuster.

Hatanaka, Kokyo. (1996). *Textile Arts of India.* San Francisco: Chronicle Books.

Icke-Schwalbe, Lydia. (July 2–4, 2001). The Art of Craft for Social and Cultural Identity in Ethnic Groups of India. Presented to the International Committee for Museums and Collections of Ethnography. Online: http://icom.museum/icme.

Indian Embroidery. Mirror Embroidery. Online: www.Indian-embroidery.info/mirror embroidery.htm.

Indian Embroidery. Shisha Stitch. Online: www.Indian-embroider.info/shishastitch.htm.

Surgillies. Mirrorwork. Online: www.surgillies.com.au/research.

Needle

A cylindrical-shaped implement with a point, eye, or hook at the end used to create fabrics or pass threads through fabrics. The first needles, known as awls or bodkins, were solid and used to punch holes through skins, through which sinews or threads were passed. Needles can be made from a variety of materials such as stone, bone, ivory, antler, wood, bamboo, plastic, steel, or any other

material that retains a rod-like shape. Needles are used for multiple purposes such as compasses and hypodermic syringes; those used in needlework include sewing needles, **embroidery** or tapestry needles, **knitting** needles, **crochet** hooks, and **tambour** hooks.

The oldest known evidence of needles with eyes was discovered by a group of American and Russian researchers at an archeological site south of Moscow. These 30,000-year-old small, pointed ivory sticks had eyelets that were gouged out and drilled. The needles were found with the remains of foxes and hares and demonstrate the importance of the needle in creating clothing. Well-insulated clothing enabled bands of early humans to survive as they migrated to increasingly frigid climates. Some archeologists believe that the invention of the needle has been underrecognized for its importance in the development of civilization.

Needles found from the Upper Paleolithic period (23,000–6,000 B.C.E.) either have the eye at one end or in the middle. In addition to the discovery of actual needles, artifacts in cave burials reveal the use of needles in creating and embellishing clothing. Quantities of shell and tooth beads provide evidence of bracelets, necklaces, headwear, and decorated clothing. **Netting,** which is usually done with a needle or shuttle, was practiced in **Scandinavia,** the **British Isles,** and Western European areas since the Mesolithic period (6,000–4,000 B.C.E.).

Bone needles and seed beads on fabric have been found among the ruins of the lake dwellings in Switzerland and caves in France and England dating to the Bronze Age. For example, ivory needles 21,000 years old were found in the French site of Jouclas, and a small scrap from Murten, Switzerland, ca. 3000 B.C.E., is embellished with seeds sewn on with a thread that pierces the base cloth and, therefore, has been sewn on by a needle. The first sewing needles were probably made of fishbones and thorns.

With the onset of the Bronze Age (2000–800 B.C.E.) came the metal needle. Bronze needles created of wire-line strands fused together at all but one point to serve as an eye have been found from this period. Ancient civilizations of the **Middle East** and north **Africa** including the Mesopotamians, Phrygians, and Egyptians all had well-developed needles that reflected the development level of their civilizations. Steel needles were used in China several centuries B.C.E., and by the time of the Roman Empire, peoples of the **Indian Subcontinent** and **Western Asia** were wearing garments sewn with needles. A Chinese tradition is the fête of the Milky Way. Each year, on the morning of August 25, girls drop a needle into water-filled bowls and tell their fortunes from the reflected shadow.

The origin of metal needles was closely tied to the history of technology. Bronze needles were followed by iron, and then steel, which is commonly used today. The technology to make steel needles spread from China into the Middle East. The Moors (Morocco) brought needle-making techniques to Spain, and the Spanish shared steel needles with the rest of **Western Europe.** There is evidence of established usage of the steel needle in Nuremberg, Germany, as early as

1370. Steel needles were introduced into England during the time of Queen Elizabeth I, in about 1560. At that time, steel needles were known as Spanish needles. Steel was a significant improvement over other materials in terms of strength and sharpness of point. The development of the steel needle led to growth and expansion of the practice of embroidery, especially **crewelwork**.

The method of producing steel needles was kept secret and was consequently lost and regained several times. It has been said that Mary I of England used steel wire needles made by a Spanish man of African descent who kept the secret during his lifetime. Afterwards, Elias Krause, a German, provided steel needles to English aristocracy. The great secret was lost after Krause's death and recovered again about 100 years later when Christopher Greening started the English manufacture of needles in 1650. Adoption of the technology of the steel needle was rapid, and in 1656 Oliver Cromwell incorporated the "Company of Needlemakers," an artisan guild.

The British dominated the world production of steel hand-sewing needles into the twentieth century, especially in the area now known as Redditch in Worstershire. Needles had been made in the area since Roman times, especially by the Cistercian monks at the abbey of Bordsley. After the dissolution of the abbey, the needlemakers scattered into the surrounding villages, and by the nineteenth century, trade was concentrated in Redditch.

Needlemaking involves using steel wire that is polished and pointed on a grindstone. The quality of English needles was well known in **North America**. For example, an invoice reveals that the settlers in early Virginia specifically asked for Whitechapel needles when ordering goods from England. Manufacturing technology from the nineteenth-century Industrial Revolution made it possible to have a specific type of needle for almost every purpose. As an industry, needlemaking was generally centered in England, and it did not take hold in American manufacturers until the 1890s. Needlemaking today is done in factories in England and all over the world. For the most part, machines have supplanted handwork in needle manufacturing.

Large quantities of needles were also manufactured in Western Europe including in the French town of Aix-la-Chapelle. The United States has been more involved in manufacturing needles for sewing machines than for hand sewing. In 1755, a British patent was issued to the German Charles Weisenthal for a machine sewing needle, although the sewing machine as we know it did not exist until it was patented by the American Elias Howe in 1846.

There are many different types of needles. Sewing needles have a point at one end and an eye at the other and are used to pass threads through fabrics. The main types of sewing needles used today are known as sharps, crewel, betweens, tapestry, chenille, bodkin, straw, and beading. Sharps are the most common needle used for general sewing. For embellishing existing fabrics, crewel needles are used for surface stitching, betweens for **quilting,** and tapestry needles for **needlepoint.** Thick threads, cords, ribbon, and elastic require a larger tool such

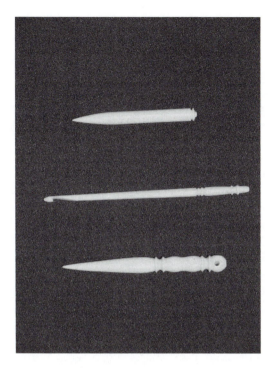

Early twentieth-century ivory knitting needle, crochet hook, and sewing needle. KSUM, gift of Mrs. William (Lillian) Smyser, 1989.51.9–11.

as chenille needle or bodkin. Sewing machines require special needles, which are categorized by manufacturer and use. Altogether, there are at least 250 varieties of needles available today.

Needles are graded from fine to coarse, with the highest numbers representing the finest needles. In general, the finer the needle, the more skillful the needle-work, although the properties of some materials require needles with larger eyes. Some of the finest needles are the pearl needle and the sablé (grain of sand) bead needles, size 14 and 16. The grain of sand needles were one inch long, silver-eyed, and made of cast steel for mounting the finest old beads. Even finer than the number 16, an almost invisible yet threadable needle is used by professional threaders and bead stringers in the pearl marts of India. These needles are made of brass and are three inches long and minutely hooked on silken thread.

In addition to needles used for sewing, some needles are used to create fabrics through interloping or twining threads. These include knitting needles, with a point at the end, and needles that have a hook, such as those used in crochet. Knitting needles are long slender rods, usually of steel but sometimes of bone, wood, imitation amber, or plastic with a point at the end and no eye. Knitting needles are sometimes known as knitting pins, especially if there is a knob at one

end of the needle. The choice of needle is based on the type of work to be done and personal preference. Knitting needles are categorized by number and range, from very large or "broomstick" needles used to make ponchos and blankets to very fine double-pointed needles used to make hosiery. The finer the knitting needle, the smaller the number.

All knitting needles are not straight. Where straight needles produce flat pieces of knitted fabric, circular needles create fabric that is "in the round." Knitting in the round is especially useful for tubular garments such as sweaters and socks, and this method is commonly used in Scandinavian countries for **Nordic knitting.** Historically, inhabitants of these and other mountainous areas throughout the world used curved needles to hold their knitting close to the body and knit as they walked. Knitting machines use a hooked-end needle and range from coarse to fine. Machine needles were adapted to hand use in the technique of **latch hooking.**

Similar to knitting in creating fabric through interloping threads, crochet is done with a hooked needle. Crochet hooks can be made of any of the same materials as knitting needles, although they must retain a straight shape. Some crochet hooks were made of highly valued materials, such as one that once belonged to the grand duchesses, which was made of mother-of-pearl bound with gold in the collection of the Brooklyn Museum. Crochet hooks can be used in the making of **lace**-like fabrics, either alone or with other tools. For example **hairpin lace** is created on a two-pronged fork with a crochet hook used to manipulate the threads. **Macramé** also can be done with a hook, as can some operations in making **bobbin lace.**

Another hook-type needle is the tambour needle, which is generally made of steel fitted with a handle of ivory or hard wood. Tambour work is usually done on sheer, plain-weave fabric such as lawn or net stretched in a frame. The hook is inserted in the fabric, hooked on the thread, and pulled through, making a chain stitch. Beads and other embellishments such as sequins are often applied with a hook. Some of the finest tambour work today is done in Paris, France, by Lesage for the high-fashion couture houses.

Other types of implements used in needlework that could fall under the category of needles are forked needles used by Pacific Island peoples to create netting, the long splinter midrib of the palm used among native Africans, latch hooks, and locker hooks.

FURTHER READING

Araújo, M. Fátima, Luis de Barros, Ana Cristina Teixeira, & Ana Ávila de melo (2004). EDXRF study of Prehistoric artifacts (*sic*) fro Quinta do Almaraz (Cacilhas, Portugal). *Nuclear Instruments and Methods in Physics Research Section B,* 213, 741–747. Online: http://search.epnet.com/login.aspx 12–6-04?.

Barber, E.J.W. (1991). *Prehistoric textiles. The Development of Cloth in the Neolithic and Bronze Ages with Special Reference to the Aegan.* Princeton, NJ: Princeton University Press.

Clabburn, Pamela. (1976). *The Needleworker's Dictionary.* New York: William Morrow.

Dennell, Robin. (1986). Needles and spear-throwers. *Natural History* 95(10), 70–79.

Gotstelow, Mary. (1977). *The Complete International Book of Embroidery.* New York: Simon and Schuster.

O'Brien, Dennis (November 21, 2004). Ancient needles a key to northern migrations. *The Denver Post,* 25A.

Payne, B., G. Winakor, & J. Farrell-Beck. (1992) *The History of Costume.* New York: HarperCollins.

Vanhaeren, Marian, Francesco d'Errico, Isabelle Billy, & Francais Grousset. (2004). Tracing the source of Upper Paleolithic shell beads by strontium isotope dating. *Journal of Archaeological Science* 31 (10), 1481–1489.

Whiting, Gertrude. (1971). *Old-Time Tools and Toys of Needlework.* New York: Dover. (Unabridged and unaltered republication of the work originally published by Columbia University Press, New York, in 1928 under the title *Tools and Toys of Stitchery.*)

Needle Felting

Creating felt sculpture by hand using one or more barbed felting **needles.** Also called "dry felting," needle felting is a fairly recent needlework technique. It is unique in that it originated as a machine-made process and has developed into a hand-needle art. Felt is the oldest textile fabric, dating as far back as 6300 B.C.E., and predates weaving and **knitting.** To make felt, unspun wool or other animal fibers are densely matted together with heat, moisture, and agitation.

Wool fibers have scales, and the process of felting causes the rough edges to lock onto each other. Although "wet felting" requires no specific chemicals or equipment, commercial and industrial felting used both. In **Western Europe,** the **British Isles,** and **North America,** mercury nitrate was used in early commercial hat felting. Exposure to mercury vapors over time could lead to dementia. This effect was the origin of the expression, "mad as a hatter." The use of mercury nitrate was outlawed for feltmaking in 1941.

Needle felting, was developed by the felt industry in the late nineteenth century when machines were invented to create large sheets of felt. Thousands of steel needles were used together to tangle unspun wool into a fabric. Needle felting creates felt without chemicals or water. The felting needles have small, downward barbs that entangle the wool fibers. The barbs or hooks grab individual fibers and drag them against each other, locking them together and creating felt. These commercial feltmaking machines make the kind of felt found in craft stores and used for automobile air filters. Felt purists do not consider needle felting to be "true felt," but the end result is very much the same. In recent decades, this commercial process has been applied to handwork, gaining popularity among needleworkers and fiber artists.

Hand-needle felting is a form of soft sculpture that allows the crafter to add fine details that are difficult to achieve in wet felting. It was developed in the early 1980s by American artisans who took a tool from the woolen mill industry and used it on a small scale: needle felting by hand. Wool may be used in its natural state or dyed. Sheep's wool is most common, although mohair, alpaca, and even dog fur can be needle felted. The needles are approximately three and a half to four inches long with a very sharp thin end with barbs. The barbs are very small and difficult to see with the naked eye. Most needle-felting needles come in a triangular shape, but there is also a star shape for finer work. Available in a range of sizes, the needles are used singly or grouped together in a hand-held tool.

Felt is made by stabbing or "needling" into the wool in a repetitive motion. The barbs of the needle entangle the natural fibers, creating a permanent bond. The needle must be poked into the wool straight up and down with a light bounce. Needle shafts are thin and will break if any sideways pressure is put on them. Once wool has been felted into place, it should only be manipulated using tweezers or a darning needle. Needle felting should not be practiced by children; the needles are very sharp and can cause injury.

The most common items made with needle felting are three-dimensional bears, dolls, and other figures like dogs, lambs, and Santas. Needle felting is especially popular among toy bear and doll enthusiasts, since felting needles can be used to create details that were difficult to achieve using the wet felting method. For example, in sculpting a doll's face, the needle can be very precise, allowing the felter to attach small amounts of fiber where they are needed.

In recent years, more and more people have been getting involved in needle felting; materials and supplies are becoming more readily available. Needle felting requires little in the way of equipment and materials. Craft supply stores are beginning to stock instruction books, needles, and wool in many colors. There are even special attachments for home sewing machines. These are especially useful for needle felting flat pieces and fiber art. Needle-felted animals and wall pieces are often embellished with beads and crystals.

There are also many small needle-felting businesses that have appeared in recent years. Hand-needle-felted bears, dogs, and Santas are available on the Internet, and needle felting is included in the art instruction at many of the Waldorf Schools. An interesting business can be found among a group of nuns of the St. Placid Priory in the United States. Since 2003, Sister Monika has been creating needle-felted birds with homegrown sheep's wool. She and others sculpt a large variety of birds from the Pacific Northwest including robins, goldfinches, sparrows, quail, tanagers, blue birds, owls, juncos, jays, hummingbirds, cardinals, wrens, and great blue herons. They sell the birds along with wool scarves and other items in their Lacey, Washington, store. Many fiber producers who raise sheep, llama, and alpaca have started adding classes in needle felting, along with supplies. These small farmers often raise their wool organic and chemical free, which appeals to the social responsibility of spinners, weavers, and knitters.

FURTHER READING

The Art of Needle Felting. (March 2004). Online: http://www.cyberfibres.com/2004–03–01/feature.

Detta's Spindle. New Things. Online: http://www.dettasspindle.com.

DIY Network. Felting and Finishing. *Knitty Gritty.* Episode DKNG-103. Online: http://www.diynetwork.com/diy/na_knitting/article/0,2025,DIY_14141_3033593,00.html.

Ellis, Sister Monika, OSB. The Priory Knitters and Spinners. Online: http://www.stplacid.org/sheep.html.

FeltCrafts. Online: http://www.feltcrafts.com/about.htm.

Fenton, Serena. Layers of Meaning. Online: http://layersofmeaning.org/archives/2005_01.html.

Fiberella. Online: http://fiberella.com/html/faq_s.html.

Jirtle, Nancy. (2004). The Art of Needle Felting. Online: http://www.cyberfibres.com/2004–03–01/feature.

Kreuzer, Kim. (December 6, 2004). Online: http://www.teddycentral.com/news.html #felting.

Make Your Own Needle Felted Teddy Bears. Bears and Dolls. Online: http://www.bearsanddolls.net/2006/06/04/make-your-own-needle-felted-teddy-bears/.

Marr Haven Wool Farm. Online: http://www.marrhaven.com/faq.html#FELTING.

Spaulding, Marie. A word about felt, felting, and needle felting. Living Felt. Online: http://www.livingfelt.com/felt.html.

Stratichuk, Janny. Felting. Feature Art & Craft Media. Online: http://www.artsandcraftsnet.ca/app/newsletter/nl0206featmedia1.php.

Wikipedia. Felt. Online: http://en.wikipedia.org/wiki/Felt.

Needle Lace

One of the two main types of handmade **lace,** an openwork fabric made with a **needle** and thread. A relative of **embroidery,** "**needlepoint** lace" uses a single continuous thread and the **buttonhole stitch.** Needle lace is slightly older than **bobbin lace,** more time consuming to make, and usually more expensive. Where bobbin lace was made by middle- and lower-class women, needle lace was largely the creation of upper-class women and generally regarded as the height of lace-making. Using a needle, long chains of stitches are looped and linked up to form net-like patterns, ranging from simple geometric to heavily scrolled motifs. Needle lace is a general term referring to many different types of laces, the earliest of which were *reticella* and *punto in aria.*

The origins of needle lace are found in fifteenth-century **Western Europe.** The first forms were made in Venice, Italy, perhaps inspired by primitive laces and trimmings of the Eastern Roman Empire. The technique quickly spread to Flanders

(Belgium and the Netherlands) and Sicily, especially for ecclesiastical embroideries. To add interest to church textiles and garments, embroiders started cutting out areas of the background fabric and edging them with the buttonhole stitch, a technique known as **cutwork.** As embroiderers became more skilled, cutwork evolved to the point where most of the base fabric was discarded. Needle lace developed into a free-form fabric, similar to the way **crochet** descended from **tambour** work.

The link between embroidery and lace is known as reticella, where a lattice grid of stitches holds the motifs together. Paintings from the mid-fifteenth century show fine cutwork, and reticella was being made by 1482. The reticella technique spread very quickly through Western Europe and the **British Isles** and over time developed into a technique that required no background fabric at all. This was called punto in aria, literally "a stitch in the air." Punto in aria is the earliest form of needle lace and was used to create many of the exquisite ruffs and collars seen in sixteenth-century paintings. The first pattern book for embroidered lace was published in 1523, and books about needle lace were available for the public by the seventeenth century.

The only equipment and materials required for needle lace are a needle, thread, and scissors. The thread was typically white linen or silk, but could be black or other colors. In the late sixteenth century, lacemakers devised a linen and parchment base for their work. The pattern was fastened to a backing fabric, foundation threads couched down along the lines, design motifs filled with rows of buttonhole stitches, motifs joined with short bars, and the finished lace was cut away from the pattern. Complicated figurative needle lace patterns can have as many as one hundred stitches to the inch.

For wealthy Europeans, needle lace was popular for cuffs, ruffs, collars, hand-kerchiefs, and trims throughout the sixteenth and seventeenth century, especially for court costume. Because of its value and restrictions on use, lace was smuggled in coffins and in hollowed-out loaves of bread. Some poor English children were taught lacemaking in an attempt to make them self-supporting. A teacher would hold classes and supervise production in a room of her cottage. The working day began at 6:00 A.M. and ended at 7:00 or 8:00 P.M. The lace dealers made the most money from lace. Lacemakers were forced to purchase their patterns and thread and then sell the finished pieces back to the dealer.

Bobbin lace was faster to make than needle lace, and therefore less expensive. Over time, it gradually took the place of needle lace, and by the early eighteenth century, needle lacemaking had all but died out. This was partly due to a change in fashion. Needle lace tended to be rather stiff, and fashion demanded a soft, draped look, which was better achieved with bobbin lace. By 1764, background net could be made on a **machine,** which negatively affected all lacemaking. Furthermore, during the French Revolution many lacemakers went to the guillotine because of their connections with the aristocrats. The net-making machine was followed by machines that could make good reproductions of almost any type of lace.

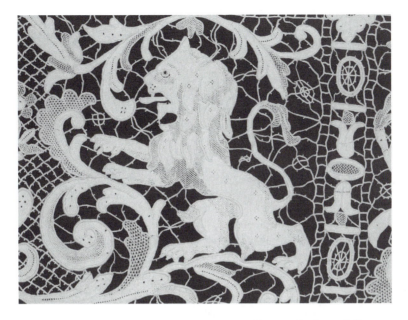

Needle lace table runner, 1875–1899. KSUM, Silverman/Rodgers Collection, 1983.1.1476.

Hand lacemaking had a brief revival among royalty and the newly industrialized rich during the Victorian era. Early designers in the late nineteenth century began to look to the past for inspiration, and lace schools were reopened for training new lacemakers. There were few surviving instruction books, so teachers had to rely on what little written documentation was available, and on experimentation. At the Presentation Convent in Ireland, a nun unpicked some Italian lace in order to learn the technique. She began to teach local women and established a lace school. Irish point quickly became very popular and was patronized by British Royalty during the nineteenth century lace revival.

Rosepoint lace is considered to be the most delicate and precious of all needle laces. The design usually represents a rose or other flower. A fine medallion takes three days to complete, and larger pieces are created by sewing medallions together. A veil made for Queen Elizabeth I of England required twelve thousand hours of work and twelve million stitches. The needle lace technique was also used to cover small elements in **stumpwork,** especially dresses and draperies. It is also used on the neck decoration of the Hausa robes of Nigeria in **Africa.** In the **Eastern Mediterranean,** Armenian needlelace is also known as *bebilla,* Nazareth lace, and knotted lace. A descendent of **netting,** Armenian lace decorated a wide range of items from traditional headscarves to lingerie. Lacemaking was part of most Armenian women's lives, and archeological evidence suggests a pre-Christian root for this art form.

For the most part, social, industrial, and economic changes brought an end to hand-needle lace as a commercial product in the early twentieth century. Needle lace is still made in the traditional method throughout the world, but mostly as hobby. Today's needle lace often borrows techniques from different styles to produce laces distinctively different from their original form.

FURTHER READING:

Armenian needlelace. Online: http://en.wikipedia.org/wiki/Armenian_needlelace.
Earnshaw, Pat. (1982). *A Dictionary of Lace.* Bucks, UK: Shire Publications.
History of Lace. Online: http://www.lacemakerslace.oddquine.co.uk/history1.html.
The Lace Guild. Online: http://www.laceguild.demon.co.uk/index.html.
McNaughton, Tomi. (1998). Online: http://www.forumsamerica.com/site/features.
Needlelace. Online: http://www.anyhow5.com/lace_history/needle_lace/index.htm.
Needlelace. Online: http://www.geocities.com/monstonitrus/a_and_s/needlelace/needlelace.
 html.

Needlepoint

A type of counted thread **embroidery** worked on a canvas foundation that is entirely covered by stitches. Needlepoint or canvaswork has ancient origins and has witnessed waves of popularity since the Middle Ages. Needlepoint is a distant relative of **lace** and, throughout history, the word needlepoint has been also been used as a general term to describe a type of **needle lace** made from **buttonhole stitches.**

The more common and contemporary understanding of the term needlepoint is wool yarn stitched on a plain-weave canvas of linen, hemp, or cotton. The regularity of canvas makes it suitable for figurative or abstract designs. Needlepoint can be worked on a frame or in hand with a blunt **needle** that does not pierce the canvas. Because of the thickness of wool yarn and the fact that the entire canvas is covered with stitches, most needlepoint pieces must be blocked and finished before end use. Other materials used for needlepoint canvas include silk, wire, perforated paper, polyester, and plastic.

The basic stitches used in needlepoint are the diagonal tent stitch, sometimes referred to as petit point, and the longer gobelin stitch, also called gros point. Other popular stitches include basketweave or continental stitch, **cross-stitch,** double cross-stitch, eyelet buttonhole stitch, brick stitch, and **satin stitch.** Most of these stitches are done on the diagonal, using the intersections in the canvas weave as a guide.

Another important type of needlepoint is done with vertical stitches and many hues of one color to produce intricate shading effects. It is referred to by several names, the most commonly known of these is Bargello, which is used interchangeably with flame stitch, Florentine stitch, and Irish stitch. In Bargello, vertical stitches of the same height are offset from each other in a process called "stepping." Hungarian point achieves a similar shading effect, but uses shorter stitches offset with longer stitches.

Ancient Egyptians used slanted stitches to sew up their tents, and canvas wall hangings at the Parthenon in Greece were completely covered in stitches. Needlepoint and woven tapestry are often confused, because the finished products are similar in appearance. In the Middle Ages, tapestries became status symbols among the aristocracy. They provided insulation and offered privacy. Kings and nobles brought their tapestries along when traveling from castle to castle and they were often exchanged after battle. These large figurative tapestries were woven on a loom using a cotton or linen warp and wool weft. With the invention of the steel needle in the sixteenth century, tapestry-like pieces began to be created in needlepoint by covering an existing canvas fabric with wool embroidery.

Throughout history, needlepoint was a favorite pastime of royalty, including Mary Queen of Scots and Queen Elizabeth I of the **British Isles.** This aristocratic connection is further reinforced in that the name Bargello is derived from a series of flame stitch patterned chairs found in the Bargello palace in Florence, Italy. As time went on, the technique of needlepoint broadened to other parts of society.

Needlepoint traditions can be found throughout the world including **Western Asia** and **Central Asia.** In China, silk and **metallic threads** worked in tent stitch are used to create bird designs or geometric patterns on fine silk canvas. These pieces are often used to decorate costume and accessories. In Japan, a technique known as *rozashi* employs vertical stitches similar to gobelin, brick, and Bargello stitches on fine silk canvas. It is said that courtesan ladies of the royal courts during the Japanese Edo and Meiji periods used rozashi to create **appliqué** pieces for kimonos, framed pictures, and small accessories. In Afghanistan, needlepoint in silk thread worked in a densely packed brick stitch can be found on traditional costume in lozenge patterns and bright colors. Western European settlers introduced needlepoint to the peoples of **Africa,** and it has become a tradition among the Mende of Sierra Leone.

Needlepoint was an important technique in seventeenth-century **North America** along with **crewelwork** and **quilting.** Because of the primitive nature of life in the American colonies, most needlepoint pieces were utilitarian and included chair covers, wallets, carpets, bell pulls, and other household items. During the eighteenth century, girls attending Boston-area boarding schools created needlepoint pictures and **samplers** designed by their teachers and derived from contemporary prints. There are at least 65 recorded versions of these schoolgirl embroideries, which are known as the "fishing lady" or

Berlinwork-type needlepoint cover on wooden stool. American, 1900–1925. KSUM, Wilkinson-Gould Collection, gift of John Wilkinson, 1987.12.8.

"Boston Common." **Berlin work** was a type of needlepoint done in wool that employed a pre-printed pattern. Berlin work was very popular in the North America from 1820 to 1880. Eventually, it was seen as requiring little skill and fell out of favor.

After Berlin work in the Victorian era, the height of needlepoint's popularity was in the 1970s. American celebrities of the time such as actresses Mary Martin, Mary Tyler Moore, Princess Grace of Monaco, and football player Rosey Grier were featured in the media and books. The American Needlepoint Guild (ANG) was formed in 1970 by a group who created needlepoint kneelers for a church in Birmingham, Alabama. ANG began holding annual conventions in 1972, which continue today. Not restricted to ecclesiastical projects, ANG members also created commemorative pieces such as the UN Peace Rug in 1975 and the State Seal Rug, which was completed in 1977.

Like Berlin work, needlepoint kits in the 1980s, often sold with the center motif already completed along with lower-cost materials such as acrylic yarn and plastic canvas, tarnished needlepoint's reputation. To counter this image, many contemporary needlepointers insist that their pieces represent the highest quality. Today, needlepoint is often done on hand-painted canvas with fine materials such as gold metallic thread and silk floss. Modern needlepoint artists combine traditional diagonal stitches with crewel and other embroidery stitches to add depth and texture, sometimes leaving spaces of uncovered canvas as part of the design.

FURTHER READING

American Needlepoint Guild. Online: www.needlepoint.org.

Art History Club. Online: www.arthistoryclub.com.

Gillow, John, & Bryan Sentance. (1999). *World Textiles: A Visual Guide to Traditional Techniques.* Boston: Little, Brown.

Gotstelow, Mary. (1977). *The Complete International Book of Embroidery.* New York: Simon and Schuster.

Harris, Jennifer. (1999). *5000 Years of Textiles.* London: British Museum Press.

The National NeedleArts Association. Online: www.tnna.org.

Scobey, Joan, & McGrath, Lee Parr. (1972). *Celebrity Needlepoint.* New York: Dial Press.

Needleweaving

A variation of **drawnwork** used to make decorative bands or borders around the edge of linen or cotton cloths. Using a simple darning stitch and contrasting colored threads, complex patterns can be achieved in lattices and crosses. Needleweaving can also be considered a type of counted-thread **embroidery** and is often used in combination with other types of embroidery stitches. The process of needleweaving actually makes the stitching part of the base material itself, reflecting a feeling of harmony. Needleweaving is historically used in ethnic embroidery, with distinctive regional styles found throughout the world. Unlike other types of embroidery, the stitches are all done of the surface and are not visible on the back side. Needleweaving is worked on the fabric floats, in an interesting combination of embroidery, weaving, and darning.

Frequently called Swedish weaving, needleweaving is known by many names including huck weaving, huckery, Swedish huck weaving, huckaback darning, huck embroidery, **needle** darning, and *punto yugoslavo*. It has a long history that dates back several centuries, but experienced its height of popularity before, during, and after World War II. American stitchers created many needleweaving designs in the 1930s and 1940s, especially on a fabric known as "huck toweling." Huck toweling has floats on the top of the fabric that are well suited for this type of stitching, although any even-weave fabric can be used for needleweaving. Dotted Swiss and checked gingham can also be employed, catching the stitches on the dots or squares instead of the raised threads. Unlike other drawn-thread embroideries, needleweaving does not weaken the base fabric, but instead strengthens it by adding stitches.

Needleweaving begins by removing one set of threads, usually the weft (horizontal), although warp threads could also be drawn. Then colored embroidery floss made of wool, cotton, or silk is woven or darned into the remaining threads

with a blunt needle in a **running stitch.** Weaving is done from the middle of the fabric out. Once the end is reached, then the embroiderer starts back at the center and weaves the second half of the yarn to the opposite edge. This is done so the stitching does not distort the weave the fabric. The needle must have an eye that is large enough to easily thread, but not too large to pull floats out of shape. Primarily a type of domestic embroidery, needleweaving commonly decorates hand towels, table linens, placemats, bed linens, and pillows. Because of the stiffness of the base fabric, it is generally not suitable for most garments, but can be used for vests, collars, cuffs, skirts, and aprons.

The strongest cultural traditions for needleweaving can be found in **Scandinavia, Eastern Europe,** and **Western Europe** for domestic textiles, **samplers,** and ceremonial folk clothing. In Czechoslovakia, needleweaving was an important part of a girl's preparation for her wedding. Embroidered bed cloths, linens, and her wedding ensemble formed her dowry, which was presented to the entire village on the wedding day. Decorative and protective motifs were incorporated in these items, reflecting legends passed down through generations of women designed to ward off evil spirits.

In Russia and the Ukraine, stylized floral borders in colored needleweaving embellish folk costume, towels, and shawls. In Germany, Schwalm embroidery is a form of **whitework** that includes surface stitches, **pulled threadwork,** drawnwork, **needle lace,** and needleweaving. Originating in the late eighteenth and early nineteenth century, Schwalm was used to decorate colorful folk costumes with heart motifs, branches, and flowers with borders in needleweaving. In Italy, drawnwork that includes needleweaving is known as *sfiltura.*

Outside of Europe, multicolored needleweaving is done in **South America** including Mexico and Peru; in Morocco, **Africa;** and in the **Middle East.** In the **Eastern Mediterranean,** Greek embroiderers create monochromatic red zigzag and diamond designs. In **Western Asia,** needleweavings in bands of patterns or individual motifs in diamond shapes are stitched in China and Japan. The Hmong women of Cambodia in **Southeast Asia** include needleweaving along with **cross-stitch** in brightly colored embroideries on black fabric. These **embellishments** are used for traditional clothing worn for celebrations of New Year, marriages, and births. On the **Indian Subcontinent,** madras plaid is embellished by drawing threads from the border and needleweaving multicolored abstract patterns.

Contemporary needleworkers use monk's cloth and aida cloth for needleweaving, making blankets, couch throws, baby blankets, pillows, wall hangings, pictures, tote bags, and floor mats along with the standard dish towels and table linens. Traditional patterns are updated with new threads and fibers including rayon floss, **metallic threads,** braids, and narrow satin or silk ribbons. Modern needleweaving often incorporates very small beads; beaded forms are also used to create elaborate jewelry designs. A recent innovation is to use needleweaving on hand-crocheted afghans and other items. The weaving is

Needleweaving, drawnwork, and other techniques on Italian textile fabric, 1650–1750. KSUM, transferred from the Allen Memorial Art Museum, Oberlin College, Oberlin, Ohio. Oberlin-Carnegie Corporation Fund, 1931, 1995.17.767.

done on the front loops of the **crochet** piece. Quilters and other needleworkers have recently rediscovered needleweaving as an interesting complement to other types of needle art.

FURTHER READING

Breneman, Judy Anne Johnson. (2005). Hmong Needlework: Traditions Both Ancient and New. Online: http://www.womenfolk.com/quilting_history/hmong.htm.

Dryad Handicrafts. Needle Weaving Embroidery (No. 79). Online: http://www.cs.arizona.edu/patterns/weaving/monographs/dry_79.pdf.

Heritage Shoppe. (2003). Huck Weaving (pattern darning). Online: http://www.heritageshoppe.com/heritage/designs/woven/huck.html.

Hodges, Gail. (Winter 1981). Huck Weaving; Melba Woodrum's Fancy Toweling. *Bittersweet* IX (2). Online: http://www.needlepointers.com/.

Iverson, Rae. Schwalm Whitework. Online: http://www.kaleidostitch.com/.

Marshall, Sandi. (1999). Swedish Weaving. Online: http://needlepoint.about.com/cs/projects/a/swedishweaving.htm.

Schwall, Katherine L. (February 19, 2001). Century Chest Project: Needlework History 1940–1970. The Embroiderers' Guild of America Rocky Mountain Region. Online: http://rocky_mtn_embroidery.tripod.com/.

Simon, Sally. (Spring 1982). Pattern Darning. *Needle Pointers* X(1). Online: http://www.needlepoint.org/Archives/00–02/darning.php.

Netting

A fabric structure with a degree of elasticity, created by linking, **knotting,** or looping each successive row to the previous one. Depending on the materials and fineness of work, netting can be used to create a variety of forms from coarse utilitarian nets to intricate **lace**-like pieces. Ancient peoples made nets for fishing and to snare animals. The earliest extant piece of netting was found in Egypt and dated to around 3500 B.C.E. It differs from **sprang** in that netting is created by looping, and sprang is created by twisting threads. There are two main forms of netting, plain netting and embroidered netting. **Embroidery** on netting is also known as filet lace.

There is evidence of netting in many ancient cultures. The robes of Egyptian kings were ornamented by a net of colored silk thread or beads as early as 2100 B.C.E. Archeologists discovered a woolen women's blouse with netted trim at the neckline in Denmark, which dates to about the same time. The use of pre-Christian symbols in Armenian netting suggests sophistication in technique before the year 0. In **South America,** pre-Columbian Peruvians created lace-like knotted netting in the Chancay period, 1100–1350 C.E. In the **Middle East,** silk net embroidered in **metallic threads** was made in Persia (now Iraq and Iran).

Netting is usually made with a netting shuttle, which is different than a **tatting** shuttle, and a spacer bar or stick. The shuttle, also known as a **needle,** holds the length of thread so it can be worked without tangling. The spacer bar, also known as a gauge, controls the size of the mesh and keeps it consistent. A flat, double-ended shuttle similar to fishermen's netting sticks, but with a slight extension at either end, was said to be the ancestor to the tatting shuttle. To begin netting, a horizontal thread or cord is attached to a frame. The yarn wound on the shuttle is then passed around the foundation cord in a series of loops. Once the end is reached, the yarn is worked in the opposite direction, building on the previous row. Fishing nets include knots, rather than only loops, to make for a stronger net.

Netted textiles have been used for many purposes throughout history including animal traps, snowshoe and lacrosse stick laces, hammocks, carrying bags,

and hairnets. In archeological finds, pottery vessels and shards show impressions of net on the surface, indicating that they were carried within a netted bag or molded in a form of network. Creating a flexible net to hold a stiff object is also seen glass fishing floats. Beginning in mid-nineteenth-century **Scandinavia,** Norwegians used glass floats to support their nets. This method of giving buoyancy to fishing nets was adopted by other peoples, and around 1910, the Japanese began making glass floats to accommodate different fishing styles and nets.

When netting is worked tightly, it can be used to make strong, flexible bags. These carrying bags, found all over the world, are often multicolored and carried on rural people's backs and shoulders. Netted hairnets have been found in archaeological digs and gravesites from the thirteenth century onwards in **Western Europe** and the **British Isles,** specifically Germany and England. The hairnet is often seen in illuminated manuscripts, accompanied by the wimple or barbette, neck coverings that symbolized a "good" woman. Hairnets from the Middle Ages were made from silk, worked as a square or in the round, and called nets or cauls. In the twentieth century, specifically in the World War II period, hairnets were called "snoods." This word originated from a type of hair ribbon, rather than the net itself.

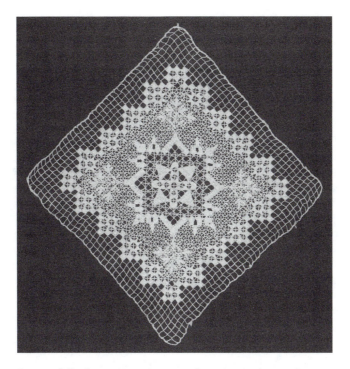

Square of filet lace netting. American, late nineteenth to early twentieth century. KSUM, gift of Mrs. Kenyon (Louise) Stevenson, 1990.18.36.

There are many variations on the basic construction of net. The density and strength of a looped or netted structure may be greatly reinforced by linking several rows together at the same time, introducing extra horizontal elements. Three important variations are fillet/filet lace, Armenian lace, and bead netting. Filet begins with a mesh or net made of fishermen's knots. Once the mesh is made, a solid design is created by crossing small **running stitches.** The finished appearance is most striking when done in **whitework.** Filet lace is also known as "embroidery on knotted net" or *lacis.*

Armenian **needle lace** is also known as *bebilla,* Nazareth lace, and knotted lace. It is a form of needle lace made by tying knots to create patterns. Similar techniques are used in other parts of the **Eastern Mediterranean,** Middle East, and **Africa** including Turkey, Cyprus, Palestine, and Algeria, but it is most often called Armenian lace. This type of lace is made by women of all classes and used as a decorative element on traditional headscarves and lingerie. Bead netting can be traced back to Ancient Egypt during the New Kingdom, 664–525 B.C.E., and can be found in most cultures around the world. It was used as an embellishment on ecclesiastical clothing as early as 1100 C.E. Some of the most exquisite bead netting was created during the Victorian period, often employing pearls and jet beads. Bead netting was a popular embellishment on fabric purses in the British Isles, Western Europe, and **North America** from 1850 through the early 1900s.

American netted purse, 1910. KSUM, gift of Dr. William E. Wakeley, 1989.91.2.

There are many cultural traditions that include netting. Some of the most notable are found in South America, the Pacific, and among Native North Americans. In what is now Mexico, netted bags were used by the Mayan people to transport corn and other products; sometimes horses were equipped with cargo nets on their backs. In New Guinea, women carry a netted bag made from cotton and wild orchid fibers, known as a *billum*. Billums are used for transporting vegetables, piglets, or babies, with the weight borne by straps worn on the forehead. Native Americans used nets made from wool, hair, hide, sinew, intestines, roots, stems, bark, and leaves twisted, twined, and braided. These nets were primarily used for fishing and carrying objects.

Until the mid-nineteenth century, fishing nets were made at home from linen or hemp. Netting was a cottage industry in the British Isles, where skilled men and women made nets over the winter months. In 1812, the first Scottish net-making machine was invented, and factory-made cotton nets were available beginning in the 1860s. After World War II, natural fiber nets were replaced by synthetic twine, which was stronger and more durable. Plastic rope and twine is used by contemporary net makers in Guatemala, but some indigenous people continue to create bags and hammocks of natural fibers.

FURTHER READING

Bead Netting History. Online: http://www.beadwrangler.com/samplers/netting1/bead_netting_history.htm.

Carroll-Clark, Susan. (1998). Netting for Hairnets. Online: http://members.tripod.com/nicolaa5/articles/hairnet.htm.

De Dillmont, Thérése. (1996). *The Complete Encyclopedia of Needlework* (3rd Ed.). Philadelphia: Running Press. (First published by Dollfus-Mieg Company, France, in 1884.)

Gillow, John, & Bryan Sentance. (1999). *World Textiles: A Visual Guide to Traditional Techniques.* Boston: Little, Brown.

Mallett, Marla. Other Antique Handmade Lace. Marla Mallett Textiles. Online: http://www.marlamallett.com/l-other.htm.

McNaughton. Tomi (1998). Online: http://www.forumsamerica.com/site/features/feature.aspx+rn+41260+Forum+Crafts+ArticleCode+358+V+N.

White James, ed. (1913). Handbook of Indians of Canada. Appendix to the Tenth Report of the Geographic Board of Canada, Ottawa. Online: http://www2.marianopolis.edu/quebechistory/encyclopedia/Indiannetsandnetting.htm.

Nordic Knitting

A general term describing colorful knitted garments in regional styles made in Norway, Sweden, Denmark, Iceland, and Finland. The most common Nordic

knitted items are patterned sweaters, jackets, stockings, and caps, which are well suited for the cold places in which they originate. The distinctive designs and fine craftsmanship of Nordic knits are known and emulated throughout the world. Nordic knitting commonly features motifs and borders inspired by Scandinavian surroundings including stars, moose, reindeer, and snowflakes. Traditionally made garments are further embellished with **embroidery,** felt, and pewter closures.

Although some sources state that Nordic knitting originated with the Vikings, the direct connection is not as clear. The Vikings did bring wool to the region, but they did not bring **knitting.** The Vikings lived in Norway, Denmark, and Sweden, not straying far from home communities until the end of the eighth century. Vikings introduced sheep into Sweden and Iceland during the ninth century, highly valuing them for both wool and meat. They did not shear sheep as we do today, but instead collected wool by plucking the animals or gathering fleece after it was shed naturally. Sheep wool was spun into yarn and woven into clothing and other textiles. The oldest sheep breed in **Scandinavia** is still in existence. After becoming nearly extinct, efforts to preserve the sheep were started in the 1940s and have been successful.

Sheep were in Nordic regions before the year 1000, but knitting, as we know it, was not. The oldest remnants of knitted pieces are socks and stockings. Rather than being created on two **needles,** these garments were made with **single needle knitting,** also known as *nålbinding.* Single needle knitting is an ancient craft that uses a needle and a single thread to form loops with the **buttonhole stitch.** The oldest extant pieces of Western European double needle or "true" knitting were found in thirteenth-century Spanish tombs, and the first written references to knitting come from the early fourteenth century. Once it reached Europe, knitting spread north to Scandinavia and east to Russia throughout the sixteenth and seventeenth centuries. The first knitted garments were imported into the Scandinavian countries in the late sixteenth century. In the seventeenth century, silk stockings, gloves, and shirts were commonly worn by the upper class in Denmark and Sweden. At first the domain of the wealthy, working class people eventually learned to knit, adapting luxury items to garments for common use. Records show that the first knitted sweaters were made in the seventeenth century.

Various types of knitting originated in different parts of Europe, largely due to knitters inventing their own patterns. The earliest Scandinavian patterns were done in stocking stitch with white wool. In the dark and cold of winter, Scandinavian knitters invented many textured patterns using knit and purl stitches. Done in solid-colored wool, these patterns are sometimes called "damask" knitting. Over time, distinctive patterns emerged; used again and again, they came to be associated with particular communities. Scandinavian knitters eventually developed regional specializations, now commonly regarded as "traditional" knitting styles. Stitch patterns were shared and spread along trade routes.

Knitted stocking from Yugoslavia or Macedonia made in the Nordic style, late nineteenth to early twentieth century. KSUM, transferred from the Allen Memorial Art Museum, Oberlin College, Oberlin, Ohio. Gift of Mary L. Matthews, 1944, 1995.17.961ab.

Originally, Nordic sweaters came in solid black and white, because those were the natural colors of the sheep wool. A big change occurred in the decade from 1840–1850. Rather than making textured patterns in solid colors, knitters in central Norway began to create jackets in black and white, done in v-shaped patterns, called "lice." The lice (white-speckled) pattern is known as *setesdal*. The setesdal sweater holds an important position in Norwegian national costume. In addition to creating an interesting pattern, carrying the second color yarn along the back of the work helped make Nordic sweaters warmer. Knitted-in patterns followed next, but they were only done on the upper part of the sweater. This was because Nordic people tucked their sweaters far down into their baggy trousers. These patterned sweaters, known as *selbu,* often featured moose and reindeer designs. Various motifs of animals, stars, and snowflakes were created in a combination of two colors, often a dark color accented with white. Fancier patterns evolved as people combined function with regional identity. In Scandinavia, sweater designs were a symbol that distinguished one community from another.

Knitting with more than one color requires special skills, including carrying the yarn when not in use on the wrong side, joining new colors, and beginning a new color without leaving holes. There are several types of multicolor knitting. Intarsia is a form where blocks of color are knitted at a time and each color is picked up as needed. In **Fair Isle knitting,** each color is used for up to four stitches and the yarn woven along on the wrong side of the piece. Another variation of multicolored knitting is simple vertical or horizontal stripes. Colorful knitted sweaters became part of Scandinavian folk costume in the mid-nineteenth century. People began to wear their Nordic sweaters to social events like church, and young women would knit sweaters for their sweethearts. Their skill and the thoughtfulness of the gift would often result in a proposal of marriage. Natural creativity led to multicolored patterns, at first adding red tones to the black and white, and then expanding to other color combinations.

Today, Nordic knitting is very popular throughout the world, furthered by teachers who have helped renew interest in traditional knitting, presenting old-style patterns and adapting them to modern uses. In Scandinavia and elsewhere, women lovingly make handknit sweaters, socks, and hats for husbands, boyfriends, or grandchildren. The extent of hand knitting in Norway is particularly notable, especially at Easter, where gifts of brightly colored handknit sweaters are proudly worn on Norway's mountain slopes and city streets. Although the Nordic sweaters' strongest association is with Scandinavian folk clothing, in some areas they are considered to be high fashion. Hand knit in combinations of colors, Nordic sweaters can be found in shops in **North America** and the **British Isles** such as on London's Kings Road, New York's Fifth Avenue, and upscale après-ski shops. In some cases, traditional styles have been updated to keep up with fashion. Along with the standard shape, Nordic sweaters are being made in a short dressy style, not only in traditional wool, but also in synthetics and cotton.

FURTHER READING

Borev, Valerie. Surfing the Norwegian Knit. Online: http://www.suite101.com/article.cfm/norwegian_culture/.

Dale of Norway. Online: www.dale.no/.

The History of Knitting. Online: http://knitknitting.com/knittinghistory.htm.

McGregor, Sheila. (2004). *Traditional Scandinavian Knitting*. Mineola, NY: Dover.

Reith, Tracy (2001). Knitting throughout the World: A Brief History. Online: http://www.chatteringmagpie.com/writing/368/knitting-throughout-the-world-a-brief-history.

Viking Pets and Domesticated Animals. Online: http://www.vikinganswerlady.com/vik_pets.shtml.

Wikipedia. History of knitting. Online: http://en.wikipedia.org/wiki/History_of_knitting.

Woolovers Ltd. Nordic Sweater. Online: http://www.woolovers.com/shop/Nordic_sweater.asp.

North America

The area of the world including the United States and Canada. North American needlework falls in two categories: Native American styles and those introduced and developed by settlers, primarily from the **British Isles,** who arrived in the seventeenth century. In the first decades of English and French settlement, there were few resources and little time for needlework. Consequently, most early colonial American stitching was utilitarian. An interesting intersection between needlework and American history is *The Hanging of Absalom,* stitched by Faith Robinson Trumbull soon after the Boston Massacre, around 1770. The **embroidery** with painted details portrays the biblical figure of Absalom as a patriot, his murderer Joab as a British redcoat, and King David as British King George III.

North American needlework is wide-ranging, with most every technique practiced in the region, including **Berlin work, candlewicking, crewelwork, crochet, cross-stitch,** embroidery, **knitting, lace, latch hooking, locker hooking, machine needlework, macramé, needle felting, needlepoint, patchwork, punch needle, quilting, ribbonwork, rug hooking, samplers, stumpwork, tatting,** and **whitework.** Other techniques, such as **drawnwork, pulled threadwork,** and **cutwork,** arrived with Scandinavian immigrants. Characteristically Native American needlework techniques and traditions include **appliqué, beadwork, embellishment,** featherwork, **plaiting and braiding, quillwork, ribbonwork, shells,** and **sprang.**

Native American peoples throughout North America have strong traditions for the embellishment of clothing, textiles, and animal trappings. Needlework was done on skins of buffalo, elk, deer, reindeer, bear, otter, seal, and walrus. Natural decorations included porcupine quills, stones, shells, teeth, **feathers,** and fish skins. Caribou and moose hair were used for embroidery. This natural floss was adopted by Ursuline nuns in Canada as a substitute for silk thread on velvet ecclesiastical vestments and textiles. European traders brought woolen cloth, cotton velvet, glass beads, and ribbons, which were creatively integrated with existing Native American traditions.

Cross-cultural influences are revealed in both material and design. Floral motifs, inspired by French embroideries, became traditions in the Great Lakes region of America and Canada. Calico fabrics introduced by missionaries to the indigenous Hawaiians developed into a unique quilting style. The Salish people of British Columbia learned knitting from Scottish immigrants. At first they knit socks, and then they advanced to heavy sweaters and jackets in natural colors with bold traditional designs.

There are several notable needlework traditions that were practiced by colonial Americans and continued to be important throughout time. These include quilting, embroidered samplers, needlepoint, and crewelwork. The first quilted objects in early America were whole cloth bedcoverings and petticoats. The patchwork quilt is largely an American invention, made possible with printed cotton in the Industrial Revolution. Girls in the American colonies learned embroidery and needlework by working samplers. Most often stitched in silk or wool on linen, samplers included the alphabet, flowers, and religious motifs. Girls also learned needlepoint or canvas work. In the eighteenth century, female students at Boston-area boarding schools worked designs that their teachers derived from contemporary engravings. There are at least 65 recorded versions of "Fishing Lady" or "Boston Common" scenes worked in tent stitch. Berlin work needlepoint became extremely popular along with many other techniques in the Victorian era of the mid-to-late nineteenth century.

Early American settlers brought lace with them, but pillows and bobbins were too bulky to be carried. There is little evidence of lacemaking in the colonial period. The one exception was found in Ipswich, Massachusetts, where a coarse lace was made with bamboo bobbins before 1820. **Tambour** and machine-embroidered net was made in the first half of the nineteenth century. Most lace made in America was lace-like needlework; embroidery, cutwork, crochet, tatting, **netting,** and macramé. Victorian era women made whitework table cloths, bed covers, and doilies. Doilies were named after a French dressmaker, Mr. D'Oyley, who encouraged their use to protect fine upholstery. Doilies were especially important because of the greasy hair oil worn by Victorian men. Doilies on the backs and arms of chairs were called antimacassars, named after Macassar Oil.

Crewelwork was particularly popular in early New England, with English pieces used as inspiration. By the eighteenth century, crewelwork was out of fashion in England, but reinvented flowing tree-of-life designs became an American cultural tradition. North American crewel was lighter in appearance, using hand-dyed wool stitched on homespun linen twill. In an effort to conserve materials, American embroiderers used slightly different stitches than their English counterparts. The one-sided **satin stitch** and Romanian or self-**couching** used thread on the surface, but did not waste it across the back. Most colonial crewel pieces use only three or four different "economy" stitches, varied for outlining and filling in shapes.

American crewelwork is characterized by a freedom and inventiveness, with simple coiling stems, fewer heavy flowers, and more ground fabric showing. Regions developed their own styles, with mounds and prancing animals near the seacoast and blue and white scattered patterns in the Connecticut River Valley. Crewelwork embellished bed hangings, pockets, pocketbooks, petticoat borders, chair seats, and sometimes dresses. The fashion for crewel faded with the American Revolution. Toward the end of the era, "rose blankets" were made.

Using heavy wool yarns, homespun wool blankets were embroidered with bold large-scale designs.

Colonial needlework was revived with the arts and crafts movement in the late nineteenth century. Candice Wheeler, along with Louis Comfort Tiffany, designed and stitched embroideries in wool and silk for the Society of Decorative Arts in New York. A graduate of the New York Academy of Design influenced by Englishmen John Ruskin and William Morris, Margaret Whiting joined with Ellen Miller to create the Deerfield Blue and White Society in 1896.

Whiting and Miller discovered eighteenth-century needlework in the homes and museum in Deerfield, Massachusetts. They began collecting examples and patterns of old crewel embroidery, unpicking some pocket fragments and learning the stitching methods. At first the society copied some of the older pieces, and then they designed and stitched original works in the style of the period until 1925. Rather than working in wool, which was often destroyed by moths, Deerfield blue and white was worked in linen thread on a linen ground.

Crewelwork experienced another revival in the 1960s and 1970s. Embroiderers Mildred Davis and Elsa Williams focused attention on colonial textiles preserved in museum collections. They were joined by Erica Wilson, who used expertise gained at London's Royal School of Needlework coupled with a new freedom. Susan Swan's 1976 book documented the needlework of colonial America, and Betty Ring uncovered the history of samplers and schoolgirl embroidery.

American crazy quilt, late nineteenth century. KSUM, gift of Dr. and Mrs. M. Janning, 1987.102.1.

The American Bicentennial and the back-to-nature movement further propelled the growth of needlework. In a process started by colonial women, American embroiderers were experimental, using bold colors and many different fibers including cotton, linen, silk, **metallic threads,** feathers, jewels, buttons, and beads. The same needlework techniques used by their ancestors were applied to modern aesthetics, making an individual and cultural statement that continues to the present day.

FURTHER READING

Gotstelow, Mary. (1977). *The Complete International Book of Embroidery.* New York: Simon and Schuster.

Harbeson, Georgiana Brown. (1938). *American Needlework.* New York: Bonanza Books.

MacDonald, Anne L. (1988). *No Idle Hands: The Social History of American Knitting.* New York: Ballantine Books.

Phillips, Ruth B. (1998). *Trading Identities: The Souvenir in Native North American Art from the Northeast, 1700–1900.* Seattle & London: University of Washington Press.

Reith, Tracy (2001). Knitting throughout the World: A Brief History. Online: http://www.chatteringmagpie.com/writing/368/knitting-throughout-the-world-a-brief-history.

Richter, Paula Bradstreet. (2001). *Painted with Thread: The Art of American Embroidery.* Salem, MA: Peabody Essex Museum.

Ring, Betty. (1993). *Girlhood Embroidery: American Samplers and Pictorial Needlework 1650–1850.* New York: Alfred A. Knopf.

Swan, Susan Burrows. (1977). *Plain and Fancy: American Women and Their Needlework, 1700–1850.* New York: Rutledge.

Ulrich, Laurel Thatcher (2001). *The Age of Homespun.* New York: Alfred A. Knopf.

Williams, Elsa S. (1967). *Heritage Embroidery.* New York: Van Nostrand Reinhold.

Wilson, Erica. (1962). *Crewel Embroidery.* New York: Charles Scribner's Sons.

Patchwork

An assembly of small pieces of fabric sewn together to create a larger fabric. The small pieces, known as patches, can be random or carefully planned, like puzzle pieces. Patchwork is most often associated with **quilting,** where patches are sewn into "blocks," which are joined to create a quilt top. As an art form, patchwork, also known as piecing, may have developed from the practice of sewing patches to damaged cloth and, in many cultures, is associated with poverty and renunciation of material goods. Over time, patchwork has become an art form, with intricate colored patterns created by stitching small pieces of fabric together.

Patchwork represents religious poverty in several cultures. A prominent example is the *kesa* or *kasaya* which originated in India in the fourth century B.C.E. It arrived in Japan with Buddhism in the sixth century C.E. and became a Western Asian tradition. The patched shawl is a symbol of Buddha, who was often depicted with a patched robe draped over his left shoulder. Worn for worship and ritual, the kesa represented a vow of poverty and served as a symbol of humility. The rectangular kesa is about one yard wide and two and a half times the length of the human body.

As a devotional act, monks cleaned and stitched together discarded fabric in a traditional manner, based on seven vertical columns. The pieces of fabric are sewn from the center, slightly overlapping one another. Patterns are based on rank and position, including the quality and color of the cloth. In some cases, a brocade fabric was cut up, rearranged, and put back together in an artistic manner. Prayers were repeated while the kesa was being sewn, put on, and taken off. The kesa was only cleaned with purified water and incense. In most cases, it was the only personal possession owned by a Buddhist monk.

In late nineteenth-century **Africa,** the Dervish army of Egypt and Sudan wore patched robes that indicated rank and status. Dervishes are an ascetic group of Sufi Muslims, known for their extreme poverty and austerity. The simple, cotton smock with colored patches, or *jibbah,* was the basic uniform worn by soldiers in the years 1885–1886. In Japan, a type of piecing known as *yosegire* began in the seventeenth century as a reaction to sumptuary laws. In 1639, the Japanese military forbade the merchant classes from wearing luxury fabrics. The creative merchants developed a form of patchwork colored with indigo dyeing and printing. Yosegire was used to decorate clothing, hangings, and screens. It influenced quiltmaking in the nineteenth century.

Patchwork quilts have been considered a symbol of a poverty and frugality in **North America,** yet that notion has been challenged in recent years. Although patchwork existed beforehand, patchwork quilts were not known until about 1840 when the Industrial Revolution made fabric readily available. Quilting quickly became a popular form of needlework and folk art in the United States, England, Canada, France, Sweden, and Germany. After quilting became a widespread activity, a myth evolved that romanticized its origins. This notion was further reinforced in the colonial revival of the 1920s and 1930s, with manufacturers and magazines labeling quilts made in the first half of the nineteenth century as "colonial." Although it may be a more recent technique than is commonly thought, there is no doubt that patchwork quilting is an important art form. American patchwork is at the pinnacle, with several thousand quilt block patterns documented and used.

The technique known as "crazy patchwork" did use scraps of silk, velvet, brocade, satin, wool, cotton, and linen to make quilts and other items in an irregular pattern. Beginning in the 1870s, crazy patchwork was inspired by Japanese art and aesthetics. Preferring asymmetry to symmetry, "oriental" designs influenced

Quilt with crazy patchwork. United States, 1885–1887. KSUM, gift of Mildred Needels, 1988.1.8.

home furnishings, clothing, needlework, and other forms of decorative art in North America and the **British Isles.** This was especially true after the American Centennial Exposition of 1876.

The word "crazy" was first used in 1878, with crazy piecing reaching its peak in the late 1880s and continuing into the 1920s. In crazy quilting, irregular shaped pieces are fit together like a jigsaw puzzle on a coarse background. Eventually the entire surface is covered and the places where the pieces join are embroidered with border stitches, mostly variations on the herringbone or **cross-stitch.** At the height of its popularity, pieces from wedding dresses, uniforms, hat bands, ribbons, and other souvenirs made up the collage of crazy quilts. They were often used as friendship quilts and recorded family histories. In a friendship quilt, family members and friends created pieces embroidered with names, dates, and sentiments.

In the Hawaiian Islands of the United States and areas of the Pacific native people create an intricate type of patchwork called *taorei* or handkerchief. Inspired by painted sleeping mats, several thousand tiny diamond or rectangular pieces are sewn together to make the design. The patched pieces are sewn by several different women, usually sisters. Taorei are valuable personal possessions, presented at life-cycle events like significant birthdays, weddings, and funerals, often wrapped around the owner at death.

Another type of distinctive patchwork is the **ribbonwork** done by Native North Americans. In the 1780s, Western European traders introduced

commercially produced silk and satin ribbons, which many tribes began using as a form of **embellishment**. Plains, Plateau, and Woodlands peoples developed an elaborate style with complicated counterchange patterns. These patterns were made in strips, which decorated women's robes and skirts. The finest ribbon-work was done by the Seminole people of Florida. Beginning in the nineteenth century, the Seminoles made intricate patchwork borders with cotton ribbon, building up layers similar to **reverse appliqué.** Seminole patchwork has become an important American folk craft, decorating clothing and blankets, although it has primarily been done by machine since about 1910.

FURTHER READING

Davies, Lady Sarah. Quilt History. Online: http://www.quilthistory.com/quilting.htm.

Fabric land. History of Quilting. Online: http://www.fabriclandwest.com/quilters%20corner/History_quilt.htm.

Gillow, John, & Bryan Sentance. (1999). *World Textiles: A Visual Guide to Traditional Techniques.* Boston: Little, Brown.

Gotstelow, Mary. (1977). *The Complete International Book of Embroidery.* New York: Simon and Schuster.

History of Quilts. Online: http://www.womenfolk.com/historyofquilts/articles.htm.

Lynch, K.C. (July 31, 1996). Butterfly Collection. *Online Daily of the University of Washington.* Online: http://archives.thedaily.washington.edu/1996/073196/butfly.html.

Pillsbury, Betty. The History of Crazy Quilts, Part I. Online: http://www.caron-net.com/featurefiles/featmay.html.

Science Museums of China. Online Tibetan robe, pulu and kasaya: http://www.kepu.net.cn/english/nationalitysw/tibet/200311250089.html.

Plaiting and Braiding

Interweaving three or more strands, strips, or lengths to create a narrow textile with a diagonally overlapping pattern. Plaiting and braiding are synonymous terms. A more precise description of these techniques is oblique interlacing. Using ancient techniques that probably predate weaving, plaiting and braiding can be used to create flat, tubular, solid, and even three-dimensional textiles. They are best used to create narrow fabrics, no more than a few inches wide. The process begins with multiple threads suspended from a foundation. Each strand is carried diagonally to one edge, alternating every other strand. The simple three-strand plait has been universally used to keep women's hair in place. Braiding and plaiting are especially suited for making straps, belts, and bags. A wide variety of patterns can be achieved by introducing colored strands and changing the

direction of interlacing. Braiding and plaiting are interlacing techniques and are different from **sprang, tatting,** and **macramé.** Sprang is done on a frame, tatting uses a shuttle, and macramé involves **knotting.**

Plaiting and braiding are part of cultural traditions throughout the world. For example, in the southwest United States, the Native North American Hopi people use a technique similar to hair braiding to make their "wedding sash." As part of a tradition, the bridegroom's family makes a broad, very long fringed sash that they whiten with clay and give as a present to the bride. The plaited sash is carried by the bride to the wedding ceremony, but she does not wear it. The wedding sash or "rain sash" is only worn by men, as a part of ceremonial dance costume. An elaborate plaiting technique is used by the nomads of **Central Asia,** who interlace braids to make an open netted structure. It is lined and made into bags to carry spoons and animal trappings. A complex and sophisticated braiding technique is Chinese braid **embroidery,** done by the Miao hill tribe of **Western Asia** and **Southeast Asia**. This unique style of embroidery creates silk braids that are couched down on rectangles of cloth.

One of the most notable uses of braiding and plaiting is hairwork. Since ancient times, human hair has been associated with life and death. Tomb paintings show Egyptian pharaohs and queens exchanging hair balls as tokens of enduring love, and in Mexico, native women kept hair combings in a special jar, which

Plaited floss and tassels on the border of a Romanian shawl, 1875–1899. KSUM, in memory of Costea, Rusanda & Roska, Elena, 1993.71.10.

was buried with their bodies. The first commercial hairwork was done in Scandinavian countries around 1800, when poor farm people began to make crafts for much-needed income. Over time, each village developed its own special trade. In one town in Sweden, a village woman taught hair plaiting to friends and relatives. Soon this small town of 1800 had as many as 300 hair workers. Because there was not much of a market in **Scandinavia,** young girls from both Sweden and Norway traveled to **Western Europe.** Carrying samples and equipment, they would arrive in teams of three or four, learn the language, and weave hair jewelry for wealthy clients.

The craft of hairwork spread throughout Europe and the **British Isles,** reaching **North America** by mid-century. In December of 1850, *Godey's Lady's Book* introduced hairwork, making it a drawing room pastime along with **crochet** and tatting. Intricate designs could be created by varying the amount of hair and the plaiting technique. Its popularity was further bolstered by a full line of hair jewelry displayed in the Crystal Palace of the Great Exhibition of Art and Industry held in New York City in 1853. The practice of hairwork was greatly enhanced by Victorian era mourning customs. Existing etiquette surrounding the death of loved ones became fashion when England's Queen Victoria lost her husband in 1861, the same year that Americans began to experience the realities of the American Civil War.

Within this culture of mourning there emerged a custom for the bereaved to give mourning rings to family members and friends as a memorial to the deceased. Jewelry was a souvenir to remember a loved one, a reminder of the inevitability of death, and a status symbol. Mourning joined hairwork when gold rings were made to hold a ringlet of hair enclosed in a locket-type setting. Eventually, the braided hair of the deceased was displayed underneath a flat or beveled glass surrounded by gold. Over time the hair itself was used to make spiral bracelets, brooches, earrings, necklaces, pins, and cuff links and was often the symbol of a close relationship. Queen Victoria presented Empress Eugenie of France with a bracelet of her own hair. Some Civil War soldiers left a lock of hair with their families so it could be included in a piece of mourning jewelry or placed in a locket upon their death. The lockets were gold or black, often engraved with "In Memory of" and the initials or name of the deceased.

Most pieces of jewelry required long pieces of hair, at least six inches or longer, depending on the item to be made. A general rule is that the starting length must be twice as long as the finished product, depending on the braided pattern. The hair was boiled in soda water for 15 minutes, then sorted into lengths and divided into strands of 20–30 hairs. The work was done on a round table with a hole through the center. Most intricate pieces were built on special molds made by local wood turners. The hair was wound on a series of bobbins, like **bobbin lace,** and then worked around the mold or wire. When the design was finished, it was boiled for 15 minutes, dried, and removed from the mold.

Many pieces of hairwork were plaited at home and sent out for mountings and findings to be handmade by a jeweler. Other items were completely made by others.

For example, hairwork watch chains became popular gifts for women to give their new husbands as a wedding gift. The bride-to-be would collect her hair and then have it professionally braided by hair weavers, sometimes called "Hair Spiders." In 1855, *Godey's* advertised a hair-plaiting service, guaranteeing a superior product made of intricate plaits of the customer's hair in fine gold mountings. There was no requirement that the hair originate from a known person. The Victorian interest in artificial ringlets, false plaits, beards, and moustaches, as well as jewelry, made the cost of hair sometimes three times as much as silver. Every spring, hair merchants visited festivals, fairs, and markets throughout France and Germany, offering young girls ribbons, combs, and trinkets in exchange for their hair.

The fashion for mourning jewelry and hairwork was over with the end of the Victorian era and the turn of the twentieth century, but still remembered by enthusiasts and collectors. The Victorian Hairwork Society seeks to promote and provide accurate information about the history, heritage, preservation, restoration, and continuation of all types of hair work. Contemporary fiber artists and Swedish commercial hairworkers continue to craft hair jewelry. They join many others who create textiles with plaiting and braiding.

FURTHER READING

The American Heritage Dictionary of the English Language (2000, Updated in 2003). (4th Ed.). Boston: Houghton Mifflin. Online: http://www.thefreedictionary.com/.

Bell, Jeanenne. Old Jewelry 1840–1950. Victorian Hairwork Jewelry. Online: http://www.heritagehaberdashery.com/specials.html.

Fladeland, Marlys. Victorian Hair Artists Guild. Online: http://www.hairwork.com/tid.htm.

Gillow, John, & Bryan Sentance. (1999). *World Textiles: A Visual Guide to Traditional Techniques.* Boston: Little, Brown.

Gonzalez, Victor. Hairwork Jewelry Worn to Mourn the Dead. Online: http://www.collectingchannel.com/cdsDetArt.asp?CID=24&PID=3661.

Harran, Susan, & Jim Harran. (December 1997). Remembering a Loved One with Mourning Jewelry. *Antique Week.* Online: http://www.hairworksociety.org.

Museum of New Mexico. Hopi Wedding Sash or Rain Sash. Online: http://www.museumeducation.org/pdf/Weaving/INFO.PDF.

Victorian Hair Artists Guild. (2005). Hair Art Techniques. Online: http://www.victorianhairartists.com/HairworkTechniques.html.

Pulled Threadwork

A type of **embroidery** that uses tension to pull apart the warp and weft yarns of a ground fabric and hold them in an open grid-like pattern. Pulled threadwork

changes the structure of the fabric, making it more **lace**-like, with a sharp contrast between light and dark. Pulled thread is an important technique used in **whitework,** where it is often coupled with **drawnwork.** While their finished appearance is similar, pulled threadwork requires a loose weave where threads can be manipulated, and drawnwork requires a firm weave that can tolerate the removal of threads. Pulled threadwork is done on a variety of materials, including raffia cloth in west **Africa** and piña cloth and hemp in the Philippines.

Pulled threadwork has a long history, with strong traditions in **Western Europe, South America, Southeast Asia,** and **Western Asia.** It was said to adorn the linen garments of Cleopatra around 50 B.C.E. and was done in India before 340 C.E. By the thirteenth century, embroiderers in Egypt, the **Middle East,** and Peru were doing pulled threadwork on natural linen with colored silk and **metallic threads.** Pulled-work borders also adorned early German altar cloths. Although not considered to be "true lace," pulled threadwork was often made to imitate lace. In some cases, pulled-work pieces were subject to the same regulations as lace and were smuggled to avoid tariffs.

Pulled threadwork can be done on fine to coarse fabrics. It has adorned the homes and garments of both aristocrats and peasants. Pulled work was generally done on white or beige fabric, although color was also used. Overall, pulled work is most successful in monochrome. When the color of fabric and thread matches exactly, the stitches become completely integrated with the ground material, leaving only the holes to create patterns in negative space.

Pulled work is best done on fabric with an open weave that is loose enough for threads to be manipulated without puckering. Using a blunt **needle** and counting threads straight or diagonally, loose stitches are made at regular intervals. The stitches are then pulled as tightly as possible, creating open spaces in the ground. The thread used for pulled work must be strong, because of the tension it must hold. Threads must also be fine, since the best effects are created when the embroidery is invisible. The most common stitches are **satin stitch,** backstitch, **cross-stitch,** and **buttonhole stitch;** each results in a variety of textures.

Pulled threadwork is often done in linear patterns on domestic linens, running the length of a tablecloth, for example. When compared with drawnwork, pulled-work pieces are more durable, since no threads are removed, yet they are still fragile. The most openly worked fabrics cannot be regularly laundered since the threads are easily displaced. The development of the finest pulled threadwork began with seventeenth-century Italian ecclesiastical linens. Worked in silk on linen, the background was in color and the motif left plain. Early patterns include geometric trees, animals, and figures in dark tones of red, rose, and green.

In eighteenth-century Western Europe, pulled thread became an important technique in its own right. With the intention of imitating lace, intricate pulled threadwork was created in France, Germany, Denmark, Spain, and Great Britain. The combination of increased availability of finely woven fabrics and the prominence of whitework in mid-eighteenth-century European fashion resulted in the development

Nineteenth-century whitework square features pulled threadwork. KSUM, transferred from the Allen Memorial Art Museum, Oberlin College, Oberlin, Ohio. Gift of Mrs. Fred White, 1943, 2006.11.100.

of more complicated pulled-work patterns. Fashionable women and men wore whitework collars, caps, cuffs, handkerchiefs, and aprons. Arguably, the finest pulled work of this period was Dresden work from Germany. Done on nearly transparent muslin, Dresden work combined drawnwork and pulled work to produce a mesh ground that was filled with many different varieties of openwork patterns.

At the same time, European men wore white twill waistcoats that incorporated **quilting,** rich surface embroidery, and pulled thread. These intricate garments were characterized by shading, which was achieved by depth of texture rather than color. Quilting and trapunto quilting were done on two layers and then one of the layers was cut away and worked in pulled thread. Over time, fashion changed. The pulled fillings were replaced by satin stitch and the technique known as *broderie anglaise* in the early nineteenth century.

Traditions in pulled threadwork are not restricted to one country or area and can be found in Eastern Europe, **Scandinavia,** the **Indian Subcontinent,** the **Eastern Mediterranean,** and South America. In many areas, especially Russia and Greece, pulled work forms a bold background on coarse linen, leaving the design plain. In Czechoslovakia, Russia, and the Ukraine, pulled threadwork is often seen on the ends of towels and traditional costumes including skirts, blouses, and aprons enhanced with embroidery and pulled threadwork. The tradition of embellishing folk costume with counted thread and pulled work is also seen in Scandinavian countries. Done in both geometric and figurative designs, motifs cross national barriers throughout

this part of the world. In the Greek Islands, pulled work is used to create geometric patterns of openwork shapes that are highlighted with satin stitch embroidery. In Athens, Greece, there is a tradition for pulled thread on fine white linen panels.

Pulled threadwork can also be found in Asia and the Americas. In Southeast Asia, specifically the Philippines, whitework is done in drawn and pulled-thread techniques. It is combined with **couching** in parts of Western Asia. Spanish and Portuguese settlers brought embroidery techniques to South America, especially Brazil, Uruguay, Argentina, and Chile. These included pulled thread and satin stitch, which became part of the cultural heritage of these regions. In the nineteenth century, Ayreshire work evolved in Scotland. Originally an imitation of Dresden work, Ayreshire became a recognizable style of whitework on its own. Ayreshire was done into the twentieth century and included **cutwork,** pulled threads, drawnwork, and **needleweaving.** It often embellished heirloom items such as christening robes in America and on the **British Isles.**

As with many other fine embroidery techniques, pulled threadwork came to be done in a less time-consuming manner beginning in the late nineteenth and early twentieth centuries. Simpler stitches combined with other embroidery techniques worked on coarse materials took a great deal less time. In the early 1970s, needlework teachers created pulled-work designs in abstract forms that reflected a more "modern" aesthetic. Intricate pulled threadwork is still practiced by enthusiasts, especially those interested in Scandinavian heritage techniques.

FURTHER READING

Farish, Jean R. (2003). Pulled Thread Stitches. Online: http://www.jeanfarish.com/cross_ stitch/primer/pulled_thread_info.htm.

Fitzgerald, Pat. (March 1992). The Fabrics of Pulled Thread Embroidery. *Needle Arts* (1). Online: http://egausa.org.

McNeill, Moyra. (1971). *Pulled Thread Embroidery.* New York: Taplinger.

Schwall, Katherine L. (February 19, 2001). Century Chest Project: Needlework History 1940–1970. The Embroiderers' Guild of America Rocky Mountain Region. Online: http://rocky_mtn_embroidery.tripod.com/.

St. George, Aldith Angharad. (Summer 2000). Whitework. Filum Aureum. The West Kingdom Needleworkers Guild. Online: http://www.bayrose.org/wkneedle/Articles/Whitework. html.

Punch Needle

A form of **embroidery** worked with a special tool called a punch **needle** that creates loops on the fabric. Punch needle is sometimes called thread painting,

since it can be used to create very complex scenes that resemble oil paintings. A wide variety of textures can be achieved with a simple stitch and various threads, yarns, and ribbons. The actual technique of punch needle is closely related to **rug hooking,** but the fineness of its appearance and wall display of finished pieces is more appropriately described as "embroidery." The punch needle technique uses a continuous piece of yarn that is inserted through a fabric with a hollow tube-shaped needle that leaves tufted loops on the top of the fabric. Punch needle embroidery results in intricate, durable images in pile.

Punch needle embroidery is known by several names including punch, punch embroidery, Russian embroidery, and *bunka*. The terms are not universally interchangeable, but they use the same tool, a punch needle. Overall, punch or Russian embroidery is the broader category title, encompassing the use of different types of materials and variable loop lengths. Bunka is the name for the Japanese variation of embroidery using a punch needle.

Although most commonly associated with Russia, punch needle embroidery was first used by ancient Egyptians who used the hollow bones of birds' wings as needles. By the Middle Ages, it was being used throughout **Eastern** and **Western Europe** to decorate ecclesiastical clothing and panels. During the reign of Peter the Great in the seventeenth century, the Russian Orthodox Church adopted a new leadership and reforms, including changes in the worship rituals. A group known as the Old Believers opposed these modernizations and split from the church. They were severely persecuted and established their own reclusive culture. Within this culture, punch needle embroidery developed into an art form. At first, the Old Believers used a needle that was only as thick as one strand of thread and made from a bird's bone. As time went on, steel needles were used. The Old Believers embroidered intricate embellishments for their clothing and passed their art through many generations. Some believe the Japanese bunka had its origins in Russian embroidery.

Most punch embroidery is worked on the back side of the fabric, so the embroiderer sees **running stitches** as they progress, with the pile created on the other side. Almost any thread or yarn can be used, as long as it will slide easily through the punch needle. The needle is a hollow shaft with an eye on the sharp pointed end. A threader is used to put the yarn through the eye, and then through the remainder of the shaft. The fabric must be held taught in a hoop and the needle held perpendicular to the fabric. The embroiderer barely lifts the needle off the fabric as the loops are created.

There are several sizes of punch needles, which can often be adjusted to make the loops different heights. The punched technique results in secure loops, without any knots that can be cut and sculpted for dimensionality and texture. Although many different yarns, threads, and ribbons can be used, the foundation fabric must be stable enough to hold the loop. The most appropriate fabrics are fairly loose weaves in linen, including damask. Needle punching can be done on heavy denim or knit fabric, although it is not as successful.

The specialized Japanese punch needle technique is known as *bunka shishu,* although the term bunka is most commonly used in the **North America.** First done in silk, bunka has come to be associated with unraveled rayon yarn worked on the top side of the design. It was first done in Japan during the early nineteenth century and was introduced to America after World War II. Legend has it that after the war, an American serviceman brought home his Japanese wife and, with her, the bunka technique. Bunka designs often include landscapes and utilize subtle shading that closely resembles painting. The rayon thread and punch needle can be used to blend colors, textures, and stitches to create depth.

Bunka kits are available from designers in Japan and Canada. The Canadian kits often include more techniques than the more traditional Japanese designs. These kits are somewhat like paint-by-numbers kits. Different size needles are used to punch various colors of thread into a numbered picture on fabric. Various stitching techniques are incorporated to give the special effects in patterns of flowers, animals, landscapes, folk art, Asian motifs, and children's designs. The height of skill in bunka can include as many as 20 different stitches, and kits are generally for the novice. Formal lessons with a trained teacher are needed to master the fine art of bunka. The American Bunka Embroidery Association promotes the art of bunka punch embroidery in the United States. One of the association's outreach efforts is to provide a list of teachers and classes for embroiderers who want to increase their skills.

A technique related to punch needle embroidery is a type of **whitework** done in Turkey. Known as *astragan ignesi* or candlewick, it uses a needle and a wooden handled hook to create tufts and raised motifs. The finished product resembles **candlewicking,** but astragan ignesi not only uses a hook rather than a straight needle, but also employs thick twisted silk, cotton, or wool yarn, rather than fluffy cotton. Like Russian embroidery, astragan ignesi is embroidered from the back side of the fabric with tufts created on the reverse. In general, this technique was used for domestic embroidery, although there is evidence that it was also taught in technical classes at educational institutions. In many areas of Turkey, bridal chests are filled with whitework bedspreads, covers, curtains, panels, and cushions, sometimes featuring traditional motifs such as two wings and a crown.

After gaining a reputation for amateurish projects using low-quality materials during the 1960s and 1970s, punched needle embroidery is gaining attention from fine needleworkers and fiber artists. It has experienced a resurgence in popularity, and new technology has aided in its expansion. Designs can be applied directly to cloth using a computer printer, and areas can be enhanced with needle punching. In recent years, punched needle embroidery has also been incorporated into crazy **quilting** and blended with other types of embroidery, especially silk **ribbonwork.**

FURTHER READING

Albers, Anni, & Lynn Heller. Return of Punch Needle Embroidery. Online: http://layersofmeaning.org/wp/?p=195.

Astragan ignesi (Candlewick). Online: http://www.kulturturizm.gov.tr/.

Brown, Victoria Adams. (1997). *The New Ribbon Embroidery.* New York: Watson-Guptill.

Marlatt, Rae. Bunka Embroidery: Painting with Thread. Online: http://www.thesophisticated stitcher.com/art2001/bunka.php.

Peace, Rissa (2004). Punch Needle Embroidery Resource Guide. Online: http://prettyimpressivestuff.com/punchneedle.htm.

Van Nuys, Sally. Russian-style Punch Needle Embroidery. Online: http://www.amherst-antiques-folkart.com/PunchNeedle_History.htm.

Quillwork

The use of flattened, dyed porcupine quills to decorate items of clothing and other objects. As opposed to most forms of needlework that are practiced in many parts of the world, quillwork is exclusively used by native people in **North America,** particularly among the New England, Great Lakes, and Plains tribes. Before white traders and settlers introduced glass beads in the mid-nineteenth century, porcupine quills were their main form of **embellishment. Embroidery** motifs using glass beads and sewing threads were often based on traditional quillwork patterns.

Porcupine quillwork is perhaps the oldest form of Native American embroidery, dating back to prehistoric times. It was in widespread use throughout the Woodland region, the porcupine's natural habitat. Western European accounts from the seventeenth century mention quillwork decorating clothing, accessories, and containers. Early designs included colored birds, animals, fishes, and flowers. For many of these peoples, doing quillwork was often seen as a sacred activity, a form of prayer. Reflective of Native American culture, the process of creation was more important than the finished piece itself.

The quills, which range from two to five inches long, must be gathered and processed before they are worked. Porcupines are nocturnal and fairly easy to catch during the day when they are resting in trees or underground burrows. The quills must be removed before the skin dries to avoid becoming brittle and easily broken. Quills are naturally white with black or brown barbed tips. They may be used in their original color or dyed by placing in a boiling colored liquid for three or four hours. Dyes were made from mosses, roots, and barks, mixed with berries, urine, or wood ash. Naturally dyed quills in red, yellow, black, blue, green, purple, and orange are quite colorfast, remaining vibrant over long periods

of time. In the 1870s, synthetic dyes were introduced to Native Americans and, after that, often used in place of vegetable sources.

Porcupine quills need to be softened and flattened before they can be applied. Native Americans moistened quills with saliva, holding the quills in their mouth and flattening them by pulling through their teeth. The end of the quill must be cut off so air can escape while it is being flattened. In addition to teeth, quills were flattened with tools made from bone, antler, or wood. The patterns were marked on a piece of brain-tanned hide, rawhide, fabric, or birch bark with bone "pens" or birchbark templates. Small holes were then punched using an awl made of bone, antlers, fish bones, thorns, or metal. The quills were attached by passing deer, moose, elk, or buffalo sinew through the holes. Made from the fibrous tendons along the spine, sinew thread becomes its own **needle** when rolled between the fingers to create a point. Quillwork generally does not penetrate all the way through the leather, with the work remaining largely on the surface. It must be done quickly before the quills and sinew dry and become stiff once again.

As each stitch is made, the quills are folded and the thread is hidden. Quills are quite short, so they are spliced, often by inserting the pointed end of the new quill into the hollow end of the old. The traditional quillwork stitches include line, straight, zig-zag, and sawtooth as well as wrapped edging and loom weaving. These stitches are used to create diamond, triangular, plaited, and checkerboard designs. Quillwork patterns decorated a wide range of items including moccasins, jewelry, pouches, baby carriers, knife sheaths, and animal trappings. They were also commonly used on wooden handles and pipe stems, baskets, and birchbark containers. Some of the most remarkable quillwork can be found on Plains war shirts. The intricate patterns would take a skilled embroiderer more than a year to complete.

Quillwork traditions were strong among Native Americans in several areas. In New England, the Mohegan peoples made hemp and basswood bags embellished with purple-black porcupine quills in a series of geometric diamond and triangular shapes. The Penobscots created pouches and bags of deer or mole skin, and the Passamaquoddy tribe was known for birchbark containers. Unfortunately, these birchbark containers ceased being made in the eighteenth century when splint and sweetgrass baskets were more desirable to settlers from **Western Europe** and the **British Isles.** In the Plains and Rocky Mountain West, Blackfoot, Cheyenne, and Sioux peoples created objects lavishly decorated with quillwork. They used porcupine quills on clothing and accessories, sometimes combining quills and ermine tails. Sioux quillwork often embellished bone "hairpipe" breastplates, pipe bags, baby carriers, and moose skin robes.

The Métis, a group of mixed Native and European peoples in western Canada, used quillwork in vibrant colors and bold motifs that expressed their culture. Through contact with Western European nuns, Métis women and girls melded their quill embroidery skills with silk embroidery techniques and patterns. Their richly and intricately decorated shirts, leggings, jackets, and moccasins were

traded to other tribes in the Northern and Central Plains. Métis quillwork influenced the Cree, who changed from geometric to floral patterns by the late 1820s. As time passed, and trade beads became more common, quillwork declined and the Métis became known for their intricate designs in beads and silk embroidery. The foundation of their later nineteenth-century motifs was solidly rooted in quillwork traditions.

The Métis were not the only tribes who favored **beadwork** over time. Today, Native American quillwork embroidery is nearly a lost art. Beading uses many of the same skills, but is less difficult in terms of manipulating materials. However, some native artists are working to maintain traditional quillwork today. The majority is done on birchbark boxes created by the Chippewa, Micmac, Sioux, Cree, and Ojibway. Although there are Native Americans who stay true to the traditional materials, needles and nylon threads are often used in place of sinew. Furthermore, non-native crafters make imitations in plastic or apply quills with glue. Fine contemporary objects made from authentic quills and sinew are expensive, ranging from $1,000 and up.

FURTHER READING

Gillow, John, & Bryan Sentance. (1999). *World Textiles: A Visual Guide to Traditional Techniques.* Boston: Little, Brown.

Native Languages of the Americas Online: http://www.native-languages.org/quillwork.htm.

Pennington, Lynne Sageflower. (October 6, 2001). The Art of Quillwork Part One. *Canku Ota (Many Paths)* 46. Online: http://www.turtletrack.org/Issues01/Co10062001/CO_10062001_Quillwork_1.htm.

Prindle, Tara. Porcupine Quill Embroidery. NativeTech: Native American Technology and Art. Online: http://www.nativetech.org/quill/quill.html.

Young, Patrick. (May 30, 2003). Métis Beadwork, Quillwork and Embroidery. Online: http://www.metismuseum.ca/resource.php/00715.

Quilting

The process of placing layers of cloth on top of each other and stitching them together with a **running stitch** or backstitch. Usually quilts have three layers: the top or outside layer, the backing, and a filling layer in between. The filling layer varies. In cold climates, quilts are usually filled with cotton or wool batting. The air space between the layers provides warmth, especially for bedding and outerwear. Quilt traditions are also found in warm climates, where the filling is a third layer of cloth that provides thickness but not necessarily warmth.

The stitches in quilts create a decorative padded effect and add aesthetic expression. Quilt tops are sometimes made of pieces of fabric stitched together, which is known as a **patchwork** quilt. The backing of quilts is almost always a solid piece of fabric.

The word quilt is derived from the Latin *culcita,* meaning a padded and tied mattress. Quilting appears to have originated in **Western** and **Central Asia** before the first century. A quilted linen carpet was discovered in a Siberian cave tomb, and a spiral quilted slipper was found in Uzbekistan, an important stop on the Silk Road to **Western Europe.** Both of these early pieces employ backstitch to hold the layers together. Quilting in Western Europe began with the quilted shirts worn by the crusaders under their chain mail. These padded garments protected the body from metal armor and attacks with weapons. The quilted shirt was eventually called a pourpoint, which was the forerunner of the Renaissance doublet and the jacket of today.

Overall, the technique of quilting is quite simple; layers of fabric are sewn together in an allover pattern. The complexity and artistic skill is revealed in the fineness of the stitches and the way the pattern is executed. There are three main methods of quilting: English quilting, Italian quilting, and trapunto. In English quilting, running stitches are worked through three layers of fabric. Running stitches are also used in Italian quilting, but they are worked in two parallel rows through two pieces of fabric. The rows of stitching create a channel through which a thicker cord is threaded. This type of quilting results in a raised pattern outlining the design motifs. Trapunto is similar to Italian quilting in that running stitches are done through two layers of fabric, but rather than running a cord through, trapunto uses small wads or cotton, which are pushed through the lining. Motifs on the surface of a trapunto piece can be textured by varying the amount of padding used in any one area.

There is little evidence of quilting in Western Europe before the twelfth century, and that is imported. The earliest extant European bed quilts originated in Sicily, and by the fourteenth century quilted clothing and bedcoverings were being made in France, Germany, Italy, Spain, and England. A notable example of these early quilts is a 1390s wedding quilt in cotton-stuffed trapunto and running stitch. The Renaissance brought increased trade and cross-cultural exchange between Western Europe and the eastern countries where quilting began. European royalty and nobility valued quilted bedcovers from the Turkish Ottoman Empire and **Indian Subcontinent.** Indian **whitework** quilts were especially popular in England. Elizabeth, Countess of Shrewsbury, was known to own a Bengali quilt of silk and cotton.

In the late seventeenth and early eighteenth centuries, Marseilles, an intricately quilted, corded, and stuffed whitework, was very popular among upper-class Europeans. Made in southern France, Marseilles work, along with English quilting, embellished petticoats, waistcoats, caps, and bed coverings. Quilted objects were beautiful and also practical in the days before central heating. These first quilts

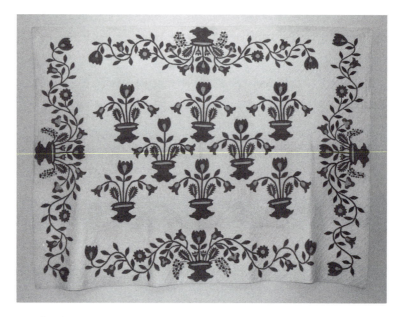

U.S. floral appliqué quilt, c. 1860. KSUM, gift of Helen M. Williamson & Jeanette Morgan Wands, 1989.57.2.

were made of "whole cloth." Whole cloth quilts had a solid top, backing, and filling quilted together in elaborate designs.

From the earliest times, quilts were also made from old worn-out cloth pieced together with patchwork and **appliqué,** but our modern conception of a relationship between colonial American frugality and patchwork quilts is somewhat of a myth. Early American quilts were made of whole cloth, and there is little evidence of patchwork quilts until the nineteenth century. Elaborately pieced quilts with carefully planned patterns were only possible because of the Industrial Revolution. By about 1840 the American textile industry had grown to the point that fabric was readily available to most families. With the greater availability and choice, women could purchase enough yardage and variety in calico to create patchwork quilts.

Although quilts and quilting are most commonly associated with America, there are many other traditions throughout the world. Some of the finest stitching is done on *kanthas,* the highly figurative whitework quilts of East Bengal (now Bangladesh). Local women use white thread to quilt together layers of discarded dhotis and saris that have been bleached white. The entire background of a kantha is worked intensively with running stitches. In some kanthas, areas are outlined in black **chain stitch** and then filled with running stitch in a contrasting color. Common motifs include animals, flowers, circus figures, and scenes from rural life and even history. Modern kanthas, like the South American *molas* (see

reverse appliqué), are influenced by Western culture. Along with local scenes from the Indian Subcontinent, kanthas may include figures such as William Shakespeare, Queen Victoria, and Vladimir Lenin.

In other parts of the world, quilting stitches are combined with other needlework techniques. For example, quilts in the Pacific Islands include intricate appliqué work and detailed **embroidery** in floral motifs with leaves. In Hawaii and Polynesia, quilt-like garments are presented at significant life-cycle events. They are passed down through generations or wrapped around the owner at death. In Japan, quilting is known as *sashiko.* Special quilted and embroidered coats known as *sashiko no donz* were worn by Japanese fishermen as a symbol of identity and status. The *donza* was made of layers of indigo-dyed cotton cloth decorated with intricate white running stitch patterns. Although important in their time, donza were rarely worn in Western Asia after the 1920s. Other than for historical record, they disappeared from use when the fishermen adopted ready-to-wear clothing.

Some of the greatest number of variations of the herringbone stitch (**crossstitch**) can be seen in the "crazy quilts" of the nineteenth century. Crazy patchwork is largely a Victorian era technique, but its popularity continued until the 1920s. Reaching its peak in the late 1880s, embroidered seam stitches and motifs on crazy quilts became art forms in themselves. Crazy quilts have their inspiration in the Japanese art displayed at the American Centennial Exposition of 1876. The embroidery on crazy quilts often features Japanese-inspired motifs such as dragonflies, spider webs, butterflies, flowers, storks, owls, and fans.

Crazy quilts were often made to record family histories and friendships. The word "crazy" was first used to describe an embroidered canvas cushion with a random, asymmetrical pattern, the result of passing among friends. Quilts and the process of quilting are strong symbols of women's culture. Quilting stitches are an important part of needlework traditions, and the quilts themselves connect with heritage.

FURTHER READING

Breneman, Judy Anne Johnson. (2005). America's Quilting History. http://www.womenfolk. com/historyofquilts/articles.htm.

Davies, Lady Sarah. Quilt History. http://www.quilthistory.com/quilting.htm.

Fabric land. History of Quilting. http://www.fabriclandwest.com/quilters%20corner/History_ quilt.htm.

Gotstelow, Mary. (1977). *The Complete International Book of Embroidery.* New York: Simon and Schuster.

Northern Comfort: Factory Prints & Fancy Piecing. http://www.osv.org/pages/Prints&Piecing. html.

Pillsbury, Betty and Vainius, Rita. The History of Crazy Quilts. http://www.caron-net.com/ featurefiles/featmay.html.

Reverse Appliqué

A type of **appliqué** where one shape is superimposed on another, creating a pattern in negative space. In reverse appliqué, a layer of fabric is treated as the background and shapes are cut out to reveal the layer below, giving the images a recessed look. Reverse appliqué is often coupled with appliqué and **embroidery.** It is a difficult type of needlework to execute and takes years of practice to master. Most reverse appliquéd pieces are worked with three or more layers, although interesting patterns can be achieved with two colors. The technique is also known as *mola,* which is a traditional textile made with reverse appliqué in Panama. Reverse appliqué is not practiced widely around the world, but is especially strong in cultural traditions in **South America** and Southeast Asia. It has gained popularity both as a tourist item and a technique in the repertoire of contemporary **quilting.**

Reverse appliqué begins with placing several layers of different colored cloth on top of each other. The most common fabric is cotton, usually in two to seven layers. The layers are basted together and the design is formed by cutting parts of each layer away with small, sharp scissors. The largest pattern is typically cut from the top layer and progressively smaller patterns from the layers underneath. Once cut, the edges of the shape are clipped, turned under, and sewn down with a tiny **needle.** The small stitches are the same as in regular appliqué, but done on the inside of the cut edge rather than on the outside edge. The pattern is varied by cutting through multiple layers at once, introducing other colors that are slipped between the layers, appliqué, and embroidery. The piece is usually stitched with thread that matches the top layer, so the stitches will be invisible. Reverse appliqué pieces vary greatly in quality, with the finest including many layers and invisible stitching. A fine reverse appliqué panel can take from two weeks to six months to complete, depending on the complexity of the design.

The most significant cultural traditions for reverse appliqué are the *molas* of the Kuna Indians and *paj ntaub* made by the Hmong people of Southeast Asia. These important textile traditions simultaneously represent continuity and change. Molas are the most important craft made by the Kuna on the San Blas Islands, an archipelago of more than 300 islands on Panama's north coast. In this matrilineal society, reverse appliqué reinforces the importance of women and earns much-needed income. The term mola is the Kuna word for blouse. The mola blouse is part of the traditional costume, along with a patterned wrapped skirt, a red and yellow headscarf, arm and leg beads, gold nose rings, and earrings. Rectangular reverse appliqué panels, commonly known as mola, are sewn to the

front and back of the blouse. The front and back panels usually share a common theme or style, but are never identical.

The reverse appliqué mola panels are a relatively recent craft for the Kuna, probably beginning in the mid-nineteenth century. From ancient times, Kuna women had a tradition of elaborate body painting in geometric designs. When the French settlers arrived in the seventeenth century, they introduced and, in some cases, imposed clothing on the indigenous people. At first, the Kuna re-created the body painting designs onto cotton fabric. Over time, they adopted the new materials and developed a cultural tradition in molas. This is a similar process of cross-cultural exchange found in the **patchwork** of the Pacific and the **ribbonwork** of Native North Americans. It is difficult to pinpoint the beginning of Kuna reverse appliqué; few extant examples exist due to the island climate. The oldest molas are known as *mukan or* "grandmother" molas. They are characterized by narrow design lines; more recent molas have much thicker lines.

Typical mola patterns are geometric and stylized natural objects including animals, marine life, birds, flowers, plants, mountains, rainbows, lizards, and coral reefs. Kuna legends and religious themes include devils, spirits, monsters, and two-headed birds. Motherhood is a common theme represented by birds and animals with fetal shapes inside the mother's body. Some molas feature scenes from everyday life such as initiation, marriage, and death. Traditional molas employed three or more different colors, usually red, black, and orange.

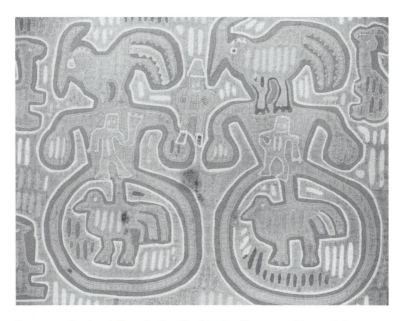

Reverse appliqué *mola* from the San Blas Islands of Panama, mid-twentieth century. KSUM, gift of The Vera Neumann Collection, 1989.63.21.

The Kuna make the finest molas for their own use and make their incomes by selling adaptations to tourists. More modern molas include images from popular culture borrowed from political posters, labels, books, and magazines. Kuna women sell their molas to tourists and craft cooperatives who market them in Costa Rica and the United States. The tourist molas tend to be smaller and use a wider range of colors, including blue, which is not included in traditional designs. They are made into pillows, wall hangings, and other objects.

The Hmong people migrated to the mountainous areas of Laos, Vietnam, and Thailand from southern China in the nineteenth century. There is a strong tradition for reverse appliqué among the women of the hill tribes in these areas. Intricate panels are added to garments, aprons, jackets, and baby carriers. Forced to flee their homes during the Vietnam War, these peoples ended up in refugee camps in Thailand. Eventually, many Hmong immigrated to **North America,** bringing their rich needlework heritage with them. The Hmong people use reverse appliqué to make *paj ntaub* or "flower cloth" in brightly colored designs that are symbolic in Hmong culture. It embellishes traditional clothing for New Year's, marriages, births, and other important events. Fine needlework is a source of great pride for Hmong women, often combining reverse appliqué with embroidery and **cross-stitch.** Common patterns for paj ntaub include the "elephant's foot," a symbol of family, and other motifs reflecting nature such as "ram's head," "snail house," "mountains," "spider web," "dragon's tail," and "water lily."

Beginning in the refugee camps and flourishing in the United States, Hmong women used their needlework skills to make blankets, pillow cases, aprons, wall hangings, and many other items to sell to the Western market. The pieces tell stories about the Hmong culture and, like **Bosnian crochet,** enable refugees to make a living in their new home. To appeal to the aesthetics of their American customers, Hmong needlework is done in softer colors. It is marketed through fairs, folk art stores, and on the Internet.

FURTHER READING

Breneman, Judy Anne Johnson. (2005). Hmong Needlework: Traditions Both Ancient and New. Online: http://www.womenfolk.com/quilting_history/hmong.htm.

Crossroads Trade. (2002). Online: http://www.crossroadstrade.com/molas.htm.

Gillow, John, & Bryan Sentance. (1999). *World Textiles: A Visual Guide to Traditional Techniques.* Boston: Little, Brown.

Gotstelow, Mary. (1977). *The Complete International Book of Embroidery.* New York: Simon and Schuster.

Graham Enterprises. (1997). Baste Method of Appliqué. Online: http://www.nmia.com/~mgdesign/qor/begin/applique.htm.

Wikipedia. Mola (art form). Online: http://en.wikipedia.org/wiki/Mola_(art_form).

Xiong, Pang. The Thread of Life: Hmong Needlework. Folk Arts Project Asian American Traditional Festivals. Online: http://www.arts.wa.gov/progFA/AsianFest/Hmong/fahmong5.html.

Ribbonwork

A general term for **embroidery** or **appliqué** using lengths of silk ribbon to embellish an existing fabric. Ribbonwork can apply to ribbon that is folded or tied, but as a form of needlework, it applies to stitched ribbons. The most well known type of ribbonwork is silk ribbon embroidery. It utilizes simple stitches and a wide variety of widths to create three-dimensional shapes, especially roses. Ribbon embroidery is often coupled with **quilting, knot stitches,** and **stumpwork.**

First used on military uniforms and ecclesiastical garments in France, ribbon embroidery became part of fashion in the Rococo period, from 1750 through the 1780s. Known as *broderie de faveur,* it was soon copied by London dressmakers. From England, the technique spread to **North America,** Australia, and New Zealand, remaining popular throughout the nineteenth century. Both amateurs and professionals used ribbons to cover fire screens, frames, pillows, pictures, parasols, hand bags, gloves, belts, hair ornaments, lingerie, and garments. Ribbon embroidery was especially elaborate on French and English ball gowns and accessories.

The first ribbons were made in the homes of Western European peasant farmers on looms rented from manufacturers. Silk ribbons were rare, and only the wealthy could afford to wear them. The wearing of ribbons came to be associated with nobility and was sometimes regulated by sumptuary law. In seventeenth- and eighteenth-century France, ribbons became an essential component of both men's and women's court dress. In a time when many were suffering, French royalty wore garments embellished with ribbons of silk and gold. During the Revolution, political allegiance was symbolized by wearing red, white, and blue ribbon cockades on shoes and hats. In mid-eighteenth-century North America, some of the leaders of Pennsylvania believed that silk manufacturing would be a worthwhile industry. A silk filature plant was built, and the Moravian School for Girls was founded in 1746. Young American girls were taught ribbon embroidery and ribbonwork. Unfortunately, a harsh winter completely destroyed their mulberry trees, and without leaves, the silkworms died.

Silk ribbon embroidery got its biggest boost with the opening of the French couture House of Worth in 1858. Worth's most famous client was Empress Eugenie, the wife of Napoleon III. Worth's master embroiderer, Michonet, began using "rococo" ribbons to adorn the gowns of Eugenie and her courtiers. Using **running stitches,** lightly shaded ribbon, and **tambour beadwork,** Michonet created the world's finest embroideries for decades. The embroidery operation of the House of Worth was taken over by Lesage in 1922. In business to the present

day, the House of Lesage continues to dress the wealthy and elite. Lesage has been responsible for approximately 85 percent of the beaded embroidery and **embellishment** seen on Paris couture collections since the 1930s.

Factory production of ribbons was greatly increased with the invention of the Jacquard loom in 1801 and a machine that wove multiple ribbons in 1815. In Basle, Switzerland, the number of ribbon looms grew from 1,225 in 1775 to 7,631 in 1870. Colonial Americans rejected the use of ribbons manufactured in the **British Isles** due to anti-English sentiments, opening their first ribbon factory in 1815. Intricate floral and pictorial ribbons were highly valued by Victorian needlewomen. They embellished their clothing and homes with ribbons, silk threads, beads, tassels, cords, **lace,** and various other trims. Crazy patchwork quilts featured ribbon roses, flowers, animals, fish, and insects. The invention of the sewing machine and growth of ready-to-wear clothing in the early twentieth century allowed for mass production of gowns, dresses, and underclothes with ribbon trim.

The term ribbonwork is used to describe both ribbon embroidery and ribbon appliqué. Many native peoples throughout **North** and **South America** use ribbonwork to embellish their ceremonial dress. In the 1780s, Western European traders introduced commercially produced silk ribbons, which many tribes began using as a form of embellishment. Women were soon sewing ribbons in various colors and widths on shirts, skirts, moccasins, and dance regalia. Due

Ribbonwork trim on a U.S. wedding dress, 1862. KSUM, transferred from the Allen Memorial Art Museum, Oberlin College, Oberlin, Ohio. Gift of Dorothy Hall Smith, Oberlin Class of 1927, 1964, 1995.17.54a-e.

to the frailty of the ribbons very few pieces survive from before the nineteenth century.

Ribbons are also used in a form of **reverse appliqué,** with geometric designs created by cutting different colored ribbons in mirror images of one another. These ribbons are then sewn onto a base fabric, sometimes a flour or potato sack, and held them in place with the herringbone stitch (**cross-stitch**), also known as the "briarstitch." Patterns of flowers and insects were drawn on birchbark or cornhusks, to be used again. For contemporary Native Americans, appliquéd shirts known as "ribbon shirts" are important parts of traditional dance costume. With ribbons cascading from the shoulders like **fringe**, the ribbon shirt is a reminder of the beaded buckskin war shirt.

Like other forms of needlework, ribbonwork has experienced periods of fashion. It gained attention in the 1940s, gracing fireplace screens in the White House and then embellishing couture gowns in the 1950s. In the early 1980s, doll designers began using fine silk ribbon embroidery for doll gowns, and by 1993, ribbon embroidery was popular again. The recent resurgence of ribbon embroidery may have started in Australia. The government put a tax on silk floss and fibers coming from Japan, but did not tax silk ribbons. Through popular magazines and the Internet, images from Australia influenced ribbon embroidery in the United States.

In the past 20 years, many books have been published about ribbon embroidery. At first, silk ribbons were hard to find, but new producers emerged during the 1990s, creating fantastic colors in silk ribbons that are also used for **knitting** and **crochet.** In recent years, ribbonwork has been extremely popular in ready-to-wear clothing and accessories. Contemporary needleworkers burn, dye, and make ribbons from recycled silk, constantly pushing the limits of these narrow strips of fabric.

FURTHER READING

Brown, Victoria Adams. (2005). Silk Ribbon Embroidery: 17th Century to the 21st Century. Crafts Across America. Online: http://www.crafts-america.com/profile/silkribbon.html.

Campbell, Susan. Potawatomi Beadwork and Ribbon Appliqué. Online: http://www.kansasheritage.org/PBP/art/dmnh.html.

Montano, Judith. (1993). *The Art of Silk Ribbon Embroidery.* Lafayette, CA: C&T Publishing.

Kling, Candace. (1996). *The Artful Ribbon.* Lafayette, CA: C&T Publishing.

Offray's. Ribbon History. *A Splendor of Ribbons.* New York: Michael Friedman Publishing Group. Online: http://www.offray.com/hist.html.

Pennington, Lynne Sageflower. (November 3, 2001). Craft-Ribbonwork-Part One. *The Canku Ota (Many Paths)* 48. Online: http://www.turtletrack.org/Issues01/Co11032001/CO_11032001_Craft_Ribbonwork_one.htm.

Ribbon Embroidery. Online: http://www.white-works.com/EmbroideryIndex.htm.

Silk Ribbon Embroidery. A Historical Perspective of Silk Ribbon Embroidery. Online: http://www.silk-ribbon-embroidery.com/Historical.htm.

University of New Hampshire Pow Wow. What is a Pow Wow? Online: http://www.unh. edu/naca/history.html.

Rug Hooking

Pulling loops of fabric strips or yarn through a woven foundation with a hand hook, creating a pile surface. Throughout history, many different cultures have made rugs from leftover fabric, yarn, and fleece, including the Coptic Egyptians, Bronze Age Scandinavians, and the Chinese. But most sources agree that rug hooking is a product of **North America,** specifically the Canadian Maritime Provinces and the New England region of the United States. Due to a lack of resources, the floors of most colonial homes were kept bare. The more affluent used paint, stenciling, and floor cloths to simulate rugs. Machine-made carpets began to be imported from **Western Europe** in the 1830s, but they were very expensive. Rug hooking enabled people of lower economic classes to create floor coverings that emulated those of the wealthy. From its humble beginnings, rug hooking grew to a cottage industry and has emerged as a medium for textile design and a recognized art form.

Some possible origins of North American rug hooking can be found in the **British Isles** and on the high seas. During the Industrial Revolution, English carpet mill workers made floor mats from small pieces of leftover yarn that were useless in factories. Sailors also did a sort of rug hooking, creating marine scenes on rough linen with raveled fabric and a marlin spike. Once rug hooking reached the mainland, it rapidly spread through Maine, New Hampshire, and the Canadian coast. Hooked rugs were fairly quick to make and helped pass the time during hard cold winters. The earliest rugs exhibit a primitive perspective and scenes of rural life including farm animals, houses, and sprays of flowers.

The rug-hooking technique is fairly simple. Fabric is cut into strips and a design is drawn on a foundation material that is mounted on a wooden or metal frame. The strips are pulled up with a small hook to form a looped pile. The hook is much like a **crochet** hook, made of whale bone or steel with a wooden handle. Combinations of coarse and fine textured cloth provide depth and character. There are different size hooks or "points," depending on the coarseness or fineness of the strips. Rug hooking is different from **punch needle, latch hooking,** and **locker hooking** in technique and appearance.

The earliest rug-hooking foundations were handwoven linen or hemp, but they were superseded by burlap in the mid-nineteenth century. Burlap shipping sacks were introduced to America in the 1850s. Recycled from bags that originally

held imported coffee, tea, grain, and tobacco, a greater availability of remnants from textile mills aided in the growth of this needle art. The first North American hooked rugs were used on tables or beds rather than on floors. They evolved into hearth rugs, which protected floors and carpets from soot and embers. Most early hooked rugs were no larger than a burlap feed sack; they were usually rectangular, and long, narrow runners were made from sewing together a series of sacks. Other hooked items include bed rugs, chair seats, wall hangings, trivets, and carpetbags.

Hooked rugs can be classified into two main categories: primitive and fine. Primitive rugs used wide strips of fabric and are characterized by a lack of scale and perspective. Fine hooked rugs used a much narrower strip of fabric and were made in realistic, pictorial, abstract, or geometric styles. All types grew in popularity throughout the 1800s, especially among rural women, who used discarded clothing and blankets to decorate their homes. Rugs were created independently or in "rug frolics," similar to **quilting** bees. Rug hooking was generally perceived to be a country craft and was rarely included in needlework schools or ladies' magazines, although designs were inspired by periodicals and greeting cards. In 1850, commercial, pre-stamped patterns and metal patterns became available. Rug hooking expanded out of New England and into the rest of the United States during the Victorian era.

Eventually, some poor women began selling hand-hooked rugs, and cottage industries sprang up in many areas. Bolstered by the arts and crafts movement at the end of the nineteenth century, cottage rug-hooking businesses began with the objective of making well-designed rugs for the growing middle class as well as providing work for those in need. A notable example is the Abanakee Rugs of New Hampshire, which began in 1894 and used Native American motifs as design inspiration. This same inspiration was used by the Subbekashe Rug Industry in Belchertown, Massachusetts, beginning in 1902.

In 1893, the Grenfell Mission was founded to help desperately poor fishing families in Newfoundland and Labrador, Canada. Their rugs, created over the winter months, became quite sought after by summer tourists. These successful projects were followed by the Maine Seacoast Missionary Society and the South End House Industry in Boston. In Cape Breton, Nova Scotia, the Cheticamp hooked rugs were known for their rich pastel colors. Cheticamp rugs are still created today.

In the 1920s, when commercial carpet became more affordable, some rug hookers abandoned their craft because of its association with poverty. It was about this time that rugs began to be recognized as a collectible art form. The publication of articles and books promoted an appreciation for early rugs and created a resurgence of interest in the 1930s. Rug hooking grew as a hobby, championed by informal clubs in the United States and Canada through the 1940s. Interest dropped in the 1950s and 1960s as styles changed, and very little hand rug hooking was done in the 1970s. Although there was a lull in the making of rugs, the craft of rug hooking took its place in American art with a rug show at the Museum of American Folk Art in 1974.

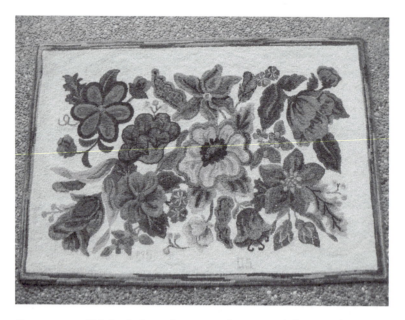

Contemporary U.S. hooked rug, late twentieth century. Collection of Madonna Shelly.

Today, many enthusiasts and fiber artists have rediscovered hooked rugs. Some "hookers" emphasize the recycling aspect of their art, using cloth that has been gathered from discarded clothing that is washed and torn apart. Rug-hooking suppliers are largely mail order businesses, offering hooks, cutters, and frames along with classes, books, shows, workshops, lectures, seminars, Internet posting groups, camps, and guilds. Museums and galleries commonly mount hooked rug shows and juried competitions, recognizing both the old and the contemporary. Hooked rugs are considered an indigenous folk art, holding a permanent place in many American and Canadian museums.

FURTHER READING

Amherst Antiques. Online: http://www.amherst-antiques-folkart.com/RugHooking_History. htm.

Jamar, Tracy. (2005). Definition of Rug Making Terms. *New Pathways into Quilt History*. Online: www.antiquequiltdating.com.

The Rug Hooker's Network. Online: http://www.creativity-portal.com/howto/artscrafts/rug. hooking.html.

Rug hooking 101. (2004). Boston Mountain Publishing. Online: http://www.rughooking101. com/articles/.

Smith, Robyn. (2003). Island Crafts: Hooking on Nantucket. *Yesterday's Island*. Online: http://www.yesterdaysisland.com/03_articles/crafts/first.html.

Traditional Rug hooking Resources. Online: http://www.rughookingonline.com/.

What Is Rug Hooking? Online: http://www.rughookingonline.com/whatis.html.
Wikipedia. Traditional Rug Hooking. Online: http://en.wikipedia.org/wiki/Traditional_
 Rug_Hooking.

Running Stitch

The most basic of all **embroidery** stitches, made when a threaded **needle** is passed
in and out of a ground fabric, giving the appearance of a broken line. Running
stitch is used to sew two pieces of fabric together and also as a decorative element.
The running stitch has existed since the invention of the needle, which goes back
to prehistoric times. Running stitch can be used to temporarily stitch two pieces
of cloth together, which is known as basting. It can also be used to permanently
quilt layers of fabric together. In **quilting,** running stitches hold the filling to-
gether, creating a padded effect. The most common use of running stitches in
embroidery is for making linear patterns. The running stitch crosses cultural and
geographic boundaries and is found throughout the world.

In the running stitch, the needle is passed in and out of the fabric, making
surface stitches of equal length. The stitches on the underside are generally half
the size or less than those showing on the face of the fabric. There are many pos-
sible variations on running stitch; the most common are the backstitch, Holbein
stitch, and darning stitch. The backstitch appears as a solid line on the surface of
the fabric. It is done by taking short, backward stitches on the surface and longer,
overlapping stitches on the back. The backstitch creates a very secure seam and
was the most often used to construct clothing before the invention of the sewing
machine. A variation of the backstitch is the stem stitch, which is very common
for **crewelwork** embroidery.

The Holbein stitch, or double running stitch, has a similar finished appearance
to the backstitch, but is done in two steps. A row of evenly spaced running stitches
is worked across the fabric, then the direction of the needle is reversed and a sec-
ond row of stitches fills in the gaps. The Holbein stitch is well suited for geometric
patterns and was frequently coupled with **cross-stitch.** Holbein was the main
stitch used in **blackwork,** which experienced its height of popularity in England
in the sixteenth and seventeenth centuries. The darning stitch is a decorative stitch,
different from "darning" or mending cloth. It is done by creating long running
stitches with tiny spaces in between. Darning stitch is often used to fill in spaces;
parallel rows of stitches are created with the spaces staggered like bricks. Darning
stitch is an important component of **needleweaving** or pattern darning.

Running stitch is most frequently used as a functional and decorative ele-
ment in quilting and trapunto. Trapunto is an earlier form of quilting, and the

earliest Western European padded bed coverings were made in 1390. On the **Indian Subcontinent,** the quilted *kanthas* of Bangladesh are intricately stitched in **whitework,** the background densely quilted with running stitches. In India, wedding scarves or *bukhani* are worn by Hindu bridegrooms over their turbans. Stylized images of elephants, parrots, flowers, and gods are created in widely spaced colored running stitches on a light background. The scarves are intended to bring luck and protection. Darning stitch and **satin stitch** in red silk on black cotton are typical of embroidery in Pakistan, which often includes ancient motifs such as the tree of life.

In **South America,** indigenous women in western Mexico use running and darning stitches to embroiderer shirts, trousers, bags, and belts for the men in their family. The most common combination is bright red and blue on white cotton. The Holbein or double running stitch is worked in two different-colored threads in **Eastern Europe.** This technique is seen in Romania, Russia, and the Ukraine. In north **Africa,** traditional embroidery includes both double and whipped running stitch, along with stem stitch. In **Western Asia,** the Peking or Chinese stitch is a form of interlaced backstitch, where a row of stitches is sewn and then a second thread is wrapped around it, creating a twisted appearance. The Peking stitch is included in eighteenth-century Chinese emperors robes, with the five-clawed *lung* dragon and sun motif embroidered in backstitch, satin stitch, stem stitch, and **couching.** The Peking stitch is different than the Pekin **knot stitch,** which is a relative of the French knot or Forbidden stitch.

One of the most significant cultural traditions using the running stitch is *sashiko* from Japan. Meaning "small stitch," the sashiko quilting technique uses small running stitches sewn in horizontal, vertical, diagonal, and curvilinear lines on one or more layers of fabric. Sashiko is done with white cotton thread on plain-weave cotton that has been dyed blue with indigo. The earliest written documentation of sashiko was in 1788, where it was noted as an important traditional craft for its grace and beauty.

The sashiko stitching strengthens the fabric, but that is not its exclusive purpose, it was considered magical and spiritual. The use of stitched patterns for spiritual protection may have originated with the Ainu, an indigenous group thought to have once occupied a large part of Japan but was concentrated on the northern islands by the twelfth century. The Ainu believed that placing designs around the neck, sleeve openings, and hem of garments prevented evil spirits from entering the wearer's body.

The relationship between stitching and protection can be seen in other aspects of Japanese traditional culture. For example, a stitched or **patchwork** pattern applied to the back neckline of a baby's kimono served as a talisman to safeguard a vulnerable area from evil. Simple stitched towels were carried by female divers to keep them from harm's way, and during World War II a belt stitched by a thousand women was thought to defend a soldier against enemy gunfire.

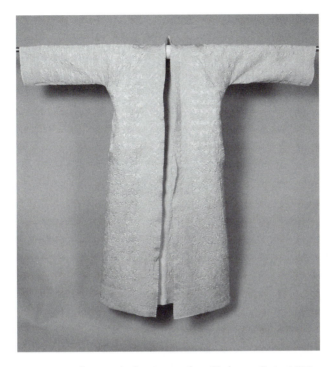

Running stitch on quilted satin coat from Turkey or Syria, 1900–1925. KSUM, Silverman/Rodgers Collection, 1983.1.967.

One of the most notable uses of the running stitch in Japan is the fishermen's coats called *sashiko no donza*. From the late nineteenth to the early twentieth centuries, young wives and grandmothers created quilted coats from layers of indigo-dyed cloth with white sashiko patterns for their husbands and grandsons. The coats symbolized a fisherman's identity to outsiders along with status in his own community. Although they began as a type of domestic needlework, the finest embroidered coats were commissioned from skilled seamstresses. The coats were not worn for fishing, but rather for occasions when the fisherman would be seen and identified by his profession. They wore their coats around town, to parties, while visiting friends, or when assuming positions of authority on the job.

The custom of the sashiko no donza declined in the 1920s, when Japanese fishermen began powering their boats with engines. The process of industrialization significantly affected local culture. Men started wearing westernized clothing and women stopped making the running stitch coats. Older fishermen occasionally wore sashiko no donza into the 1950s, but as a sign of identity, the needlework tradition had ended. The sashiko technique was adopted by fiber artists in Japan and elsewhere who have taken the simple running stitch from a folk tradition into fine art in the twenty-first century.

FURTHER READING

Bridgeman, Harriet, & Elizabeth Drury. (1978). *Needlework: An Illustrated History.* New York: Paddington Press.

Coss, Melinda. (1996). *Reader's Digest Complete Book of Embroidery.* Pleasantville, NY: Reader's Digest.

Gillow, John, & Bryan Sentance. (1999). *World Textiles: A Visual Guide to Traditional Techniques.* Boston: Little, Brown.

Gotstelow, Mary. (1977). *The Complete International Book of Embroidery.* New York: Simon and Schuster.

Stitch with the Embroiders Guild. Running stitch. Online: http://www.embroiderersguild.com/stitch/stitches/index.html.

Takeda, Sharon Sadako, & Luke Roberts. (2001). *Japanese Fishermen's Coats from Awaji Island.* Los Angeles: UCLA Fowler Museum of Cultural History.

Wilson, Erica. (1973). *Erica Wilson's Embroidery Book.* New York: Charles Scribner's Sons.

Samplers

A way to record stitches that became symbolic of female education and accomplishment. At first, samplers were encyclopedias, examples of **embroidery** stitches and patterns used for referral. In the eighteenth and nineteenth centuries, they became a major part of girls' education and a tangible record of the female experience. The word sampler comes from the Latin *exemplum* and the Old French *essemplaire,* meaning an example to be followed, a pattern, or model. The earliest written evidence of samplers in **Western Europe** and the **British Isles** was recorded in a Spanish inventory from 1509. Before pattern books were available, stitches and motifs were documented on long narrow strips of fabric. The first pattern books were published in Germany, Italy, and France beginning in 1524. They included collections of sample stitches and designs that could be copied.

The earliest known dated sampler was made in England in 1598 and incorporated floral and animal designs, samples of various patterns and stitches, and an alphabet. Some of the motifs were copied from a pattern book and accompanied by **metallic threads,** pearls, and beads. Early samplers were stitched by adult women and included variations of **cross-stitch** and **buttonhole stitch.** Many included elaborate scrolled designs in double **running stitch** or Holbein stitch, popular for **blackwork** at the time. Early samplers were strips of linen kept wound on rods in fancy sewing boxes for reference.

Narrow-band samplers often included rows of repeating designs, ranging from curving vines to formalized rows of flowering plants. Spot samplers became popular in the seventeenth century. They included randomly placed plants and animals such as carnations, thistle, tulips, stags, birds, butterflies, and insects. Sometimes

motifs were cut out and appliquéd onto bed hangings or other furnishings. As time progressed, samplers became more orderly and included the embroiderer's name and the date. The appearance of a signature indicates a shift in purpose.

With the growing availability of pattern books in Europe and **North America,** samplers evolved from a form of reference to a demonstration of skill. In the eighteenth century, samplers became a vehicle for the education of girls. Samplers taught essential needlework skills for making and marking household linens and clothing. Marking samplers included various alphabets that were used to identify linens, similar to a monogram. Darning samplers employed types of **needle-weaving** to practice and demonstrate skill in repairing damaged cloth. Before mechanized weaving, it was important to make fabric last as long as possible.

Girls were taught to stitch at a very early age, starting with linens and clothing and later advancing to more decorative needlework. Samplers were made by girls 6 to 15 years old, with an average age of 11. Cross-stitch and counted threadwork were well suited for the rendering of alphabets and numbers. Sometimes called lettering samplers, needlework helped teach basic literacy and mathematics; some samplers even included the multiplication tables. Samplers became a symbol of a young woman's talent and education, framed and displayed for visitors and future husbands.

Samplers embroidered in silk or wool on plain-weave linen grew increasingly popular in England, Canada, and America throughout the eighteenth century. Floral or geometric borders and biblical verses meant to instill moral virtues were added. Some samplers included mourning poems, indicative of the high mortality rate of the time. During the second half of the eighteenth century, samplers began to include architectural motifs, local scenes, and figures. Houses, flower gardens, animals, windmills, churches, schools, shepherds, and birds were

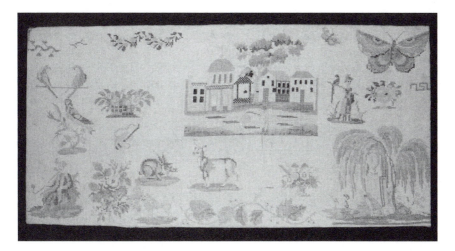

Embroidered cross-stitch sampler. U.S. or English, 1750–1799. KSUM, Silverman/Rodgers Collection, 1983.4.306.

included in cross-stitched landscapes. Some images depicted real buildings, documenting a girl's everyday life.

Girls attending Boston-area boarding schools created **needlepoint** pictures designed by their teachers based on contemporary prints readily available in eighteenth-century America. Sometimes multiple schoolgirls would stitch the same design. One example is the "fishing lady" or "Boston Common" pictorial needleworks. There are at least 65 recorded versions of these scenes, which provide us with insight into social history of the federal period. Pictorial embroideries expanded the stitcher's repertoire of techniques, adding backstitch, **chain stitch,** eyelet stitch, feather stitch, herringbone stitch, split stitch, stem stitch (running stitch), French and bullion **knot stitch,** and **stumpwork.** Girls would spend many months, and sometimes years, working increasingly difficult embroideries.

In the later part of the eighteenth century, the education of American girls became more serious, and so did their needlework. They stitched map samplers to exhibit knowledge of geography. Some map samplers were three dimensional, made as round globes. In addition to maps, girls commemorated family occasions, producing images of events and objects in their lives. One theme expressed in samplers of the late eighteenth and most of the nineteenth century was death and mourning. Samplers included family trees and the hair of deceased relatives in **plaiting and braiding**. Many pictorial embroideries were stitched following the death of George Washington. Evolving from a tradition of commemorative art that honored deceased heroes, mourning pictures exemplified refinement and culture.

Usually a professional artist or teacher would be commissioned to draw the mourning picture. Worked in silk floss on silk fabric, these painterly embroideries would include India ink, paint, or pencil for detail on facial features and hands. Images were punctuated with black chain stitch borders and fancy spangles. Mourning pieces in England and America had a symbolic language in their composition. Gravestones, monuments, and urns were accompanied by lush Eden-like gardens and mourning figures adapted from ancient Greek and Roman art. The weeping willow, an ancient symbol of mourning and resurrection, figured prominently. Other symbols of mourning culture included the fallen oak or elm, which represented strength and dignity, the evergreen for life-in-death, columbine flowers for the Holy Spirit, the thistle for earthly sorrow and sin, and the forest fern for humility.

Styles of sampler embroidery changed to reflect fashions in needlework. By the middle of the nineteenth century, **Berlin work** samplers were popular. Samplers were decorative articles that fit well with the Victorian aesthetic in decorative arts. The making of samplers declined with the turn of the twentieth century. Girls were formally educated, and Home Economics, established in 1908, did not generally include hand needlework. Historic samplers gained attention during the colonial revival of the 1920s and 1930s, but it was not until the 1950s that collectors and museums began preserving these messages from the past. Today, samplers and mourning pictures are highly valued as antiques and cultural records of women's history.

FURTHER READING

Diannic Designs. The History of Cross-stitch. Online: http://www.diannicdesigns.com/info. asp.

Exemplum Samplers (2004). Sampler History. Online: http://www.exemplum.co.uk/history. html.

Gotstelow, Mary. (1977). *The Complete International Book of Embroidery.* New York: Simon and Schuster.

Harbeson, Georgiana Brown. (1938). *American Needlework.* New York: Bonanza Books.

Historical Sampler Company. History of Samplers. Online: http://www.historicalsampler company.co.uk/History.htm.

Richter, Paula Bradstreet. (2001). *Painted with Thread: The Art of American Embroidery.* Salem, MA: Peabody Essex Museum.

Ring, Betty. (1993). *Girlhood Embroidery: American Samplers and Pictorial Needlework 1650– 1850.* New York: Alfred A. Knopf.

Swan, Susan Burrows. (1977). *Plain and Fancy: American Women and Their Needlework, 1700– 1850.* New York: Rutledge.

Satin Stitch

A series of straight **embroidery** stitches placed side by side to fill in a motif or shape. The satin stitch is used in some of the most beautiful embroideries in the world, producing a shiny, satin-like appearance. Many needlework traditions include this versatile stitch, crossing cultural and geographic boundaries. The satin stitch is simple in technique, but requires patient skill to keep the stitches regular within a defined space. Satin stitches can be worked horizontally or diagonally, but they must be placed very close together to achieve a smooth surface. The stitch begins by bringing the **needle** up on the outside edge of a motif, carrying it across the ground fabric, and inserting it on the other side. Satin stitches are identical on the front and back, lying flat and parallel, just touching each other.

There are several variations of the satin stitch including padded satin, long and short stitch, and surface satin stitch. When a padded effect is desired, motifs can be outlined in **running stitch** or **chain stitch** and satin stitches worked over the stitching. This gives the motif a higher profile. For a three-dimensional effect, satin stitches can be worked over a wooden or cardboard foundation, like in **stumpwork.** The long and short stitch is popular for color shading in **crewelwork.** Two lengths of satin stitch are alternated, following the shape of the motif.

The surface satin stitch is more economical in terms of thread and can be used to cover larger areas. Stitches are only worked on the surface of the fabric without carrying the thread along the back. Surface satin stitch is not as smooth in appearance, because the stitches cannot be placed as close together. Crewelwork

done in colonial **North America** featured the surface or one-sided satin stitch, known as the New England economy stitch because it consumed less yarn than the method used in the **British Isles.**

The satin stitch is a common part of needlework traditions throughout the world, with some of the most notable in north **Africa, South America, Western Asia,** Southeast Asia, and the **Indian Subcontinent.** In Morocco, satin stitch is used to decorate *tensifa,* harem or mirror curtains. Floral patterns are executed in fine silk, imitating the smooth sheen of flowers. A similar effect is used in the large satin stitch flowers on the *manton de Manilla,* a traditional Spanish shawl with long **fringe.** The influence of Spain is seen in the embroidery of South America. For example, in Ecuador, floral patterns are done in satin stitch, **cross-stitch,** and **buttonhole stitch.** Women's folk costume in Nicaragua and El Salvador includes a short-sleeved cotton blouse called a *huipil.* The huipil is heavily embroidered around the neckline and yoke in satin stitch, **needleweaving,** and chain stitch. Both satin stitch and surface satin stitch are used to create brightly colored floral and spiral designs in silk or cotton thread.

Satin is the most frequently used stitch in Chinese embroidery. Using the traditional five dominant colors; blue, yellow, red, white, and black, satin stitch was used to depict auspicious creatures on robes and jackets. Eighteenth-century emperor's

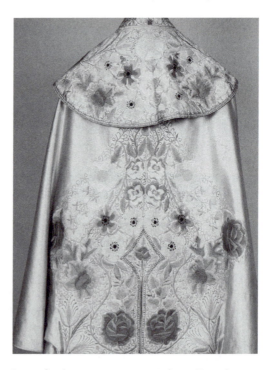

Large floral pattern in satin stitch on Spanish cape, twentieth century. KSUM, Silverman/Rodgers Collection, 1983.1.979.

robes included the five-clawed *lung* dragon and sun motif in satin stitch, stem stitch (running stitch), and couched metallic thread. The folk embroideries of Korea, Japan, Indonesia, and Vietnam include techniques adapted from China. Satin stitch, long-and-short stitch, and **couching** are prevalent throughout all of Asia.

In China, the highest level of skill is required to produce double-sided embroidery, which depicts an image on both sides of a single piece of silk. This extremely complicated technique is believed to exist only in China, with roots stretching back to the third century. Double-sided embroidery is done on transparent sheets of woven silk with very fine silk thread. Threads finer than a human hair are used, with knots hidden invisibly between layers of satin stitch. The height of skill is when an embroiderer can create two different images of different colors on each side of a fabric. The realistic designs that can be achieved with fine satin stitch are like painting, requiring a tremendous amount of energy and patience. A complicated double-sided piece may take as long as two years to finish.

During the Republic of China period (1912–1949), fine embroidery went into decline, although examples of Chinese embroideries were included in the Panama World Fair in 1915. The embroidery industry was restored in 1950 when the People's Republic of China was established. The central government set up research centers and launched training courses in embroidery, and the Embroidery Research Institute was established in 1957. Contemporary Chinese embroiderers use silk so fine that the threads they are barely visible to the naked eye.

The two popular forms of embroidery in India are satin stitch and **mirror-work,** most frequently worked on articles of clothing and wall hangings. In the Punjab region of the Indian Subcontinent, satin stitch embroidery is known as *phulkari* or "flower work." The finest phulkari is called *bagh* or "garden." In bagh, the entire face of the ground fabric is covered with horizontal and vertical surface satin stitches. Phulkari is stitched in marigold colors of untwisted silk floss on rust-colored cotton fabric. The shawls cross national borders; they were part of everyday clothing for rural women in India and Pakistan before the countries were partitioned in 1947. Phulkari remains a cultural tradition in both countries. On the birth of a girl, the maternal grandmother begins embroidering a bagh, which takes several years to complete. The shawl becomes part of the trousseau, worn at her wedding and treasured as a family heirloom.

FURTHER READING

China Culture.org. Chinese Embroidery. Online: http://www.chinaculture.org/gb/en_artqa/ 2003–12/31/content_45156.htm.

Coss, Melinda. (1996). *Reader's Digest Complete Book of Embroidery.* Pleasantville, NY: Reader's Digest.

Four Famous Chinese Embroidery Styles. Online: http://www.china-window.com/china_culture/ arts_crafts/four-famous-chinese-embro.shtml.

Gillow, John, & Bryan Sentance. (1999). *World Textiles: A Visual Guide to Traditional Techniques.* Boston: Little, Brown.

Gotstelow, Mary. (1977). *The Complete International Book of Embroidery.* New York: Simon and Schuster.

Stitch with the Embroiders Guild. Satin Stitch/ Long and Short Stitch. Online: http://www.embroiderersguild.com/stitch/stitches/index.html.

Wu Hsiao-ting. (2006). The Art of Chinese Embroidery. Online: http://taipei.tzuchi.org.tw/tzquart/2006sp/qp4.htm.

Scandinavia

The area of the world including Denmark, Finland, Norway, and Sweden along with Lappland and the North Atlantic islands of Greenland and Iceland. Because of political and cultural interaction, Scandinavian needlework techniques are not restricted to one country or area, and extensive cross-cultural exchange is an important part of the history of the area. For example, Iceland was originally settled by the Vikings from Norway with some Celtic peoples from the **British Isles** who began arriving in the ninth century. In the year 1000, Christianity was adopted, and the country remained Catholic until 1550. During this time Icelandic **embroidery** was almost exclusively for ecclesiastical use, including frontals, altar cloths, and vestments.

Greenland links the needlework of **North America** and **Scandinavia.** The majority of the population of Greenland is of mixed Eskimo and European descent. It is thought that the Eskimo people crossed from North America to northern Greenland. The few remaining Eskimos in the more northerly part of the island work embroidery similar to North American Eskimos.

The most prominent needlework technique in Scandinavia is embroidery, followed by **knitting,** knotted rugs, **lace,** and **appliqué.** Embroidery is a traditional craft worked by women in their homes. The most popular Scandinavian techniques and stitches are **drawnwork, pulled threadwork, whitework, cross-stitch,** backstitch, **chain stitch, running stitch, satin stitch,** eyelet **buttonhole stitch,** and French **knot stitch. Needleweaving,** also known as Swedish weaving, is also popular. Scandinavia is known for its drawnwork, specifically Hardanger and Hedebo, which emerged in the seventeenth century. Hedebo is a combination of drawnwork and buttonhole stitch that developed in Denmark. Hardanger is a tradition in Norway, using satin stitch and drawnwork or **cutwork.**

Scandinavian embroidery is done on linen or cotton fabric with wool or cotton threads. The linen cloth is often left in its natural color, but it is also bleached and dyed black. Cotton thread can match the color of the ground cloth or contrast, and wool yarn is characteristically used in bright colors. Scandinavian embroidery is often worked in one color thread such as blue thread on white fabric. Cutworks and drawnworks are usually done in matching color, although pink, red, or blue are used.

Design motifs cross national borders. Typical Scandinavian patterns include blocks of squares and other geometric motifs, including wheel and fan shapes. Pictorial patterns include the earth mother, flowers, and religious themes such as Adam and Eve.

Women's traditional folk costume has changed very little over the past 300 years. Skirts, blouses, and linen caps are decoratively embroidered. Scandinavia is also well known for its decorative borders on table linens and wall hangings. A cultural tradition that displays needlework skill is the *tjell*, an elongated rectangular piece of linen decorated with embroidery. Cushion covers for seats of horse-drawn carriages were very popular in the nineteenth century. Heavy wool in chain stitch and French knot stitch was either worked by women for their own use or commissioned from professionals.

Nordic knitting is used to create colorful garments in regional styles. Knitted sweaters, jackets, stockings, and caps are well suited for the cold climate of Scandinavia. Knitted felt is also used for thick winter caps. Knitted felt is made by creating an object twice the size needed and then using heat, moisture, and agitation to felt the wool fibers together. Appliqué is a cultural tradition among the Sami, nomadic reindeer herders of Lappland. Sami costume is often decorated with appliquéd ribbon and braid. Other **embellishments** used in Scandinavia include **metallic threads,** sequins, and **beadwork.**

Lacemaking is most commonly associated with Sweden with two types of Swedish lace, ornamental and domestic. The finest laces were made of gold and silver metallic threads in the sixteenth century, although records show gold **netting** made by nuns in the fourteenth century. Metallic lace was the domain of royalty. The young granddaughter of King Gustavus Vasa, who reigned from 1523–1560, was buried in a dress and shoes covered with gold and silver lace. Traditional Swedish costume includes **bobbin lace** made from linen thread. Similar to torchon, geometric designs were most commonly made in one- to two-inch-wide strips. These insertions embellished church and household linens, along with bridegroom shirts.

Rya are Scandinavian shag rugs with a long pile. They originated for bed coverings, used with the pile side down for extra warmth. In the eighteenth century, Finnish people adopted the rya and made it a cultural tradition, developing striking colors and patterns. In Finland, ryas are used as prayer rugs during the wedding ceremony and become family heirlooms. Rya can be constructed by weaving or **knotting** with a tapestry **needle,** similar to **latch hooking.** Loops of wool yarn can be left as is or cut. Colorful Finnish ryas feature abstract geometric shapes, reflecting modern design aesthetics. In the 1960s and 1970s, handmade rya patterns of distorted concentric circles in dark purple, red, orange, mauve and burgundy were copied by commercial designers.

For many generations, the regional embroidery styles of Hedebo and Hardanger were not well known outside Scandinavia. They were created by peasants for domestic textiles and clothing, including the traditional linen wedding shirt given by the bride to the groom. Usually worked in white thread on white fabric, colored thread and fabric were also used. Hedebo patterns were adapted

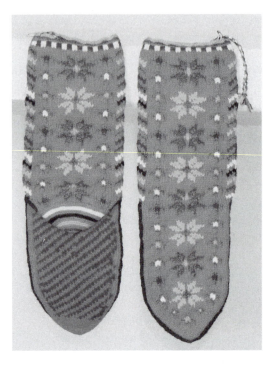

Scandinavian knitted socks with characteristic pattern-
ing, early to mid-twentieth century. KSUM, Silverman/
Rodgers Collection, 1983.1.1921ab.

from woodcarving shapes on peasant furniture, and around 1840, geometric cut
and drawn spaces were added. Hardanger includes rows of openwork squares in
universal designs such as the eight-pointed star.

The immigration of Scandinavian peoples from 1840 to 1920 introduced
Hedebo and Hardanger to the United States. Publications of pattern books,
including *The Complete Hardanger Book* in 1904, increased the practice of these
traditional styles. Attention to Scandinavian needlework grew in the late 1970s
and continues today. Each year, the Nordic Needle shop in Fargo, North Dakota,
sponsors a contest for original designs and publishes them, bringing Scandinavian
heritage into the present and sharing it with the larger world.

FURTHER READING

All Fiber Arts. Brief history of the Rya Rug. Online: http://www.allfiberarts.com/library/aa98/
aa012098.htm.

Berg, Liisa. The Finnish Ryijy. Online: http://www.ryijypalvelu-rp.fi.

Finnish Heritage Museum. Online: http://www.kaspaikka.fi/rug/.

Gotstelow, Mary. (1977). *The Complete International Book of Embroidery.* New York: Simon
and Schuster.

Gustafson, Carolynn Craig. (1987). *The Hardangersom of Versterheim: The Norwegian-American.*
Volume I. Fargo, ND: Nordic Needle.

Hooked Rugs: Hand Hook Rug-Making. Punch Needle Rug-I.
Stitch Rug-Making. Online: http://www.wisegeek.com/what-a.
making.htm.
The Nordic Needle. Online: www.Nordicneedle.com.
Thompson, Angela, and Bayne, Avril. (n.d.). Hedebo. Online: http://lace.lacc
Hedebo.html.

Shadow Work

A type of **embroidery** done on sheer fabric, stitching on the back side of the fabric, which appears opaque on the front. In shadow work, diagonal crisscrossed threads create a very subtle shadow, which is highlighted by small stitches. The primary stitch used is herringbone (**cross-stitch**), but shadow work is better described by its appearance than by any specific stitch. Most stitches used in shadow work are flat, lying close to the surface of the underside, which gives a distinctive textural appearance. Shadow work is most commonly seen in **whitework,** but any tone-on-tone or color combination can be used, even red on white. The most common motifs in shadow work are floral with creeping vines and leaves with long tendrils. Jasmine, rose, lotus, and the *buti* or paisley motif are very popular.

Shadow work is also known as *chikankari,* which means "fine work," on the **Indian Subcontinent.** The origins of this name are somewhat obscure, but it is probably a derivative of *chikeen,* a Persian coin or delicately patterned embroidered fabric. Along with the name, the chikankari technique may have also come from Persia, which is Iran and Iraq today. The earliest written records of "flowered muslin" in "Indian" lands were made by Greek travelers in the third century. Shadow work was included in the folklore of both India and Persia and may be included in cave paintings that date back to the fifth century C.E. Chikankari can be traced back to the great Islamic empires of the sixteenth and seventeenth centuries, including Safavid Iran, India, and Turkey. All three empires were affluent and encouraged the development of art and craft. The most probable origin of chikankari was when Queen Noor Jehan, inspired by Middle Eastern embroidery, introduced shadow work to her attendants. Noor Jehan was the wife of Indian Mughal Emperor Jahangir, who ruled from 1605 until 1627. He was succeeded by his son, Shah Jahan, who built the Taj Mahal.

Shadow work can be done in a variety of stitches, with the most important feature that it be visible through sheer fabric. The shadow work stitch is worked on the reverse side of the fabric, on two parallel lines or an open shape, like a leaf. The herringbone stitch alternates back and forth between the lines, crossing on the back side and leaving a clean backstitch outline on the front. The finest shadow work is done in small closely packed stitches.

Shadow work can be done in cotton, rayon, and silk embroidery thread on any fabric that is sheer enough to allow the floss to be seen, including organza, organdy, voile, and batiste. Traditional chikankari includes six basic stitches: herringbone stitch (**chain stitch**), **running stitch,** double backstitch, **buttonhole stitch,** chain stitch, and stem stitch (running stitch). These six stitches are used separately or in combination, creating as many as 32 different variations. An alternate shadow method is called "Indian darning," where the entire motif is worked in backstitch and then thread is woven between the stitches on the reverse side to create the shadow.

Western Europeans and people of the **British Isles** have greatly valued Indian fabrics from Greek and Roman times, with the Romans calling the fine and delicate textiles "woven winds." Over the centuries, many yards of fabric were produced in India and exported to Europe. Fine, white fabrics were symbols of social class, without ostentation. Shadow work flourished in the Indian Mughal Court at Delhi in the sixteenth and seventeenth centuries. It was so favored by the rulers that royal workshops were established where the white, floral embroidery was practiced and perfected. The royal workshops of India and Persia (Iran and Iraq) encouraged the creation of art in paintings, textiles, jewelry, and other objects. Persian floral designs greatly influenced Indian embroiderers, who stitched in more flowing designs than those found in the **Middle East.** Indian embroiderers embellished long, flowing garments for royalty including tunics, sashes, skirts, and veils.

When the Mughal courts disintegrated, artisans scattered during the late eighteenth and early nineteenth century. They settled in the northern city of Lucknow, India, where the light embroidered fabric known as chikankari has been made for more than 200 years. The English were enamored with the flowing white textiles that were exported by the British East India Company. Cross-cultural exchange between Europe and India influenced both chikankari and French whitework embroidery in motifs and technique. Indian artists began to make objects that were desirable to Western tastes including tablecloths, bed linens, pillow covers, and curtains. By the nineteenth century, chikanari embellished table runners, mats, napkins, and tray and tea cozies. The technique of shadow work became popular as a form of Victorian embroidery, used as a decorative trim for collars, blouses, handkerchiefs, lingerie, and christening gowns, joining other types of whitework such as Scottish Ayrshire, Irish Carrickmacross, and German Dresden work.

Although the demand for export embroidery grew, the quality of work declined. Rather than work on their own finely crafted textiles, English merchants expected Indian artisans to embroider machine-made fabric that originated in British factories. Over time, chikankari became a domestic craft practiced by poor Muslim women for survival. With the commercialization of the embroidery industry, quantity was desired, at the expense of skill.

Today, there are approximately one million people involved in the Lucknow, India, chikankari industry. Unfortunately, embroiderers make very low wages and are often mistreated by middlemen and brokers. In the last 25 years, government efforts have made inroads in bettering the lives of the *chikan* workers. They

Skirt or blouse flounce with shadow work embroidery, 1900. KSUM, transferred from the Allen Memorial Art Museum, Oberlin College, Oberlin, Ohio. Gift of Emil Pulver in memory of Helen Foreman, 1980, 1995.17.1660.

seek to ensure fair wages and proper marketing, while improving the quality of the work. Some small firms still practice the traditional chikankari, and they have gained the attention of fashion designers. Fine shadow work is receiving global recognition and is in great demand both within and outside India. In recent years, chikankari has witnessed a revival. Lucknow needleworkers are adapting their craft to better suit the Bombay fashion market and Bollywood films.

FURTHER READING

Chakravarty, Ruth. (2003). Chikan—A Way of Life. Online: http://eurIndia.pc.unicatt.it/english/public_results/missions/Ruth%20Chakravarty.pdf.

Gardner, Beth. (2002). The Sharp Needle. Online: http://www.ega-gpr.org/article_shadow.html.

Hand Embroidery. History of Chikan Kari. Online: http://www.hand-embroidery.com/history-of-chikankari.html.

Heritage Shoppe. (2001). Embroidery Articles—Shadow Work. Online: http://www.heritage-shoppe.com/heritage/stitches/shadowwork.html.

Indian Embroidery Resources. ChikanKari Embroidery. Online: http://www.Indian-embroidery.com/chikankari-embroidery.html.

Root, Rissa Peace. (2004). A Shadow Work Embroidery Primer. Online: http://www.pretty impressivestuff.com/shadowwork.htm.

Shadow Work. (May 15, 2006). Online: http://www.theneedlework.com/shadow-work/.

Southern Stitches. Shadow work embroidery instructions. Online: http://www.southern-stitches.com/hrlmsewing.html.

Shells, Coins, and Sequins

Decoration applied to or incorporated in textiles and clothing. Rather than serve a functional purpose, shells, coins, and sequins are designed to glitter and sparkle. They are forms of **embellishment,** along with seeds, beads, beetle wings, fish scales, **feathers,** teeth, buttons, tin cones, **fringes,** tassels, ribbon, and braids. Prehistoric clothing, textiles, and jewelry were embellished with whole shells, shell beads, and shell discs. Shells, coins, and sequins are part of cultural needlework traditions all over the globe. For over 4,000 years, shells, coins, and sequins have been used as currency, spiritual protection, and a symbol of wealth and pride.

Three of the most important shells used in needlework are cowrie, dentalia, and mother-of-pearl. Abundant in the Indian Ocean, in parts of **Africa,** and in Southern Asia, cowrie shells were widely traded and used as far from the ocean as Tibet. The cowrie's size and shape makes it well suited for attaching to fabric, but its significance is an association with spirituality and magic. The opening of the shell is thought to resemble a woman's body. Associated with motherhood, cowries are often included in a bride's dowry. Women carry or wear cowrie shells to ensure fertility. Cowrie shells are also thought to resemble an eye and are used as beads and talismans to protect against the evil eye.

Native North Americans made jewelry and embellished clothing with dentalia, a horn-shaped ocean mollusk that comes in various sizes. Found in graves dating back to 1800 B.C.E., dentalia shells were highly prized marks of wealth and status. They originated in the northwest coastal region and were widely traded, becoming a frequent decoration for the peoples of the Great Plains. Dentalia were thought to have spiritual power, especially for women. Young girls wore dentalia shell necklaces and widows wore dentalia and stone pendants, which acted as charms and were passed through the family.

The thin coats of crystal inside a shell are called mother-of-pearl. Surprisingly durable, mother-of-pearl can be cut, ground, polished, and drilled. Mother-of-pearl is commonly used for pearl buttons, which are often used purely for decoration. Some of the diverse groups that embellish with pearl buttons are the Pearly Kings of London, England, the hill peoples of Pakistan, and the Haida, Tsimshian, and Tlingit people of the American Northwest Coast. In the Great Plains, Native Americans made "hairpipe" beads from the center of conch shells and used them to create breastplates, pipe bags, and baby carriers.

For at least 400 years, Native Americans used wampum as currency. Wampum were made from purple and white shells, most commonly the quahog clam, whelks, and abalone, which were made into sashes. Wampum beads were rectangular in shape with drilled holes. They were woven into a shell-beaded fabric or strung in complex arrangements. Wampum were used to keep records

and send messages, especially regarding diplomatic treaties. The more predominantly purple the wampum belt, the stronger the message that an agreement was important, serious, or sad. Native use of wampum and shell decoration declined when Western European traders and settlers introduced glass "pony" beads.

Since money was invented in ancient Anatolia (Turkey), coins have been worn as jewelry and sewn onto clothing. In addition to safeguarding valuables, wearing coins displays wealth. Folk costumes for young brides and small children often include shiny objects designed to confuse and avert the evil eye. On children's hats and women's blouses, sparkling and flashing pieces, like coins or **mirrorwork,** are thought to give magical protection. Medallions and metal chains are related to coins, but are generally ceremonial and associated with military power.

Sequins originated in the seventeenth century as small, gold Venetian (Italy) coins. Usually small very thin metal or plastic disks, sequins are lighter than coins and more resilient than glass. Sequins became an inexpensive way to make a costume or textile eye-catching and glamorous. They were called "spangles" in the nineteenth century; Victorian era spangles were smaller than the sequins used from the 1920s onward.

Some of the most fascinating cultural traditions include combining many different embellishments in the same textile. In Bulgaria, Hungary, and other parts of **Eastern Europe** the folk costume includes felted and bead knitted caps, waistcoats, and purses embellished with **embroidery,** fringes, beads, coins, metal

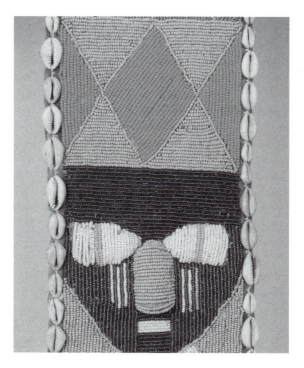

Nigerian mask with cowrie shell decoration. KSUM, gift of Dr. Lotar and Luanna Stahlecker, 2004.31.101.

chains, shells, and buttons. Women's clothing is also decorated with **ribbonwork,** spangles, and long tubular beads. Similar embellishment can be found in the **Eastern Mediterranean** among shepherds in Macedonia and Greece. In **Central Asia,** clothing and other objects are decorated with blue beads and seashells, talismans to avert evil and misfortune. In Afghanistan and Turkmenistan, children's clothing can be decorated with coins, discs, bells, beads, cowrie shells, and sometimes amulet cases containing texts from the *Koran.* In Syria, women often wear headscarves with sequins and coins sewn independently around the edges.

Cowrie shells can be found on *cholis* (blouses), shawls, and neck decorations in India and Pakistan, where they are often combined with rickrack braid, embroidery, and mirrorwork. One of the most interesting uses of embellishment is the *chakla* from the **Indian Subcontinent,** a quilted or appliquéd ceremonial cloth, usually embroidered with eye-dazzling zigzag patterns, which often include cowrie shells and colored sequins. The *kalagas* of Myanmar (Burma) can be described as encrusted with sequins. This unique type of **stumpwork** includes images of people or animals that are padded and embellished with couched cords, glass studs, sequins, and **metallic thread.** In Burma, the Philippines, Indonesia, and Malaysia cowrie shells and mother-of-pearl sequins are used on bags, skirts, and jackets. In many areas of the world, shells, coins, and sequins are used to embellish clothing and textiles, but for purely decorative purposes. In many cases, the symbolism and magic associated with these materials have long since faded away.

FURTHER READING

Giese, Paula (1996). Wampum—Treaties, Sacred Records. Online: http://www.kstrom.net/isk/art/beads/wampum.html.

Gillow, John, & Bryan Sentance. (1999). *World Textiles: A Visual Guide to Traditional Techniques.* Boston: Little, Brown.

Gotstelow, Mary. (1977). *The Complete International Book of Embroidery.* New York: Simon and Schuster.

Khandro.net. (1998–2006). Shells. Online: http://www.khandro.net/nature_shells.htm.

The Oregon History Project (2006). The Oregon Historical Society. Online: http://www.ohs.org/education/oregonhistory.

Single Needle Knitting

An ancient needlework technique that uses a single-eyed **needle** and short lengths of yarn to create a sturdy, elastic fabric. Single needle knitting employs the **buttonhole stitch** to make loops that are built up row by row. Although it appears similar to a

twisted stockinette stitch, single needle knitting does not unravel like **knitting** or **crochet,** since the thread is drawn entirely through each stitch as it is made. The thread is not pulled tight into a hard knot; the stitches are created loosely, often wrapped around a thumb or needle, resulting in a series of interlocking loops. The resulting fabric can be very elastic or quite stiff depending on the stitch and material used.

Practiced in many parts of the world, single needle knitting predates both knitting and crochet. It is slower to produce than those more modern techniques, because the entire length of yarn must be pulled through each stitch. Single needle knitting also requires more skill to produce a fine product. The fabric created by this technique was thick and warm, which made it well suited for cold regions such as **Scandinavia, Western Europe, Central Asia,** and the mountains of **South America.**

This technique is called "single needle" to distinguish it from "true" knitting, which is done on two needles. It is known by many names including pseudo-knitting, cross knit looping, looped fabric construction, needle looping, looped needle **netting,** and fancy buttonhole filling. Next to single needle knitting, the most common name for this technique is *nålbinding.* Of Scandinavian origin, like **Nordic knitting,** the word nålbinding was introduced in the early 1970s. It is made up of two Norwegian words: *nål,* meaning needle, and *binding,* meaning to bind or sew. There are many different spellings of nålbinding, but they all refer to single needle knitting.

Several challenges exist when tracing the origin of single needle knitting. Because natural fibers are perishable, most early examples are merely fragments of fabric. This has been further complicated by archeologists lacking training in the history of needlework, who incorrectly identified single needle knitting as true knitting. This is understandable, given that the single needle method was all but extinct by the time archeological excavations began in the eighteenth century. Because of misidentification and the lack of extant pieces, the true extent of single needle knitting throughout history is unknown.

The oldest positively identified fragment of single needle knitting was found in a cave in the Judean desert, Israel, and dates from 6500 B.C.E. The next oldest was found in Denmark and dates from the Stone Age, around 4200 B.C.E. The majority of early specimens were found in Denmark, although toed sandal socks were found in Egyptian tombs, dating from the fourth or fifth century B.C.E. On the other side of the world in South America, the Nazca peoples of pre-Columbian Peru created intricate human and animal figures on the **fringes** of woven cloths as early as 200 B.C.E. Characterized by frequent color changes, this technique preceded contact with the Spanish by hundreds of years. Other early examples include fragments dating to 200 C.E., which were found in excavations of Dura Europos, a Roman outpost in the **Middle East.**

Single needle knitting is done with a large needle with a blunt end. The first needles were made of antler or bone, but steel tapestry needles work equally well. Using lengths of yarn about 18 inches long, a loop is made in the yarn. The loop is held flat and then the needle is fed through the loop making a buttonhole stitch. The thread is pulled through the loop, but the knot is not tightened, but left loose,

forming a new loop. A cylindrical object, like a finger or a dowel, is often used to keep the tension of the loops even. Pieces of yarn are joined together as the work progresses, forming a chain and then building row upon row of loops.

There are several different types of single needle knitting, ranging from simple to highly complicated. The size of the needle and the yarn determine the gauge. There are at least 30 different stitches, described by the way the needle is threaded through the loops. The more complicated stitches go through more than one of the previous loops and take a variety of paths. Single needle knitting may be made as a flat piece or in the round. Working in the round forms circles and tubes suitable for making socks and mittens. The oldest needle-knitted items are socks, although it was also commonly used for mittens, hats, milk strainers, bags, and fishing nets.

Caps and socks dating from the fourth to the sixth centuries C.E. were excavated from Egypt and acquired by the Imperial Museum of Austria in 1890. The majority of single needle knitted artifacts were made in the Middle Ages (500–1450 C.E.) and come from Scandinavia and **Eastern Europe** along with royal and ecclesiastical tombs scattered through Western Europe and the **British Isles.** Notable examples from the Viking period (793–1066) are mittens from Iceland and a gold mesh hair net or snood from Denmark. A wool sock found in York, England, dates from 970 C.E. The sock was created by single needle knitting and is evidence of Viking influence on the British Isles. Stocking fragments and mittens dating from the tenth and twelfth centuries have been found in Iceland, Finland, Norway, Sweden, Switzerland, Poland, and Russia. Other single needle knitting examples have been found in Italy, Lappland, and on the continent of **Africa.** Native North Americans of southern Arizona and northern Mexico were still using a form of single needle knitting in the 1920s.

One of the most highly developed cultural traditions in single needle knitting can be found in the Nazca culture of ancient Peru. Dating from nearly 2,000 years ago, these textiles are in surprisingly good condition, keeping their color due to the arid climate. Practically all the known Peruvian fabrics come from "mummy bundles" found in coastal graves. Like Egyptians, ancient people in Peru buried their dead wrapped in quantities of cloth.

Single needle knitting was used to create three-dimensional figures that served as fringe or separate braids. Designs were commonly drawn from the natural world, including humans in elaborate outfits and headdresses, animals, and plant motifs. When used as fringe on the four sides of a woven textile, the legs of figures would often be embroidered and then three-dimensional bodies created in single needle knitting. The Peruvian work is remarkable in its fineness and in that each figure differs slightly from the others. These textiles exhibit a complex, active imagery that reflects the culture that created them.

Single needle knitting continues to be practiced in many places around the world, although it is considerably less popular than other types of needlework. It is currently being done in Central Asia, the Middle East, the Pacific Islands, and Southeast Asia including the countries of Iran, New Guinea, and Taiwan. The most complicated

variations are done in Sweden, Norway, Denmark, and Finland. Part of the lack of contemporary practice may be that single needle knitting is quite hard to learn and takes much more time to finish than double needle knitting or crochet.

FURTHER READING

Gallery: Peru comes to Brooklyn. The Brooklyn Museum of Art in New York. Online: http://www.rumbosonline.com/articles/15–88-gallerybrooklyn.htm.

Haymes, Anne Marie (Decker). (2001). What is Nålbinding/ A Brief History of Nålbinding/ Names of Nålbinding. Online: http://www.geocities.com/sigridkitty/.

Hutchinson, Elaine. (1992). The history, origins, construction and use of "needle-binding" with specific reference to the "Coppergate sock" (updated by Hazel Uzzell 2004). Online: http://www.regia.org/naalbind.htm.

Knitting. Online: http://www.alitadesigns.com/knitting.php.

Naalbinding. Online: www.stringpage.com/naal/naal.html.

Naalbinding. (February 21, 2006). Online: http://everything2.net/index.pl?node_id = 1788011.

Reith, Tracy (2001). Knitting throughout the World: A Brief History. Online: http://www.chatteringmagpie.com/writing/368/knitting-throughout-the-world-a-brief-history.

Wikipedia. History of knitting. Online: http://en.wikipedia.org/wiki/History_of_knitting.

Wikipedia. Naalebinding. Online: http://en.wikipedia.org/wiki/Naalebinding.

Smocking

A type of surface **embroidery** worked across pleated fabric. Among embroidery techniques, smocking is unique in that it serves both functional and aesthetic purposes. It provides decoration, while at the same time it controls fullness, which creates shape. Smocking is almost exclusively used on clothing, since it makes woven fabric very elastic and comfortable. The stitching is called smocking, and the traditional blouses on which it was done are called smocks. In the manipulation of fabric, smocking adds texture and color as well as changes the weight of fabric.

Smocking emerged in thirteenth- or fourteenth-century England, where it was used on linen clothing worn by farmers in the countryside. The garment known as a smock evolved from the Anglo-Saxon *smocc*. The smocc was a plain knee-length full outer garment worn over farmers clothing to keep them from getting soiled. The smock was made of between five and eight yards of linen, which was gathered into pleats that were secured with embroidery stitches. The original function of smocking was to provide a way to tightly gather extra material across the chest and shoulders. The layers of cloth and heavy embroidery allowed for fullness that did not restrict movement and at the same time made the smock very durable and hard wearing.

Although the smock is associated with male clothing, peasant women also wore smocked garments. Smocking was incorporated into the female *smicket,* which was a loose garment worn next to the skin. In the nineteenth century, the smicket began to be known by the name chemise. Smickets and chemises were undergarments that were often hidden from view, so the term smock is more often associated with male occupational clothing.

During the eighteenth and the first half of the nineteenth century, smocks came to reflect the increased status of agricultural workers in the **British Isles,** specifically England and Wales. Smocks were embellished on the yoke and sleeves with distinctive patterns that indicated the area from which the farmer originated as well as the wearer's occupation. For example, the smocks of shepherds were embellished with crooks and sheep, while those of gravediggers were covered in crosses. There were three main styles of traditional smocks: the slipover style, which is identical on the front and back; the shirt style with a front placket and buttons; and the coat type, with buttons down the full length of the center front.

Traditional smocks were usually made from twill weave linen or cotton, in natural colors of creamy white to buff. Usually embroidered in a matching color, smocks were also made in blue, green, and brown. The quality of stitching on smocks ranged from

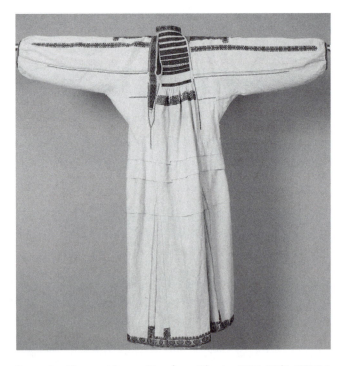

Romanian blouse with smocking from Oltenia, 1925–1945. KSUM, Princess Ileana of Romania Collection, 1987.15.4.

crude homemade garments to fine threadwork done by professionals. A high-quality smock was an important symbol of identity. Smocks made by specialists could cost workers as much as a week's wages. Although very important in earlier times, by the mid-nineteenth century smocks were no longer worn by agricultural workers. The decline of smocks was directly related to the Industrial Revolution. The introduction of farm machinery posed a safety threat to the farmer in his voluminous smock.

There are two main ways of smocking: English and American. Both begin with fabric approximately three times the width of the desired finished product. English or geometric smocking is a two-step process where horizontal rows of dots are marked with regular spacing. A **needle** and thread is passed in and out of these dots and pulled tight so that the fabric is drawn into small, vertical pleats. Using these gathering threads as a guide, embroidery stitches are used to ma-nipulate the pleats to form raised patterns of waves, diamonds, or honeycombs in a variety of stitches including outline, stem (**running stitch**), trellis, double wave, and diamond stitch. In the earliest examples, the same stitch is used from the beginning to the end of each row, but in contemporary smocking, different stitches are used in the same piece. Once the embroidery has been completed, the gathering threads are pulled out and the smocking is steamed into shape.

As fewer men wore traditional agricultural clothing, smocking began to appear on woman's and children's clothing in **Western Europe, North America,** the Pacific Islands of Australia and New Zealand, and South **Africa.** Along with the spread of smocking, a simpler way of creating it also emerged. In what is now known as American smocking, the appearance is the same, but pleating and stitching are done in one step. Like English smocking, dots are marked on the fabric, but over time geometrically patterned fabric, usually a gingham check, was also used as the base. In skipping the gathering stage, the resulting smocked fabric is less elastic and less regular than with the two-step process. American smocking is more common in con-temporary needlework and is usually the type described in commercial patterns.

There are several lesser-known variations of smocking including lattice, counter-change, picture, and grid smocking. Lattice smocking is also known as North Ameri-can or Canadian smocking. In this technique, fabric is gathered in both directions. Lattice smocking is not as elastic as English smocking and is often used to decorate velvet cushions and clothing. Counterchange smocking is worked on even check or striped fabric. Like in American smocking, the lines of the fabric are used as guides, but rather than a creating a geometric pattern, counterchange smocking results in solid bands or blocks. In picture smocking, the pleats are drawn very tightly on the back side to help stabilize the pleats and prevent distortion. The picture is then em-broidered on the front in parallel rows of stitches that create solid shapes and figures.

Continental smocking uses a simple smocked design that is heavily em-bellished with embroidery. Embroidered flowers of bullion **knot stitch,** lazy daisy stitch (**chain stitch**), and French knot stitch are applied randomly over the whole area, often completely covering the surface. Grid smocking is also known as Italian shirring. Rather than creating a pattern on straight pleats, the

fabric is gathered using a grid pattern and the gathering stitches themselves control the fullness of the pleats. Because of the way the stitches are done, grid smocking has no elasticity. It is sometimes also embellished with embroidery.

Along with the tradition of smocking on English agricultural workers' clothing, other smocking traditions can be found around the world. For example, in Holland, linen smocks were highly prized, cherished, and often included in wills. Dutch smocks were made of square and rectangular-shaped pieces that were embellished with embroidery over the pleats on the chest and upper sleeves. In eastern Afghanistan, men wear loose, white cotton shirts pleated and embroidered with black thread. Vertical bands of delicate black stitches are used to tightly pull the fabric into long ridges. Diverse arrays of patterns are created in black and white, often with pink stitching along the neckline.

Although smocks declined in use by farm workers, other English people championed the use of this intricate embroidery technique. Smocking was an important part of the "aesthetic" dresses and tea gowns of women involved in the arts and crafts movement. For example, Mrs. Oscar Wilde and her circle incorporated smocking on their dresses in the 1870s and 1880s. Several dressmakers in London, England, and Paris, France, including Liberty of London, began producing smocked dresses as a specialty during this time.

In the early to mid-twentieth century, there was a resurgence of interest in English smocking for its decorative qualities. Mothers created smocked children's garments for special occasions such as christenings and parties. Smocking rose in popularity in the 1940s when a South African man invented a smocking pleater. The pleating machine can be used on any type of fabric and eliminated the need for the time-consuming marking and gathering of the base fabric. By mid-century, fashion designers and manufacturers combined different fabrics and styles of smocking in maternity dresses, children's clothing, nightgowns, christening gowns, and aprons. Checked gingham was especially popular for children's clothing and household items, such as aprons and curtains.

In the 1960s caftans became a fashion trend. Home sewing patterns for caftans included iron-on patterns for smocked motifs. Haute couture designers have included smocking in a variety of fabrics on finely hand-stitched garments. In the late twentieth century, the Smocking Arts Guild of America (SAGA) was founded with the purpose of "preserving and fostering the art of smocking and related needlework for future generations, through education, communication, and quality workmanship." The efforts of SAGA along with the attractive appearance of delicately pleated and stitched fabric has allowed smocking to continue as a unique way of embellishing and shaping clothing to the current day.

FURTHER READING

Durand, Diane (1982). *Diane Durand's Complete Book of Smocking*. New York: Van Nostrand Reinhold.

The Highveld Smockers Guild. The History of Smocking. Online: http://smocking.org.za/smocking/history.php.

The Museum of English Rural Life. Smocks. Online: http://www.reading.ac.uk/Instits/im/
 the_collections/the_museum/smocks.html.
Schwall, Katherine L. (February 19, 2001). Century Chest Project: Needlework History
 1940–1970. The Embroiderers' Guild of America Rocky Mountain Region. Online:
 http://rocky_mtn_embroidery.tripod.com/.
The Smocking Arts Guild of America (SAGA). Online: http://www.smocking.org/.

South America

The area of the world including, but not limited to, the countries of Argentina, Belize, Bolivia, Brazil, Chile, Colombia, Costa Rica, Ecuador, El Salvador, Guatemala, Honduras, Mexico, Nicaragua, Panama, Paraguay, Peru, Uruguay, and Venezuela. South American needlework is better understood by style than by country. Stretching back 5,000 years, the strongest traditions are found in Middle America and on the west coast. The earliest extant textiles were made by ancient indigenous cultures, including the Maya, Inca, and Aztec. The indigenous people of South America had early contact with Spain and Portugal, and from 1521, when the Spanish finally defeated the Aztec rulers, South America was known as "Latin America."

Some of the oldest needlework in the world was done in South America by the Paracas and Nazca people. The oldest of these, Paracas, flourished in Peru from about 900–400 B.C.E. In 1925, archeologists found embroidered mantles, shirts, loin cloths, capes, and other clothing preserved in funerary bundles. Paracus **embroidery** was worked in pattern darning, a type of **needleweaving.** Designs with possible religious significance in shades of maroon and brown were embroidered with long **running stitches.** Also in Peru, the Nazca culture used **single needle knitting** to create intricate human and animal figures on woven cloths as early as 200 B.C.E. "True" **knitting** may have arrived in Peru and Bolivia with the Spanish conquistadores. Not much is known about other ancient South American needlework because, apart from mummy bundles, few textiles survived.

Indigenous techniques include **embellishments** such as featherwork, beetle wings, pompoms, braiding, and **fringe.** Featherwork is widespread through South America; some of the world's most brilliant plumage is found in the Amazon rain forest. **Sprang** and **knotting** are used for bags, belts, sashes, purses, and shawls. Off the Caribbean coast of Panama, the Kuna people make *mola* blouse panels with **reverse appliqué.** Molas are the result of the arrival of Christian missionaries who required native people to be clothed. Originally, folded calico was wrapped, stitched, and embroidered. The Kuna people developed the mola by interpreting traditional body painting in appliquéd pieces of cloth. In Brazil, African people shared their artistic sensibilities, influencing all types of Brazilian art including symmetrical patterns that resemble African **beadwork.**

In South America, Spanish influence is most evident in ecclesiastical and domestic embroidery. It is thought that Western European settlers introduced **drawnwork** and **pulled threadwork,** but there is evidence of these techniques before contact. In some cases, European techniques became native traditions. For example, Paraguay became known for **lace** made from the aloe plant. From the 1840s until the twentieth century, fine knitted openwork stockings and shawls were made for export. "Sun lace" was another technique, named for the aloe fibers that appeared like sunlight. Sun lace was very intricate, incorporating as many as 12 different variations of the sun motif. A lace collar could take weeks to complete.

Western European design is evident in the large floral motifs. Some of the Spanish settlers brought textiles with them to the New World. These embroideries served as inspiration, and in some cases, were copied exactly. In the mid-nineteenth century, **Berlin work** charts were used as patterns by South American embroiderers. Embroidery is most prevalent on clothing, but also decorates religious hangings, domestic linens, and stitched pictures. In the more heavily European-influenced areas, such as Argentina, girls made **samplers.** Motifs, color schemes, and materials differ greatly by region.

South American embroidery ranges from a limited palate of red and blue to bold primary colors. Worked on cotton in cotton, silk, or wool thread, South Americans stitch floral, spiral, and geometric designs. **Satin stitch** is the most popular, but backstitch, **chain stitch, cross-stitch,** needleweaving, and running stitch are all used. Bullion **knot stitch** and **ribbonwork** are major components of Brazilian embroidery. Some South American embroidery features ancient motifs like the Aztec

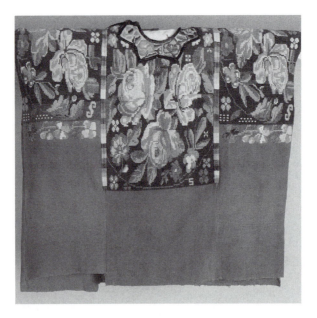

Berlinwork-like floral patterning on Guatemalan *huipil* blouse.
KSUM, gift of DeVoe M. Ramsey, 1998.93.15.

two-headed snake-bearing eagle, also seen on the Mexican flag. Folk costume sometimes includes traditional pre-Christian images of devils, spirits, and monsters.

In many areas of South America, both men's and women's folk costume was embroidered. Traditional male dress included a heavy cotton shirt with decoration around the neck opening or across the yoke. The shirt was worn with drawstring waist pants and a sash. Women's square-cut blouses or *huipils* were made from a folded piece of cotton fabric with a vertical slit at the neck and the side seams sewn. Huipils have extensive decoration worked across the front yoke. They are worn tucked into tube-shaped skirts that are secured at the waist. Many South American people have adopted Western dress and customs, but there are some notable exceptions.

Among the Huichol people of Mexico, women embroider shirts, trousers, bags, and belts for the men of their family. The Nebaj women of Guatemala wear a heavily embroidered huipil with a shawl, a red and yellow striped skirt, and a woven belt or sash. The shawl is draped over one shoulder or used to sling a baby. Elaborate headdresses are wrapped into the hair. In the High Andes of Argentina, Chile, Colombia, Ecuador, and Venezuela, alpaca, llama, and vicuña hair is used to knit soft garments for men and women. Men record their marital and social status on hats and belts they knit. The traditional hat or *chullo* consists of intricately patterned bands depicting animals, birds, and lettering in bright dyed and naturally colored wools. In Ninhue and Isla Negra, Chile, women create colorful stitched pictures with a random satin stitch punctuated by chain stitch and French knot stitch. Chilean embroideries depict colorful scenes of everyday life in a painterly manner. The Ninhue embroidery project started in 1971, establishing a center to provide local women with lessons, fabric, and wool. The outcome has been **needle** paintings that record family heritage, documenting important events and people in these women's lives.

FURTHER RESEARCH

Earnshaw, Pat. (1982). *A Dictionary of Lace.* Bucks, UK: Shire Publications.

Gillow, John, & Bryan Sentance. (1999). *World Textiles: A Visual Guide to Traditional Techniques.* Boston: Little, Brown.

Gotstelow, Mary. (1977). *The Complete International Book of Embroidery.* New York: Simon and Schuster.

Harris, Jennifer. (1999). *5000 Years of Textiles.* London: British Museum Press.

Kennett, Frances. (1995). *Ethnic Dress.* New York: Facts on File.

Traje en Guatemala. Online: http://www.rutahsa.com/traje.html.

Sprang

An ancient method of interlinking, interlacing, or intertwining parallel stretched threads that are fixed at both ends. Similar in appearance to **netting,** sprang has

great elasticity in its width and length. Sprang differs from braiding and other types of **plaiting** in that both ends are secured while it is being worked. Rather than crossing threads over each other, they are twisted on a frame with the top and the bottom of the fabric created simultaneously in mirror image. Sprang is one of the oldest needlework techniques and has been practiced in a wide range of geographic areas.

Because of its ability to stretch, sprang was widely used for functional everyday clothing before the development of knitting. It was useful for creating caps, hoods, bonnets, hairnets, snoods, mittens, stockings, sleeves, scarves, collars, capes, sashes, and drawstring bags. Because of the utilitarian nature of these items, they were well used and not treasured as textile artifacts. In fact, it was not until the nineteenth century and the discovery of sprang in archeological sites that it was recognized as a separate and distinct form of needlework. Many museum objects that were wrongly classified as **knitting** or **lace** have now been correctly identified as sprang.

The word sprang is of Scandinavian origin and was used to describe any openwork textile, but has come to specify the stretched-thread intertwining technique. Along with sprang, this technique has been called Egyptian plaiting, twine-plaiting, knotless netting, frame plaiting, loom braiding, and *linkning*. It is called sprang in English and Swedish, *bregding* in Norwegian, *slinging* in Danish, *Egyptisch vlechtwerk* or *vlechten* in Dutch, and *stäbchenflechterei* in German.

Sprang is created by manipulating a set of threads stretched between two beams or on a rectangular frame. No hooks or **needles** are used, but small sticks may be set in to prevent the work in progress from unraveling. The pattern is created from the top and the bottom and meets in the middle where it is finally secured. Images on ancient Greek and Italian pottery that were originally identified as tapestry or **embroidery** frames are most probably those used for sprang. Traditions of sprang has been recorded in North **Africa,** the **Middle East, Central Asia,** the **Indian Subcontinent, Eastern Europe, South America,** and **North America** including the countries of Egypt, Syria, Libya, Persia, Tunisia, Afghanistan, India, Pakistan, Estonia, Finland, Yugoslavia, Peru, Venezuela, Colombia, Mexico, Guatemala, and the United States.

Sprang was practiced in the Neolithic period and spread southward at the start of the Iron Age. The earliest extant examples of sprang have been found in Denmark, Egypt, and Peru. In 1871, a wool hairnet was found in an oak coffin burial in Denmark and dated to the Early Danish Bronze Age, 1400 B.C.E. At almost the same time, archeologists working on Coptic graves in Egypt discovered bags and caps made of wool and linen sprang dated to about 500 B.C.E. Excavations in Peru found evidence of an early version of sprang dating to 1100 B.C.E. Woolen sprang and **single needle knitting,** braids, **fringes,** and cloths from the late Paracas and Early Nazca period were made before 900 C.E.

Although widely practiced across time and distance, many of the cultures who created textiles with sprang techniques did not keep records of their

accomplishments. After the discovery of sprang in archeological digs in the nineteenth century, sprang traditions and artifacts began to gain recognition. One example is military sashes in a diagonal sprang pattern that were very popular in the late eighteenth and early nineteenth century. These sashes were called *faja* in Spain and were worn by military generals as a sign of rank. Similar sashes in brightly colored silk were worn in Holland, Denmark, Germany, and France. This tradition came to Canada and the United States; George Washington wore a red silk sprang sash about 1779.

In 1882, Coptic artifacts made from sprang were brought from Egypt to Austria. They inspired a rope-making factory near Vienna to make sprang hammocks. A copy of ancient sprang was made and shown at the Paris World Fair of 1889, where it led to an increased interest both in making sprang and recognizing sprang production in **Western Europe.** In the 1890s, villagers in the Ukraine were found to be making traditional women's caps with sprang. Similar traditions in other parts of Eastern Europe and **Scandinavia** were found for making headdresses, scarves, and belts in the Caucasus, Romania, Czechoslovakia, Yugoslavia, Croatia, and Denmark. Sprang was practiced in these areas into the 1950s.

Sprang traditions have also been found among Native North American tribes. Some examples are woolen scarves made by the Winnebagos of Wisconsin and the Hopi wedding sash. Sprang is also used to make belts and elaborately patterned silk drawstrings for trousers in Pakistan on the Indian Subcontinent.

A tradition that still continues today is the use of sprang in South America, specifically Guatemala, Colombia, and Mexico. In these areas, sprang is sometimes done on a backstrap loom or portable frame. The most common items are hammocks and bags. The word hammock is derived from a native word, *hamaca,* meaning fishing net. Colombian artisans make sprang hammocks that are exported all over the world. A small shopping bag called a *mechita* continues to be made and used in Colombia. The traditional agave fibers have now been supplanted by synthetic materials.

Overall, the practice of fine sprang work has been lost to history. Items such as caps, socks, and gloves are now almost exclusively created with knitting. In recent years, some fiber artists have rediscovered sprang and use it to create decorative hangings.

FURTHER READING

Barber, E.J.W. (1991). Prehistoric textiles. *The Development of Cloth in the Neolithic and Bronze Ages with Special Reference to the Aegan.* Princeton, NJ: Princeton University Press.

Collingwood, Peter. (1974). *The Techniques of Sprang.* New York: Watson-Guptill.

Gillow, John, & Bryan Sentance. (1999). *World Textiles: A Visual Guide to Traditional Techniques.* Boston: Little, Brown.

Harris, Jennifer. (1999). *5000 Years of Textiles.* London: British Museum Press.

Regia. Sprang. Online: www.regia.org/sprang.htm.

Santa Cruz Handweavers. Sprang. Online: www.santatcruzhandweavers.org/anneblinks/sprang.html.

◉

Stumpwork

A complicated form of **embroidery** and **appliqué** that is characterized by three-dimensional motifs. In stumpwork, or raised embroidery, elements are made on foundations of horse hair, cotton, wire, and small molds. From the fifteenth and sixteenth centuries, raised embroidery embellished ecclesiastical garments in **Eastern** and **Western Europe,** including Italy, Germany, Hungary, and Czechoslovakia. Yet the term stumpwork is most often associated with English ladies. For a short time in the late seventeenth century, stumpwork boxes, cabinets, mirrors, and frames showcased needlework skills that went far beyond those of making **samplers.** Girls sometimes as young as eleven years old worked masterpieces in fine silk and **metallic threads.** Stumpwork pieces often became part of a girl's dowry and an important document to be passed on to future generations.

Raised embroidery is also known as raised work, embossed work, cut canvas work, and embroidery on the stamp. It did not receive the name "stumpwork" until the 1890s. Stumpwork may relate to the foundation used, thus embroidering "on the stump." In early seventeenth-century England, pieces of canvas embroidered in tent stitch were pressed into shape with heated irons. The hollows were filled up with cut-up silk and paste. Sometimes elements were padded with hair or wool, carved wooden foundations, beads, pearls, and heavy silver metallic threads. By the end of the seventeenth century, padded scrolling plant and flower designs were known as "embosted work." The French word *estompe* means embossed.

Another possible origin is related to the word "stamp," thought to refer to designs copied from popular prints or stamped on fabric. Another possibility is that the name is derived from "stump drawing," which used a small eraser to soften harsh pencil marks. Today, needleworkers use the terms three-dimensional, dimensional, stumpwork, and raised work to describe both the seventeenth-century technique and more modern variations, such as Brazilian embroidery (see **knot stitch**).

The first raised embroidery was done by professionals who created *"brodees en relief"* on satin church vestments. They enhanced their silk and metallic thread embroidery with padded biblical figures. A notable example dates from 1487. Made in Czechoslovakia, this violet-colored satin chasuble includes the Virgin Mary and St. Wenceslas surrounded by angels. As with many other types of needlework, raised embroidery did not remain exclusive to the church. In 1545, eleven-year-old Princess Elizabeth I made a book binding in raised work. By the late 1500s, embroiderers added wooden molds covered with **needle lace**. It was at this time that many different styles of needlework merged, culminating in stumpwork.

Stumpwork embroidery had an immense but short popularity in England between 1650 and 1700. Most stumpwork designs centered on biblical and

mythological scenes with plants, animals, castles, and figures. Motifs also reflected a growing interest in Western Asian design in the seventeenth century, prompted by expensive imported Chinese and Japanese lacquerware, ceramics, painted and embroidered cottons, and silks. Some stumpwork designs appear to be from the same source. Needleworkers copied engravings purchased from traveling drafts-men and pieces worked by others. They may have been able to purchase the pat-tern already drawn out on fabric. For the most part, stumpwork was domestically designed, often including motifs that were out of proportion with one another.

In its height of popularity, stumpwork covered boxes, mirror frames, and wall hangings. Treasured velvet book bindings and book cushions embellished with jewels, pearls, beads, and gold metallic threads were kept in embroidered bags and cases. Once a girl had mastered the stitch sampler, she would move on to raised work. Stumpwork pieces often have an innocent appearance, with figures sometimes dressed as little dolls. They include shoes, hats, ruffled collars, and skirts that can be lifted up to show a petticoat. The finest details received atten-tion including soft sculptured or painted faces, plaited human hair, and posed hands. Stumpwork pieces were a sign of female accomplishment, often carrying the embroiderer's initials and year in small pearl beads.

Stumpwork describes many different techniques and materials including **nee-dlepoint,** needle lace, and embroidery stitches over wooden beads and wire. It was generally done on thick white silk satin or velvet with cotton, silk, wool, and metallic threads. Stumpwork was enhanced with **beadwork,** silver **lace,** spangles, sequins, metallic coils, seed pearls, and jewels. Padding materials included wool, fabric, leather, hemp, parchment, cardboard, and wire for elements that stood away from the base fabric. The most important stumpwork stitches are **button-hole stitch,** bullion knot stitch, **couching,** tent stitch (see **needlepoint**), **chain stitch,** and backstitch (**running stitch**).

Fine stumpwork was never widely practiced in **North America.** There is one early example of a frame made by Rebekah Wheeler, a 19-year-old from Con-cord, Massachusetts, in May 1664. It includes a biblical scene and some beads, but less padding than seen in English stumpwork. In general, American colonists had limited access to fine embroidery materials. Since colonists raised sheep and spun wool, American raised work concentrates on wool, sometimes known as plush or **Berlin work.** Whether from a scarcity of materials, a change in fashion, or the difficulty of keeping intricate dimensional scenes clean, stumpwork was virtually unknown by the early eighteenth century.

There are two notable examples of cultural traditions that use raised elements in Southeast Asia and **Africa.** In Myanmar (Burma), elaborate hangings known as *kalagas* include padded figures of humans and animals embellished with couched cords, glass beads, sequins, and metallic thread. Neck decoration on the Hausa robes of Nigeria is embellished with raised elements made from needle lace and stumpwork. All but forgotten for two hundred years, American needle artists are rediscovering raised embroidery. New designs combine traditional techniques with

modern motifs and materials. Contemporary stumpwork often includes more time-effective elements such as larger motifs, thicker threads, and coarser fabrics.

FURTHER READING

Davies, Janet M. (2000). Stumpwork Embroidery. Online: http://www.jmddesigns.co.nz/stphis.htm.

Diehl, Liz Turner. Stumpwork. Online: http://www.kaleidostitch.com/.

Lewandowski, Dianne E. (2002). Raised Work—Stump Work, a Confusion of Terms. Online: http://www.heritageshoppe.com/heritage/essays/raisedwork.html.

Shinn, Catherine. Stump Work. Online: http://www.catherineshinn.com/acatalog/stump_work.htm.

Wallis, Branwen Madyn. Elizabethan Raised Embroidery. Online: http://moas.atlantia.sca.org/oak/15/eliz.htm.

Whiteworks. Stumpwork. Online: http://www.white-works.com/stumpwork.htm.

Tambour

A type of **chain stitch embroidery** worked with a tambour hook or **needle** on fabric stretched taught on frame. Although originating on the **Indian Subcontinent,** the **Middle East,** and **Central Asia,** it gets its name from the French word "tambour" or drum, which the tightly stretched background material resembles. It is a quick method of covering large areas of fabric with embroidery and was the precursor to the technique of **crochet,** sometimes known as crochet tambouring. The frame, hook, and needlework are all referred to as tambour.

The tambour frame is generally round and similar to those used for embroidery, although the hoops are often large to accommodate the size of the piece being worked. The original frames consisted of two hoops of wood, one fitting into the other, between which the fabric was stretched. A very fine metal hook is screwed into a hollow handle, usually made of ivory or bone, which holds varying sizes of hooks. The size of the hook required corresponds to the thickness of the thread and can be as thin as a sewing needle.

The hook is held in the right hand above the frame, while the left hand under the frame controls the continuous thread. The hook is pushed up through the tightly stretched fabric, brings the thread to the top in a loop, and then goes down and up again, creating a continuous line of chain stitches. The rapid upward and downward movements of tambour work inspired the mechanism that led ultimately to the invention of the sewing machine.

Chain stitch is one of the oldest of the embroidery stitches, and its creation with a small hook was first practiced in India, where the tambour hook is called

an *ari* and the design is worked without a frame. Chain stitch embroidery done with a hook originated with Indian leather workers who embellished leather belts. Eventually the hook technique was adapted to create a fine chain stitch on fabric. Credited with originating this technique, the Mochi cobbler caste of Kutch in northwest India used the ari to embroider skirts, blouses, and temple hangings in silk thread on satin. Traditional designs created by professional embroiderers included parrots, peacocks, flowers, *buti* or paisley, and human figures.

The finest Mochi embroidery was created in the late nineteenth and early twentieth century for wealthy landowners. Over time, the Mochi patrons declined in wealth and moved to Bombay. By 1947 traditional Mochi embroidery had virtually disappeared. Another tradition for hooked embroidery was on the west coast of India, where Goa embroiderers created quilts of bleached white cotton decorated with tamboured chain stitch in yellow silk floss. This type of embroidery was a well-developed art when the Portuguese arrived in Goa in the early sixteenth century. Goa was a Portuguese colony until 1962, and its embroidery was greatly influenced by Christianity and by Portuguese aesthetics. European-style hunting scenes with men on horses or elephants pursuing deer, birds, or other game were popular with tourists.

With culture contact, finely embroidered objects traveled north from India, Persia (Iran and Iraq), and Turkey on trade routes. English Queen Elizabeth I's wardrobe records included small white caps decorated with tambour work. Early European tambour work was done in French and Italian cloisters for church textiles, thus acquiring the name "nun's work." The hook embroidery technique, practiced on a hoop, reached the rest of **Western Europe** and the **British Isles** in the eighteenth century.

The height of tambour work in France, England, and the United States was between 1780 and 1850, when embroidered white muslin dresses, collars, cuffs, caps, fichus, and small capes were popular. Patterns for **whitework** were available in women's magazines by the early nineteenth century. Tambour work was worked in cotton and, sometimes, crewel wools. High-quality French home furnishings, dresses, and accessories were tamboured in silk on a satin ground. Tambour work was also done in fine silver **metallic thread** and silver wire. In 1834, a Paris, France exhibition unveiled a machine that could produce tambour stitches many times faster than could be done by hand. Hand tambour work continued to be practiced, but declined in popularity after that.

There are some exceptions. Near Lyons, France, muslin drapes continued to be worked by hand into the early twentieth century. Peasants in Valencia and Majorca, Spain, traditionally did tambour work in blue wool on linen for headscarves, bed linens, and table sets. The practice declined in the nineteenth century, but was revived in the early twentieth century. The original work filled in areas with chain stitch, but now **cross-stitch** is used.

Two forms of **lace** created by the tambour method worked on a foundation of net are Coggeshall and Carrickmacross. In the nineteenth century, embroidered lace production became a cottage industry in England and Ireland. The chain stitch on net was especially popular for wedding veils in the British Isles and **North America.** Tambour work is an important traditional needlework technique

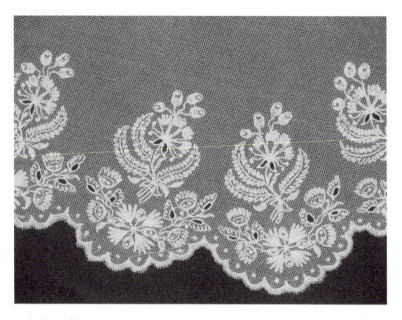

Irish lace collar made with tamboured chain stitch, 1830. KSUM, gift of Kathy Nyer, 1989.12.3.

in the Middle East and Central Asia, including Persia (Iran and Iraq) and Turkey. In the area around Bokhara, Uzbekistan, cotton hangings and coverlets called *suzanis* are finely stitched as part of a bride's dowry. Suzanis feature richly colored carnations and pomegranate blossoms in chain stitch and **couching.**

Tambour beading is a method of attaching beads to fabric for luxury clothing and decorative fabric. This type of **beadwork** is sometimes called Lunéville after a town in France where the technique originated in 1867. Beads, sequins, mirrors, silk thread, chenille yarns, braids, and gold and silver metallic threads can all be attached with the hook. From 1860 to the present day, the House of Lesage has been using the tambour hook to add embellishments to haute couture clothing. Needlework enthusiasts from around the world travel to Paris, France, to take classes with Lesage's master embroiderers.

FURTHER READING

De Dillmont, Thérése. (1996). The Complete Encyclopedia of Needlework (3rd Ed.). Philadelphia: Running Press. (First published by Dollfus-Mieg Company, France, in 1884.)

Fukuyama, Yusai. (1997). *Tambour Work.* Berkeley, CA: Lacis.

Gillow, John, & Bryan Sentance. (1999). *World Textiles: A Visual Guide to Traditional Techniques.* Boston: Little, Brown.

Gotstelow, Mary. (1977). *The Complete International Book of Embroidery.* New York: Simon and Schuster.

Hatanaka, Kokyo. (1996). *Textile Arts of India.* San Francisco: Chronicle Books.

Swan, Susan Burrows. (1977). *Plain and Fancy: American Women and Their Needlework, 1700–1850.* New York: Rutledge.

White, Palmer (1988). *Haute Couture Embroidery: The Art of Lesage.* Paris: Vendome Press.

Tatting

A **lace**-like needlework made by **knotting** with a shuttle and thread. Knots and loops form picots, which are then drawn into circles and semicircles. Designs are produced by different arrangement of these motifs. The same effect can be created with a **needle** and thread, which is known as needle tatting. Traditionally, the term tatting refers to the technique and the textile created with a shuttle. It is known as *frivolite* in French, *frivolitet* in Swedish, *occhi* (eyes) in Italian, *schiffshenarbeit* (shuttle) in German, and *karriko* in Finnish.

Because of its open appearance, tatting is frequently confused with **crochet,** but it is a separate technique. Rather than interlooping threads, tatting is more closely related to other knotted needlework such as **macramé** and **netting.** Tatting progresses quicker than handmade **bobbin lace** or **needle lace.** It can be done with a variety of materials including cotton, silk, and **metallic threads.** It is commonly used for edgings on underclothing, home furnishings, and ecclesiastical textiles and was very popular in Victorian times.

The technique of tatting was widespread throughout the world including **Western Europe, Central Asia,** and **Western Asia.** Because of its geographic range, there is some dispute as to its origins. Although some sources trace tatting as far back as the fifteenth century, the commonly held belief is that it evolved from knotting, which was practiced in Western Europe and the **British Isles** beginning in the late seventeenth century. In the 1690s, Chinese textiles embellished with areas of small **knot stitches,** known now as the Forbidden stitch, reached Europe. Rather than creating motifs with individual knots, Europeans took lengths of thread, knotted them at quarter-inch intervals, and couched the pre-knotted material onto fabric. Thread wound on a shuttle was easier to manipulate into a knot than thread wound in a ball. Knotting shuttles were about six inches long, much longer than those used for tatting. Shuttles were highly embellished and were a way to demonstrate wealth.

Knotting was especially popular among ladies at English and French courts, and there is written and visual evidence to support this. Some examples are Sir Charles Sedley's 1707 literary skit, *The Royal Knotter,* which is believed to refer to Queen Mary (wife of William III), Sir Joshua Reynolds's (1723–1792) portrait of the Countess of Albemarle, P. Rotari's 1742 portrait of Princess Kunigunde with knotting bag, and a newspaper account of Madame de Pompadour losing her

shuttle in 1765. Other notable royal knotters were Queen Maria Teresa of Austria and Queen Marie and Queen Carmen Sylva of Romania, who followed a fashion of having tatted furnishings in their private chapels. Queen Anne of England was also known for her tatting, and the flower of the cow-parsley, which resembles tatted work, is known as Queen Anne's Lace.

Gradually, the knotting technique evolved from a series of knots into rings or picots, which could be used for edgings and trimmings, but the word tatting does not appear in English literature before 1842. Because of the lack of early documentation of the word tatting and differences in appearance between knotting and tatting, some researchers believe that tatting is a completely separate form of needlework that came about on its own.

Regardless of its evolution, tatting became very popular in Europe and the United States in the mid-to-late nineteenth century. Evidence of the extent of tatting in this period include a set of needlework books published in New York in 1843 containing tatting, the introduction of tatting as a cottage lace industry during the Irish Potato Famine of 1847, the awarding of the grand prize for tatted work at the 1851 Great International Exhibition, and the highly intricate tatted pieces displayed at the Centennial International Exhibition in Philadelphia in

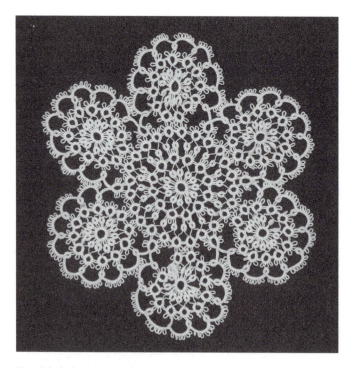

Tatted doily, late nineteenth to early twentieth century. KSUM, Silverman/ Rodgers Collection, 1983.1.2338.

1876. The popularity of tatting waned with the close of the nineteenth century, and there were minor revivals in the early twentieth century, but for the most part it was dormant from the World War II period until the end of the century, when needleworkers began to be interested in the technique again.

The modern tatting shuttle is no more than three inches long, much smaller than the knotting shuttle. It is has a short central column on which the thread is wound, covered by two boat-shaped pieces, pointed and curved towards each other at the ends. The closeness of the ends enables the shuttle to pass smoothly through the loops of thread without catching. Tatting shuttles can be made of polished bone, tortoise shell, steel, and plastic. Using the shuttle, cow-hitches or lark's head knots are created on a running loop, which is then pulled up to make a ring or picot. The same stitch is used over and over to form the pattern. Some popular tatting patterns include the English stitch, French stitch, pearl edging, shamrock stitch, and hen and chickens.

Tatting can also be created with a needle and a long length of thread. This is called needle tatting or Dutch needle tatting. The same cow hitch or lark's head stitch is done, only with a tapestry needle instead of a shuttle. Needle tatting is considered easier to work because the stitches slip off the needle to form the rings or picots. The shank of the needle and the end with the eye must be of the same diameter to facilitate slipping the stitches. Needle tatting allows for a greater variety of materials such as fluffy, textured, and metallic threads or beads, which do not work as easily with the shuttle.

FURTHER READING

Auld, Rhoda, L. (1974). *Tatting: The Contemporary Art of Knotting with a Shuttle*. New York: Van Nostrand Reinhold.

Chang, Europa. (1996). A History of Lace. In J. C. Turner and P. van de Griend (Eds.). *History and Science of Knots,* pp. 347–379. Singapore: World Scientific Publishing.

De Dillmont, Thérése. (1996). The Complete Encyclopedia of Needlework (3rd Ed.). Philadelphia: Running Press. (First published by Dollfus-Mieg Company, France, in 1884.)

Nicholls, Elgiva. (1962). *Tatting Technique and History.* London: Longacre Press Ltd. (1984). New York: Dover.

Rusch-Fischer, Dan. (2001). Tatting Myths Dispelled. Online: www.tribbler.com/tatman/myths.html.

Whiting, Gertrude. (1971). Old-Time Tools and Toys of Needlework. New York: Dover. (Unabridged and unaltered republication of the work originally published by Columbia University Press, New York, in 1928 under the title *Tools and Toys of Stitchery.*)

Tunisian Crochet

Derived from the basic method of **crochet,** a technique where all the stitches of a row are placed simultaneously on a long hook rather than being worked one loop at

a time. The Tunisian crochet method closely resembles **knitting,** resulting in a dense fabric with a definite front and back side. A large wooden hook, known as an Afghan hook, is used. It is similar to a crochet hook, but has the same thickness throughout its length and a knob at the end. Tunisian crochet can be made solid or with open-work spaces and is well suited for multicolored patterns. The variety of stitches is not as wide-ranging as in ordinary crochet, but the regularity of the stitches makes Tunisian crochet an interesting background fabric for **cross-stitch embroidery.**

Tunisian crochet is known by many different names including Afghan crochet, tricot crochet, hook knitting, Tunisian knitting, and Shepherd's knitting. It has sometimes been called railroad knitting, supposedly named for English working-class girls who crocheted while waiting for the train to take them to the mills. Although the technique is the same, different names were used through history and in various parts of the world. For example, Tunisian crochet is called "tricot crochet" in France and *hakking* in Norway.

The exact origins of both the technique and name of Tunisian crochet are unknown. It may have evolved from hooked knitting, a type of knitting practiced in **Africa** and **Central Asia,** including Egypt, Afghanistan, and Tunisia. Hooked knitting utilizes two long **needles** with hooked ends. It has also been thought that Tunisian crochet may have evolved as a simple method for sailors and shepherds to make clothing. There is clear evidence that it was practiced in **Western Europe** and the **British Isles** by the mid-nineteenth century. Tunisian crochet was included in many Victorian era publications. For example, an 1882 publication offered instructions for two *couvrepieds* (French for "foot covers") in Tunisian crochet. It was very popular in Norway, especially in coastal areas, from the nineteenth century through the 1920s. Tunisian crochet has been somewhat overlooked in **North America.** Most early books were published in Europe, and American needleworkers were not generally aware of the diversity of stitches that could be made.

Tunisian crochet is created in a two-step method. The first is known as the "forward": The loops are gathered on the hook working from right to left. The second step is known as the "return": Loops are connected to each other and dropped off the hook. The front of the piece always faces the stitcher. Since the crochet is done both forward and backward, there is no need to turn the piece around. Tunisian crochet can result in a fairly stiff fabric. Larger hooks, one to three sizes larger than for normal crochet, are used to soften the end result.

In terms of pattern and design, the most important factor is the foundation stitch. The appearance, texture, and gauge of the stitch can all be varied based on the technique used to form the foundation of the piece. Variations of Tunisian stitches are created based on where the hook is inserted, how the loops are treated once pulled up, and how they are worked off the hook. Some of the longer afghan hooks have cables on the end that take the weight off the hook and facilitate a more even tension.

Two challenges in Tunisian crochet are curling and pulling. The work tends to curl at the edges and pull slightly to the left. There are special stitch techniques that can be employed to reduce curling, and the finished piece can be dampened and

blocked into shape before its final use. The tight, dense stitches of Tunisian crochet produce a soft, elastic fabric that is well suited for keeping the cold out. The two-step method adds another layer of insulation, which is useful for winter apparel such as mittens, hats, cardigans, shawls, scarves, shirts, undergarments, and baby booties. It is especially effective for outerwear, blankets, and bed coverings.

An interesting intersection of different types of needlework is found in Tunisian crochet and cross-stitching. The fabric formed by Tunisian crochet has regular "squares" that can be used for counted motifs and lettering. A variety of yarns can be used, including crewel or tapestry wool, rayon, silk, or cotton floss. It is important to use enough floss to cover the area sufficiently and avoid bunching. The threads should lay very flat and not create excess bulk. Doing the cross-stitches a little looser than on a woven fabric helps compensate for crochet's stretch. Stitches are made so they are invisible on the back side, slipping the needle between the crocheted loops, rather than pushing it all the way through the base fabric. Doing Tunisian crochet in an intarsia, or double-sided color pattern, is also very popular. Patterns can be created by seamlessly changing colors while working from a graph.

FURTHER READING

Bagatell. Hakking: An Obsession. Online: http://www.spellingtuesday.com/archive-2002–03.html.

Chez Crochet. Tunisian Crochet 101. Online: http://www.chezcrochet.com/page0002.html.

De Dillmont, Thérése. (1996). *The Complete Encyclopedia of Needlework* (3rd Ed.). Philadelphia: Running Press. (First published by Dollfus-Mieg Company, France, in 1884.)

Heritage Shoppe. (2001). Tunisian Crochet Basic Stitch. Online: http://www.heritageshoppe.com/heritage/stitches/Tunisian.html.

Kurr, Elizabeth. (January/February 2004). The Riddle of Tunisian Crochet. *PieceWork* 12(1), 60.

Petit, Sandra. (2005). Tunisian Crochet—Afghan Stitch: Tunisian Crochet. Crochet Cabana. Online: *http://www.crochetcabana.com*.

Stanziano, Dee. (2006). Get to Know Them: The Different Types & Techniques of Crochet. Online: http://members.aol.com/crochetwithdee/typesof.html.

Wikipedia, the free encyclopedia. Tunisian crochet. Online: http://en.wikipedia.org/wiki/Tunisian_crochet.

Western Asia

The area of the world including, but not limited to, the countries of China, Japan, Korea, Taiwan, and Tibet. Needlework of Western Asia, especially **embroidery,** is heavily influenced by Chinese motifs and techniques. Chinese embroidery reached Korea and Japan as early as the fifth century, along with **couching,**

metallic threads, and **satin stitch.** Over the centuries, each country developed individual cultural needlework styles from these common roots. Chinese embroideries also influenced needlework of the **Middle East** and **Western Europe,** traveling along the Silk Road. The Chinese were the first to discover the secret of sericulture or silk production. Silk may have been used for as long as 12,000 years, but the commonly held legend of its discovery dates from 3000 B.C.E.

Regardless of its exact date of origin, China's silk needlework was coveted and emulated by the rest of the world. Some of the oldest extant Chinese textiles are "longevity" and "token" embroideries, indicating that a high level of technical development existed 2,000–3,000 years ago. Examples of **chain stitch** on a silk ground fabric have been found in tombs from the Warring States period (475–221 B.C.E.). From the earliest times, both religious and spiritual symbolism embellished Chinese and Western Asian textiles. Buddhism came to China from India and is prevalent in the region. Religion is evident in the *kesi,* a **patchwork** shawl worn by Buddhist monks as a symbol of poverty. The Ainu, an indigenous group from the northern Islands of Japan, believed that the placement of certain **running stitch** designs around the neck, sleeve openings, and hem of a garment prevented evil spirits from entering the body.

Japanese embroidery traditions go back at least a thousand years. Embroidery was introduced to Japan by Korean artisans around the same time that Buddhism arrived. At first, embroidery was used for religious ceremonies, then court costumes, and later it became part of Japanese culture. Korean embroiderers decorated screens, costumes, and domestic linens. There were four main types of embroidery in Western Asia: costume, royal, artistic, and religious. The most notable Chinese embroideries reflect the cultural importance of the Imperial court rather than the geographical divisions.

Embroidery is the dominant form of needlework in Western Asia, although there are traditions for many other techniques including **appliqué,** patchwork, braiding, **punch needle,** tassels, sequins, **shells, needlepoint, mirrorwork, knotting,** and **lace.** Appliqué was used for costume items, such as collars for court officials. Women of the hill tribes traditionally decorate their costume with appliqué, **reverse appliqué,** and embroidery with silk braids. Similar to **ribbonwork,** Chinese braid embroidery uses one or two colors of silk braid couched in pleated triangular or zigzag designs. *Bunka shishu* or Japanese punch embroidery uses delicate rayon thread and a punch needle. Needlepoint on fine gauze is found in China and Japan. Silk and metallic threads were worked in tent stitch to create bird designs and geometric patterns on costume and accessories. Other **embellishment** on Western Asian textiles includes tassels, shells, and beads.

Following the Chinese Boxer Rebellion of 1900 to 1911, nuns, missionaries, and teachers introduced lacemaking to help poor people earn a living. **Crochet,** filet **lace** (see **netting**), **drawnwork, bobbin lace,** and **needle lace** were made for export to Western Europe and the **British Isles.** Chinese workers were paid very low wages, and English lacemakers complained about the unfair competition from China in 1907. Improved machines eventually ruined hand lacemaking in China.

Silk is the dominant fiber used in Western Asian embroidery, but metallic threads, wool, flax, cotton, ramie, and hemp are also used. Chinese and Japanese

embroideries are world-renowned for their closely worked stitches in fine thread. The most common stitches in Western Asia are satin stitch, couching, long and short stitch, Pekin or Chinese **knot stitch, cross-stitch,** double-sided satin stitch, Peking stitch, a form of interlaced backstitch (running stitch), and **needleweaving.**

The five traditional colors are blue, yellow, red, white, and black. Western Asian embroidery is often done in a variety of colors, although polychrome designs are also seen, usually in red or blue. Rural people traditionally use cotton thread on indigo-dyed cloth. Using the running stitch or cross-stitch, aprons, jackets, and children's clothing reflect folk culture. This is especially seen in **quilting** on Japanese fishermen's coats, a symbol of occupational pride.

The most famous and characteristic Chinese embroideries were worked for the emperor's court in Peking before the Revolution of 1911. Court embroideries included costume decoration, hangings, and cushions created by highly skilled men and women. Excellent examples can be seen in eighteenth-century "Dragon Robes," which include the five-clawed *lung* dragons and sun motifs. Symbolism is very important in Chinese embroidery, with the lung dragon reserved for the Imperial family. Birds and other animals in satin stitch and couched gold metallic thread signified civil and military rank. Western Asian textiles feature flowers, birds, butterflies, and fish along with mythological creatures, abstract geometric motifs, and symbols.

Traditionally, brides would embroider or commission finely embellished robes and accessories, even footwear. Floral patterns sometimes included messages. Other trousseau items, such as pillowcases, were embroidered with symbols of good luck. Chinese decorative knotting often include the swastika knot, designed

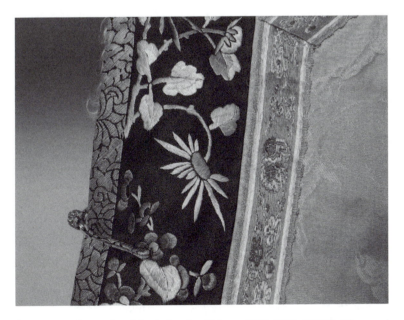

Fine satin stitch motifs on Mandarin robe. Chinese, 1875–1899. KSUM, Silverman/ Rodgers Collection, 1983.1.811.

after the ancient Buddhist motif, symbolizing the Buddha's heart, power over evil, and accumulation of good fortune. Chinese knots are used to express wishes for good fortune and wealth, the joys of matrimony, and religious ideals. Chinese children's clothes are also decorated with best wishes for happiness, health, and avoidance of evil spirits. An interesting embroidery tradition is the Nü Shu women's language. Messages in stylized Chinese characters are communicated through cross-stitches surrounded by dots.

Unfortunately, the fine embroideries ever present in Western Asian costume greatly declined in the twentieth century. During the Republic of China period (1912–1949), needlework dropped off, but was revived by embroidery centers established in the 1950s. Japanese needlework has continued to thrive, boosted by a culture that values aesthetic beauty and cultural treasures. Japanese embroidery is popular among enthusiasts, and lessons are taught in the United States. Contemporary fiber artists throughout the world travel to Japan to learn from masters. Korean needlework has largely disappeared with modernity. Recent efforts seek to document the history and method of traditional techniques before they are lost from the Korean historical narrative.

FURTHER READING

All about silk. Online: http://www.asianartmall.com/AllAboutSilk.html.

A Brief History of Japanese Embroidery. Online: http://www.japaneseembroidery.com/About_ Us/about_us.html#A%20Brief%20History%20of%20Japanese%20Embroidery.

Chung, Young Yang. (2005). *Silken Threads: A History of Embroidery in China, Korea, Japan, and Vietnam.* New York: Harry N Abrams.

Gandvi, Dai, and Youmin, Guo. Chinese Embroidery. Online: http://artisticchinesecreations. stores.yahoo.net/embroidery.html.

Gotstelow, Mary. (1977). *The Complete International Book of Embroidery.* New York: Simon and Schuster.

Harris, Jennifer. (1999). *5000 Years of Textiles.* London: British Museum Press.

Marlatt, Rae. Bunka Embroidery: Painting with Thread. Online: http://www.thesophisticated stitcher.com/art2001/bunka.php.

Tamura, Shuji. (1998). *The Techniques of Japanese Embroidery.* Iola, WI: KP Books.

Wikipedia. Korean embroidery. Online: http://en.wikipedia.org/wiki/Korean_embroidery.

Western Europe

The area of the world that includes, but is not limited to, Belgium Italy, France, Germany, the Netherlands, Portugal, and Spain. Among the most prominent needlework techniques in Western Europe are **embroidery** and **lace,** although

there are also traditions for **crochet, knitting,** and **Berlin work.** Through exploration and conquest, Western Europeans greatly influenced needlework in **North and South America.** The most well-known contemporary embroidery house is Lesage, which began in mid-nineteenth-century Paris, France. Since then, Lesage has produced fine **beadwork** and **ribbonwork embellishment** for four generations of major fashion designers. Western European needlework is closely related to that of the **British Isles.**

Evidence of Western European needlework dates back to prehistoric times. French archeologists found beads of stone and animal teeth made as early as 38,000 B.C.E. One of the oldest European embroideries is the Bayeux "tapestry." Documenting the Norman Conquest in the late eleventh century, the Bayeux is not a tapestry at all, but wool embroidery on a linen ground. Stitched by a team of embroiderers in about 1077, the Bayeux tapestry is 230 feet long and includes **chain stitch,** split stitch, and **couching.** Although made in what is now England, the Bayeux Tapestry is a significant example of early European needlework.

The Catholic Church was an important patron of Western European needlework beginning in the tenth century. Some of the finest ecclesiastical embroidery was stitched by male professionals from the middle of the thirteenth century to the middle of the fourteenth century. In later years, Catholic nuns created intricate ecclesiastical textiles in **whitework.** "Nun's work" was the starting point for both lace and crochet. The innovations developed by these skilled needleworkers led to **drawnwork,** then **cutwork,** and by the Renaissance, nuns were stitching "in the air," which came to be known as lace.

The origins of many Western European embroidery traditions come from the **Middle East** and north **Africa.** As a result of Moorish (Morocco) invasions, the Crusades, and cross-cultural trade, Turkish and Islamic floral designs were adopted by Western European needleworkers. Embroidery styles for both religious and secular objects followed the Spanish and Portuguese to the New World from the sixteenth century on. Western European techniques were disseminated throughout the world by settlers, who adapted them to local materials and motifs, becoming cultural traditions of their own. For example, among the Quiché people of Guatemala, designs taken directly from embroideries brought by Spanish settlers can be seen on folk clothing. In a similar acculturation process, European embroidery techniques can also be found in the **Eastern Mediterranean** and Southeast Asia, including the Greek Islands, Indonesia, and the Philippines. When French settlers introduced clothing to Panama, the Cuna people tranferred their traditional body painting designs onto *mola* blouses using **reverse appliqué.**

The most prominent Western European embroidery techniques are **blackwork,** couching, **cross-stitch,** cutwork, drawnwork, **knot stitch, metallic threads, pulled threadwork, tambour,** and whitework. Western Europeans also practiced crochet, knitting, **macramé, needlepoint, smocking,** and trapunto **quilting.** Embroidery was used for both ecclesiastical purposes and for household linens. Many variations of embroidery techniques were demonstrated on **samplers.** The fashion for samplers began in the seventeenth century and spread throughout Western Europe and the

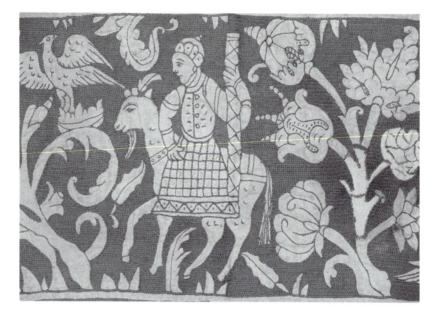

Fragment of secular embroidered furnishing fabric from Spain, 1650–1699. KSUM, transferred from the Allen Memorial Art Museum, Oberlin College, Oberlin, Ohio. Charles F. Olney Fund and anonymous gift in honor of the 80th birthdays of Mr. and Mrs. Clarence Ward, 1965, 2006.11.46.

British Isles, becoming especially popular in the Netherlands, England, Germany, and Spain. Samplers were practiced until the beginning of the twentieth century.

Lace is a Western European invention that emerged in the fifteenth century. Most laces are named by their places of origin. Because of fluctuating boundaries, laces from the current countries of Belgium and the Netherlands are known as Belgium, Brussels, Flemish, and Dutch. Both **needle lace** and **bobbin lace** were made in this area, often with parts of the process performed by different women under the supervision of a master. The Netherlands were important for producing fine flax, which was used for both bobbin and needle laces in the seventeenth century. Torchon is a bobbin lace made with heavy flax thread in the eighteenth and nineteenth centuries. It was produced commercially in Belgium, France, Italy, Sweden, and Spain. Torchon received a reputation for being coarsely made and was sometimes called "peasant" lace. This is in contrast to the many fine laces produced in Western Europe, such as Alençon, the "queen of lace."

Alençon is a town in Normandy, France, that became famous in the sixteenth century for its cutworks. In 1665, it was chosen as one of the main centers for the development of the French lace industry. Alençon emerged as a distinctive meshed needle lace about 1717. Alençon lace had a sharp, firm texture that was achieved by heavy cording, which supported the entire design. Its most complicated forms were made prior to the French Revolution in 1789, but its reputation was revived in the early nineteenth century by Napoleon I.

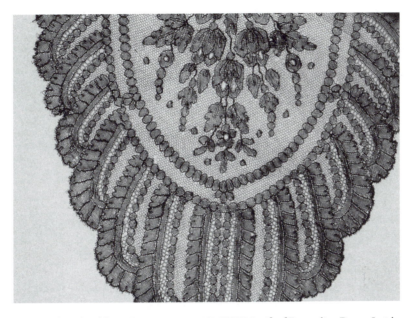

Chantilly lace shawl from France, 1850–1860. KSUM, gift of Evangeline Davey Smith, 1991.11.73.

At his coronation by the pope in 1804, Napoleon wore a cravat and collar made of Alençon lace. A bedcover and canopy of Alençon lace was ordered for the Empress Josephine, but unfortunately she never was able to use it. In 1809, Napoleon pushed Josephine out of their marriage because he wanted a royal heir. The 20 square yards of lace were completed when he married his second wife, Marie-Louise, in 1810. The Alençon lace pattern included a border of lilies of France and swarmed with bees, the symbol of Bonaparte. After Napoleon's defeat and banishment in 1815, Alençon languished until 1830 when the disestablishment of the Spanish convents brought lacemaking nuns to France. In the 1860s, Alençon created some very expensive pieces including a dress and flounces bought by Napoleon III for his wife, Empress Eugenie. The Russian aristocracy was also fond of Alençon, ordering wedding dresses, handkerchiefs, fans, and parasols. The royal patronage of French lacemaking ceased with the fall of the Second Empire in 1870, although more ordinary pieces continued to be made. Machine-made lace seriously damaged the hand lacemaking industry in the 1880s. Lacemaking is still taught at the workshops in Alençon, by nuns, and small commercial items are produced.

FURTHER READING

Alençon Lace. Online: http://www.ville-alencon.fr/dentelle/anglais/Sommaireanglais.htm.
Alita Designs. Early Embroidery. Online: http://alitadesigns.com/early_embroidery.php.
De Dillmont, Thérése. (1996). *The Complete Encyclopedia of Needlework* (3rd Ed.). Philadelphia: Running Press. (First published by Dollfus-Mieg Company, France, in 1884.)
Earnshaw, Pat. (1982). *A Dictionary of Lace*. Bucks, UK: Shire Publications.

Gillow, John, & Bryan Sentance. (1999). *World Textiles: A Visual Guide to Traditional Techniques.* Boston: Little, Brown.

Gotstelow, Mary. (1977). *The Complete International Book of Embroidery.* New York: Simon and Schuster.

White, Palmer (1988). *Haute Couture Embroidery: The Art of Lesage.* Paris: Vendome Press.

Whitework

A general term for white **embroidery** on white material, used to describe color, rather than technique. Included in whitework are various types of embroidery including **drawnwork, pulled threadwork, cutwork, needle lace, appliqué, netting, macramé, candlewicking, shadow work,** and **tambour** work. Whitework may be done on coarse to fine fabrics, ranging from opaque linen to net. It relies on a stark contrast between light and dark with stitches to provide surface texture. Embroiderers all over the world have produced beautiful whitework in many distinctive styles, often combining several techniques in the same piece.

Egyptians embroidered with white thread on bleached linen fabric, and extant whitework has been found in Coptic tombs. Whitework using small **knot stitches** was done in China before recorded time. From **Western Asia** and the **Middle East,** whitework techniques traveled to the **Indian Subcontinent.** It is in India that the finest whitework traditions have their roots. Cotton is indigenous to India, and fine lightweight muslins were starched and embroidered in Madras, Delhi, Calcutta, and around the Ganges River. When the Portuguese entered India at the turn of the sixteenth century, Vasco de Gama returned with a white embroidered canopy made in Bengal.

Whitework's range is wide, through both time and geographical region, with traditions include the **running stitches** on quilted *kanthas* of Bangladesh, clothing in **Africa** and **Central Asia,** Western European **needleweaving** or darning **samplers,** folk costume in **Eastern Europe,** and domestic linens created in the **Eastern Mediterranean** and Southeast Asia. There are three main techniques used in whitework: openwork, cutwork, and needle lace. The main stitches include **satin stitch, chain stitch,** backstitch, **stem stitch (running stitch),** and herringbone (**cross-stitch**) in both counted thread and curvilinear patterns. Within the category of openwork are drawnwork and pulled threadwork, where elements are manipulated or removed to create a pattern, including Hardanger and Hedebo from **Scandinavia** and Ayreshire from the **British Isles.**

Rather than relying on the geometric grid of the warp and weft threads, cutwork allows for various shapes to be removed from the ground fabric with the raw edges finished in **buttonhole stitch.** Cutwork includes *reticella* and *broderie anglaise,*

and Italian reticella is the link between embroidery and true **lace.** In reticella, large amounts of background are cut away and the open spaces are filled with bars made of buttonhole stitch. Over time, the background fabric was completely discarded and free-form buttonhole stitch bars began to form needle lace.

The oldest examples of Western European whitework are twelfth-century altar cloths from Germany. In the thirteenth and fourteenth centuries, ecclesiastical whitework was done in Switzerland, Italy, and Scandinavia. European white-on-white embroidery began in convents, where nuns raveled threads from linen cloth to use for embroidery because they could not afford silk and gold **metallic threads.** Some of the pieces may have been created for nobility, who then donated them to the church. Similar embroideries were worked in color, but white symbolized the purity of the Virgin Mary and was predominant for altar cloths. Large whitework church hangings also served as veils that separated the altar and the choir from the congregation.

Secular designs in geometric patterns that reflected the Moorish (Morocco) tradition and Islamic art from the Middle East and Africa entered Western Europe through Spain. By the fifteenth century, stylized motifs filled with textural repeat patterns were popular for table linens, towels, and curtains. Whitework begins to appear on secular clothing in the sixteenth century, when it was used to embellish the visible edges of shirts and chemises. Over time, increasingly open whitework patterns led to the development of needle lace.

Whitework embroidery on a semitransparent ground spread very quickly through Western Europe and the British Isles, beginning in the seventeenth century. Worked by both domestic and professional embroiderers, whitework

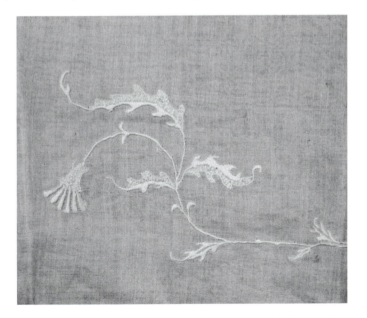

Whitework embroidery on U.S. pillowcase, 1900–1925. KSUM, gift of Martha McCaskey Selhorst, 1996.58.431.

was popular for clothing and accessories including shirts, underclothes, bed pillows, coverlets, baby clothes, shawls, and dresses. Some notable styles of whitework stitched on net or gauze include Irish Carrickmacross and Indian *chikan* work. Carrickmacross developed as a cottage industry in the first quarter of the nineteenth century as a white gauze appliquéd on net. Much older than the European forms, chikan work from India is white-on-white shadow work on sheer muslin. Done on the Indian Subcontinent for centuries, chikan work employs herringbone stitch (cross-stitch) done on the back side of the fabric. The stitches, coupled with other openwork techniques, result in an interesting contrast between dark and light.

In the nineteenth century, machines, including the Schiffli machine, were developed. Over time, these machines were improved to imitate fine whitework and lace, making it difficult to distinguish between hand and machine stitches. Whitework continues to be practiced at home, often for weddings and christenings as well as by enthusiasts of Scandinavian embroidery. As is the case with other forms of needlework, contemporary whitework is often coarser in both fabric and stitch than its predecessors. Fine hand whitework continues to be done in limited quantities by skilled professionals in Hong Kong (Western Asia), Madeira (Africa), the Philippines (Southeast Asia), and Venice, Italy.

FURTHER READING

Earnshaw, Pat. (1982). *A Dictionary of Lace*. Bucks, UK: Shire Publications.

Gillow, John, & Bryan Sentance. (1999). *World Textiles: A Visual Guide to Traditional Techniques*. Boston: Little, Brown.

Gotstelow, Mary. (1977). *The Complete International Book of Embroidery*. New York: Simon and Schuster.

St. George, Aldith Angharad. (Summer 2000). Whitework. Filum Aureum. The West Kingdom Needleworkers Guild. Online: http://www.bayrose.org/wkneedle/Articles/Whitework. html.

Whiteworks. Online: http://www.white-works.com.htm.

Bibliography

Clabburn, Pamela. (1976). *The Needleworker's Dictionary.* New York: William Morrow.

Coss, Melinda. (1996). *Reader's Digest Complete Book of Embroidery.* Pleasantville, NY: Reader's Digest.

De Dillmont, Thérése. (1996). *The Complete Encyclopedia of Needlework* (3rd Ed.). Philadelphia: Running Press. (First published by Dollfus-Mieg Company, France, in 1884.)

Earnshaw, Pat. (1982). *A Dictionary of Lace.* Bucks, UK: Shire Publications.

Embroiderers' Guild of America, Inc (EGA). Online: http://www.egausa.org.

Emery, Irene. (1980). *The Primary Structures of Fabrics.* Washington, DC: The Textile Museum.

Gillow, John, & Bryan Sentance. (1999). *World Textiles: A Visual Guide to Traditional Techniques.* Boston: Little, Brown.

Gotstelow, Mary. (1977). *The Complete International Book of Embroidery.* New York: Simon and Schuster.

Harbeson, Georgiana Brown. (1938). *American Needlework.* New York: Bonanza Books.

Harris, Jennifer. (1999). *5000 Years of Textiles.* London: British Museum Press.

An Introduction to Textile Terms. (1997). Washington, DC: The Textile Museum.

Kennett, Frances. (1995). *Ethnic Dress.* New York: Facts on File.

The National Needlearts Association. Online: www.tnna.org.

Ryan, Mildred Graves. (1979). *The Complete Encyclopedia of Stitchery.* Garden City, NY: Doubleday & Company.

Whiteworks. Online: http://www.white-works.com.htm.

Whiting, Gertrude. (1971). *Old-Time Tools and Toys of Needlework.* New York: Dover. (Unabridged and unaltered republication of the work originally published by Columbia University Press, New York, in 1928 under the title *Tools and Toys of Stitchery.*)

Wikipedia, the free encyclopedia. Online: http://en.wikipedia.org.

Wilson, Erica. (1973). *Erica Wilson's Embroidery Book.* New York: Charles Scribner's Sons.

Index

Page numbers in **boldface** type refer to main entries.

About the Author

CATHERINE AMOROSO LESLIE is an Assistant Professor in The Fashion School at Kent State University where she teaches History of Costume, History of Textiles, Fashion Merchandising, and workshops in the Needle Arts.